ART AND AUTHENTICITY

ART AND AUTHENTICITY

Edited by Megan Aldrich and Jos Hackforth-Jones
With essays by Megan Aldrich, David Bellingham, Jonathan Clancy,
Lis Darby, Natasha Degen, Anthony Downey, Sophie von der Goltz, Jos Hackforth-Jones,
Barbara Lasic, Noël Riley, Bernard Vere and Morgan Wesley

Lund Humphries in association with Sotheby's Institute of Art

First published in 2012 by Lund Humphries in association with Sotheby's Institute of Art

Lund Humphries
Wey Court East
Union Road
Farnham
Surrey GU9 7PT
UK

Lund Humphries
Suite 3-1
110 Cherry Street
Burlington
VT 05401-3818
USA

www.lundhumphries.com

Lund Humphries is part of Ashgate Publishing

Sotheby's Institute of Art
30 Bedford Square
Bloomsbury
London WC1B 3EE
UK

Sotheby's Institute of Art
570 Lexington Avenue, 6th Floor
New York
NY 10022
USA

British Library Cataloguing in Publication Data

Art and authenticity
 1. Art--Philosophy. 2. Art--Expertising
 I. Aldrich, Megan Brewster
 701-dc23

Library of Congress Control Number: 2012938618

ISBN: 978-1-84822-098-0

Megan Aldrich, Jos Hackforth-Jones, David Bellingham, Jonathan Clancy, Lis Darby, Natasha Degen, Anthony Downey, Sophie von der Goltz, Barbara Lasic, Noël Riley, Bernard Vere and Morgan Wesley have asserted their right under the Copyright, Design and Patents Act, 1988, to be identified as the Authors of this work.

Designed by David Preston

Printed in Spain

Contents

08 Introduction *by* Jos Hackforth-Jones and Megan Aldrich

Part 1: Material Authenticity

22 **1.** Attribution and the Market: The Case of Frans Hals *by David Bellingham*

38 **2.** A Dialogue of Connoisseurship and Science in Constructing Authenticity:
 The Case of the Duke of Buckingham's China *by Morgan Wesley*

50 **3.** A Venetian Sixteenth-century Costume Book as an Authentic
 Visual Record *by Sophie von der Goltz*

62 **4.** The Authenticity of Traditional Crafts: The Case of Ernest Beckwith
 by Noël Riley

72 **5.** Acquiring and Displaying Replicas at the South Kensington Museum:
 'The Next Best Thing' *by Barbara Lasic*

88 **6.** Authentic the Second Time Around? Eduardo Paolozzi and Reconstructed
 Studios in a Museum Environment *by Bernard Vere*

Part 2: Conceptual Authenticity

100 **7.** Authenticity, Originality and Contemporary Art: Will the Real Elaine
 Sturtevant Please Stand Up? *by Anthony Downey*

108 **8.** Issues of Authenticity in Contemporary Design: The *Smoke* Series by
 Maarten Baas *by Lis Darby*

122 **9.** Creating an Authentic Style: John Soane's Gothic Library at Stowe
 by Megan Aldrich

138 **10.** 'Authentic' Identities: Cross-cultural Portrayals in the Late Eighteenth
 Century *by Jos Hackforth-Jones*

154 **11.** Passing the Buck: Perception, Reality and Authenticity in
 Late Nineteenth-century American Painting *by Jonathan Clancy*

166 **12.** National Authenticity on Display? Exhibiting Art from Emerging Markets
 by Natasha Degen

176 Notes

194 Further reading

202 Index

Acknowledgements

This book arose from Megan Aldrich's long experience and understanding of the distinctive approaches employed at Sotheby's Institute of Art. As Morgan Wesley's chapter makes clear, any discussion of authenticity, particularly material authenticity as we have defined it, owes much to the history and heritage of the Institute and its many inspirational teachers.

In addition to the authors, a number of colleagues have made enduring and rich contributions to this text not only during initial discussions and seminars in 2009–10, but also at a research retreat in 2010. We thank Elisabeth Bogdan, Chantal Brotherton-Ratcliffe, Anne Farrer, Iain Robertson and Marcus Verhagen, all of whom in different ways gave us fresh insights. Kathleen O'Neill made substantial contributions to our understanding of authenticity in relation to the Pre-Raphaelite painters' use of literary and visual sources. James Malpas's imaginative paper on authenticity and Japanese armour reminded us of the potentially wide reach of this subject.

We must express particular thanks to David Levy, President of Education at Cambridge Information Group, for a series of stimulating, thought-provoking, and occasionally challenging discussions surrounding the concept of authenticity and its application to the world of art, especially in the areas of contemporary and African art. David has pushed us to think much harder about authenticity, and to question commonplace assumptions, and for this the book, and we, are greatly in his debt.

In New York we thank Lesley Cadman, Director of Sotheby's Institute of Art New York, for her support and collaboration. Jos Hackforth-Jones thanks her parents, Paul and Susan Hackforth-Jones for first stimulating her interest in this subject.

Both editors are enormously grateful to Helen Rees-Leahy, who read and commented on a draft of the introduction and whose insights enabled us to move towards a clearer exposition of the arguments. Any lapses or mistakes are, of course, our own. Lucy Myers, Managing Director at Lund Humphries, gave us helpful feedback on structuring and ordering the text. We thank her for this and for her ever-patient and positive collaboration.

We must thank a number of staff at the Institute for their assistance, including Heidi Rasmussen, Simon Rudd, Gemima King and Julia Shapley. The editors would also like to thank the following: Peter Funnell, Alexandra Ault, Adrian Le Harivel and Judith Prowda.

Finally, Hannah Sunter has worked efficiently and effectively not only to collect and caption photographs, but also to present a clear and clean manuscript to Lund Humphries, thus earning their commendations and our gratitude. We are most grateful for her continued enthusiasm and dedication to this project.

MA and JH-J

Introduction

by Jos Hackforth-Jones and Megan Aldrich

Questions of authenticity in relation to art have greatly exercised the public imagination in recent years both within the art world and, more broadly, within the popular press. This interest has been demonstrated by higher-than-expected attendance at a number of exhibitions (some of which have been highly contentious) addressing material, as well as conceptual, authenticity and privileging connoisseurship and the processes of attribution and authentication.

At a fundamental level, understanding the concept of material authenticity when applied to art involves acquiring knowledge of the physical condition of art objects. Beginning with empirical observations about the materials, techniques, condition and configuration of an artwork, to establishing a date and an attribution by means of such observations in conjunction with available documentation, the art expert, researcher or connoisseur aims to attribute works of art to specific periods and regions of production, and to suggest an artist, designer or maker. This process can be fraught with difficulties. Provenance can be extremely helpful, as can other forms of contextual information, along with a knowledge of how objects were restored, altered and reproduced over time, as well as when they came into and went out of fashion. Understanding conceptual authenticity is a more subtle and complex process. Some of the chapters in this book lead the reader toward a consideration of more abstract questions: what is the relationship between authenticity and originality; can the notion of authenticity be applied to subject matter and/or style; what constitutes either inauthentic or authentic presentation and display of artworks; is the copy or replica less authentic than the original; and, finally, can an object be materially authentic but conceptually inauthentic?

The intense levels of debate surrounding certain attributions can arouse much public interest since they may involve enormous sums of money and, on occasion, lawsuits. This debate has been showcased in recent exhibitions at the National Gallery, London in 2010 and 2011, and in an exhibition of 2010 held at the Victoria and Albert Museum in London and curated by the art and antiques unit of Scotland Yard, who deal with art fraud in Britain. This exhibition generated so much public interest that it had to be extended. In France, examples of a more conceptual approach to authenticity include '*Seconde Main*' (or, 'Second Hand') at the Musée d'Art Moderne in Paris in 2010, which focused on the reappropriation of copying by modern and contemporary artists.[1]

In the press, interest and excitement around such exhibitions tends to relate to the detection of fraud and echoes the public fascination with market forces and the frequently large sums of money at stake in the reattribution of an artwork.[2] Media perception of the public's interest in such matters centres around the notion that people take a certain satisfaction in seeing experts fooled. Arguably, this fascination is heightened by museums' own traditional coyness about such matters. The exhibitions mentioned above, therefore, make a refreshing change and offer a glimpse behind the façade of cultural authority. Added to the 'whodunit?' focus of the exhibitions might be the public's interest in the aesthetic qualities of the 'inauthentic' work. This phenomenon posits value as a function of aesthetic success as, for example, with respect to the *Etruscan Warrior,* a famous fake owned by the Metropolitan Museum of Art in New York; it applies equally to the *Amarna Princess* by Shaun Greenhalgh, the so-called Bolton Forger, which was exhibited at the Victoria and Albert Museum in 2010. Therefore, if the art establishment does not authenticate a work, or, worse still, declares it a fake, does it then also appear to withhold permission for the public to derive enjoyment from the work? In other words, to what extent does the construction of authenticity by a recognised authority determine public enjoyment of an artwork?

In the 'academy' – a term which, in this context, denotes tertiary institutions of learning and cultural institutions such as museums – interest is located around issues of quality and the task of determining the authenticity of an artwork via the processes of connoisseurship and ascertained provenance, contextual understanding and, more recently, technical and scientific testing. One chapter in this book, by Morgan Wesley, explores the way in which scientific materialism in the modern age – that is, since the late nineteenth century – has sought proof of authenticity via the most up-to-date technical and scientific processes. Most recently, IT specialists have begun to develop computer programmes intended to authenticate artworks, although it remains to be seen whether such methods will stand the test of time. Moreover, such

processes need to work in concert with connoisseurship in order to achieve meaningful results. These are all means by which the cultural authority of a work of art may be constructed. However, this approach has been challenged by contemporary artists who understand the concept of authenticity in a different way, as demonstrated in Anthony Downey's chapter on the postmodern artist Elaine Sturtevant.

This book, then, will explore themes and definitions of authenticity as applied to a wide range of artworks drawn from different historical periods. Beginning with connoisseurship as a cornerstone for assessing material authenticity, we then move on to consider empirical and quasi-scientific analysis, before finally engaging with more philosophical and theoretical understandings. The essays quickly move beyond the question of 'What is a fake?' towards more subtle and nuanced understandings of authenticity. This book ultimately suggests that there are many kinds of authenticity, given the complex circumstances surrounding the creation and afterlife of works of art.

Connoisseurship and authentication

The *Oxford English Dictionary* defines a connoisseur as 'a person with a thorough knowledge and critical understanding of a subject'.[3] Connoisseurship, 'with its suggestion of interiorised understanding',[4] had by the 1970s become associated with the dilettante and also, perhaps, with the notion that, being subjective, it cannot easily be taught. Much art history over the last forty years has reacted against this tradition of connoisseurship. Since the 1950s a number of scholars, including Edgar Wind and Erwin Panofsky, have engaged in a critique of some of the approaches associated with authenticating artworks – namely, connoisseurship and attribution. From the 1970s academic interest in this subject waned, but more recently there has been renewed interest in the field both within the academy as well as in the public sphere, as we shall see in the following case studies.

Connoisseurship, then, is one long-established way of validating the material authenticity of an artwork. Embedded within the idea of connoisseurship are the vital processes of attribution and authentication which are an integral part of the work of museum curators and dealers. These processes can have a profound impact on the art market, as seen in the chapter by David Bellingham on the connoisseurial debate surrounding works attributed to the Dutch artist Frans Hals. The role of the connoisseur is to attribute authorship, validate authenticity and appraise quality. The strengths of this approach, as well as its pitfalls, were demonstrated in the exhibition 'Close Examination: Fakes, Mistakes and Discoveries' at the National Gallery in London in 2010. In the accompanying publication, *A Closer Look: Deceptions and Discoveries*, Marjorie E. Wieseman outlined the manner in which contemporary connoisseurship works in conjunction with art historical, contextual and technical research. Together they can be extraordinarily effective in determining authenticity. This was a courageous exhibition, for the National Gallery reattributed works, in some cases de-authenticating them – and, by implication, devaluing them. What is now considered an 'ambitious attribution' of a portrait acquired in 1845 and attributed to Hans Holbein the Younger was, after a close formal and technical examination, thought to be a misattribution; surprisingly, this ultimately led to the resignation of the gallery's curator at the time, Charles Lock Eastlake.[5] Subsequent archival information and scientific testing confirmed the nineteenth-century mistake.

Various understandings of what it means for an artwork to be authentic affect both cultural and monetary appraisal systems of artworks, particularly with respect to Old Master paintings. Art market professionals and collectors together with, on occasion, museum curators are frequently intent on validating art objects not only as autographic but also as prototypal works by the artist. A case in point is the art market, which particularly values works that are autographic and thus can be securely attributed to a particular artist, as well as works that are prototypal – that is, both typical and considered primary examples of that artist's *oeuvre*. The National Gallery's exhibition, then, reminded us that museums are both the bastions and the gatekeepers of authenticity. Replications, whether by studio apprentices or copies made at a later date, are currently considered of fractional market value, although the issue is more complex in relation to contemporary art, as we shall see.

A recent case study: authenticating Leonardo da Vinci

[On] visiting a friend in Switzerland, he opened a drawer and found himself looking at an unframed drawing of a young girl in profile, wearing Renaissance costume; 'my heart started to beat a million times a minute. I immediately thought this could be a Florentine artist. The idea of Leonardo came to me in a flash ... but I dared not speak the L-word.'[6]

Is it wishful thinking 'to attribute an unsigned drawing with no signature or substantial provenance to one of the greatest masters of the Renaissance'?[7]

The drawing referred to is of a young woman with her hair and clothing in a style fashionable in Renaissance Milan, where Leonardo da Vinci was based during the 1490s (fig. 1).[8] It first came to light in a Christie's sale in New York of January 1998, where it was catalogued as 'German school early 19th century' and sold as the 'property of a lady' for $21,850, a high price for an unknown drawing of the German school.[9] It was bought by a New York dealer who exhibited it in 2007 with a label stating that it was based on paintings by Leonardo da Vinci and may have been made by a German artist. The dealer, Peter Silverman, who purchased it in 2007, followed a conventional process of authentication once he had formed his own view of the drawing. The process typically evolves in three stages. In the first stage the owner (or dealer) shows the work to a restorer in order to assess the degree to which restoration has obscured the original work.[10] In other words, stage one involves establishing its physical authenticity. In the case of this drawing, it emerged that it had undergone little subsequent restoration.

The second step in the process of authentication is to ensure the support of a recognised expert – generally a member of the 'academy' – in order to endorse the work. One expert became convinced that the drawing was by Leonardo and advised Silverman to progress to the next, or third, step of having a detailed technical analysis made of the work. In the event, Silverman had both the pigments and the vellum analysed. Both were dated between 1440 and 1650, thereby confirming

that the drawing could have been made during Leonardo's lifetime, although a forger could certainly have reused an old piece of vellum. The drawing lacks a provenance, or established history of ownership, which is usually helpful in supporting authenticity. In March 2008 it was shown to Martin Kemp, Emeritus Professor of the History of Art at the University of Oxford, and a distinguished Leonardo da Vinci scholar. After a thorough examination of the work and an analysis of the drawing, composition, iconography and pigments, Kemp gradually became convinced that the work was an authentic drawing by Leonardo da Vinci. This was potentially a tremendously exciting discovery since it was the first major work by this artist to emerge for over a century. Kemp then spent a year researching the drawing and establishing further contextual evidence, most notably the identity of the sitter. In the autumn of 2009 he announced to colleagues and the press that he considered the drawing authentic. He named the portrait *La Bella Principessa* (or, the Beautiful Princess) and identified her as a member of the Sforza, the ruling family of Milan for whom Leonardo worked during part of his career.[11]

Kemp acknowledged that there was no single piece of evidence to prove conclusively that the drawing is by Leonardo, but he cited a number of factors to support his conclusions.[12] A key part of his analysis was the left-handed hatching evident on the drawing (Leonardo, of course, was left-handed). Multispectral imaging was done in Paris in the laboratory of Lumière Technology by Pascal Cotte (fig. 2).[13] This analysis revealed *pentimenti* (changes) and made it possible to look more closely at the pigments and the left-handed hatching around the face. Other kinds of evidence for the drawing's authenticity were put forward. A fingerprint identified by a forensic scientist was said to be a very close match to one found on Leonardo's painting of *St Jerome in the Vatican*. Such a fingerprint analysis might appear to be the ultimate test of authenticity, confirming in a 'forensic' manner that an artist was present at the moment of manufacture. However, this part of the process has recently come into question and is the subject of a current debate.[14]

To further fuel the intense media interest in this unfolding narrative, the owner of the work prior to 1998 filed papers in

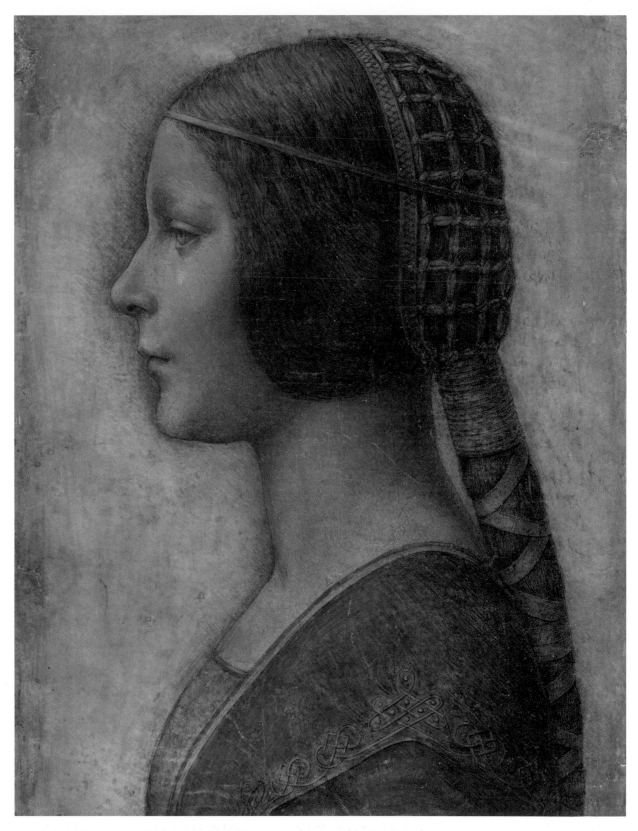

Fig. 1: *La Bella Principessa*, late 15th century, chalk, pen, ink and wash tint on vellum, 33 x 22 cm. *Private Collection*
Attributed in 1988 to an unnamed artist of the early 19th-century German school, the drawing was subject to intense media interest in 2009 when it was declared an authentic Leonardo. The attribution remains controversial.

a New York federal court accusing Christie's auction house of failing to 'exercise due care', failing to utilise appropriate scientific technology to determine the true identity of the drawing, failing to recognise the drawing as genuine, and selling it for 'a small fraction of its actual value', citing as evidence the discovery of the fingerprint. [15] Christie's responded by pointing out that the attribution had still not been established and was questioned by a number of Leonardo experts. In other words, the opinion of the academy about this drawing is far from unanimous. Ultimately, connoisseurship relies upon a body of expert opinion and a consensus from the majority of experts. At the time of writing, the authentication of *La Bella Principessa* has not achieved this consensus from the majority of Leonardo experts. A great deal of material evidence surrounding this drawing has been generated by technical and scientific examinations, but the majority of experts remain unconvinced that there is sufficient established context with which to conclusively establish its authenticity. [16]

In the foreword to their book on this subject, Martin Kemp and Pascal Cotte confirmed that, in spite of initial interest from major museums and galleries, all declined to exhibit the drawing for fear of being compromised. That is, the inclusion of *La Bella Principessa* in a major exhibition would serve to legitimise the authorship of the drawing and lend weight to a process of sale. It was not included in the National Gallery of London's major exhibition, *Leonardo da Vinci: Painter at the Court of Milan*, in 2011–12. The gallery's director, Nicholas Penny, when introducing Martin Kemp's lecture on this painting at the National Gallery in June 2010, formally disassociated the National Gallery or its trustees from any views expressed in the lecture and went on to dispute the authenticity of the painting while also acknowledging that he had not, in fact, seen the work. Klaus Schröder, director of the Albertina Museum in Vienna, refused to exhibit the drawing, telling the American publication *Art News*: 'We are not convinced that it is an authentic drawing by Leonardo. It was examined by our own research centre, our curators, our restoration department, and the Vienna Academy of Fine Arts. No one is convinced it is a Leonardo.' Therefore, there appears to be no consensus among established experts for authenticating the drawing.

The considerable media excitement over the 'discovery' of this drawing, possibly by Leonardo da Vinci, illuminates some of the issues involved in authenticating artworks, especially those by major artists who command spectacular prices on the art market. The unfolding narrative regarding the authentication of the drawing referred to above has included the academy, the museum and gallery world, the marketplace, including art dealers and auction houses, and the law courts (especially in the United States). It reminds us that, traditionally, both the academy and the museum world have been uncomfortable with discussions about the monetary value of art and the art market, in general. If the authentication of *La Bella Principessa* should be accepted as secure, dealers in the United States estimate that the valuation of the drawing could be as high as £100 million (approximately $150 million).

The cultural authority of museums

The role of the museums in the process of authentication is an interesting one, for museums play a vital role in promoting the acceptance of artworks as authentic. Experts tend to avoid liability not by stating a work is inauthentic, but rather by confirming that a work will (or will not) be included in the forthcoming catalogue of a major exhibition of an artist's work. [17] The striking comparison here is with the oil painting, *Salvator Mundi*, attributed to Leonardo da Vinci and included in the 2011–12 exhibition at the National Gallery in London. This painting had been over-painted in the nineteenth century, with the face and background particularly badly done, and there had been some later surface abrasion. It was, according to *The Art Newspaper* in November 2011, the quality of the painting which led to its reassessment as a genuine Leonardo. [18] The consensus among experts is that this painting is by the master, making it the sixteenth extant painting by Leonardo, and carrying an astonishing potential value of £125 million. The reasons for this consensus are integrally associated with connoisseurship, provenance, and scientific and technical examinations. The current owners have assured the National Gallery that it will not come onto the market in the shorter term. This is an important

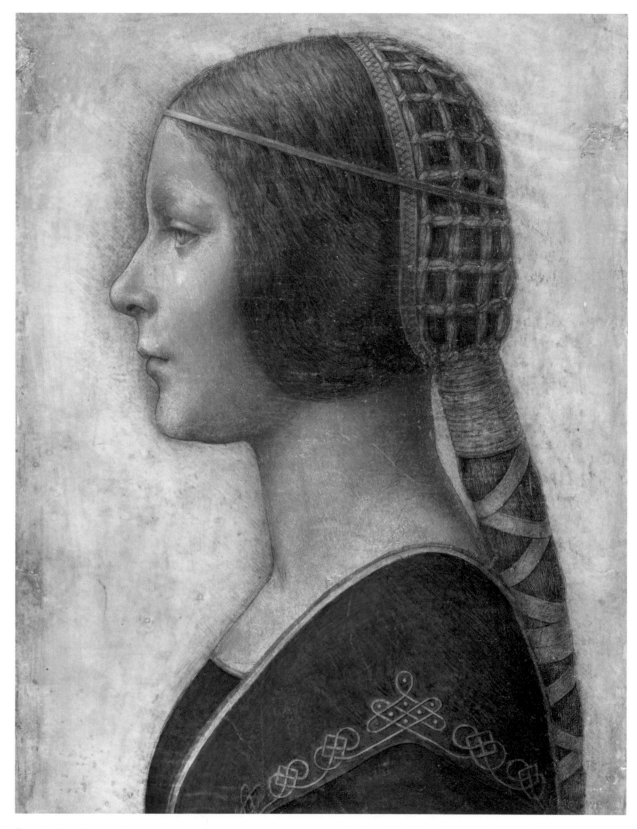

Fig. 2: *La Bella Principessa*, late 15th century, chalk, pen, ink and wash tint on vellum, 33 x 22 cm. *Private Collection, Lumière Technology labs*
This multispectral image made it possible to closely examine the pigments, left-handed hatching and *pentimenti*.

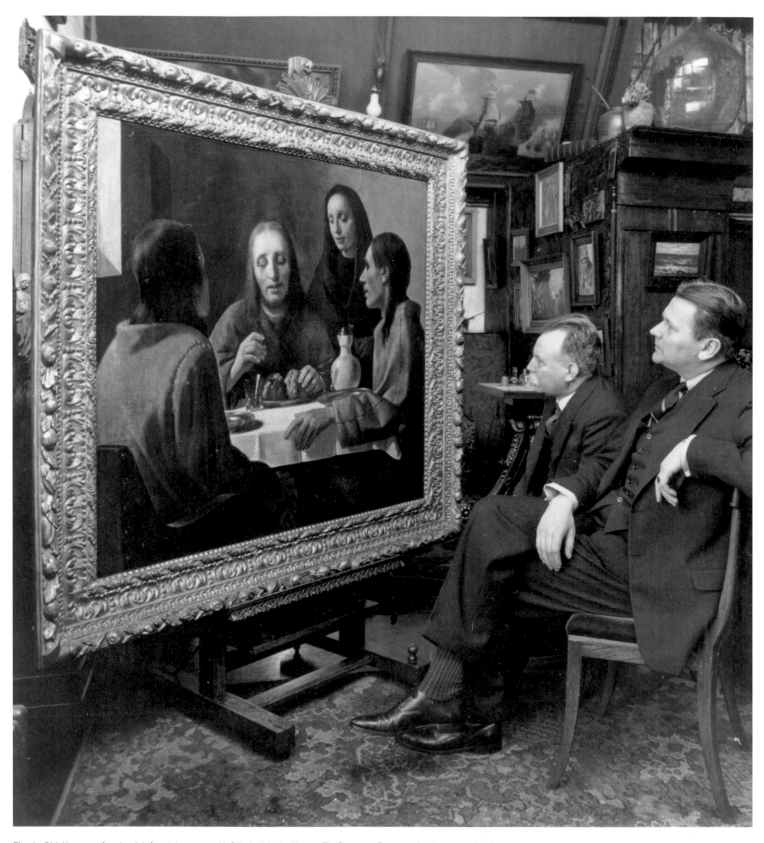

Fig. 3: Dirk Hannema (on the right) and the restorer H. G. Luitwieler looking at *The Supper at Emmaus* after its restoration in 1938. The work was subsequently revealed as a forgery by Han van Meegeren. *Photo: Museum Boijmans Van Beuningen, Rotterdam*

commitment to make as a public institution such as the National Gallery cannot be seen to be lending weight to a process of sale and, in effect, manipulating market value.

In his assessment of *La Bella Principessa*, Martin Kemp has brought into play scientific testing, alongside his own connoisseurship and scholarship, in order to establish the authenticity of the drawing. However, in his lecture at the National Gallery in 2010, Kemp acknowledged that, even if the drawing were not by the hand of the master, it remains a beautiful object in its own right, affording great visual pleasure to the viewer. Therefore, it could be argued that the drawing retains an authentic aesthetic integrity, regardless of the yet to be established facts of its authorship and dating.

Processes of authentication, fakes and the market

In July 2010 the entire issue of the *Burlington Magazine* was devoted to 'Attributions, Copies and Fakes'– in other words, to the pursuit of authenticity, a reminder that the academy is once again becoming more interested in this arena. On the cover of the magazine was a 1930s photograph of a notorious forgery of *Christ and the Disciples at Emmaus*, supposedly by the Dutch artist Jan Vermeer, but in actuality the work of the now-famous forger, Han van Meegeren (fig. 3). To the right of the photograph sits the Dutch connoisseur and museum director Dirk Hannema, who bought this work, with the restorer H. G. Luitwieler on the left. Abraham Bredius, the renowned curator, collector and scholar of seventeenth-century Dutch art, exclaimed at the perfect condition of this work when he saw it, opining that it appeared 'just as if it had left the painter's studio!'[19] This unintended irony was in fact extremely accurate, given the painting had just left the forger, van Meegeren's, studio. The forgery was uncovered through a combination of scientific and technical evidence, together with van Meegeren's confession. It is known as one of the great blunders of twentieth-century art historical scholarship. Intertwined in a discussion of the creation of fakes in relation to authenticity is another imperative: the need to distinguish between the authentic and the original. That is, a work may not be authentic in terms of its authorship and period, but it may be

an original artwork or a copy by another (generally later) artist which gives genuine pleasure to its viewers. Therefore one can still have an authentic aesthetic response to a work, as Bredius did, regardless of questions of authorship, dating and circumstance.

Material Authenticity

The six authors within the first section of this book all address aspects of material authenticity in various ways, and by means of a range of tools that include illustrations and copies, documentary and technical evidence, and historical context. One question researchers have grappled with is whether illustrations of artworks which no longer survive can be relied upon for accuracy, and therefore, as sources of knowledge about lost material.

In Chapter 1 David Bellingham examines the complex interrelationship between understandings of authenticity and the art market. Via a case study of the re-attribution and authentication of a painting by the Dutch artist Frans Hals, Bellingham explores the dialogue between connoisseurship and science which is crucial to our understanding of authenticity. Bellingham takes us through the process of authentication by experts in different countries and of differing opinions, and he demonstrates how this process of debate, in the absence of a firm consensus among the 'academy', has a direct impact on the market's response to such works.

Morgan Wesley picks up the dialogue between connoisseurship and science in Chapter 2 with respect to the formerly unattributed and little-known 'Buckingham jars' at Burghley House in Lincolnshire. The field of historic ceramics is full of puzzles and previously misattributed works. While using these small, highly decorated jars as a case study, Wesley leads us through an examination of the history and development of the processes of attribution and authentication over time. In considering the intersection of a variety of empirical, technical, and contextual sources of information, Wesley sheds light on how new knowledge is established in the field of decorative art.

Sophie von der Goltz's chapter is more narrowly focused on a particular example: it is a case study of how multiple approaches can be applied to the process of establishing whether illustrations

represent documentary evidence for lost material culture. Her discussion begins with an examination of a sixteenth-century book of fashion plates published in Venice. As surviving costumes from this period are extremely rare, von der Goltz tests the accuracy of the engraved plates by reconstructing a garment based directly on these illustrations. She then goes on to examine other forms of evidence for their authenticity, including the clothing depicted in contemporary Venetian paintings by leading artists like Titian, and the context of contemporary Venetian society.

In the next chapter, Noël Riley addresses the phenomenon of practitioners continuing to use well-established forms and ornament over time, even when they are no longer new or cutting edge. This characterises many traditional forms of art and design which often run in parallel with avant-garde movements. In considering the career of the little-known woodcarver Ernest Beckwith, working in rural England during the late nineteenth and early twentieth centuries, Riley argues for the authenticity of traditional design and materials, a theme of great interest to figures such as John Ruskin and William Morris during the nineteenth century and an alternative to the relentless search for the 'new'.

There are multiple viewpoints from which the phenomenon of authenticity can be addressed. Chapter 5, by Barbara Lasic, moves us into the realm of replication and reproduction of artworks, although none of the material she discusses was created with the intent to deceive. Can it, therefore, be considered as 'authentic'? She looks at the deliberate commissioning of replicas as a way in which the South Kensington Museum (now the Victoria and Albert Museum) extended its didactic reach as a centre for the teaching of good design. Lasic explains the ways in which the museum displayed replicas alongside 'genuine' art objects, thereby blurring the boundaries between the authentic and the inauthentic, and describes how the museum deployed photography as a critical tool for investigating authenticity.

Bernard Vere continues the discussion of replication and recreation in his chapter on reconstructed artists' studios, an increasingly common museum phenomenon in recent years. In recreating the studios of Francis Bacon and Edward Paolozzi, for example, within museum settings, these institutions are following

a modernist attitude towards authenticity and the genius of the artist, whereby the process of inspiration and creation of the artwork is emphasised. These meticulously reconstructed studios contain the artist's authentic physical objects, but they are located in an inauthentic setting and are frozen in time, injecting an inauthentic note into these museum interiors, no matter how exact their recreation. Vere's chapter on the seeming paradox of inauthentic authenticity closes the first section of the book.

Therefore, during the writing of this book, it became apparent that authenticity is a multilayered phenomenon. Questions which at first may seem straightforward lead the researcher into more complex territory. For example, in order to determine that the 'Buckingham jars' may be important early examples of European porcelain, it is first necessary to determine what constitutes 'authentic' porcelain. Some questions lead immediately into more abstract terrain. As Bernard Vere argues, what might seem initially to be a straightforward and authentic recreation of an artist's studio becomes either inauthentic, or a reconstruction which is represented as authentic. Vere conceptually dismantles this reconstruction process in order to demonstrate its multivalent interpretations, as we move from material authenticity to authenticity of a more conceptual nature.

Conceptual Authenticity

The advent of new media such as photography, film, or more recently the Internet has had an enormous impact on contemporary understandings of the work of art. In the 1960s and 1970s a number of artists challenged the definitions of authorship and originality within an economy of mass production. One of the most notable groups was Art and Language, a group of artists, writers and academics formed in the late 1960s. Art and Language adopted a conceptual approach and 'created works identical to the originals which would come to embody postmodernism and, in particular, appropriationism in the eighties.'[20]

In the twenty-first century, the remake may act in a subversive manner to undermine the authenticity of the original work. This 'disturbance' raises questions about notions of 'authenticity' and 'masterpiece'. Anthony Downey's chapter

reminds us that many artists, notably Elaine Sturtevant, reproduced and reinterpreted artists such as Marcel Duchamp and Andy Warhol, and separated the notion of authenticity from originality. Sturtevant deconstructs for us the idea that a copy is necessarily a paler imitation. Her work is, as Downey makes clear, a rigorous investigation into the limits of terms such as authenticity and reminds us that the idealisation of authenticity in the twentieth century should be questioned. Perhaps the comparison might be with the cinematic remake or the interpretation of a musical score, neither of which are regarded as inauthentic in contemporary culture.

As the director of the Whitechapel Art Gallery, Iwona Blazwick, has remarked, in the twenty-first century authenticity is perceived by avant-garde artists to reside in the 'archive'. Here Blazwick refers to the archive as that body of information wherein reside key reference points and historical information which armies, political juntas, regimes and individuals may have attempted to obliterate. The archive can exist both literally, in visual and literary form such as in film, photography and documentation or, in a more abstract sense, via memory and oral tradition. For artists born and brought up in places as diverse as Chile, Lebanon, Russia, Afghanistan, China and the former Yugoslavia, the only authenticity they feel they can rely on is that which resides in the archive. [21]

In Chapter 8, Lis Darby addresses issues of authorship, authenticity and originality within the field of contemporary design. Taking the Dutch designer Maarten Baas' *Smoke* series as a case study, she argues that, in relation to contemporary design, an object is seldom the product of one artist's creativity and imagination. In an increasingly globalised world it is accepted that a designer is subject to a multiplicity of influences. Designers frequently work with archetypes so that a work may reference the past and have a sense of cultural authenticity. However, individual authenticity may be more elusive, particularly given that contemporary designers must often work in collaboration and often do not participate in the physical production of their work. Their work may possess material authenticity and conceptual authenticity at the same time, although the designer is typically more involved with the latter. The converse situation applies

to Ernest Beckwith (discussed in Chapter 4), who painstakingly produced his woodcarvings by hand in his own workshop but generally used the designs of others.

Megan Aldrich's chapter reminds us of the search for an authentic style in nineteenth-century England, where the gothic tradition could be regarded as more authentically English than the invocation of the classical. The authenticity of this style was validated by associations with past personages and historical events. Our understanding today of medieval architecture distinguishes Anglo-Saxon from gothic. However, in 1805 John Soane created a gothic library at Stowe House in Buckinghamshire which is a combination of different medieval and post-medieval styles – a conflation which occurs by virtue of the particular associations and meanings that these styles had for the owner of the house. Such a misreading of the past was exacerbated by misunderstandings about the date and origins of particular types of furniture. To this end ebony furniture from southeast Asia was authenticated as Tudor by the great connoisseur Horace Walpole. One could conclude that, physically, the furniture was inauthentic, but conceptually it was authentic. Here we have a process of authentication by historical association – the search for objects and designs which carried a particular historical resonance for the nineteenth century.

Both Jos Hackforth-Jones' and Jonathan Clancy's chapters engage in different ways with the relationship between works of art and reality. In Chapter 10, Hackforth-Jones considers the notion of authenticity in relation to non-European celebrity visitors to London in the eighteenth century who were painted by some of the leading portrait painters of the day, together with the various codes and conventions employed for the visual portrayal of authentic identity. This case study focuses on the seemingly authentic identity of Mai (or Omai), a Tahitian visitor to London in 1774. Mai was presented at court and proceeded to move in the first circles of society, presenting himself simultaneously (and convincingly) as both an English gentleman and a high-born Tahitian. This performance of authenticity was an extraordinary accomplishment since it was performed without words (Mai spoke little English) and was captured in Reynolds' famed portrait. The visual representations of these two identities have had an impact

on the enduring popularity of this celebrated portrait. In actuality Mai came from a middling class of Raiateans and had his own agenda for visiting England. Part of the continuing appeal of this proto-Romantic portrait lies in viewers' perception of its authentic associations.

Jonathan Clancy continues this discussion of conceptual authenticity in relation to subject matter. His account of nineteenth-century American painters such as William Michael Harnett, Victor Dubreuil and John Haberle, with a focus on their visual representations of money, also engages with the issue of material authenticity. He begins by addressing the most essential questions with respect to material authenticity – that is, verism in nineteenth-century depictions of American banknotes and related issues of representation and faking. He moves on to consider broader questions being asked during this period: both 'is this real?' and 'is this art?'. Clancy also addresses the notion of conceptual authenticity in the context of the nineteenth-century debate: 'is reality a fixed truth or something merely perceived?' If there is no such thing as a fixed truth, what relevance do notions of authenticity have? Nineteenth-century anxieties over what 'authentic' might mean are, Clancy suggests, part of the spirit of the age.

Finally, Natasha Degen's chapter explores the notion of conceptual authenticity vis-à-vis the art market. She argues that museums are sites of authenticity both in relation to the way in which they serve to validate the authorship of artworks and because museums also create authentic national narratives. Many museums, for example, still construct art histories in terms of national schools. With respect to contemporary art, she argues that there is now what might be called a 'new nationalism' in relation to the display of contemporary art that is part of a global corporate agenda. This relates particularly to the art of emerging countries. In their desire to forge political connections and international links, both individual nations and international corporations have the potential to compromise the ideal of the museum as a site of authenticity. In recent years, museums have been powerful agents for cultural communication between countries at a time when diplomatic and political relationships may have become strained. A case in point is the British Museum's cultural exchanges with Iran. Degen's argument is that the museum and/or the exhibition venue is further compromised by corporate sponsorship, cultural diplomacy and speculative collecting, so that inauthentic narratives in the representation of international contemporary art may emerge.

Concluding remarks

The differing viewpoints and perspectives touched upon in this introduction arose out of a series of stimulating and enjoyable conversations not only with the various authors represented here, but also with many other interested individuals who have shared their own insights with the editors. In particular, we would like to thank our colleagues at Sotheby's Institute of Art, who enthusiastically pursued the ideas behind this project at a faculty research symposium in 2010. Whether or not they are represented in the chapters of this book, they nonetheless contributed ideas, suggestions and insights. The result is far from definitive. This remains an exploratory set of discussions which raise some interesting questions that we hope other authors will be inspired to pursue. At the time of writing, the topics of authentication of artworks, in particular, and material and conceptual authenticity, in general, continue to receive regular media attention. A recent case in point is that of the Australian artist Margaret Olley, who died in 2011, and whose Sydney studio is being recreated hundreds of miles further north at the Tweed River Art Gallery. The architect recently flew to Dublin to see Francis Bacon's reconstructed studio, which has been described in the press as a blueprint for the Olley reconstruction.[22]

Art authentication is, perhaps, an endlessly fascinating game, but it must be appreciated as a complex business. If there are truths that emerge from the writing and editing of this volume, one of them would be that the notion of the authentic in relation to art appears to be a cultural construct which emerged primarily as a post-Romantic phenomenon alongside the rise of the notion of the individual creative genius of the artist. Here authenticity and originality were considered synonymous. This idea of authentication as an endgame reached its height during the twentieth century, particularly with regard to modernism and

the modernist notion of the artist as a magician/creator. Without question, the impetus to authenticate artworks in a quasi-scientific way was fuelled by the rise of the international art market. The phenomenon of twentieth-century modernism has also served to validate the notion of the superior authenticity of ritual in the process of making an artwork. With respect to African art, for example, our colleague David Levy warns against such privileging of ritual and the resultant impact of this on the value of an artwork, so that works of art perceived to have been made as part of a ritual process frequently sell for many times the price of their counterparts which are not perceived in this way. Authenticity, then, appears to be the outcome of perception.

The twentieth century, with its emphasis on the creative hand of the individual artist, has been at odds with the Renaissance and post-Renaissance tradition, along with much non-Western and contemporary art. In these latter traditions, the replication and copying of an established model is not perceived as an inferior process but has validity in its own right. These represent very different approaches to the making of an artwork which possesses authenticity. From a traditional woodcarver in Essex, to the commissioning of copies of great works of design by the Victoria and Albert Museum in the nineteenth century, to numerous examples of contemporary art and design, many kinds of artworks continue to privilege both the copying and replication of earlier work and the notion of art as a continuous and collaborative process, albeit from very different perspectives. As editors we hope that you will find this variety of approaches to be as stimulating and rewarding as we have done, and that, far from being dismayed by the complex and multivalent nature of the field, readers of this book will be encouraged to explore further this rich and ever-changing subject.

PART ONE

MATERIAL
AUTHENTICITY

1. Attribution and the Market: The Case of Frans Hals

by David Bellingham

Over the last thirty years, the general cultural notion of authenticity has grown in importance to become part of the zeitgeist of that generation. In the field of fine art, the Rembrandt Research Project has led the way, publishing its first catalogue raisonné in 1982.[1] More recently, in 2010 the National Gallery in London mounted a major exhibition, 'Close Examination: Fakes, Mistakes and Discoveries', in which contemporary discourses of authenticity, as a dependent of both traditional cognitive experience and progressive science, were brought up to date.[2] The Rembrandt Research Project, based in the Netherlands, set out to radically revisit and revise the Rembrandt corpus 'that in the course of time has become corrupted'.[3] Much of the stimulus for this came from the rapid post-war development of new techniques of conservation based on scientific analysis, combined with the realisation that much of the earlier connoisseurship within this field had been overly subjective. The research criteria of the project team gave primacy to a new combination of art historical objectivity and up-to-date science. The project members were most interested in the growing 'relationship between our [art historical] study and scientific research in the laboratory ... to benefit as much as possible from the latter and from the various photographic techniques; yet on the other hand we were aware that technical information alone would not provide us with criteria for authenticity.'[4] No such project, however, has been undertaken for the work of Rembrandt's near-contemporary and compatriot, Frans Hals, and his corpus remains in a confused state which confounds both museums and the market. This chapter will examine examples from both arenas.

Frans Hals

The painter Frans Hals was born in Antwerp between 1581 and 1585 and died in Haarlem on 29 August 1666. Although there are no records of his birth, by the end of his life he was the most sought-after portraitist in Haarlem. Most of his works were individual portraits of members of the bourgeoisie, and a few were jolly 'genre' scenes and portraits of the lower classes, including girls and boys.[5] None of his sitters were persons who obtained great importance within the history of the Netherlands, or even Haarlem itself, after their deaths. Even the sitters in the famous group portraits of members of Haarlem's civic guard or of the boards of the regents of the town's hospitals or almshouses remain unknown outside of the local history of Haarlem. Similarly, Frans Hals himself does not appear in any of the important contemporary documentary sources for Netherlandish art.[6]

The implications of the relative anonymity of the subjects of Hals' paintings within a discussion of authenticity and art are twofold. With a few exceptions, the sitters were not of sufficient importance for their portraits to be copied during their own or Hals' lifetimes. Therefore, discussions of contemporary originals and copies are rarely an issue. Likewise, the fact that the identity of the sitters was, relatively speaking, forgotten within a generation of their deaths, led to many of Hals' paintings being lost forever through a general lack of interest in them as meaningful images. Whereas equally highly rated painters of biblical or mythological subjects were regularly copied because the artists themselves and/or their more universal subjects from the higher genre of history painting remained famous after their deaths, Hals' contemporary reputation as a portraitist would have gone to the grave with him, and it remained there for 150 years or so before he was eventually rediscovered as a 'great painter' in the second half of the nineteenth century.[7]

The revival of interest in Hals in the nineteenth century had little to do with his subjects: what was admired by a mix of art historians and collectors as well as, and more unusually, artists themselves, was his spontaneous and exciting technique, as well as his realism and emotional impact, qualities equally admired by Hals' Haarlem contemporaries.[8] These same qualities had been antithetical to eighteenth and early nineteenth-century critics, who preferred a more controlled and refined application of the paint, as well as a more classical and ideal aesthetic.[9] However, in the so-called Age of Realism and Impressionism, during the nineteenth century, with the advent of apparently 'spontaneous' styles pioneered by the French Barbizon school and followed through by Monet and his peers, admiration for Hals' work grew rapidly in both Europe and North America. The consequent increase in demand from collectors far outstripped the supply of authentic Frans Hals originals. This led to a proliferation of

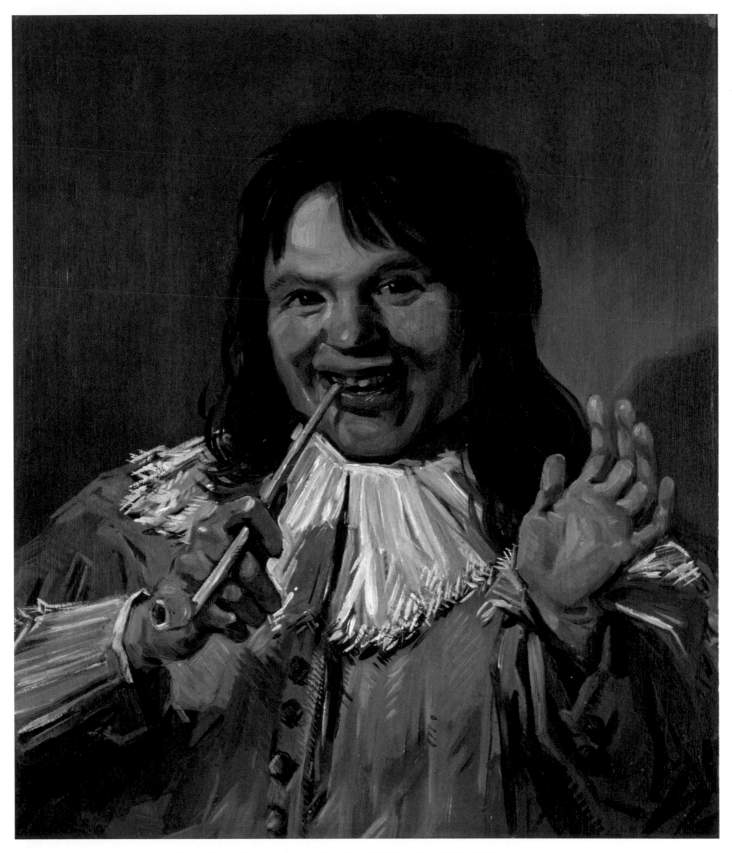

Fig. 1: Forgery purporting to be a Frans Hals by Han van Meegeren, *Boy Smoking a Pipe*, c.1922, 57.5 x 49 cm (22.6 x 19.3 in). *Museum voor Stad en Lande, Groningen*

misattributions and the creation of forgeries, which will always attend the popularity and increasing market value of an artist. [10] It is perhaps significant that one of the earliest forgeries by the most infamous forger of the twentieth century, Han van Meegeren, purported to be a Frans Hals, and was both validated and bought for 30,000 guilders by the Hals connoisseur Hofstede de Groot (fig. 1). This reminds us how intricately issues of attribution and connoisseurship are bound up with art market prices.

The provenance and attribution of Hals' body of work has evoked controversy from the late nineteenth century to the present day, and therefore provides rich material for the history of authenticity and its relation to the market, especially during the last thirty to forty years, during which time a particular kind of 'authenticity' culture has emerged. In a general sense, this has become manifest in all aspects of cultural production, with, for example, increasing numbers of enthusiasts expecting Mozart to be played on 'original' instruments, and ethical dilemmas relating to the need to maintain cultural objects as closely as possible to their pristine state by means of conservation. The Hals authenticity debate and the Rembrandt Research Project have emerged as an important part of this recent cultural development, out of which a new attribution ethos has emerged in the market for Old Master paintings.

Connoisseurship and science

A major touring exhibition of the paintings of Frans Hals was held at the National Gallery of Art in Washington in 1989, followed by the Royal Academy in London and the Frans Hals Museum in Haarlem in 1990. The exhibition brought to the fore the opposing views of the world's two main Hals experts, the American scholar Seymour Slive (b.1920) and the German scholar Claus Grimm (b.1940), whose monograph on Hals appeared at the time of the exhibition. [11] The most controversial difference of critical opinion concerned attribution, with Grimm arguing that at least 28 works featured at the Royal Academy were not by Hals. Slive himself had earlier considered that only around 70 per cent of the paintings he catalogued were authentic. This very public controversy sent panic signals through the art world, with both public and private collectors doubting the authenticity of their own Hals paintings, and dealers and auction houses adopting a new attitude of due diligence towards the works passing through their hands.

The 1989–90 controversy was grounded in connoisseurship – that is, the received tradition that a practiced expert observer can tell an original from a fake or forgery by using a combination of visual memory and optical astuteness in order to identify the unique 'hand' of the artist. However, the 1980s and 1990s were also decades in which scientific analysis of the physical properties of art objects was rapidly gaining in importance as an authentication tool, and one which apparently challenged established ideas of connoisseurship. Scientists argued that traditional connoisseurship, because it relied on sensual perception, was subjective and open to human error, whilst scientific analysis in laboratory conditions was objective and therefore far more trustworthy. During the first decade of this century, a consensus has developed in both museums and the art trade that a combination of connoisseurship and scientific analysis provides the best solution to the authentication of the art object. The 'Close Examination: Fakes, Mistakes and Discoveries' exhibition in the National Gallery, London in 2010 provided a timely public 'retrospective' on the connoisseurship–science debate, in which the visitor was drawn 'into the complex issues – not all of them fully resolved – confronted by gallery professionals'. [12]

Attribution by connoisseurship has existed since antiquity but was first theorised into a quasi-scientific and empiricist tool during the 1870s by the Italian art critic Giovanni Morelli (1816–91). [13] Morelli argued that opinions and attributions of paintings should 'not only be aesthetic and subjective ones, depending on individual taste and humour; they must be based on tangible facts perceptible to every observing eye'. [14] It is perhaps significant that this work appeared in the same period during which Frans Hals was rediscovered, because Morelli encouraged closer appraisal of the object and its painted surface which led to the appreciation of this artist's particular 'painterly' style. Morelli's object-based approach, often paradoxically criticised for its attendant subjectivity, led to his falling out with academic art historians, because of his controversial claims that '… there is but little to

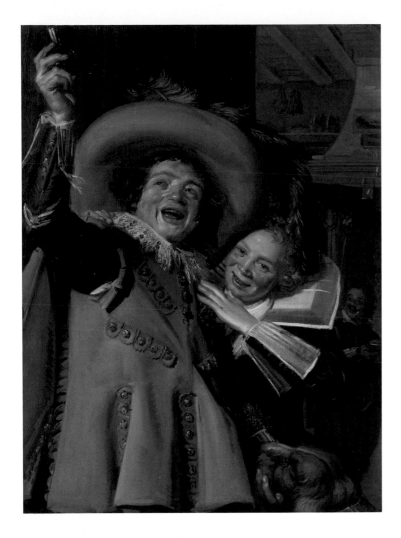

Fig. 2: [Attributed to] Frans Hals, *Young Man and Woman in an Inn* (*'Yonker Ramp and His Sweetheart'*), 1623, oil on canvas, 105.4 x 79.4 cm (41.5 x 31.25 in). *Metropolitan Museum, New York, accession no. 14.40.602*

be learnt from books on art, – nay, that most of them blunt and paralyze our taste for a true living knowledge of art, rather than quicken and refine it'. [15]

One of Morelli's art historical adversaries was the Berlin Museum director, Wilhelm von Bode (1845–1929). He had a special interest in Frans Hals, submitting a doctoral thesis on his work in 1870 and thus marking the growing interest in the painter and other Haarlem masters at that time. [16] During the 1920s, the earliest known scientific analysis of Frans Hals' paintings was made by the chemist A. M. de Wild. [17] He used microscopy and chemical tests to identify pigments, including the indigo employed in the blue silk sashes in the famous civic guard portrait paintings now in the Frans Hals Museum, Haarlem. The guards were depicted wearing them from 1627 onwards, when the blue in the new Dutch republican state flag became politically significant. [18] The civic guard portraits were restored between 1985 and 1987 and further microscopic tests were made on the indigo sashes. [19] The advanced instruments facilitated more detailed analysis of cross-sections of the paint layer, leading to an understanding of how Hals' particular application of indigo helped to preserve its colour. Indigo is a particularly fugitive pigment with relatively rapid fading when exposed to light. The microscopic cross-sections revealed that Hals applied five to six layers of the pigment, which led to only the surface layers fading and becoming transparent, thus both protecting and at the same time revealing the indigo layers below in their full glory. [20] During these analyses, Hals was also discovered to have lightened his indigo with an unusually coarsely ground white lead. This detailed scientific understanding of an artist's particular practices can assist in the identification of an authentic work. The provenance of the civic guard paintings is documented in an unbroken line: they first decorated the headquarters of the various guard companies; they were moved to the Haarlem city hall in 1820; and they were transferred to the Frans Hals Museum in 1913. Their well-researched physical and aesthetic qualities serve as benchmarks against which paintings of more obscure provenance can be tested.

Processes of authentication

An example of the problems involved in the process of authentication can be seen in a genre/history/portrait painting now in the Metropolitan Museum of Art in New York (fig. 2). The

early decades of the twentieth century saw a growth in American interest in the Baroque period, and the works of Frans Hals were particularly sought after. This painting was bought in 1905 from the Paris and New York dealer Gimpel & Wildenstein for $155,840 by the New York collector Benjamin Altman (1840–1913), who bequeathed it to the museum along with the rest of his collection upon his death in 1913.[21] The 1905 price of $155,840 can be contextualised by comparing it to the price of another type of luxury object, the Model T Ford motor car, which in 1908 was selling for $850. Therefore the painting would have purchased over 180 cars. Walter Liedtke, the museum's curator of Dutch and Flemish paintings since 1980, refers to 'this famous genre painting by Frans Hals', and the catalogue entry clearly states that the oil-on-canvas painting of *Young Man and Woman in an Inn ('Yonker Ramp and His Sweetheart')* was signed and dated (right, above the fireplace) with the famous FHALS monogram and the year 1623.[22] The museum unambiguously presents the work as an authentic autographic Frans Hals painting. However, the museum catalogue's own notes and references to the painting indicate that issues regarding its authenticity are far from resolved. The catalogue states that the traditional title, given to the painting in a sale of 1786, is probably incorrect, and that two modern experts agree with a reinterpretation of 1923, which argued that it represents *The Prodigal Son*, and that a painting of that title appears in documents dating to the lifetime of Hals. However, Liedtke himself agrees with more recent interpretations that: 'the main figure ... would have been understood by Hals' contemporaries as a modern-day type, similar to but not identical with the biblical wastrel'.[23]

Perhaps the most sensible answer is that the painter intended it as a conflation of genres, a common artistic strategy in the seventeenth century.[24] The catalogue references to the critical reception of the work state that a smaller version of the work exists in a private collection.[25] It also emerges that throughout its reception history, no scholarly consensus has emerged, at least in the published scholarly sources, regarding its authenticity. In 1910 Cornelis de Groot stated that the painting was by Frans Hals, and that the smaller version was a copy by the artist himself.[26] In 1923 Monod referred to the smaller version as a copy by the

'circle of Frans Hals'.[27] In the same year Valentiner argued that the smaller version may be by Frans' brother Dirck (1591–1656), but in 1936 changed his mind and saw the smaller work as a preliminary study, a view shared twenty years later by d'Otrange-Mastai.[28] In 1941 Trivas argued that neither painting was by Hals.[29] After the war, these differing attributions continued, coming to a head when Seymour Slive accepted the larger painting as a genuine Hals, based on its iconographical similarity to well-documented Hals paintings, with the smaller version copied by another hand. Grimm argued that both paintings were later copies after Hals.[30] In spite of the weight of twentieth-century scholarly opinion towards the painting not being an autographic work, Liedtke, quite disingenuously, states: 'In recent decades, only one critic has doubted Hals' authorship ... For all other writers, and for the great majority of specialists who have not expressed themselves in print, the canvas is one of Hals' most important contributions to the theme of "everyday life".'[31] It perhaps comes as no surprise that the 'one critic' is the American Slive's European counterpart and arch-rival, Claus Grimm! This would appear, therefore, to be a heavily biased and simplistic summary of the debate regarding the authenticity of the painting. Thus in spite of continuing disagreements concerning the subject, provenance and attribution of this painting during the past one hundred years, it remains on display in an international museum as a genuine Frans Hals.

Determining authenticity

There are obvious pressures on both public and private sector institutions to publicise their art objects as authentic. Visitors to public museums want to see the 'real thing', and expect absolute transparency in the labelling of exhibited objects. The National Gallery, London was therefore brave to mount an exhibition in which its own scientific department cast doubt on the authenticity of some of its own paintings. However, there were several works on display for which scientific analysis proved more positive. For example, a Caspar David Friedrich landscape, long thought to be an autographic repetition by the artist, was shown to be the original version by the revelation of its underdrawing by means

of reflectography.[32] The art market might be expected to be far less transparent. However, dealers and collectors have arguably become far more sensitive to issues of authenticity over the last generation; this is hardly surprising given the meteoric price rises, especially of 'authenticated' works by the most famous artists. In the art market, investment in an expensive laboratory test of a painting has been proven to be increasingly worthwhile in order to securely attribute a particular work, as the following case involving the attribution and sales history of a Frans Hals painting will demonstrate.

One of three extant versions of one of Frans Hals' most celebrated portraits, *Willem van Heythuysen, Seated on a Chair and Holding a Hunting Crop,* known as the 'Rothschild' version, came up for sale at Sotheby's London on 9 July 2008 (fig. 3).[33] It had previously sold at an anonymous sale at the Palais Kinsky, Vienna, on 12 October 2004 (lot 2) as 'Studio or Follower of Frans Hals', for €571,120.[34] The anonymous buyer took the painting outside the European Union, as denoted by a temporary import symbol in the catalogue entry. The surprisingly impressive price for an apparent 'copy' indicated that at least one underbidder had seen something special in the painting. All was revealed in the catalogue entry for the 2008 sale. The purchaser of 2004 immediately set about proving that this painting, long believed to be an autographic repetition of an original hanging in the Musées Royaux des Beaux-Arts de Belgique, Brussels, was in fact the original work, with the Brussels painting demoted to the status of the later copy (fig. 4).

In connoisseurial terms, the inferior quality of the Brussels painting can today be clearly seen by comparing the two images. The museum version exhibits a far rougher surface, with clumsy brushstrokes (compare figs 5 and 6). Why had this obvious difference not been noticed by earlier connoisseurs and art historians? The 'Rothschild' painting was first described as an autographic replication of the museum painting in 1907.[35] Since 1865, it had been in the possession of the famous Rothschild family, who had purchased it for 35,000 francs from a Dutch baron in his Paris sale. The problem would appear to have been simple: namely that the Brussels museum version was on public display and therefore much better known than the one in private hands. Therefore the weight of opinion, given its high-profile international public museum provenance, was towards its being the original version. Furthermore, it was impossible to compare the two versions side by side. Modern connoisseurship has been proven more astute.

In 1988 the art historian Norbert Middelkoop and conservator Anne van Grevenstein studied the two paintings, together with a third version (known as 'the Mildmay version' after its owner). These modern scholars had the benefit of photographs, enabling direct visual comparison, although they only had a black-and-white image of the Rothschild version, the location of which was by then unknown to them, because it had been sold by the Rothschilds to a New York dealer by 1950 and was now either in Brazil (by 1963) or Austria (by 2004).[36] They came to the conclusion that the 'Mildmay' version was a seventeenth-century copy of the original. Their reasons were a mixture of traditional connoisseurship and science: 'the painting, qualitatively speaking, falls short of Frans Hals' typical work. Compared with the other two versions ... the subject's pose is rather stiff and the vacant facial expression creates a forced impression.'[37] The probable seventeenth-century date was scientifically attested by the evidence of both dendrochronology and pigment analysis. Tests demonstrated that its wooden panel came from a tree felled around 1599, and that all of the pigments discovered in the work were available to Hals. The Brussels version was also subjected to dendrochronology, and it was ascertained that the tree was felled in about 1642. Therefore this version would have been painted nearer the year of van Heythuysen's death in 1650. The painting has an intriguing inscription on its reverse: 'Willem van Heythuysen. Founder of this Hofje. Deceased 6 July 1650'. Before the painting came to the Brussels museum in 1870, it had hung in the Hofje van Heythuysen, a kind of almshouse funded by a bequest in the will of van Heythuysen. Middelkoop concluded that the Brussels version might well have been painted after its sitter's death, and as the 'Mildmay' version appears to have been painted in the 1640s, both may have been autographic repetitions of the original painting, dated by the sitter's clothing to about 1638. Middelkoop is explicit that the Brussels version is a repetition, probably by Hals himself, but only implies that the 'Rothschild'

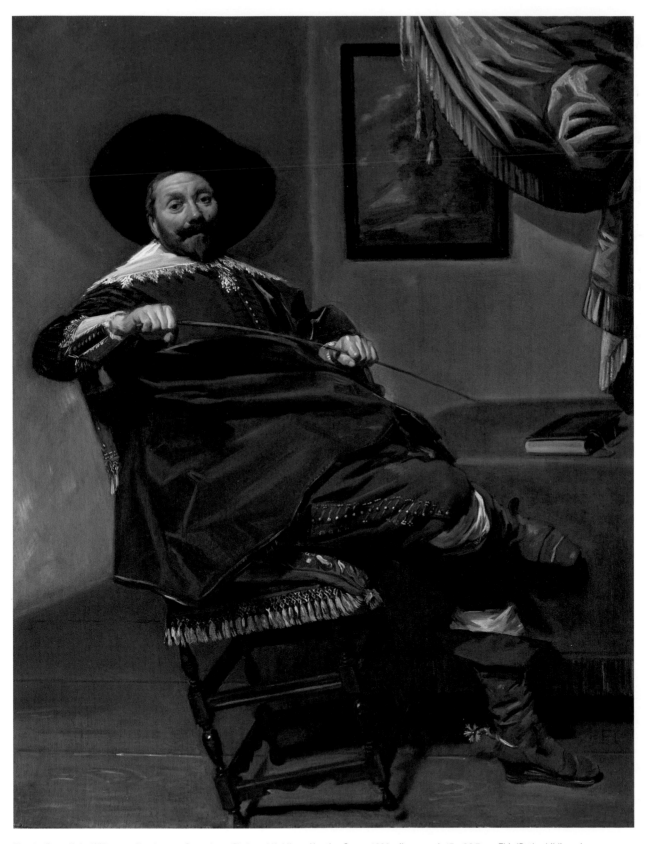

Fig. 3: Frans Hals, *Willem van Heythuysen, Seated on a Chair and Holding a Hunting Crop*, c.1638, oil on panel, 47 x 36.7 cm. This 'Rothschild' version was thought to be an autographic copy but modern appraisals suggest it is the original painting. *Old Master Paintings Evening Sale, Sotheby's London, 9 July 2008, Lot 26*

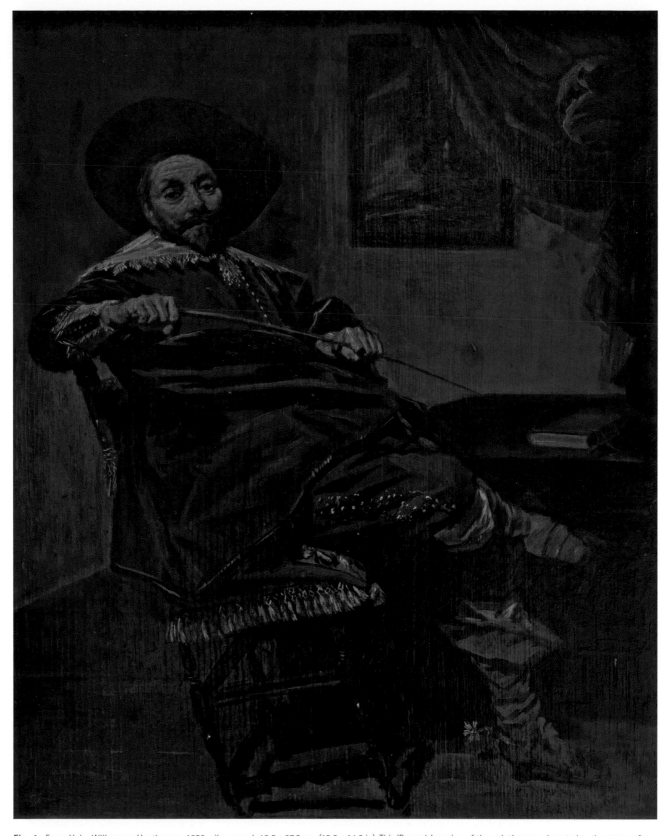

Fig. 4: Frans Hals, *Willem van Heythuysen*, 1650, oil on panel, 46.5 x 37.5 cm, (18.3 x 14.8 in). This 'Brussels' version of the painting was demoted to the status of an autographic replica when the 'Rothschild' version (fig. 3) came to prominence. *Musées Royal des Beaux-Arts, Brussels, cat. no. 2247*

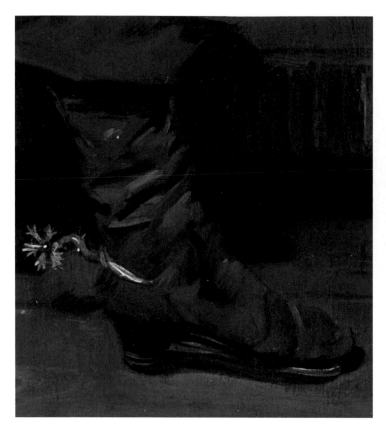

Fig. 5: The 'Rothschild' version of the van Heythuysen portrait (fig. 3) displays superior brushwork and a finer surface when compared with the 'Brussels' version, seen right.

Fig. 6: On close examination, the 'Brussels' version of the van Heythuysen portrait (fig. 4) appears clumsy when compared to the 'Rothschild' painting.

version might be the original: 'The face of the subject [in the 'Brussels' version] betrays the work of a copyist with his own mind: in this portrait Willem van Heythuysen looks considerably older than in the 'Rothschild version'.'[38]

What happened after the publication of Middelkoop and Grevenstein's book? It seems strange that whoever sold the Rothschild version in Vienna in 2004 was unaware of the book's suggestion that this painting might be the original of these three versions. However, that is what seems to have happened, presumably with bidder and underbidder well aware of Middelkoop's hypothesis. Having acquired the Rothschild version, the new owner sent it for scientific analysis, which added a more objective credibility to the previous empirical connoisseurship. Once again, it was the dendrochronology which proved most interesting: it was discovered that the panel of the Rothschild version had been taken from a tree felled around 1635 and therefore available to Hals for a 1638 painting. Furthermore, conservators Martin Bijl and Pieter Biesboer, whilst cleaning the work, also discovered that the wood had been sawn by hand. They have argued, in unpublished reports, that most Dutch wood was machine sawn after 1635, and that this supports the argument that the Rothschild version is, indeed, the original version. Once cleaned, the finesse of the surface and its brushstrokes, when compared with the other two versions, became apparent. According to the Sotheby's catalogue note, Grimm, who had

earlier referred to the Brussels version as the original version, has now accepted that the Rothschild painting holds this status.[39] Grimm's academic adversary Slive, whose previous publications refer to it as a copy, has not given an opinion since the sale, although the Brussels version is described by him as 'not a copy until proven to the contrary', which indicates his scepticism and latent disagreement with Grimm.[40]

In the Sotheby's catalogue, the condition report included some extra observations which strengthened the case that the Rothschild painting could be the original version.[41] For example, *pentimenti* were observed throughout the painting. *Pentimenti* refer to the visible signs that the artist has changed his mind regarding the composition during the act of painting: in this case, *pentimenti* are visible in fundamental aspects which increase the exciting dynamism of the work, such as the tilt of the chair and the positioning of the hat. The existence of *pentimenti* is often cited as evidence that a work is an original, because a copyist would normally directly transfer the original composition onto their own base, and would be unlikely to make many changes, unless they made errors in the copying process itself. The condition report also found few signs of later retouching of the paint, and commented: 'The magnificently fresh, powerful brushwork is in beautiful condition throughout.' Standard auction house condition reports are not carried out under laboratory conditions, and therefore there was no scientific information regarding pigments. However,

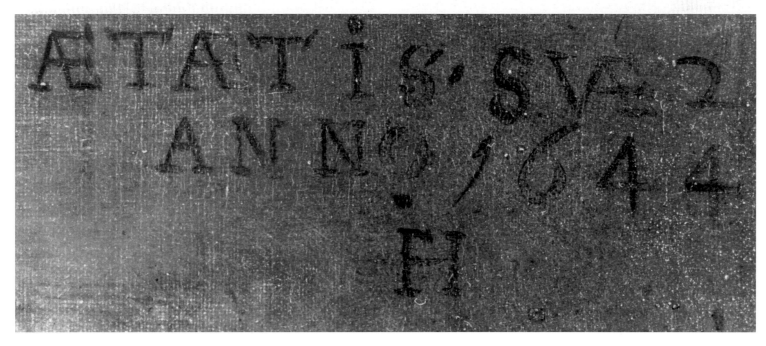

Fig. 7: Jan Hals, *Portrait of a Gentleman*, 1644: detail of inscription on reverse of canvas with monogram altered from JH to FH.

'minimal retouching', and exceptionally fine condition will always add value to an Old Master painting.

Authenticity and the market

The new arguments for the identification of the Rothschild painting as Hals' original version of this subject were included in some detail in the Sotheby's catalogue. The painting, sold just four years earlier as 'Studio or Follower of Frans Hals', for €571,120, was now estimated to be worth £3–5 million, and sold for an astonishing £7,097,250 (with buyer's premium), just £1 million less than the world record for Frans Hals of £8,251,500 set at Christie's London in July 1998, and around fifteen times the amount paid in 2004. The vendor marketed the painting most skilfully prior to the sale, loaning it to exhibitions at both the National Gallery in London in 2006 and the Mauritshuis in The Hague in 2007, finally selling in the summer of 2008, when with hindsight it can be seen that the Old Master market was at its height, collapsing just six months later along with all other art market sectors. This, combined with the modern appraisal of the work by means of both connoisseurship and scientific analysis, was testified by the success of the Sotheby's sale. The premium placed on Hals autographs is reflected in the higher prices realised at auction when compared with those works only attributed to the artist.

This high market premium on autographic paintings by masters such as Frans Hals might partly explain the development of new techniques of attribution.[42] Similarly, the market share of Frans Hals originals, attributions and replications indicates the relative rarity (16 per cent) of originals coming to auction. Furthermore, around 25 per cent of Frans Hals' paintings remain in private collections, meaning that there is still potentially a reasonable supply of his works waiting to come to market.

One type of modern scientific investigation not evidenced in the Sotheby's catalogue involves looking beneath the paint surface by employing infrared reflectography and x-ray photography. These techniques can reveal what lies beneath the layers of pigment, including any underdrawing (infrared) as well as the manner in which the artist has built up the layers of paint (x-ray). The results can provide additional information with which to determine the authorship of a particular painting, proving or disproving whether it is an original or replica. An interesting example of this occurred when two paintings were investigated in the North Carolina Museum of Art, the subject of an exhibition in 2000.[43]

A painting known as *Portrait of a Gentleman* (figs 8, 9) had been acquired by the museum in 1952 as a work of Frans Hals. The attribution, as with the New York Metropolitan Museum of Art painting discussed above, was based on the famous monogram signature of Frans Hals (fig. 7). The monogram was subsequently

Fig. 8: Jan Hals, *Portrait of a Gentleman*, 1644, oil on canvas, 76.2 x 63.5 cm (30 x 25 in). *North Carolina Museum of Art, Raleigh, cat. no. 52.9.42*
This painting was attributed to Frans Hals until examination of the monogram revealed that the original 'J' had been changed to an 'F'.

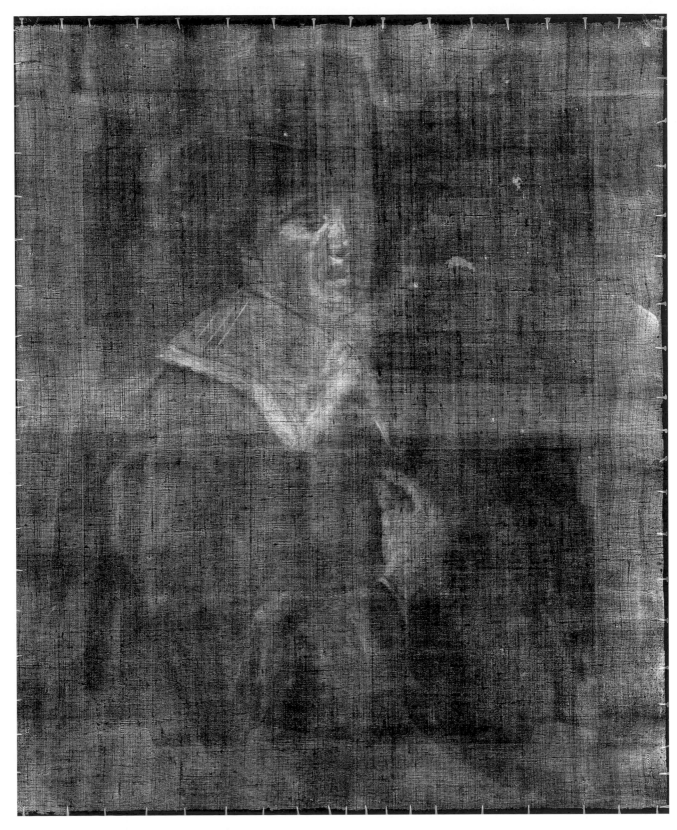

Fig. 9: Jan Hals, *Portrait of a Gentleman*, 1644 (x-ray).
X-ray analysis reveals that unlike his father, Jan took the traditional approach and made a preparatory underdrawing followed by the careful application of shallow layers of paint.

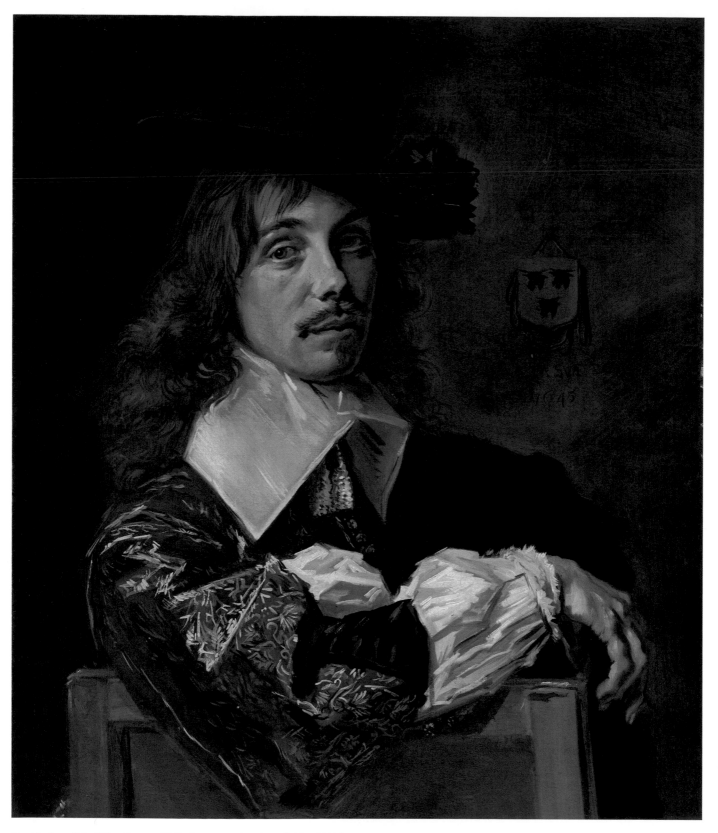

Fig. 10: Frans Hals, *Willem Coymans*, 1645, oil on canvas, 77 x 64 cm (30.3 x 25.2 in). *National Gallery of Art, Washington, DC, cat. no. 1937.1.69*
The portraiture of Frans Hals appears more dynamic than the relatively flat paintings of his son Jan (see figs 8, 9).

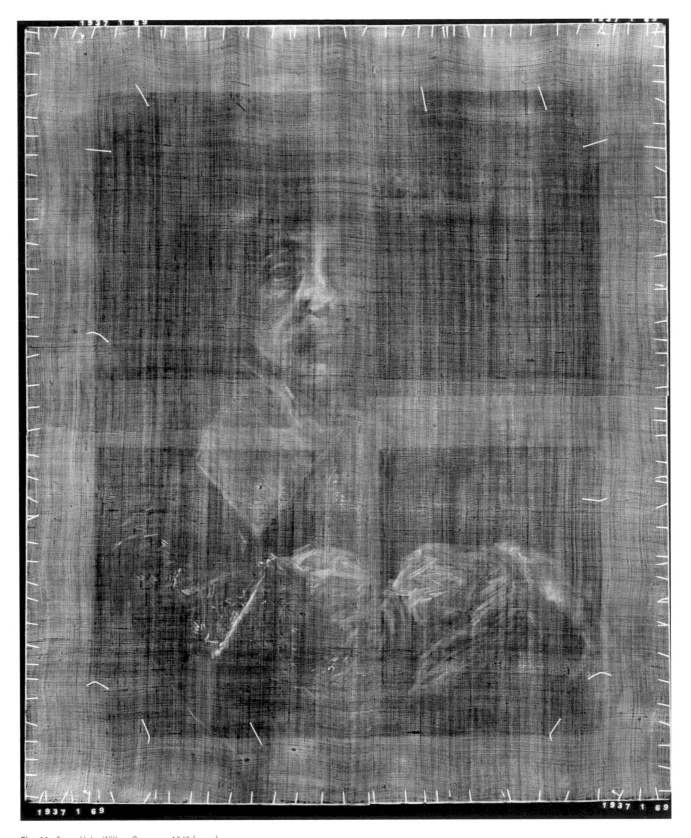

Fig. 11: Frans Hals, *Willem Coymans*, 1645 (x-ray).
X-rays reveal the unconventional and spontaneous approach Frans Hals took when creating this portrait, working up the image with blocks of oil paint rather than making a preparatory image as favoured by his son (compare fig. 9).

discovered to have been deliberately tampered with, by changing the original J, which in Dutch at that time was a dotted capital i, into an F. Therefore, the painting was reattributed to Jan, son of Frans Hals.

Infrared reflectography revealed that Jan used an unusual lead white and chalk ground layer bound in glue, whilst Frans tended to use the more traditional tan/brown pigments in a double layer of oil. After this, as revealed by x-ray analysis, Jan applied the traditional preparatory underdrawing, followed by carefully applied and relatively shallow layers of paint, whilst Frans broke with tradition by working up a spontaneous image with blocks of oil paint (figs 10, 11). The resulting paintings demonstrate the father's much more dynamic approach to the portrait, compared with the son's comparatively flat image.

This recent scientific research into Hals' formal techniques has become part of a growing bank of information which facilitates future attributions of his works. Since their assessment of the authenticity of Frans Hals in their catalogues of the 1970s and 1980s, some of Slive's and Grimm's attributions have begun to appear a little old-fashioned and subjective, with subsequent changes of opinion inevitably occurring once works are subjected to scientific analysis. With ever more sophisticated scanning software, it can be conjectured that in future years a computer might take on the role of the connoisseur, and there has already been some modest success with a 'connoisseurial computer' programmed to detect differing types of brushstroke by employing complex algorithms in imitation of the optical formal analysis of art historians. [44] As has been seen, science has mounted a strong challenge to more traditional connoisseurship. However, the relationship has become nicely symbiotic, with the increasing employment of science to assist the human senses in 'narrowing down the area of misunderstandings', which Ernst Gombrich stated to be a primary aim of the art historian. [45]

This chapter has demonstrated how the various discourses of authentication affect both cultural and monetary appraisal systems. Art market players and, perhaps more surprisingly, museum curators are equally intent on validating art objects not only as autographic, but also as original – in other words, prototypal – works by the artist. Replications, be they produced by studio apprentices, or copies of later date, are currently considered of fractional value, both in the cultural context of the museum, as well as in the sales room. For the time being, the authenticity stakes within the Old Master painting sector will remain high until the supply of important autographic works eventually dries up as they are acquired by non-deaccessioning public museums. At that point, a new 'substitute' market may well emerge, not only for less highly rated artists, as is already the case today, but also for replicas. The recent increased scholarly interest, at least in classical studies, in the cultural status of replication has led to a number of revisionist theories which argue for an upgrading in the cultural value of replicas also produced during the classical period. [46] Perhaps this pioneering academic research will eventually influence our own valuation systems, and replicated art will begin to regain the higher cultural and market status it had during the nineteenth century.

2. A Dialogue of Connoisseurship and Science in Constructing Authenticity: The Case of the Duke of Buckingham's China

by Morgan Wesley

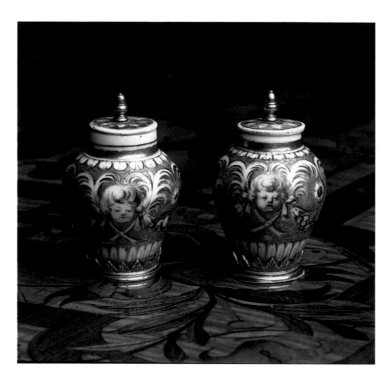

Fig. 1: The Buckingham jars, maker unknown, image from the original exhibition catalogue. Hard-paste porcelain, 1656–83, approx. 4.4 cm high. Burghley House, Stamford, Lincolnshire. *Photo: Burghley House Preservation Trust Archives 1991*

A pair of European Porcelaneous Miniature Vases and Covers, probably *circa* 1660. Of high-shouldered Chinese *guan* form, painted in iron-red, puce and black on a 'stippled' gilt ground with *putti* heads, each with a different expression – in repose, alert or amused. The short plain neck encircled by a collar of gadroons. The base with a border of stiff leaves. [1]

The pair of vases in Figure 1 was discovered by Gordon Lang (1942–2010), Honorary Keeper of Ceramics at Burghley House in Lincolnshire, while cataloguing the collections during a probate inventory in 1981. Inside one of these small jars was a slip of paper with the inscription 'Duke of Buckinghams China' in eighteenth-century script and written with chestnut brown ink, prompting immediate interest in the miniature vases (fig. 2). These two 'Buckingham jars' were small, delicate, and appeared to be made of some kind of porcelain. Decorated with rosettes, garlands, and the faces of *putti*, both jars were mounted with a brass alloy band around the foot, and featured covers with small metal finials.

In 1983 the decision was taken to produce an exhibition showcasing the Burghley House Japanese porcelains, which represented the earliest dated collection of such material in the West. Lang's *The Wrestling Boys: An Exhibition of Chinese and Japanese Ceramics from the 16th to the 18th Century in the Collection at Burghley House* (1983) introduced the world of ceramic scholarship to the holdings of the house and set the stage for a long history of similarly important exhibits in future years.

The Buckingham jars took their turn in the house's ceramic spotlight in 1991, when the catalogue for the exhibition of *European Ceramics at Burghley House* was being assembled. It was at this point that the question of patronage, raised by the slip of paper and the jars' appearance in early house inventories, had to be answered before the attribution could be finalised for the catalogue entry. Of substantial question was the nature of the jars' composition, since the production of porcelain was unknown in the West at the time delineated by the schedule, that is, prior to 1683.

This chapter will explore three axes of information that are applied by ceramic historians in assessing authenticity and in developing an attribution for an unknown work or group

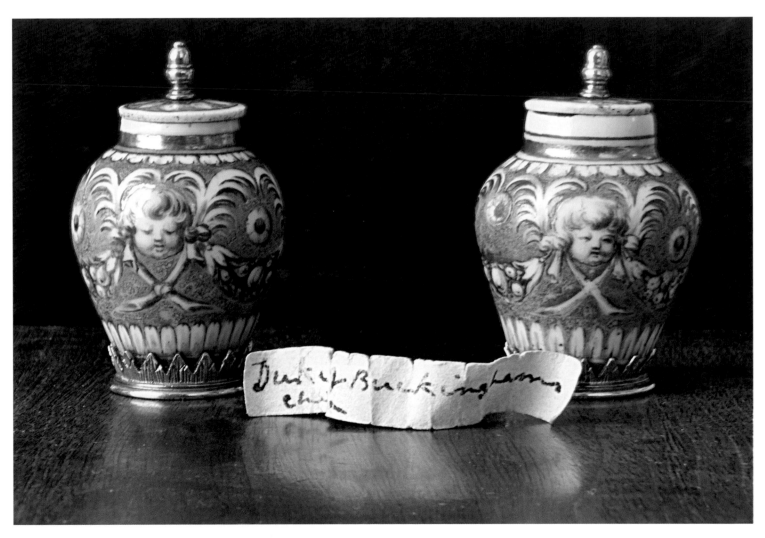

Fig. 2: The slip of paper found in one of the two smaller Buckingham jars, in the characteristic hand of Brownlow, 9th Earl of Exeter, *c*.1763. Burghley House. Stamford, Lincolnshire. *Photo: author's own 2011*

of ceramic wares. Issues of definition, misattribution, and developments in the analysis of ceramics will be considered, before finally applying these techniques to best attribute the Buckingham jars.

Connoisseurship, documentation and foundations of scientific analysis: the role of interdisciplinary discourse in authenticity

The issue of authenticity within the field of ceramics is moulded into the form of a dialogue, conducted between defined structures of information. It is a construction of the combined knowledge of the various connoisseurs, scholars, and scientists who are expert in the discipline. It is, paradoxically, also an area of study that fixates on the unknown and undiscovered, yet focuses intellectual and market value on the specific point of attribution – that is, the factual nexus of time, place and product of a ceramic work. It is within this conversation between data and intuition that any examination of the notions of authenticity and attribution must begin.

To understand the reason for this dialogue in attributing artworks, one must consider the basic attributes of 'fact' in the context of history. If the art object in question is one created outside the realm of living memory, then the specifics of its origin and the narrative surrounding it can only be reconstructed from disparate information. Archives, tax records, wills, diaries, sketchbooks, paintings, photographs, as well as the object itself, provide the primary sources for the discussion, but each is seen through a lens of interpretation and speculation. The results of these researches, which are sometimes complementary, but often contradictory, must be amalgamated in order to construct the perceived authenticity of a ceramic work, or, indeed, any other type of artwork.

In the field of ceramics, 'documentary' objects are wares that can be traced through their provenance to their original source and, usually, their date of production. They form a miniscule percentage of the objects in collections and are the cornerstones of our current knowledge. An excellent example is the pair of magnificent Yuan dynasty temple vases in the Sir Percival David Collection at the British Museum, dated to AD 1351, which are the oldest documentary blue and white porcelains known. Proving a work's documentary nature is a critical goal to researchers in ceramic history and only a very few pieces meet all the criteria for unambiguous attribution in this manner; they provide a yardstick against which to measure all other works. It was originally hoped that once the various techniques of attribution were applied to the Buckingham jars, they would fall within the realm of documentary objects.

The word 'constructed' becomes integral to understanding the final attributions given to artworks because, despite the best efforts and attempts of experts, there will always remain an element of doubt in these attributions. A theory can always be proven wrong by the appearance of a contradictory example, but it is virtually impossible to prove something right beyond a shadow of a doubt.[2] Because of this counterfactual truth, the discipline is left with the best possible assemblages of knowledge, threatened by error and misinterpretation.

In current scholarship, the dialogue between object and information can be broken down along the three primary axes of investigation: the connoisseurial, the documentary, and the scientific. It is this assemblage of techniques and skills that allow us to begin the re-examination of the foundations of knowledge in the ceramic discipline in an attempt to create a stable new ground upon which to move forward. In examining the history of the discipline, we can see the birth of each of these axes and the growing relationship between them as the field attempted to establish a basis for physical authenticity.

Connoisseurship: visual authenticity and cultural context

The process of attribution has traditionally been rooted in connoisseurship, whereby the evaluation of a work is based on physical characteristics such as its form, colour, decorative elements (both sculptural and painted) and the visible artefacts of the means of production. This does not presume that experts have historically worked in a hermetic vacuum of information, but rather that their primary source material was acquired through careful examination of the object and comparison to prepossessed

knowledge. During the early period of Renaissance collecting and for some time following, this approach was mandated by the lack of external information and became a best-fit system of identification. During the nascent phases of collecting in continental Europe, material (objects, documents pertaining to wares, and letters with relevant content) travelled at limited and inconstant rates between maker, distributor and collector. These movements were limited by the duration of sea transport, the inherent risks of the overland routes, political instability and a certain amount of jockeying for informational supremacy. In a system where transmitted knowledge is suspect at best, or filtered, skewed, and falsified at worst, the ability to glean minute details of an object's origin or creation from visual examination is invaluable. [3]

The period from c.1500 to 1900 was dominated by the connoisseur, whose legacy has been a confusion of attributions and the creation of a slanted academic view based on collections established during this period. [4] Many of the early attributions were unable to separate an original production from a somewhat later copy. Despite this, the early connoisseurs and collectors did, oftentimes, form opinions remarkably close to modern understanding.

Documentation: historic authenticity and communication of knowledge

During the late seventeenth and early eighteenth centuries, the reliability of communication was bolstered by the gradual increase in postal efficiency, the slow discontinuance of the practice of travellers and merchants carrying letters as personal favours, as well as increased security on routes of oceanic and overland travel. The ability to work from documents, letters, diaries and archives in a manner recognisable to the discipline today began to develop in this period. This was due in part to the ever-expanding 'Republic of Letters', initiated by academics, scientists and interested individuals of the seventeenth century and further developed and consolidated across Europe during the eighteenth century. [5]

This is not to say that the information resulting from increased transit was suddenly more reliable or more insightful than that of the fifteenth and sixteenth centuries, only that there was more likelihood of accurate information reaching an expert or collector. An expansion of the ceramic consciousness developed in the latter half of the seventeenth century, with commentary on ceramics becoming more refined due to an increase in collectors' awareness of the value of records (the specifics of a particular object, maker, or location of production) and other documents as intellectual commodities.

Certain traditional barriers did remain in place during the early eighteenth century, even with its increased informational transparency. The separation created by language, culture and geography between the clamouring hordes of European buyers and the producers in the Far East was to persist until well into the nineteenth century, though occasionally circumvented by individual missionaries, traders and explorers. The very few documents that did pass from China and Japan to Europe were received with great interest and had lasting impacts on the perceived landscape of ceramic production in the West.

Take, for example, the transmitted knowledge of Père d'Entrecolles, a Jesuit missionary in China during the early eighteenth century, who sent back letters to Père Orry, procurer of the Chinese and Indian missions for the Jesuit Church, located in Paris. The two letters written by d'Entrecolles in 1712 and 1722 were to form the cornerstone of European knowledge of the Chinese method of porcelain manufacture. [6] This information ran as a parallel solution to the 'secret' discovered and put into practice by Ehrenfried Walther von Tschirnhaus and Johann Friedrich Böttger in Saxony at the Meissen Factory. [7] Even with widespread dissemination of the knowledge that Europeans were already producing effective porcelain, the focus of many later experiments was fixed on finding sources of the Chinese materials *kaolin* (china clay) and *petuntse* (porcelain stone) referred to in d'Entrecolles' letters.

These two substances, as used by makers in southern China, became the *sine qua non* of porcelain production in later eighteenth-century Europe as d'Entrecolles' published letters were circulated. Because of the direct contact that d'Entrecolles had with original Chinese production, the method he recounted was considered more 'authentic' than the solutions incorporated at

the Meissen factory. This viewpoint continued to gain credence throughout the eighteenth century until opinion dictated that, to constitute a 'true' porcelain production, wares had to have been produced with *kaolin* clay and china stone. [8] Great effort was expended in shipping samples to England from as far away as North Carolina, and a methodical investigation to find the rare clay was launched, resulting in the eventual discovery by Thomas Cookworthy of suitable clays in Cornwall during the middle of the eighteenth century. [9]

By establishing a perception of authenticity and primacy of the Chinese material in defining 'porcelain' during the eighteenth century, the impact of d'Entrecolles' letters had a lasting impact on the way in which ceramicists historically view the term. During this period a single documentary source was often considered to be an adequate basis for knowledge and attribution, and it is only in the last hundred years that these historiographic issues have been substantively examined.

In much the same way that connoisseurs depend on documentary pieces for comparison, archivists and researchers require reliability in their sources. They can be led astray in many of the same ways as connoisseurs, the foregoing paragraph regarding 'authentic porcelain' being a perfect example. As with connoisseurship, when any incomplete, misleading or faulty material becomes part of the body of general knowledge, the cycle continues and the disinformation spreads through the discipline. With each publication and citation the information becomes 'authentic' and is used as the basis for further cycles of misinformation, a problem endemic within the decorative arts.

Scientific analysis: physical authenticity and technical accuracy

Scientific analysis, the third axis of constructed authenticity, developed hand in hand with the progress and refinement of the documentary approach to materials. With the burgeoning interest in scientific experimentation that emerged in the early seventeenth century came the invention and application of various techniques by intellectuals, alchemists, and potters working to unravel the secrets of ceramic manufacture.

While these early experimental practices were limited by available source material, fuel, functional equipment, and 'scientific' knowledge, their interaction with documentary sources and connoisseurship was able to dispel misconceptions and provide increased clarity within the ceramic discipline. Some of the first significant advances were a result of the experiments of John Dwight in producing a porcelain body that lacked *kaolin* clay or china stone. Dwight's knowledge of the principle properties of the elements allowed him to construct a synthetic porcelain alternative, forty-nine years before the letters of Père d'Entrecolles circulated. [10]

Similarly, it was solid experimental practice, applied to the information and myths circulating from travelers to the Far East, that allowed Tschirnhaus and Böttger to identify clay of the right properties in early eighteenth-century Saxony and to later refine the stone flux needed to make the first Meissen porcelains. This early chemistry laid the foundations for the advances achieved as the discipline of making porcelain moved into the nineteenth and early twentieth centuries. The complex interactions of elements, heat and time were better understood, and scientists were able to break finished ceramic wares down into their chemical components. This knowledge allowed Georges Vogt in 1900 to publish critical papers questioning the requirements for porcelain production described by d'Entrecolles, and revealing that a variety of different combinations were used in China, some porcelains being made almost entirely of crushed stones and others composed of almost pure clay. Such ideas were virtually anathema in discussions on the production of 'true' porcelain prior to Vogt's research. [11]

Further scientific advances through the twentieth century brought with them other technologies that would enable both dating of ceramic objects to the time of firing and examination of the crystalline structure of ceramic bodies and glazes. [12] It was popularly believed that the time had arrived in which experts had the resources to break down the information barrier created by the lack of compositional knowledge and establish the facts and authenticity of ceramic wares with unqualified certainty. For many authors and experts struggling with the notion of the construction of absolute authenticity, this idea of a scientifically

Fig. 3: Detail of The Devonshire Schedule, '*China Guilt and Enamel'd*'. Burghley House, Stamford, Lincolnshire. *Photo: author's own 2011*

tested proof of an object's age or structure was what they had been seeking to allay their fears of incorrect attributions by means of connoisseurship or documentary research.

Unfortunately, the information produced during the nascent period of scientific analysis was offset by prohibitive costs and an inaccessibility of necessary equipment. Furthermore, the processes available all required the removal of a sample from the item to allow for precise testing, thereby destroying or permanently altering the object in the process. Because of these significant limitations, only a select group of pieces could feasibly be tested, usually those with significant connection to documentary works. While advances in technology now allow for the non-destructive testing of certain attributes of ceramic components, most notably elemental composition, this field is still being explored for its commercial and academic potential.[13]

The major hindrance to scientific analysis lies in the interpretation of the quantitative results produced by the procedures. Simple mistakes in calibration or of sampling can lead to the invalidation of test results of ceramic wares. In these cases, the mistakes can lead to an attribution based on flawed science, in much the same way that misinterpretation of documents, diaries and archives leads to issues of faulty connoisseurship.

Building authenticity: a contemporary case study, the Buckingham jars

The construction of the Buckingham jars' attribution in 1981 and its subsequent re-evaluation and evolution until the present day is particularly illustrative of the role all three axes play. Having considered the evolution of individual components of the dialogue of authenticity and attribution, it is useful at this point to examine the roles of all three in an ongoing investigation.

During the 1981 probate examination of the collection at Burghley House, a schedule of deed dating to 1689 and originally drafted in 1683 was discovered. This document, the 'Devonshire Schedule', bequeathed property belonging to Elizabeth, Countess of Devonshire, *née* Cecil (1617–89) to her daughter Anne, Countess of Exeter. It provided critical early provenance for the

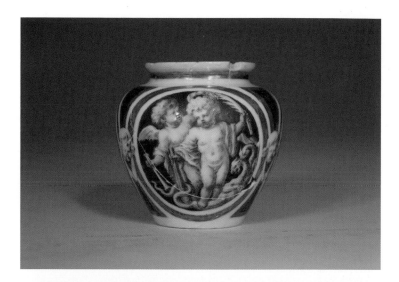

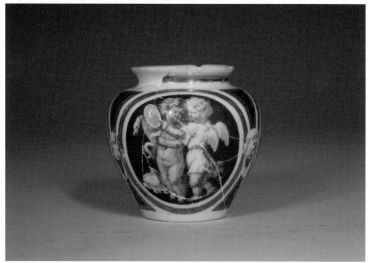

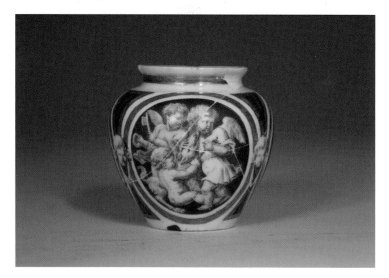

Buckingham porcelains, describing them clearly in the section under 'China Guilt and Enamel'd' (fig. 3).[14] The jars also appear in later inventories taken in the house, first in daybooks of Brownlow Cecil, Ninth Earl of Exeter, dating to the 1760s, and then again in an inventory of 1863.[15] In all cases a missing larger jar decorated with allegorical scenes is described alongside the smaller two.

Because of the dating demanded by the Devonshire Schedule and the jars' translucent appearance, Gordon Lang began consulting with curators at the British Museum and the Victoria and Albert Museum regarding the possible origin of the two small vases. At the recommendation of all parties, scientific analysis was carried out at the British Museum Research Lab (BMRL) to answer some basic questions regarding composition. These tests were also intended to rule out the possibility that, rather than being ceramic, the jars might be opacified glass, as enameling on glass was a common decorative technique but unheard of as ornamentation on ceramics in the seventeenth century. The BMRL analysis, conducted by Andrew Middleton using x-ray fluorescence (XRF) on the body of one of the small jars, and x-ray diffraction (XRD) on one of the small covers, concluded that the jars were of a porcelain composition as 'there was no evidence for the presence of elements such as tin, antimony, or arsenic, which might have been associated with glass opacifiers'. Additional analysis of the glaze components revealed the presence of lead, making an oriental origin unlikely, as that metal is distinctly absent in the bodies and glazes of Chinese and Japanese porcelains of the period. Finally, the lack of mullite (a very specific crystalline structure that is formed in porcelains made of kaolinic clay and china stone) in the cover tested was taken as further proof that these wares were not produced in the Far East.[16]

The interpretation by the BMRL was excellent, making use of the data available, and the report by Andrew Middleton was both insightful as to the jars' composition and the need to examine them more thoroughly when other samples became available or techniques improved. A critical point arose from this initial analysis: since no destructive testing could be conducted on the body of the jar itself, it was only the tested cover (which was

Fig. 4: The Virtues jar, maker unknown. Top to bottom **a** Fortitude cartouche; **b** Prudence cartouche; **c** Fidelity cartouche. Hard-paste porcelain, 1656–83, approx. 6.5 cm high. Burghley House, Stamford, Lincolnshire. *Photos: author's own 2011*

assumed to be of similar manufacture) that revealed no mullite crystal formation.

The resulting attribution suggested for the jars was 'probably soft-paste porcelain, of uncertain origin', and this played a critical role in how they were catalogued in 1991. Lang was also keen to note their similarity to the Chinese *guan* form (a type of baluster vase shape, commonly used in sixteenth-century temple wares), and he dated the jars to c.1660, based partially on the importation of this shape into Europe.

As of 1991 the ceramic world was left with the intriguing mystery of two small and clearly well-manufactured porcelaneous jars possessed of an excellent documentary provenance, dating to 1683 or earlier, and absolutely unconnected with any known ceramic production. The slip of paper found in one of the small jars, and attributing them to the Duke of Buckingham, further added to this puzzle since the connection to Buckingham remained unknown.

In 1998 another piece (or, more specifically, pieces) came to the attention of Jon Culverhouse, then house manager at Burghley. He discovered the collected fragments of a small vase in a box that had previously been overlooked and had them re-assembled. The third vase described by the various inventories was no longer missing. This 'Virtues' jar, named for its allegorical scenes of Fortitude (fig. 4a), Prudence (fig. 4b), and Fidelity (fig. 4c) became a key component in expanding the knowledge surrounding the jars.

The fragmentary nature of the Virtues jar allowed, in 2007, the analysis by scanning electron microscopy of the precise elemental composition of the body paste and glaze of the Buckingham porcelains. This analysis was conducted at Imperial College London by the author and Raphael Sa on three samples taken from damaged areas of the work.[17] As predicted in the 1991 BMRL report, the body '[contained] potassium, iron and lead; calcium [was] also present but only as a very low proportion (Ca<<K)'. The surprise came in the amounts and ratios found in the 2007 analysis. Contrary to the expected low alumina levels (alumina is an element too light to be reliably detected by XRF in 1991) and higher quantities of the sodium, potassium, and calcium prevalent in soft-paste porcelains, the ratios closely mirrored those of hard-paste porcelains, with characteristically high levels of alumina.[18]

With these results, the questions of authenticity and attribution became critical. Rather than being simply an unknown soft-paste porcelain, for which there was seventeenth-century historic precedent, these small vases seemed to bring the pre-eminence of the production of European hard-paste porcelain by Ehrenfried Walther von Tschirnhaus and Johann Friedrich Böttger at Dresden in 1709 into question. The date of 15 January 1708, when the first successful porcelain trials are recorded in Böttger's notebooks, represented the 'Eureka' of the West's long desire to reproduce Chinese porcelains. Could the vases at Burghley argue for a date at least twenty-five years earlier and in a different country?[19]

It is at this point that connoisseurial opinion, documentary evidence, and scientific analysis had to be brought into dialogue with one another to create a framework for an attribution of the jars. Each individual discipline contributed critical information but was not encompassing enough; it was thus necessary to create a consilient argument drawing on all three.

Connoisseurship, through examination of the decoration, told us that the source images used were Italianate in nature and the colours resembled early attempts at enameling, but could bring us no closer to a date for the pieces (and, as discussed by John Mallet, had actually linked another vase similar to the Virtues jar to the Medici Porcelain production).[20]

The classical role of the connoisseur in the seventeenth century resulted in the jars' name and original connection to the Duke of Buckingham. The script found on the small slip of paper discovered inside one of the smaller jars can be matched to the hand of Brownlow Cecil, the aforementioned ninth Earl of Exeter, and is in fact written in the same ink as his daybook inventories of the 1760s. Brownlow was well known to involve himself deeply in researching the pieces that comprised his collection, and was attentive to the need for both correct attribution and lack of ambiguity necessary to impart an object with particular financial value.

Brownlow dutifully recorded, in the daybooks, information regarding Buckingham's presumed involvement in the creation of

Fig. 7: **left** Octagonal plate, Chelsea Factory, England. Soft-paste porcelain, c.1765, approx. 7cm wide. **right** Small octagonal cup, Kakiemon style, Japan. Hard-paste porcelain, approx. 4cm high. Burghley House, Stamford, Lincolnshire. *Photo: author's own 2011*

the jars and the slip of paper that continues to give name to the group of porcelains was added. In such a way, a critical piece of information shifted from the realm of the connoisseur to reappear as a documentary source for current scholarship.

Documentary evidence tells us that the pieces existed in the collection at Burghley house as early as 1690, but dated to earlier than 1683, when the Devonshire Schedule had been drafted. Prior to their appearance in records in 1683, no mention of them exists in the records at Chatsworth House where Elizabeth Cecil had lived prior to bequeathing them to her daughter Anne. The records confirm that the works were in the collection at Burghley for an uninterrupted period between 1690 and the present. Additionally, the Virtues jar was already recorded as damaged and much repaired by 1854 though no mention of its cover appears after Brownlow's eighteenth-century inventory. Covers are featured in the accounts of the smaller jars in 1690 and 1854, though descriptions of the form of these covers were vague, with only the mention of metal mounts in 1854.

The final axis of investigation, the scientific analysis, left us with a mixture of information. The specific analysis of the

Fig. 8: Louis Testelin, 'La Fidelite', from *Les Vertus Innocentes*, engraving on paper, 23.8 x 20cm by Ludwig Ferdinand and published by Jean Mariette from the edition *c.*1680.
Image © Biblioteca Nacional de Portugal 2009

LA FIDELITE.

Ce Chien, cette Clef, cet Anneau, Doit sur son Cœur mettre le Sceau,
Montrent qu'vne amitié fidelle, Pour se conseruer Immortelle.

Virtues jar showed that it was consistent with the production of hard-paste porcelain and showed similar results to those predicted by Andrew Middleton based on the XRF analysis. These results, contradictory to the lack of mullite in the XRD analysis of the covers, led this author to speculate that the covers were produced independently of the bodies. A known practice of having soft-paste replacements made and matched to tea wares at Burghley in the eighteenth century provided further support to the argument (fig. 7). This supposition was born out by later analysis, using non-destructive environmental SEM, and conducted by Michela Spataro, Nigel Meeks, Mavis Bimson, Aileen Dawson and Janet Ambers at the British Museum in 2008. Their analysis showed similar compositions between the bodies of the small and large jars, with the covers comprised of a different body paste.[21]

Sir Timothy Clifford solved another critical element of the puzzle by recalling a folio of prints by Jacques van Merle that he had seen in the print rooms of the Victoria and Albert Museum (fig. 8).[22] These prints, dating to 1654, provided another bracketing date for the attribution as well as commentary on the Buckingham enameller's editorialising.

Combining all these sources, we were left with the following basic information: three jars, of hard-paste porcelain with a lead glaze; decorated in an Italianate style based on seventeenth-century engravings in red, green, black, and puce enamels with gold gilding; produced between 1654 and 1683; likely European with attribution to the patronage of the Duke of Buckingham by eighteenth-century connoisseurs (fig. 9). Reconciliation of all this information with existing ceramic productions still left several questions unanswered when papers on the Buckingham porcelains were presented in 2008 at Somerset House, London to the English Ceramic Circle.

Could these works be linked to any known production, whether English, European or elsewhere? Were they the final result of the experimentation that John Dwight was conducting in England in 1672-3? Were they foreign ceramics decorated by a novel and talented enameller in the employ of the Duke of Buckingham? These questions remain unanswered, though attempts are being made to gather disparate connecting threads into a more fully realised picture and continue the process of constructing an attribution.

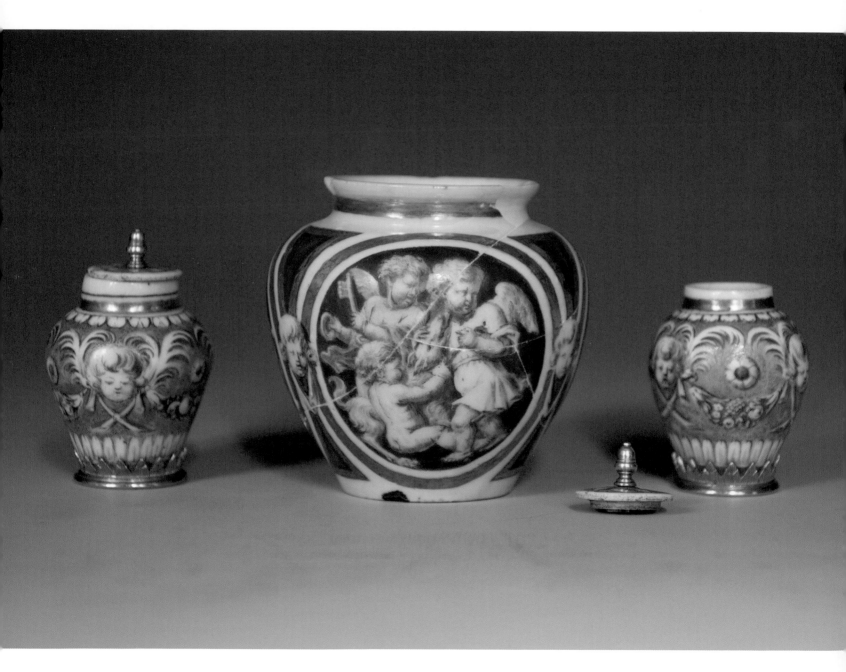

Fig. 9: The Buckingham jars. Porcelain, 1656–83, Burghley House, Stamford, Lincolnshire.
Photo: author's own 2011

In the case of the Buckingham porcelains the assembly of information from all axes of investigation allowed a more complete history to emerge, building on, and sometimes correcting, the work of early scholars and connoisseurs as far back as Brownlow Cecil. While documentary losses have made it problematic for current researchers to definitively connect the jars to the Duke of Buckingham, or to identify exactly the scope of the initial production, discoveries have provided some new information. For example, a piece previously in the collection formerly belonging to the Earl of Stamford, twin to the Virtues jar, was included in the 2008 English Ceramic Circle papers.[23] Unlike the work at Burghley, it included the original openwork lid, resolving one of the mysteries surrounding the jars. This second, larger jar also confirms that the sophistication of the manufacturing process made it possible to successfully replicate specific standardised designs.

Comparative physical material is lacking in various areas, leaving certain postulations partially unexplored, and the majority of the material resulting from John Dwight's porcelain trials is currently untested (although the issue is being addressed as this book goes to press). Given the great variance typical in all types of experimental bodies, the samples currently employed to rule out Dwight as a likely producer are too restricted. The speculation that the Buckingham jars may have been imported from the Far East and enamelled by a western artisan has found no specific analytical support, but enough material, such as apothecary bottles or local wares, remains untested that this cannot be ruled out.

That all these questions remain unanswered after rigorous examination demonstrates the uncertainties inherent in attributions. The Buckingham jars illustrate that, even with the combination of a wide variety of comparative material, strongly documented provenance, and scientific analysis, establishing a satisfactory attribution and, therefore, an object's authenticity requires the experience and collaboration of numerous experts over an extensive range of disciplines.

Closing thoughts

The dialogue between disciplines that address ceramics has been enriched to a point where innovative research into some of the less well-recorded material has begun. With an understanding of the strengths and weaknesses of a 'constructed authenticity', ceramic historians can use the differing axes of investigation to generate a more critical framework for examining historic wares. As these efforts expand, the new results will call into question older attributions and redefine the shape of the ceramic field. The current ability to work within a more consilient methodology is also beginning to remove some of the historical limitations on knowledge and communication that were discussed in this chapter.

The growing ability of experts to access information on a virtually instantaneous basis means that restrictions on the flow of documents, historically limited by physical issues of their transport and the vetting of their information due to poor access and low circulation, have been largely resolved. The question to consider now is how valid the attribution of works is, when based on a very few documentary objects, and what level of 'proof' is required to defend the authentication of pieces.[24] The case study of the Buckingham jars demonstrates that the discovery of a hitherto unknown body of wares can substantially alter the fabric of knowledge within the history of ceramics, and it is only through methodical review of all available evidence from each informational axis that we can begin to properly attribute and authenticate the work.

3. A Venetian Sixteenth-century Costume Book as an Authentic Visual Record

by Sophie von der Goltz

Cesare Vecellio's sixteenth-century book of costume engravings

In the sixteenth century the emergence of costume books reflected growing curiosity about other cultures and nations. European sea powers were discovering new lands, international trade was flourishing and travel was increasing.[1] The importation of exotic textiles, ceramics, spices and other goods sparked an interest in the way people of other nations and regions lived, including the way they dressed, or, as Cesare Vecellio put it, 'the diversity of clothing worn by the peoples of various nations, which reflects the regions they come from as well as those who wear them'.[2] Vecellio, born in 1521 in Cadore, near Venice, was a sixteenth-century Venetian artist who was best known for his books on costume and lace patterns.

Nowadays Cesare Vecellio's costume book, *Habiti antichi et moderni*, is seen as one of the most important sources for sixteenth-century costume. Not many Venetian garments are known to have survived the centuries, leaving costume historians with painterly and other visual evidence, written descriptions and their own speculation. As *Habiti antichi et moderni* includes detailed descriptions and a large section on Venice, it is often quoted as one of the leading forms of evidence for authentic Venetian clothing of the sixteenth century. It was published in two editions, first in 1590 as *Degli habiti antichi et moderni di diverse parti del mondo*, and again in 1598 as *Habiti antichi et moderni di tutto il mondo*.[3] It was the first time a history of dress had been attempted, covering clothing from the Old Testament and Ancient Rome to sixteenth-century Venice. It also tried to address a large variety of regions and countries, including Africa, India and Asia. The second edition was expanded to include the Americas. However, as Vecellio lived and worked in Venice, the Venetian section is the largest and, in all probability, the most accurate in depicting authentic Venetian dress of the time. As Vecellio noted, clothing often represented the status of the people who wore it, not only in terms of profession and class, but also in the norms and traditions of that society. In order for Vecellio's illustrated costumes to be considered authentic, the accuracy of his engravings needs to be established. If the clothing of his time is not accurately depicted, how can the costume plates give an authentic picture of Venetian society? The following chapter will investigate the accuracy of Vecellio's upper and middle-class costume engravings by using a variety of methods, and it will suggest that they may be taken as authentic representations of sixteenth-century Venetian dress and society.

A brief analysis of the Venetian plates

To begin, it is necessary to gain a basic understanding of sixteenth-century dress, as depicted by Vecellio. Figure 1, entitled *Nobile ornata*, illustrates a noblewoman's dress for public festivals. The square-necked bodice is of front-laced form with ladder lacing over a stomacher, running to a rounded point below the waist.[4] The shoulder seams are embellished by pleated lace or fabric and the neckline and cuffs are edged with lace. The skirt is very full and probably pleated and attached to a waistband. A partlet is draped over the woman's shoulders and is attached to a falling ruff, which frames the woman's décolletage.[5] She is additionally adorned with a pearl choker and two long necklaces with large pendants. Her hair is formed into two small horns, softened by some curls falling onto her forehead. Underneath the outer garments, a *camicia* and possibly a corset would have been worn.[6] The structure of the depicted costume corresponds to the basic description of Italian sixteenth-century clothing in modern books.[7]

A good example of men's clothing shown by Vecellio is the plate *Rettore di Scolari*, or 'Rector of the Students' Schools' (fig. 2). It depicts a Venetian academic dressed in a padded and buttoned doublet with a small ruff and short, round breeches. His lower legs are covered in hose and his cuffs are embellished with ruffles or lace. He is also wearing a long open gown trimmed with fur, and his head is adorned with a square cap. This corresponds very well to modern descriptions of Venetian sixteenth-century male dress, where it is explained that a man's outfit consisted of a drawstring shirt, a doublet, sometimes a gown, breeches, and upper and netherhose.[8] The comparison of modern descriptions to Vecellio's plates, however, does not really answer the question of their accuracy or authenticity, as these descriptions are themselves based on extant costume books and other historical

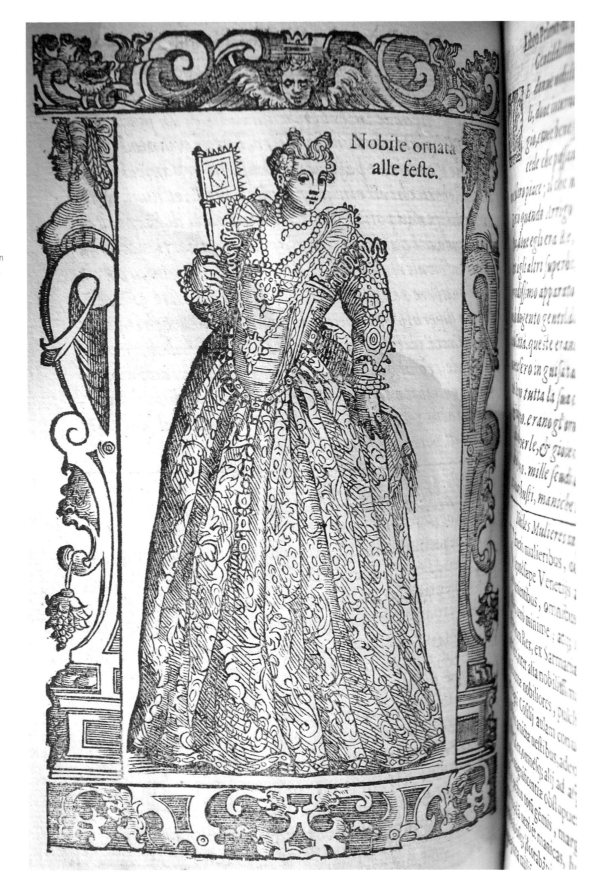

Fig. 1: Cesare Vecellio, *Nobile ornata* from *Habiti antichi et moderni di tutto il mondo*, 1598, p. 101. *Sotheby's Institute of Art Library, London; Photo: Ray Marsh*

Fig. 2: Cesare Vecellio, *Rettore di scolari* from *Habiti antichi et moderni di tutto il mondo*, 1598, p. 121.
Sotheby's Institute of Art Library, London; Photo: Ray Marsh

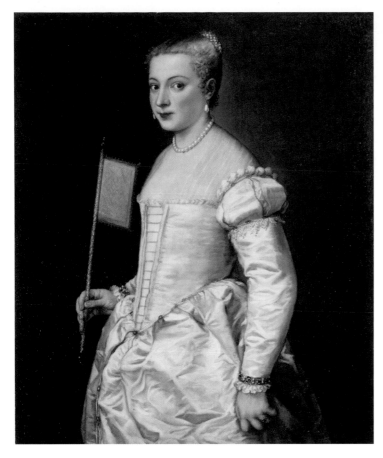

Fig. 3: Titian (Tiziano Vecellio), *Girl with a Fan*, c.1561, oil on canvas, 102 x 86 cm. Gemäldegalerie Alte Meister, Staatliche Kunstsammlungen Dresden. *Photo: Elke Estel/ Hans-Peter Klut*

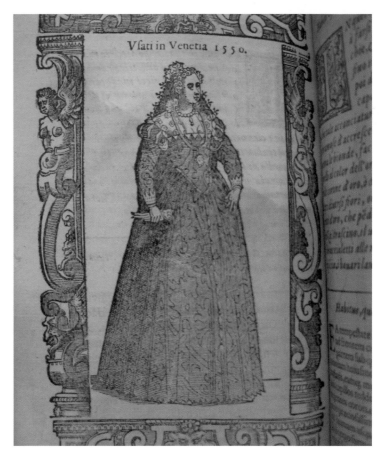

Fig. 4: Cesare Vecellio, *Usati in Venetia 1550* from *Habiti antichi et moderni di tutto il mondo*, 1598, p.77. *Sotheby's Institute of Art Library, London; Photo: Ray Marsh*

sources. Another way to determine the accuracy and authenticity of Vecellio's Venetian engravings lies within sixteenth-century Venetian painting, which offers good comparative sources for examining the plates. Some painters included detailed depictions of dress not only in portraits, but also in history paintings.

Titian's and Veronese's costumes

An effective comparison can be made by examining a portrait by Vecellio's cousin, Titian (c.1490–1576), the most famous Venetian painter of the sixteenth century. His painting *Girl with a Fan*, from c.1561 (fig. 3) is a half-length portrait of a girl in a white satin costume consisting of a bodice over full skirts. The upper sleeves are puffed, slashed and embellished with a lace border. The lower sleeves and neckline are also decorated with lace. The bodice runs to a sharp point below the waist and is of the front ladder-laced type. The opening, which is filled by the stomacher, is of a triangular wedge shape. The outfit is accessorised by a diaphanous partlet, a pearl necklace, pearl drop earrings and a Venetian fan. In the text accompanying Vecellio's engraving *Spose sposate* ('brides who have just been married') Vecellio explains that a white satin outfit is worn by a bride.[9] His engravings and description coincide

almost exactly with Titian's painting. The outfit also partially resembles several of the other costume plates, as well as, to an extent, Figure 1. The basic shape of a front-laced bodice with a low point over full skirts, is the same. Also the lace edgings occur in both images. However, the sleeve and partlet styles are vastly different from one another. The partlet in the painting is a plain piece of fabric draped over the shoulder, whereas the partlet in the engraving is additionally embellished with a lace border and a falling ruff. Additionally, the stomachers also differ from one another. Titian's has a sharp triangular shape, whereas Vecellio's is almost a rectangle that is rounded at the bottom end. It may be assumed that this was a stylistic element which changed in the last decades of the century.

It is highly likely that *Girl with a Fan* was painted twenty years before the sketch for Vecellio's engraving was prepared, meaning that fashion changed during that time. When examining Vecellio's other plates from the Venice of his day, (termed 'modern' in his book), it is clear that the rectangular stomacher with the rounded point was a normal stylistic detail at that time in Venice. Vecellio's plate, *Usati in Venetia 1550* (fig. 4) shows a female costume from 1550 without front-lacing, which has a much sharper, less rounded point below the waist. Vecellio did

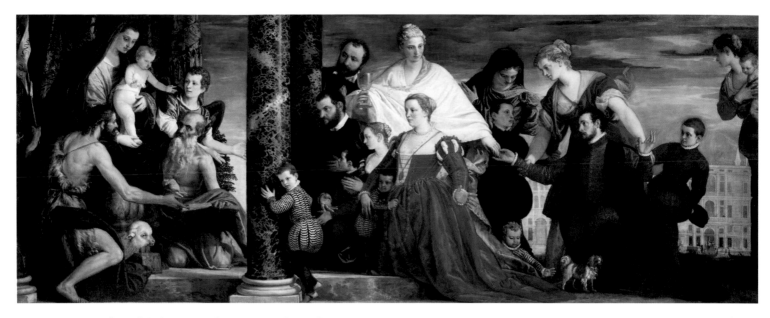

Fig. 5: Paolo Veronese (Paolo Caliari), *Adoration of the Virgin by the Coccina Family, c.*1571, oil on canvas, 167 x 416 cm *Gemäldegalerie Alte Meister, Staatliche Kunstsammlungen Dresden. Photo: Hans-Peter Klut*

not depict a front-laced version from 1550 or 1560, but another contemporary painting may help with a solution to the problem, as portraiture can provide a source for authentic dress.

The *Adoration of the Virgin by the Coccina Family* (fig. 5), from *c.*1571, is by the Venetian artist Paolo Veronese (1528–88) and was painted a decade closer to the time when Vecellio's 'modern' Venetian costumes would have been engraved. The painting depicts the enthroned Virgin and Child surrounded by saints, with Alvise Coccina and his family as donors. The most interesting costumes are those of the wife and mother in the centre, and of Alvise's dead brother, Antonio, on the right.[10] The wife is wearing a red velvet bodice and skirt. The bodice has a low, square-cut neckline and ends in a low point. It also laces at the front over a plain white stomacher. The edges of the bodice over the stomacher are almost parallel and end in a rounded point, which is much more like Vecellio's costume plates. The painting is about ten years later than Titian's portrait and suggests that the fashion for front-lacing changed within that time.

Vecellio's plates obviously illustrate the later fashion, whereas many paintings by Titian and Veronese depict earlier styles. The tops of the sleeves below the shoulders are similar to those shown in Titian's painting (fig. 3). Again, they puff out right below the shoulder seam and are slashed vertically at regular intervals, showing the white fabric underneath, probably the *camicia*. That type of sleeve can actually be found in a few of Vecellio's plates, including the *Usati in Venetia 1550* shown in Figure 4. The partlet worn by Coccina's wife is different to the one depicted by Titian and actually resembles Vecellio's partlet with falling ruff (fig. 1). It goes up to the neck and turns into a small ruff. This one, though, is stiffer and much smaller than the falling ruff, and similar examples can be seen in other Vecellio plates. It is possible

that this style of partlet with attached ruff was fashionable later in the century, as the earlier Titian portrait depicts a very plain diaphanous partlet. All in all, Vecellio's female costumes strongly resemble the costumes in Venetian paintings from the second half of the sixteenth century.

The costume of the young man in the Coccina family *Adoration* is also worth discussing, as it is very similar to the one worn by the *Rettore* in the aforementioned plate *Rettore di Scolari* (fig. 2). Antonio's costume in the painting plainly shows a padded doublet buttoned down the front with matching short round breeches, a black velvet gown draped over the shoulders, dark hose on the lower legs and a small ruff around the neck. The *Rettore* wears a long open gown over a doublet with ruff and short round breeches, closely resembling Antonio's outfit. However, in both of Vecellio's engravings the men are wearing hats; Antonio is not. It is possible that Veronese thought the depiction of a figure wearing a hat in the presence of Virgin and Child was disrespectful. After examining several Veronese paintings, it is obvious that he did not paint hats very often. Other Venetian painters did sometimes depict hats, such as Tintoretto (1518–94) in his portrait of Procurator Jacopo Soranzo from *c.*1550, and Titian in the portrait of Doge Marcantonio Trevisani. Perhaps hats were not included when the artist wanted to give the painting a more casual and intimate appearance, and were included when the painting was to be a more formal representation of the sitter's dignity and standing in society. In the case of the Coccina *Adoration*, Veronese may have been trying to hint at a close and intimate relationship with the Virgin and Child. It is also feasible to assume that hats were only worn at government ceremonies and festivals. The hats depicted in Vecellio's book tend to accompany the costume of those with a

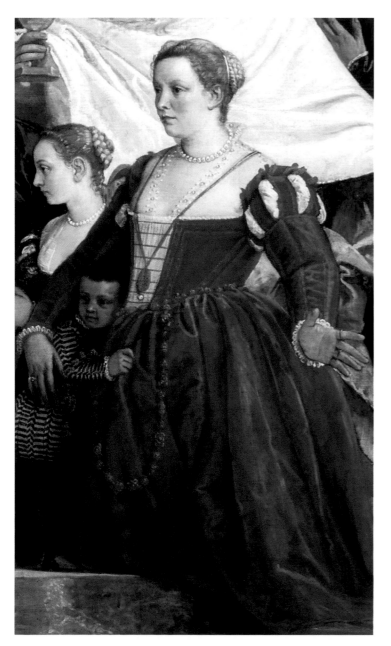

Fig. 6: The wife's costume in *Adoration of the Virgin by the Coccina Family*, shown more clearly below, illustrates how fashions had changed in the 10 years since Titian's *Girl with a Fan* (fig. 3) was painted.

government position or some official standing in society. However, even the usual nobleman's costume is shown with a hat, and Vecellio mentions some of the hats illustrated in the engravings, explaining their different names and shapes. Veronese's and other artists' disregard for hats in their paintings could, therefore, be due to artistic preference.

Venetian paintings would seem a good comparative source for determining the pictorial authenticity of Vecellio's engravings, as there is no indication that Vecellio took his ideas from life. He may have used Venetian paintings for inspiration, just as later artists used his book as inspiration. Another way of investigating the authenticity of Vecellio's plates lies in examining extant sixteenth-century garments, but few pieces of Venetian dress have survived the centuries. However, the rest of Italy had similar styles and construction methods to Venice, making other surviving sixteenth-century Italian clothing a useful means of reflecting upon the accuracy of Vecellio's portrayal of dress.

Exploring authenticity: existing garments

One female garment which has survived more than four hundred years is Eleonora di Toledo's funerary costume, as seen in the sketch in Figure 7. [11] It is especially interesting for the study of the construction of a sixteenth-century bodice. The gown was originally buried with Eleonora di Toledo in 1562 and discovered in 1857. Only fragments remained. [12] After a delicate restoration, it was possible to partly reconstruct the bodice and skirt. The design of the bodice is based on geometry. The back consists of a triangular section, which connects to a front section based on another stylised triangle. The back was attached to the front by silk ribbon laces, which were knotted at the top and spirally laced through the eyelets. [13] Sleeves tended to be detachable at the time and were also fastened through the use of ribbons. (This technique was also used in another extant Florentine gown, which can be viewed in the Museo di Palazzo Reale in Pisa.)

A Venetian bodice would have probably been very similar in terms of construction. In all likelihood, bodices without front lacings were laced at the side seams and were also based on triangular shapes. However, the back panel went to a small point

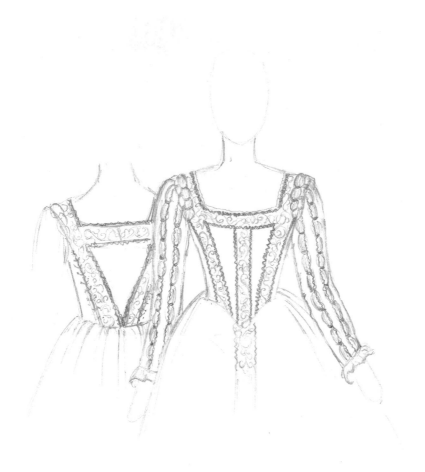

Fig. 7: Sketch of the funeral dress of Eleonora de Toledo, c.1562. *Sketch by the author*

instead of ending in a horizontal line, thereby mirroring the front. [14] Sleeves were also detachable, as mentioned by Vecellio. [15] As bodices were frequently stiffened with cardboard or firm fabric in Florence, it is likely that this was also practised in Venice. [16] Much of the embellishment of Eleonora's gown has disintegrated over time. However, some of the main edge trimming has survived and it is this, in addition to the shape, that can be compared to some of Vecellio's engraved bodice decoration. The bodice in Figure 1 seems to have some similarities. Other than being of front-laced shape, it is of triangular construction with a low front point and square neckline and has similar band-shaped trimmings running down the sides and top of the front section. The skirts in both are also of similar shape. Not much more can be compared visually, as it is not possible to see the actual construction of a garment depicted by Vecellio. We can conclude, however, that in this instance his engraving seems to be an authentic representation of sixteenth-century female dress.

An authentic recreation

The recent recreation of a Venetian garment offers one interesting method for closing the gap left by lack of evidence in the field of sixteenth-century Venetian costume. In this way, the author

set out to test the accuracy of Vecellio's engravings by making a lady's bodice based upon his representation of it. This presents a new way in which to explore the authenticity of his images of Venetian clothing.

It was necessary to begin with the essential sixteenth-century undergarment, the *camicia*, which is relatively simple to recreate as it consists only of rectangular and square pieces of fabric. For the recreation, instead of linen, muslin was used in order to produce a similar effect. The first step in making the bodice was to put together the basic shape. Pattern pieces cut from silk and based on stylised triangles were sewn together to create the form shown in Figure 8. A layer with sewn-in boning was then attached to form the flattened silhouette of the time. Satin bias binding gave the raw edges a finished look. A separate boned piece, of rectangular shape with a pointed end, made up the stomacher of the bodice. It slid in underneath the front edges and was held in place by hooks and eyes and tight ladder lacing made up of red satin cord laced through eyes on the inside of the bodice edges. To make authentic sleeves, they had to be of detachable design. A standard curved shape was used. They were connected to the straps of the bodice through the use of loops and small gold buttons. Both laces and button closures could be used to connect sleeves to a bodice during Vecellio's time. [17]

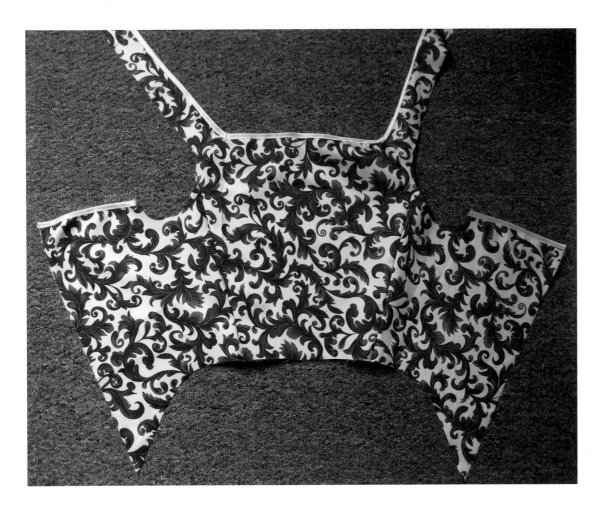

Fig. 8: Stage one of the bodice.
Made and photographed by the author

To achieve an authentic recreation of Vecellio's bodice, as seen in Figure 1, embellishments and a partlet are essential. Cotton lace was sewn to the upper edge of the bodice and stomacher, wide gathered lace to the sleeves' cuffs, and stiff white and gold gathered lace to the shoulder seams. White and gold braid emulates the trim running along the vertical and horizontal edges of the bodice in Vecellio's engraving. The partlet was constructed of three thin rectangular muslin pieces that tie at the front and under the arms. When examining the placement of the falling ruff illustrated in Figure 3, it seems quite likely that it was attached to the partlet. The small ruff, or collar, in the Veronese painting in Figure 5 forms a section of the partlet. In the engraving it appears to be a long piece of fabric irregularly pleated, or gathered, in order to achieve the effect. Extant examples of ruffs and collars were mostly made of fine linen, but the recreated ruff has been made of white polycotton, which is crisp and thin enough to serve the purpose. The ruff was completed by sewing together wide strips of the fabric, adding delicate lace, gathering it into the required length, and attaching it to the inner hem of the partlet.

The finished product in Figure 9 shows a relatively reliable recreation of a sixteenth-century bodice. Visually it resembles Vecellio's engravings and also paintings of that time. In addition, it has some authentic constructional aspects such as the button closures on the sleeve and geometrically based pattern pieces. Having achieved the right silhouette, it becomes clear through this reconstruction that Vecellio's costumes are convincing in appearance with respect to their structural components. This does not address, however, the authenticity of the illustrated costumes in terms of their societal context and the individuals who wore them. Clothing has always been used as a means for promoting national and cultural identity, and as an indicator of social standing. It should, therefore, be possible to examine the authenticity of the book's Venetian plates by examining the social aspects of Vecellio's costumes, now that their accuracy has been established.

Representing Venetian society through dress

Venetian society had a class structure with three clearly defined classes: the nobility, the citizen class, and the lower class. In themselves, each class consisted of several sub-categories. Vecellio mostly depicted costumes from the upper and middle classes, but he also showed some dress of the lower classes of Venetian society. Those are, however, more difficult to analyse as the poorer classes are depicted less often and their clothing was usually a

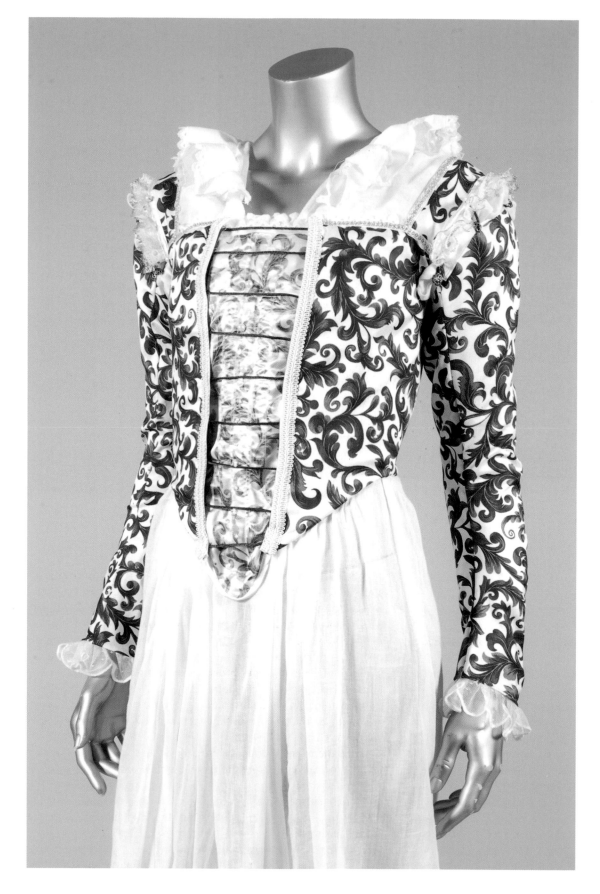

Fig. 9: Finished bodice.
Made and photographed by the author

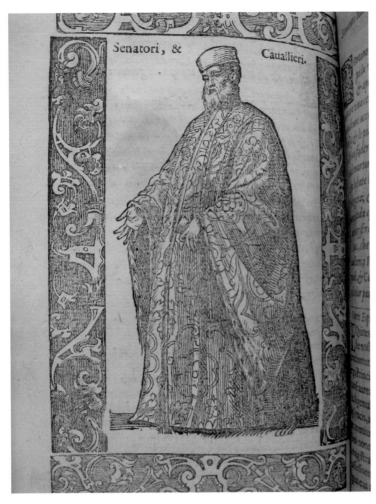

Fig. 10: Cesare Vecellio, *Senatori & Cavallieri* from *Habiti antichi et moderni di tutto il mondo*, 1598, p. 80. *Sotheby's Institute of Art Library, London*

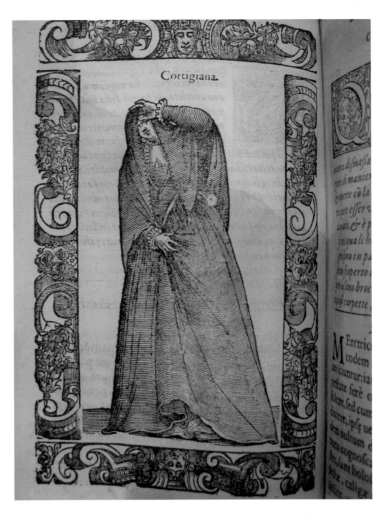

Fig. 11: Cesare Vecellio, *Cortigiana* from *Habiti antichi et moderni di tutto il mondo*, 1598, p. 107. *Sotheby's Institute of Art Library, London*

much simpler, more utilitarian version of what was worn by the fashionable classes.

The costume plate *Senatori & Cavallieri* (Senators and Knights) in Figure 10 depicts the costume worn by senators; by members of the official councils, the *Collegio* and the *Consiglio*; and by governors of the most important cities. Their elevated positions of political power are reflected in the richness of their clothing. They usually wore the ducal gown with wide open sleeves and richly patterned fabric. The ducal gown in gold was reserved for the *doge*, the head of the Venetian state. On special occasions, however, it was permitted to add a stole made of gold brocade. [18] In winter, gowns were lined in expensive marten, sable or lynx, the three most luxurious types after ermine in the hierarchy of furs. [19] The ducal gown signified power and wealth to any Venetian at the time. Because of its obvious costliness, even visitors from other regions were likely to recognise that they were in the company of a man of importance. *Habiti antichi* includes the clothing worn by other powerful members of society, such as the dress of a member of the Council of Ten, the *Avogadori* (or,

state lawyers), and the *Cancelliere Grande*. These positions were some of the most powerful in the city and were signified by a red robe or gown and stockings. [20] Even though their gown was overall plainer and less luxurious than the ducal gown, it was made of rich red velvet of the highest quality. The exact tone of red and the quality of fabric sent a specific message to the Venetian people, who were able to distinguish many different grades of dye, weave and texture. [21] In Vecellio's engravings, costume has the capacity to indicate the power and wealth of the wearer. Many patricians and citizens wore simple black wool gowns over their doublet and breeches, making it difficult to distinguish between many male ranks in the upper and middle classes. [22] It was more important to distinguish the lesser from the more powerful professions, whether noble or citizen, than to distinguish between a noble or citizen in terms of their social class. Vecellio's engravings seem authentic in this regard, for they clearly distinguish the differences between the various professions. [23]

Women had a passive role in Venetian society during the sixteenth century. Their main function was to marry and give

birth to an heir. However, sometimes when it suited the Republic's interests they were also used decoratively as 'advertising' for the beauty and luxury of Venice, especially during the 'La Sensa' festival. [24] Unmarried noblewomen were typically relegated to the domestic sphere and were not usually allowed to participate in public life. They were sometimes seen going to church wearing long veils to cover their heads. As one scholar has expressed it, 'In part to ensure the purity of its women, especially the wives and daughters of the elite, Venice regulated them strenuously. Their space was to be private, not public.' [25] When an upper-class woman was seen in public, she had to ensure that her dress clarified her marital status and position in society. [26] In Figure 1 the costliness of the ornaments and brocaded fabric point to an upper-class lady of Venice. Additionally, the wearing of expensive jewellery such as pearls was restricted to a person of wealth and standing.

The authentically dressed courtesan: a case study

It is an interesting fact when considering dress in sixteenth-century Venice that a courtesan's costume could appear very similar to that of a noblewoman, and problems of distinction understandably arose from this. [27] This does not mean to suggest that the Venetian section of *Habiti antichi* was inauthentic, for Vecellio actually highlighted the problems that sixteenth-century Venetians experienced in distinguishing between upper-class women and courtesans. As a result of the inflation of dowries, marriage was sometimes not a financial option, with the consequence that some women were forced into high-class prostitution. Often women of the 'citizen' class, in particular, could not afford to marry and became courtesans in order to support themselves. [28] The fashions of the famous Venetian courtesans warrant a closer look here in terms of their portrayal in Vecellio's book. Although Vecellio gives only two distinct images of courtesans in *Habiti antichi*, he mentions them several times in the accompanying texts to the engravings depicting noble women's dress.

In what way were courtesans visually recognisable? In the sixteenth century, Venice was well known for them. Visitors often came to the city to see the well-known *cortigiane oneste*

(the 'honest courtesans'), who were well educated and offered their customers refined and intellectual company in addition to physical services. [29] In return, they enjoyed social freedoms other women could only dream of. *Cortigiane oneste* could participate freely in Venetian social life without additional condemnation and were often much better educated than noblewomen. They also had the opportunity to be in charge of their own money and possessions; other women did not. [30] Luxury goods were an important part of a Venetian courtesan's image and the service she provided. Clothing and fashion, in particular, were used as a medium for social pretension that was exploited in order to attract customers. Through the implementation of sumptuary laws on a courtesan's dress and restrictions on her mobility in public, the Venetian government tried to enforce disappearing social boundaries. [31] However, these laws were often ignored, or courtesans found ways around them. As Rosenthal expresses it in her book on the courtesan Veronica Franco, 'the *cortigiana onesta* satisfied her society's need for a refined yet sexualised version of the aristocratic woman'. [32]

Vecellio's costume plate entitled *Cortigiana* (fig. 11) depicts a woman in a bodice with a low front point and square neckline, full skirts, and a veil which covers her head and most of her upper body. In the accompanying text Vecellio explains that courtesans often wore married noblewomen's and widows' fashions to suggest respectability. They frequently used colours worn by brides, and some even dressed in the way of unmarried girls. Vecellio continues to say that, as they looked just as modest as noblewomen did, it was often difficult to distinguish their actual profession. As sumptuary laws forbade them from wearing pearls, a bare neck could be a possible indication. However, courtesans often used a *bertone*, a man pretending to be their husband, in order to circumvent sumptuary restrictions, including the law pertaining to the wearing of pearls. [33] Courtesan's gowns were made of the most expensive materials and sometimes embroidered all over at additional cost. Rosenthal explains that courtesans did not have to follow the given rules for depicting their marital status and identity through their clothing, thus giving them the possibility to pick and choose their dress at will. [34] It seems that, although the government of Venice tried to enforce laws to

strengthen the social order, courtesans managed to circumvent and reinterpret those laws for their own advantage. Their ability to select a role to play through their choice of dress makes it clear that they enjoyed much more freedom than a noblewoman of the same time.

Vecellio obviously understood the difficulty of distinction that arose from this, as he tried to explain the similarities and differences between both types of women. Engravings such as *Venetiane per casa* or *Donne la vernata* depict women of high rank, but also courtesans who often wore the same style of dress. Vecellio recommended using their behaviour as an indication of the type of women they were. In public they carried themselves boldly, showing a fair amount of skin in terms of their faces and décolletage, as well as legs in stockings.[35] Although Venetian noblewomen were mostly hidden away from public view, some of them did go out in public, and it probably depended on their surroundings whether or not they could be recognised as noblewomen. Courtesans, in a way, constituted a class of their own. By pretending to be of noble rank, but actually having their own rules, they managed to operate with more freedom than most women of their day.

Vecellio also depicts lower-class prostitutes, who he called *Meretrici publiche*, or 'prostitutes in public places'. Typically these women did not have a shared way of dressing, as they had varying degrees of income and could not afford to dress in finery. A typical feature, however, was that of the doublet worn over a man's shirt. On the bottom they often wore a tied short or long apron. Their *pianelle*, which were high platform shoes, tended to be more than half a foot high, and decorated with trimmings and ribbons.[36] Vecellio explained that they stood at doors or windows, making eyes at passers-by. Ordinary prostitutes seem to have been much easier to recognise than courtesans. They showed more skin and had a penchant for cross-dressing.[37] In addition to their revealing dress sense, they also had a more unreserved and cruder way of broadcasting their profession. Obviously, there were distinctions of class among the 'fallen' women. Vecellio makes it clear that a trained eye was necessary to differentiate types of women socially, and it seems that some were not able to tell the difference between a high-class courtesan and a noblewoman. Courtesans were and still are associated with luxury. Therefore they had to dress luxuriously to impress the right category of customer – that is, wealthy, upper-class men. As Rosenthal mentioned, they were a kind of sexualised noblewoman, filling a gap that 'normal' women were not able to fill, because of society's constraints upon them.[38] As courtesans did not belong to any of the honourable female classes, they were able to enjoy certain freedoms, as reflected in the way they dressed. They had the opportunity to choose a variety of outfits worn by women who held different positions in society, such as unmarried ladies or widows. By combining different roles and switching characters by means of dress, they created individual styles. Very possibly they were the true trendsetters of female fashion in Venice.[39]

Vecellio's upper- and middle-class Venetian women in *Habiti antichi et moderni* are not only accurately portrayed, as shown by the comparison to paintings and the recreation of a bodice, but they are also authentic in the sense that Vecellio's plates and descriptions depict and clarify the class structure and highlight the problems of distinction within the society of that time. The engravings showing some of the lower-class professions may also be worth examining on a separate occasion. As a Venetian living at a time of extensive interaction with foreign cultures, peoples and ideas, Vecellio was able to grasp how Venetian society dressed and what it meant by doing so. Therefore, it can be concluded that, at least as far as Vecellio's engravings of Venetian costume are concerned, there seems to be a reasonably high degree of accuracy in his depictions. In addition, historical scholarship supports the conclusion that the distinctions of rank which he illustrates did, indeed, exist in Venetian society of the sixteenth century, and his plates of Venetian dress can, therefore, be considered authentic.

4. The Authenticity of Traditional Crafts: the Case of Ernest Beckwith

by Noël Riley

Fig. 1: Photograph of Ernest Beckwith as a young man, c.1890.
Courtesy of Andrew Beckwith

Ernest Beckwith (1872–1952) (fig. 1) was a woodcarver and furniture craftsman who worked in rural Essex, in eastern England, at the end of the nineteenth century and into the first half of the twentieth century. The era into which Beckwith was born was a time of looking backwards as well as forwards – that is, back to the lessons of history (especially medieval history) in order to stay connected to traditional techniques and designs and the comfort of tried-and-trusted methods of hand work in the face of rapidly developing technology and the social upheavals resulting from industrialisation. Through his pursuit of the traditional and time-honoured designs and techniques of production taught to him as a young man and which he brought with him into the twentieth century, Ernest Beckwith's career raises some thought-provoking questions around one aspect of the notion of authenticity: his work was not intended to be either original or distinctive, insofar as we understand these concepts today.

It would be tempting to link Beckwith's career to the ideas of the art critic John Ruskin and his most famous pupil, William Morris. However, the connection between Beckwith, the traditional craftsman, and Morris, the socialist entrepreneur, is a tenuous one. There is nothing in Beckwith's career to suggest that he was particularly aware of Morris and his writings, although Beckwith was exactly the kind of craftsman who interested Morris in a rather abstract way. Much of Beckwith's work certainly reflects a firmly rooted respect for craft skill and an abhorrence for pretension, and yet, ironically, the interest of twentieth-century scholars and writers in the Arts and Crafts Movement, focusing on techniques, historical revivals, politics and philosophy, has tended to obscure the activity and achievements of an army of country craftsmen working conscientiously and skilfully in towns and villages all over Britain throughout the nineteenth century and for at least half of the twentieth century. Ernest Beckwith was just one of this large number of traditional craftsmen and women who remain largely unknown and uncelebrated today.

The post-1960s veneration of originality in design, materials or methods of construction – that is, the obsession with distinction[1] – has tended to sideline, at least in Britain, traditional crafts. Despite the often high levels of skill shown in their execution, objects made with traditional woodworking

techniques, using time-honoured forms which have come down through generations in the apprentice system, have tended to be undervalued in the twentieth century. Such objects formed the bread-and-butter trade of craftsmen like Ernest Beckwith, who used traditional methods and skills that his contemporaries and their clients took for granted, and valued.

In recent years such skills have enjoyed a re-evaluation, but then, more often than not, they have to be harnessed to sophisticated design concepts unique to the maker for their success. Such individuality in creation obviously comprises one form of authenticity, and it is usually an expensive one where furniture is concerned. Other types of authenticity that have become important to us include the certifiable genuineness of historic works of art, as discussed elsewhere in this volume. Concern with provenance plays a part in this. Nowadays we tend to be dismissive of the romantic approach to artefacts, whereby ancient objects are venerated because of their supposed but unsubstantiated association with a particular time or people. Examples of this can be seen in the eighteenth-century collection of Horace Walpole, which included a comb that was supposed to have been used by the Anglo-Saxon saint, Queen Bertha, a hat believed to have belonged to Cardinal Wolsey, and a lock of hair, purportedly of Mary Tudor.[2] In addition, the carved and turned ebony chairs that Walpole and many others of his time revered as at least Tudor, if not medieval, are now known to have come from southeast Asia no earlier than the seventeenth century.[3]

A related aspect of authenticity, as applied to furniture, is the search for the 'genuine'. Since the early twentieth century, furniture historians, antique dealers and buyers of furniture have been much concerned to establish whether or not so-called period furniture is really of the time when it purports to have been made, or whether it has been reproduced, altered or restored. Such considerations carry a great deal of financial weight, aside from moral precepts of integrity and honesty. However, it is important to emphasise that period authenticity was of little concern to most furniture craftsmen working in earlier times, whether they were supplying fashionable households with stylish pieces in, for example, the eighteenth-century Chippendale or Hepplewhite styles, or humbler interiors with furniture of traditional and regional forms that would survive hard usage. This was certainly the case with Ernest Beckwith.

Beckwith is probably typical of many craftsmen of his period who, working hard, happily and very skilfully, made a modest living by producing a broad range of woodwork in response to his clients' needs rather than in response to any design theory, artistic movement or concern for originality; indeed, it seems to have been the tried and trusted traditional methods and designs that he valued most. Beckwith's clients included the restorers and beautifiers of churches and historic houses, middle-class householders looking for everyday furnishings, and designers in need of a collaborating craftsman to carry out their concepts. Which, if any, of these broad lines of activity could be considered more or less authentic than the others is an interesting question. While much of Beckwith's work and that of many similar craftsmen of his time emphasises careful handicraft, using good materials and reflecting an abhorrence of showiness for its own sake, it is unlikely that he would have taken on the lofty ideals or progressive design principles of middle-class theorists like John Ruskin, William Morris and the designers of the self-conscious Arts and Crafts Movement. Instead, Beckwith was typical of many working men with minimal academic education who learned their craft through apprenticeship and honed their skills through experience and hard work.

Authentic traditions and 'antique' furniture

Beckwith was born and lived all his life in the substantial Essex village of Coggeshall, a centre of weaving and textile manufactures since the medieval period and, in the mid-nineteenth century, still well known for the production of silks, velvet and plush in addition to straw plaiting and basket making. A type of tambour lace known as Coggeshall lace is probably the most remembered (and revived) of these industries in our own time. By the 1890s, when Beckwith was a young man, the cloth trade had been replaced by other commercial activities such as brewing, seed growing and the manufacture of gelatine and isinglass.[4] It is clear that Beckwith's own production was part of

Fig. 2: One of a pair of oak brackets carved by Ernest Beckwith, aged 14, at the beginning of his apprenticeship. Although he later supplied a range of useful furniture – antique, restored, altered and even completely new – carved work was always his preference. *Courtesy of Andrew Beckwith*

a lively continuum of traditional trades in Coggeshall, where the woodworking trades also flourished. Half a dozen cabinet makers and five furniture brokers, or dealers, are listed in directories in the later years of the nineteenth century.[5] Several of the cabinet makers worked as woodcarvers, too, and this activity continued well into the twentieth century, especially when demand for memorials to the fallen in the First World War stimulated a surge in production.

Ernest Beckwith was the first member of his family to become a woodworker. After leaving school at the age of thirteen he was apprenticed to the Coggeshall carver and cabinet maker, William Bally Polley, who had supplied the carved oak pulpit, choir stalls and altar rails to Coggeshall Church in 1871 as well as carved work to other local churches. Polley went on to train a number of carvers of the next generation. Figure 2 shows an example of work Beckwith completed early in his apprenticeship.

By 1893, at the age of twenty-one, Beckwith was sufficiently skilled in carving, cabinet making and all forms of joinery to set up his own workshop in East Street in Coggeshall. This property remained the family base for the next eighty years. The premises comprised a shopfront and showroom facing the street, with living accommodation behind and above. A first-floor workshop reached by an outside ladder was augmented by another in the garden as the work increased and, with it, the number of employees taken on. These included skilled craftsmen who worked for Beckwith for many years, and apprentices who came and went in a shorter span. In addition, a derelict public house next door provided storage space for furniture awaiting repair or alteration.[6]

The street-facing showroom was the key to Beckwith's bread-and-butter trade, which was the supply of furnishings, mainly to the local gentry. He rarely went out in search of stock, or to attend local auctions, but was well supplied by a few regular traders of the type now known as runners but then more prosaically called 'rag and bone' men. Occasionally they would bring in useful items dating from before 1830 (the usual definition of 'antique' furniture, at least until the 1960s), and Beckwith would repair minor damage, replace missing handles or feet, and polish up such pieces before placing them in his showroom. More often his acquisitions would be in a broken or damaged state or in a form no longer considered fashionable or useful, and they would be mended or modified to fit in with the needs and tastes of clients. This might mean making a bedside night table into a cupboard with a drawer, a bidet into a usefully small chest of drawers, or reshaping a whatnot into a music canterbury.[7] Large tester beds of the eighteenth century, and earlier, were not in much demand, so their carved or turned posts were converted into standard lamps or pedestals for flower vases. Whether these items were 'authentic' antiques because they were derived from old pieces and produced from centuries-old timber, or whether they were simply useful furnishing items, would not have been an issue for Beckwith, who was a practical craftsman and not a theoriser.

Always appreciative of good quality timber, Beckwith would reuse wood from derelict or unconvertible antiques for making attractive and serviceable items such as stools, towel horses, bookcases or occasional tables. In some instances he would cleverly doctor a plain piece, adding a little carving, reshaping legs, or enhancing a side chair by adding curved arms (figs 3, 4). In addition to these useful antique or remodelled pieces, Beckwith would be called upon to undertake furniture repairs for local people who valued his skills highly. His showroom was evidently a magnet for those on the lookout for attractive and, preferably, antique items of furniture for their houses. Many who brought him a chair or a cabinet to mend would leave with another piece from this ever-changing stock. A significant portion of the furniture passed down in the author's own family has resulted from such serendipitous purchases from Beckwith's shop.

Furniture such as this cannot be regarded as 'fake' since it was never made with any intention to deceive. Beckwith was, after all, following J. C. Loudon's recommendation of a century earlier, that old fragments from the 'abundant remains' of historic woodwork should be made up into useful furniture.[8] In Beckwith's time old furniture was often cheaper than new, and he was undoubtedly one among countless cabinet makers and dealers who supplied the homes of the middle and upper classes with reworked or altered antique furniture during the first half of the twentieth century. While he was probably more skilful than many of them,

Fig. 3: A typical Beckwith 'improvement', this was originally a plain, eighteenth-century mahogany tripod table. Beckwith carved out the solid top, creating a scalloped edge; he also turned and carved the embellishments on the central pillar and carved the leaf motif and the paw feet on the legs. Much of the stock in his shop in Coggeshall consisted of pieces like this, either altered from their original form, or made from old materials. *Courtesy of the author*

Fig. 4: An eighteenth-century mahogany splat-back side chair; the scrolling arms were added by Beckwith in the 1940s. *Courtesy of the author*

both in terms of executing woodwork and in the ability to spot potential in the miscellany of items brought to him, his business was surely replicated in many parts of Britain. In Beckwith's case the employment of craftsmen and apprentices who could keep the shop well supplied with stock, as well as fulfil many of the individual commissions and repairs that supported the business, enabled him to focus on woodcarving, his own preferred activity and also the pre-eminent skill of William Polley, to whom he had been apprenticed. He worked almost always in oak, which he was able to source locally. [9]

Woodcarving for the Church: a continuing tradition

A major part of Beckwith's output was carved work for churches and secular buildings, and without doubt this has proved his most significant legacy. In our own period, when woodcarving has virtually disappeared as a regular professional trade, its importance in the first half of the twentieth century may seem surprising. Besides Beckwith, there were at least two other carvers with independent workshops in Coggeshall at this time, and they are known to have collaborated with each other occasionally. [10] Even then, carving was immensely time consuming and hardly profitable. It is clear that Beckwith's work in this field was at least to some extent supported by the more mundane output of his workshop. [11]

Beckwith and his contemporary carvers were working at the tail end of the great nineteenth-century explosion of church rebuilding and refurbishment, and there was still plenty of work for them. Screens, pulpits, panelling, pews, altars and memorials were produced in profusion within, and lychgates into churchyards seem to have been a Beckwith speciality without. Many of these lychgates were set up as memorials after the First World War, and at least eight of them survive in various Essex parishes (fig. 5). Based on a fifteenth-century form, each is slightly different, but almost all of them have gabled roofs above timber-framed enclosures with braced entrances and arcaded sides with panelling below. [12] This structure allowed for carving on the fascia boards under the gabled roof, on the spandrels of the arches and in some cases on the crossbeams of entrances. In most cases these gates

Fig. 5: Lychgate at the Church of St Mary, Gestingthorpe, Essex, typical of many carved by Beckwith in this area; most were memorials to men killed in the First World War.
Courtesy of the author

Fig. 6: Detail of carving in the lychgate above.
Courtesy of the author

Fig. 7: Oak vestry screen from the church of St Andrew, Clevedon, Somerset, carved by Ernest Beckwith (1932), with a hierarchy of 'gothic' borders, cusped arches, quatrefoils and mouchettes. Many of these motifs were inspired by A. C. Pugin's *Gothic Ornament. Courtesy of the author*

were attached to medieval churches, and while they blend with the gothic style they are visibly distinct from fifteenth-century or earlier work.

Beckwith's carved work for the interiors of churches also conformed to the gothic style prevailing in the nineteenth and early twentieth century. Whether he was supplying chancel or tower screens, pulpits or memorial boards, his confidently delineated cusped arches, crocketed pinnacles and arcading are always in evidence, usually surmounted by bands of floral and leaf carving. Much of this was inspired by designs in A.C. Pugin's *Gothic Ornaments*, first published in 1831. Beckwith owned an 1854 edition of this book, and several of his church carvings can be directly traced to motifs illustrated in it (fig. 7), a demonstration of the way in which he brought well-established ideas of the nineteenth century forwards into the twentieth. [13]

There was also much work to do for secular buildings. Essex is particularly rich in its heritage of timber-framed houses, and appreciation of them was growing in the late nineteenth and early twentieth centuries. [14] Many were in need of restoration and others were treated to additions of carved work and panelling to accord with owners' visions of their Tudor buildings. One of the

most interesting examples of Beckwith's work in this field was the restoration of Paycocke's, a fine, sixteenth-century Coggeshall merchant's house, now owned by the National Trust (fig. 8). It was rescued from dereliction in 1904 and given a sensitive facelift involving the replacement of carved sills, windows and other features. Beckwith carried out these new carvings so successfully that for many years they were regarded as part of the original fabric and only recently has Beckwith's contribution been fully recognised. [15]

In an age dominated by machine production, it is difficult for us now to comprehend the deep level of concentration and skill involved in the repetitive hand processes of carving long runs of ornament. Beckwith had a 'feeling of compulsion in the creative process' and, for him, the concentration and tenacity involved in woodcarving were a deep source of satisfaction and contentment. [16] His grandson paints a vivid picture of Beckwith the craftsman retreating to his workshop for two or three hours most evenings, after the day's labours were over and the other workers had departed, to stand at his bench in solitude carving runs of flowers, fruit and foliage for his church commissions, smaller ornaments for spandrels or memorial boards, and sections of

Fig. 8: The street front of Paycocke's in Coggeshall, Essex, after restorations and additions by Ernest Beckwith in 1908–9.
Courtesy of Andrew Beckwith

Fig. 9: A set of mahogany 'ribbon-back' chairs made by Ernest Beckwith and copied from Plate XV of *Thomas Chippendale's Gentleman and Cabinet-maker's Director* (London: three editions, 1754, 1755 and 1762). *Courtesy of Andrew Beckwith*

linenfold or compartments of 'romayne' work for the redecoration of old houses.[17]

Beckwith also applied his carving skills to making reproductions of eighteenth-century furniture, not with any intention that his work should deceive, but rather because it was saleable. In this, he was in some respects following another well-established tradition: the making of copies. He owned a reprint compilation of Chippendale, Sheraton and Hepplewhite furniture designs which he used as a guide for at least one mahogany desk after Chippendale, and several sets of chairs with vigorously carved splats (fig. 9).[18]

Although Beckwith rarely designed the work he carried out, he would have had a free hand in executing the details of its carving. The first of his lychgates was almost certainly the one at Gestingthorpe (fig. 5), set up in 1914 in memory of Captain Lawrence Oates, a local inhabitant, who had died so heroically on Scott's Antarctic expedition in 1912. The design was based, as already noted, on a fifteenth-century type and was provided by the London architect Arthur Blomfield Jackson (1868–1951). Beckwith followed its pattern, with his own variations, for his subsequent lychgates.[19] On at least two occasions he worked to the designs of the Chelmsford architect Wykeham Chancellor (1865–1945), first on the chancel screen at St Peter's-in-the-Fields, Bocking (1910) and, much later in 1936, for the provost's stall in Chelmsford Cathedral (later removed). The traceried panels and pronounced trifoliate finials to the desk ends were said to have

'allowed the carver to demonstrate all his creative and artistic skill'.[20] The pulpit at St Gregory's, Sudbury, was the result of collaboration with the local artist F. P. Earee (1888–1968). While Beckwith conformed to the gothic style in these projects, he exercised his own discretion in the disposition of motifs and the 'handwriting' of his carving: his grandson, also a woodcarver, is quick to distinguish his work from that of other craftsmen of the same period working in a similar manner. While his work represents a continuing general tradition, it nevertheless has a personal authenticity and integrity.

For what was probably his most prestigious church commission, the chancel screen, choir stalls and altar at St Mary the Virgin, Saffron Walden, Essex, executed in 1923–4, Beckwith worked to the designs of Sir Charles Nicholson (1867–1949). While Nicholson planned the broad structure of linenfold panelling, vaulted canopies and attenuated traceried arches in the screen, Beckwith would have determined the details of the carving. The crisp and confident runs of floral ornament and the assured regularity of the panelled sections are typical of his work. On one side of the screen the depiction of a young hare is a delightful rebus commemorating one of the churchwardens whose name was Leverett. This imposing screen was one of the few examples he was persuaded to sign: both 'CHN' (for the architect) and 'EWB fecit' appear on one of the stalls attached to the east side of the screen. Normally Beckwith was unwilling to add his name to his work, maintaining that 'if the work has any merit it will speak for

itself.[21] This attitude is in sharp contrast with today's emphasis on trumpeting the individual's role in the making process, and demonstrates Beckwith's innate confidence in his authentic participation in an honourable historic continuum.

A modernist interlude

Beckwith's collaboration with W. F. Crittall, the son of the founder of the well-known metal window company based in Braintree, Essex, is sometimes regarded nowadays as the most significant aspect of his career.[22] It is certainly the one point where his work as a furniture maker converged with a recognised contemporary design movement. 'Pink' Crittall was trained as an artist, and throughout his life he engaged closely with progressive art and design; he had a particular interest in the arts of Japan and China. For fifty years he had charge of the technical and design aspects of the firm and was responsible for the uncompromisingly modernist architecture of Crittalls' garden village, Silver End, built on the edge of Braintree in 1926–32.[23]

Beckwith and Crittall had known each other since 1908, when Beckwith was engaged in the restoration of Paycocke's in Coggeshall, and for many years they worked together to produce furniture for the company's offices and for various members of the Crittall family, most notably the furniture of Crittall's own house, acquired in 1934. As with the majority of Beckwith's commissions, no formal drawings for these items survive: Crittall would sketch his ideas on the backs of cigarette packets or envelopes, and Beckwith would put them into practical effect, most often using walnut or mahogany recycled from old and broken furniture. In the timbers he used he was following a more traditional path than many of the modernist designers of the time. However, useful forms such as cabinets, bookcases, chairs and tables would be treated to severe geometric embellishment or carvings evoking oriental or pre-Columbian motifs. This collaborative partnership between designer and craftsman demonstrated a perfect understanding between the two men and lasted for nearly half a century.[24]

Beckwith's own opinion of this furniture was probably less enthusiastic than that of the present followers of design, who hold its unique and distinctive character in high regard. Pink Crittall's modernist ideas may have seemed, to Beckwith, a mere passing fashion, lacking what he saw as the more enduring harmonies of eighteenth-century furniture design, faithfully copied. For an artisan with five children, a longstanding and compatible client like Crittall must have been a godsend, and Beckwith's chief objective would have been to fulfil his wishes. The carefully crafted, hard-wearing furniture Beckwith created was often pleasingly distinctive, yet he would have been astonished at the prices these examples of his work for Crittall now fetch on the rare occasions when they come up for sale, as opposed to the modest prices commanded by his more traditional work.[25]

An authentic legacy

Always a diffident man, Beckwith would have had little interest in originality for its own sake, in contrast to present-day attitudes. Rather the opposite, he is known to have expressed the view that if a style was to be copied, it should either be done faithfully or left alone.[26] His legacy is 'authentic' in so far as we know about the provenance and intentions underlying much of his work, but when authenticity stretches out to originality of ideas or design, this can be at the cost of other values such as technical skill or the quality of materials. Beckwith's concern was with fine craftsmanship (especially in his carving) and solid worth in producing useful furniture to satisfy his clients. His work participates in a long-established continuum of traditional craft and design and shows a sincerity of purpose that is, perhaps, ultimately more important.

My thanks are due to Andrew Beckwith,
Ernest Beckwith's grandson, also a woodcarver,
for his help in the preparation of this chapter.

5. Acquiring and Displaying Replicas at the South Kensington Museum: 'The Next Best Thing'

by Barbara Lasic

Under the aegis of the National Inventory Research Project (2010), the Victoria and Albert Museum recently attributed a pastoral scene previously thought to be a nineteenth-century pastiche to the eminent French rococo painter François Boucher (fig. 1).[1] While the discovery was cause for celebration, it brings into focus the importance museums attach to cataloguing, and thereby authenticating, their collections. However, the fact that the painting was previously thought to be a copy illuminates the museum's open attitude towards the inclusion and presence of such material in its collections. This attitude was laconically summed up by Richard Redgrave, a key official at the South Kensington Museum (later to become the Victoria and Albert Museum) who, when discussing travelling exhibitions in 1860, wrote: 'we cannot send the crystals of the Louvre round, so we send the next best thing'.[2] In this case, the 'next best thing' was photographs of the objects which had been 'coloured by (a student) in the Louvre from the works themselves'.[3] Such a pragmatic approach fully 'crystallises' the didactic agenda of the museum's early years and its ambivalent and ambiguous approach to the authenticity of the objects in its collections.

Enlightening the nation: a didactic resource

Born out of the proceeds of the Great Exhibition of 1851 in London and informed by the strength of its international industrial displays, the South Kensington Museum can be rightly regarded as the first museum in Britain founded as a monumental national educational tool with the dual mission of enlightening the nation at large and improving the standards of national taste. Controlled and administered by the Department of Practical Art, later called the Department of Science and Art, the museum's first incarnation was as the Museum of Manufactures at Marlborough House; it was moved to South Kensington and named the South Kensington Museum in 1857, before being renamed the Victoria and Albert Museum in 1899. The nucleus of the museum's collections was acquired with government funds from the 1851 Great Exhibition; it consisted of a selection of textiles, glass, pottery and metalwork from foreign and national manufacture and had been set up originally as a didactic resource for teaching students of the School of Design.[4] As will be discussed, the institution's educational mission framed and influenced its attitudes towards 'authentic' objects and the display of copies in its galleries. The period 1855–1900 was an ambitious and prolific era of expansion for the newly established museum. Its early collecting policies were bounded by a complex network of competing and often conflicting forces. The perceived superiority of foreign goods geared the museum's policies towards the acquisition and display of historical decorative arts, as it was widely believed that it was the study of historical models that enabled foreign designers, French ones in particular, to produce goods of the highest quality.[5] There was a general consensus amongst art officials that historical decorative arts were more likely to embody correct principles of design, and constituted 'a storehouse, of which the treasures must be known ... before [students were] in a condition to become explorers in [their] turn'.[6] In short, museum officials believed in the reformative and educational power of the 'exquisite and the old'.[7]

While Henry Cole, the museum's first director, wanted to include exemplary objects that would inspire contemporary designers, the connoisseurial concerns of the museum's first curator, John Charles Robinson, prompted him to acquire good art for its own sake, which led, among other things, to the foundation of the museum's remarkable and well-published collection of Italian sculpture. A shrewd and innovative loan policy, combined with Robinson's expertise, enabled the South Kensington Museum to remain largely unaffected by the soaring prices of historical decorative arts in the second half of the nineteenth century.[8] In fact, Robinson's visionary flair enabled him on several occasions to anticipate such market rises. Discussing an important sale of 1864, Robinson noted 'the fine specimens are likely to command much higher prices than such works have ever realised before ... many objects are now likely to sell for as many pounds as similar ones have been purchased by me in Italy for shillings'.[9] Henry Cole explicitly acknowledged the museum's limitations in the *Art Journal*: 'in more costly purchases such as Sèvres, we do not at present feel confident enough to spend a thousand pounds for a vase; but I should like to see a few thousands spent in Sèvres china'.[10] Cole's words are evidence of the museum's desire to

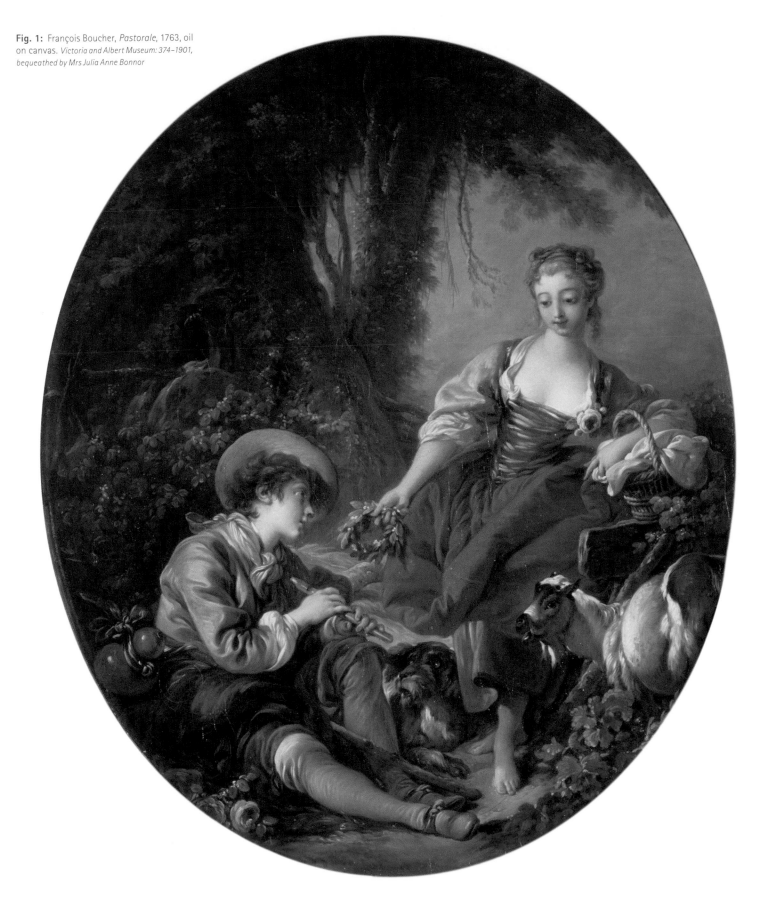

Fig. 2: R. W. Herman, *Drawing from a Plaster Cast*, 1840, black and white chalk.
Victoria and Albert Museum: E.1967–1909

acquire 'authentic' historical goods. Nevertheless, limited in what it could acquire, the museum ingeniously circumvented financial constraints by resorting to the use of copies when originals could not be obtained. Authenticity of period and provenance was not an essential requirement for the acquisition of objects: their design value and perceived instructional use and merit were equally considered.

Copies as exemplars

Cole and Robinson's episodic confrontations and often conflicting outlooks regarding connoisseurial versus didactic concerns never seriously challenged and affected the perceived and intended purpose of the collections. From precious French soft-paste porcelain to modest machine-made textiles acquired from the Great Exhibition, museum objects had a common denominator: in line with the doctrines of the design reform movement of the later nineteenth century, they were intended as exemplars and were expected to disseminate correct principles of design to artisans and to the nation at large. [11] Copying was, from the start, central to the museum's logic, and the students of its affiliated school of art were required to copy the works on display as part of their artistic training. Richard Redgrave's National Course of Art Instruction (NCAI), established in 1852, firmly positioned drawing as a compulsory and paramount element in art education and the curriculum dispensed by the school. While museum catalogues scrupulously analysed the perceived aesthetic merits and faults of the exhibits, the students of its affiliated school of art visually dissected their various components to extract the 'essence' of good design and learn how to reproduce it. The school's curriculum disseminated the construct that good design was reproducible and not necessarily the product of a single specific time, place and hand. Authenticity of period and provenance was not valued for its own sake and objects were not exclusively judged on the basis of their intrinsic worth, rarity, or association with a celebrated maker. Instead, they were primarily assessed on their perceived aesthetic merit.

Examination of the exhibition catalogues published by the South Kensington Museum in the 1850s and 1860s brings into focus the institution's ambiguous attitudes towards some of its original (and costly) pieces. Discussing a boat-shaped Sèvres *jardinière* Robinson commented that it was 'somewhat contorted [and] not inelegant' but that it should not be 'held up as a model for imitation ... we should be compelled to condemn it as radically false and vicious, inasmuch as nearly all laws of ceramic propriety are here violated'. [12] Evidently, the curator's set of values used to determine the desirability of objects differed from that of private collectors. However, it is interesting to note that an object's ability to convey good principles of design did not necessarily determine the outcome of its inclusion in the museum collections: objects such as the precious Sèvres *jardinières* described by Robinson above were sought after and acquired by the museum. Here we have evidence of the museum's lack of clearly defined acquisition policies inasmuch as authenticity and perceived good design were both criteria that were regularly ignored in order to acquire some of the rarest and most sought-after objects on the market, and thereby bolster its status as a world-class institution.

Drawing from plaster casts, an essential element of artistic training since the eighteenth century, was widely practiced. Today, the collections still contain some of the drawings made by students at the school of art, as exemplified by the drawing by R. W. Herman, which, according to the acquisition register 'obtained the first prize ever offered by the Government School of Design for drawing ornament from the cast' (fig. 2). [13] A sheet of sketches signed 'F. Shelley' testifies to the wide geographical and historical spectrum that copying encompassed (fig. 3). The nine specimens of ceramics drawn by Shelley span three centuries, two continents and four countries. Highly finished presentation works, we know that they were executed as part of Shelley's student training for examination as each watercolour is blind stamped with the letters 'ESK', meaning 'Examined South Kensington'. Today, these sketches can still be linked to objects in the collections: for instance, the pilgrim's bottle from Urbino can now be seen in the museum's newly refurbished Medieval and Renaissance galleries, and the piece described by Shelley as a Turkish earthenware 'bottle' can be identified as a sixteenth-century Iznik vase (fig. 4). [14] Museum objects and their copies thus engaged in a silent dialogue. Intended as tools, their uniqueness and rarity was

THIS EXAMPLE MUST NOT BE HUNG IN A STRONG LIGHT.

VASE, SICULO-ARABIAN, 13TH CENTY (EARTHENWARE).

BOTTLE, TURKISH. (EARTHENWARE.)

BOTTLE, DAMASCUS. 16TH CENTY (EARTHENWARE).

FLASK OR PILGRIM'S BOTTLE. ITALIAN, (URBINO). 1560.

VASE. ITALIAN. (URBINO OR FERRARA) 1570.

VASE. CHINESE. 14TH CENTY (PORCELAIN).

VASE, MAIOLICA, ITALIAN (GUBBIO) 16TH CENTY

VASE. ANCIENT GREEK.

VASE, MAIOLICA, ITALIAN (GUBBIO) 16TH CENTY

16950.

LENT BY THE
VICTORIA AND ALBERT MUSEUM

continuously challenged by their repeated subjection to replication and imitation. As will be discussed shortly, copying was not exclusively a didactic strategy and it is well known that collectors and connoiseurs alike commissioned replicas of celebrated pieces. [15]

Reflexive documents such as sketches like those executed by Shelley give us a visual point of access into the ways in which the nascent collections were perceived by their contemporaries, and they allow us to see the objects through the eyes of the students of the school of art. More than tangible testimony to the didactic use of the museum collections, these sketches tell us which objects and details were copied and considered important. They are a direct reflection of the nineteenth-century canon of applied arts. Here, the student's choice of aesthetic examplars crystallised contemporary commercial historicist fashions. It is well known, for example, that under the directorship of Léon Arnoux (1816–1902) the renowned English ceramics firm of Minton's became increasingly interested in the design and ceramic technology of a wide range of periods and cultures. Iznik goods (fig. 4) were one of several types that attracted the company's attention, as evidenced by this bottle vase with stylised decoration that borrows directly from the repertoire of Iznik wares (fig. 5). [16] There is little doubt that aspiring designers would have maximised their chances of commercial success by copying and assimilating the aesthetic principles of the goods that were also the most marketable.

Replicas for the public

While copies, drawings and casts, in particular, were traditionally associated with art academies and employed as teaching tools, at South Kensington copying was not restricted to the realm of artistic education and professional training. On the contrary, replicas were intended for the public at large and were fully embedded in the museum's general intellectual programme. As we shall see, they were far more than mere repositories of a body of abstract design principles. Revered and admired for their aesthetic merits, they expanded the museum's collections, took pride of place alongside 'authentic' objects, and were reconfigured as 'real' exhibits in their own right. The museum collected a wide range of reproductions, both machine and hand-made, which

Fig. 4: Iznik bottle, c.1535–40, fritware. *Victoria and Albert Museum: 70-1866*

Fig. 5: Minton & Co, bottle vase, c.1862, bone china.
Victoria and Albert Museum: 8098–1863

included photographs, plaster casts, fictile ivories, electrotypes, and painted or drawn copies.[17] Significantly, in the museum's early days, replicas were subjected to the same acquisition procedure as 'authentic' pieces inasmuch as they were given a sequential museum number that did not betray their identities as copies. A cursory glance at the list of museum numbers inscribed in the museum's early registers would make it impossible to establish the 'authenticity' of the pieces they refer to. They do not give any indication of their date, maker and status as facsimile or original, thereby blurring the distinction between originals or copies, and also suggesting that, for record-keeping and collection management purposes, this distinction was then not a major concern.[18] Significantly, as shall be discussed later, this amalgamation into a single whole makes clear the high regard in which replicas were held by museum officials at that period of time.

The museum made pioneering use of photography, and photographs were one of the earliest types of copies to enter the collections. Officials at the Department of Science and Art, and Henry Cole, in particular, were quick to harness the formidable potential of this rapidly evolving medium through which they believed knowledge of art could be successfully and rapidly disseminated.[19] Of course, the South Kensington Museum also acquired some of the greatest names of nineteenth-century artistic photography at that period of time, including works by Gustave Le Gray and Lady Hawarden. However, in its early years the museum's approach to photography was as much documentary as artistic.

The role of photography

Photography was widely perceived as being ideally suited to the recording of objects: 'Of the many functions of photography there is probably none … for which that process is so eminently suited as the delineation of works of plastic art, the preciousness of which depends as much on the perfection of intricate ornamental design as in beauty of forms or costliness of material.[20] With an educational goal in mind, Cole began a systematic programme of photographic documentation of the collections under his care. The first campaign was launched in 1853 at Gore House. The

photographer Charles Thurston Thompson, who later became the museum's first official photographer, was entrusted with the task of capturing the spectacular pieces of furniture forming part of the 'Specimens of Cabinet Work' exhibition.[21] These came from a pool of exalted lenders, and many were of the highest artistic significance, such as the jewel cabinet made by J. H. Riesener for the Comtesse de Provence (now in the Royal Collection) or a Boulle table made for the Elector of Bavaria from the collection of the Duke of Buccleuch. Thurston Thompson did not just record individual pieces. He was effectively freezing the show for posterity, capturing its various displays, and the groupings of objects. A bound volume is still extant in the V&A collections and reads like a two-dimensional (albeit monochrome) tour of the show.[22]

The photography programme at the Department of Science and Art was formalised in 1854, a year after the Gore House show, when it was agreed that three photographs should be made of every object on loan to the museum: one for the lender, one for the institution, and another to be circulated to provincial schools of art, thus disseminating the agency and influence of the reproductive medium beyond the confines of the institution. The museum entered into formal agreements with a number of high-profile and respected photographic firms, including Chapman and Hall, and Cundell, Downes and Co. Those photographs were in turn sold on behalf of the museum by the Arundel Society, 'a public society [which was] not looking to [make] large profits'.[23] The growth of the photography collections was exponential: by 1858 the museum owned 1,500 photographs of works of art, and by the end of 1880 the figure had reached 50,000.[24] These were held in the National Art Library, where 'a complete collection may be consulted'.[25] They were valued for the knowledge they embodied, and were used by museum staff as research tools as part of their curatorial practice. J. C. Robinson acquired many photographs during his numerous trips abroad, and, in his introduction to his 1862 catalogue of Italian sculpture at the South Kensington Museum, he explicitly articulated that examination of 'drawings, photographs, engravings, casts etc. of the complete works, or at least of similar ones' was an essential component of the process of authenticating and judging works of art.[26] Here we see, therefore, how photography was intended as a tool to support and establish authenticity. Photography had, indeed, become an intrinsic element of the pursuit of connoisseurship, although, of course, it was not restricted to the realm of museums, as evidenced by Prince Albert's 'Raphael' project, initiated in 1853. The Raphael project involved compiling a photographic record of all of the artist's works, including drawings and engravings, in order to show the full design process, from sketch to finished product.[27]

Both copies and replicas were subjected to the same administrative regime and the museum kept accurate records of their entry in its collections. It published yearly catalogues of its new acquisitions, noting where they came from, by whom they were made, and at what price. Duplication was not just allowed, it was encouraged. For instance, over two hundred and sixty drawings of Italian art and architecture made or commissioned by Ludwig Grüner, Prince Albert's artistic adviser, entered the collections in the first three decades of the museum's foundation. In parallel to those drawings, the museum acquired quasi-simultaneously the engravings produced after Grüner's drawings, thereby collecting reproductions of copies and effectively duplicating the replicating process.

The Wallace Collection

This is not to say that the South Kensington Museum's policies on copying were adopted by sister institutions. In 1901, officials at the newly founded Wallace Collection objected to the copying of objects on the grounds that:

> the rule was made ... in order to avoid inconvenience to the public by taking down the pictures at a time when it was above all things necessary to allow a free ... enjoyment of the collection to the Nation ... had any extensive photographing been permitted, it would have been necessary to dismantle the galleries in whole or in part, or to exclude the public ... from galleries altogether.[28]

The copying of pieces of furniture from the collection was similarly prohibited as the trustees felt that:

TRANSVERSE SECTION
THRO' CENTRE LINE

ELEVATION OF LEG
as in Plan G.

Contour of Leg

SECRETAIRE.

INLAID WOODS AND
ORMOLU MOUNTS.

FRENCH.
PERIOD OF LOUIS XV.

1116–1882.

Scale 3" to the foot

Fig. 6: Drawing of a secretaire, from W. G. Paulson Townsend, *Measured Drawings of French Furniture from the Collection in the South Kensington Museum*, 1899. *National Art Library, Victoria and Albert Museum: 47.F.27*

it would be in the highest degree undesirable to have pieces of furniture ... copied in facsimile. The result would be that after a certain number of years the owners would pretend to own the originals and assert ... that the Wallace Collection only contained the copy. [29]

One can argue that while copies canonised original, 'authentic' pieces and enhanced their status as exemplars of beauty and craftsmanship, they also challenged the exclusive, insulated character of the collections from which the models were taken. Officials at the Wallace Collection evidently anticipated and feared the potentially subversive effect of copying. They envisaged its practice as a contravention of the unique and original status of the collection in their care. Such a refusal is striking given the number of copies commissioned by the 4th Marquess of Hertford. Indeed, Hertford commissioned replicas of some of the pieces shown at the Gore House exhibition of 1853, including Riesener's jewel cabinet from the Royal Collection, and Boulle furniture from the collections of Earl Granville and the Dukes of Buccleuch and Hamilton. [30] In contrast to the Wallace Collection, at South Kensington the material and intellectual ownership and authenticity of the objects was never felt to be put at risk by

the process of copying. On the contrary, the museum published measured drawings of its own pieces of furniture (figs 6, 7). [31] Officials were evidently keen to disseminate information on correct and authentic manufacturing techniques, in terms of the historical period of production, and to ensure that future copies were going to be as close to the originals as possible. However, one might argue that via these drawings the museum was also in effect officially authenticating good design and encouraging the public to replicate it.

The Convention of 1867

The international aspect of collecting and commissioning replicas at the South Kensington Museum was fully brought to the fore at the 1867 *Exposition Universelle* in Paris, when, under the impetus of Henry Cole, a convention to reproduce and exchange 'national' works of art was signed by European rulers, including Queen Victoria's two eldest sons, the Prince of Wales and the Duke of Edinburgh; Ludwig, Prince of Hesse; Albert, Crown Prince of Saxony; Jerome Napoleon Bonaparte, Prince de France; Alexander, Tsarevitch of Russia; Umberto, Crown Prince of Italy; and Frederick, Crown Prince of Denmark. The convention

Fig. 8: Trajan's Column in the Cast Courts at the South Kensington Museum, *c.*1880, albumen print. *Victoria and Albert Museum: 73:676*

established a reciprocal agreement between countries to reproduce 'fine Historical Monuments of Art ... by Casts, Electrotypes, Photographs and other processes, without the slightest damage to the originals'.[32] The initiative was rooted in the belief that 'the knowledge of such monuments [was] necessary to the progress of Art, and the reproductions of them would be of a high value to all Museums for public instruction'.[33] Prince Albert fully supported the venture and, in a letter to the Duke of Marlborough, then president of the Council on Education, he expressed his belief that 'the museums in this country will derive benefit from this convention'. In his 1864 Memorandum on the International Exchange of Copies of Works of Art, Henry Cole stressed that 'admirable substitutes [could] be easily obtained with perfect security to the originals'.[34]

The practical effects of the Convention of 1867 are difficult to assess. International exchanges had been fully operational from the mid-1850s, and they did not witness a dramatic rise after the signature of the Convention but rather continued steadily. At South Kensington, the international agenda continued to be actively promoted and became the object of national interest. In 1880, *The Times* noted, for instance, that the director of the museum had 'just returned from an official visit to the museums and to the Imperial and other collections of St Petersburg and Moscow ... in order to ascertain what examples of gold and silversmiths' work in these collections might be reproduced, to add to the large number of facsimiles of art treasures ... already existing at South Kensington'.[35]

The wider diffusion of copies

As discussed, in its early days the museum's attitude towards the period authenticity of its objects was fluid and largely determined by its didactic programme. The perceived instructional uses of copying at South Kensington should not, however, altogether detract from the commercial and financial benefits that could be gained from such practices. Copying was a lucrative business. Books, photographs, casts and electrotypes were not just deployed in museums or schools of design, but were also readily available to be purchased by visitors. Officials were keen for the public to bring back a piece of the museum (albeit a fictile one). Such purchases were thought to be germane to the museum's educational mission, and casts and electrotypes were seen to be as useful in display cases as in suburban drawing rooms. Evidently, the multiplication of copies and their wider diffusion in the public realm was highly beneficial to manufacturers. The making of reproductions provided manufacturers with a steady source of income, allowing them to diversify their range and reach a wider consumer market.

For instance, through its partnership with the South Kensington Museum, Elkington's benefited from publicity across the Atlantic: the *American Art Journal* noted in 1877 that the Corcoran Gallery of Art in Washington had received from the firm 'a reproduction ... of the celebrated "Straus Tankard" in the South Kensington Museum', adding that the museum already possessed a copy, but that the new addition was 'more interesting, as it is an exact imitation of the original'.[36] Furthermore, the endorsement of a respected institution considerably bolstered the prestige of those firms. In its catalogue for the Universal Exhibition of 1873 in Vienna, Elkington's was able to quote the museum curator, George Wallis, praising the quality of its goods.[37] The wide commercial distribution of copies from the museum's collection can be compared to diffusion of measured drawings of its furniture. Here, again, the museum was effectively making a value judgment by authenticating what it perceived to be good design and actively encouraging its wide consumption and dissemination.

The Cast Courts at South Kensington

The most spectacular physical realisation of the museum's 'reproductive' programme was, arguably, the two Cast Courts, which opened to the public in 1873 (fig. 8).[38] They were intended to house the museum's collection of large plaster casts and 'show the student how great masters have decorated architecture with sculpture, what amount of relief, of finish, of detail, conveys to the spectator the impression the sculptor has intended to produce'.[39] In his description of the South Court, Pollen explicitly referred to the superlative attributes of the site, which was 'suited to the erection of full sized casts of architectural monuments', adding that 'many of the objects contained in the court ... could not be

Fig. 9: Making a cast of the Sanchi Tope, c.1870–4, oil on canvas.
Victoria and Albert Museum: 09200(IS)

shown in any building of the ordinary proportions of a "hall"'. Designed by General Henry Scott, the courts were widely praised: 'the two halls of the court are finely proportioned and remarkable chambers'.[40] Containing 'monumental and decorated architecture [arranged] in historical order', both courts were international in scope and illustrated 'examples of monuments, of the same size as the originals ... Ancient Roman, Spanish, French, English, Scottish, Norwegian, German and Flemish architecture'.[41] They contained reproductions of some of the most iconic buildings and monuments in the world, including the spectacular façade of the Cathedral of Santiago de Compostela, made for the museum in 1866, or the monumental Trajan's Column. Examination of contemporary responses indicates that they were widely perceived as momentous educational tools, but also as spectacular objects in their own right able to elicit powerful aesthetic and emotional responses in the same way as original pieces. In his novel *Love and Mr Lewisham*, H. G. Wells wrote of the evocative effect of the Cast Courts: 'one may ... talk of one's finer feelings and regard Michael Angelo's horned Moses, or Trajan's Column [in plaster] rising gigantic out of the hall below and far above the level of the gallery'.[42]

The reproductive process and the physical relationship between the 'parent' object and its copy was, however, not simply alluded to in official reports or museum catalogues and guide books. Dramatised and aestheticised, copies took pride of place in the museum's galleries. Indeed, next to the now extinct cast of the Sanchi Tope Eastern Gateway, were displayed three anonymous paintings (fig. 9) to illustrate the casting process.[43] Acquired at the same time as the cast itself, these evocative pictures fully convey the difficulty of this Herculean enterprise and show extensive contingents of men and cattle carrying heavy machinery while negotiating sinuous mountain paths.[44] Here we see, therefore, how the museum's museological modus operandi was explicitly articulated to the public: it was both teaching through casts, and teaching about casts.

One should not infer from the creation of the Cast Courts that, in the museum's early days, replicas were systematically spatially circumscribed. They could be displayed alongside 'authentic' historical objects. For instance, in 1874, Pollen mentioned that 'Italian sculpture, original and in plaster casts, [was] shown in the corridors that surround the north court'.[45] As early as 1857, a photograph of the 'art museum' shows the cast of Michelangelo's *David* surrounded by a plethora of objects in diverse media and of various epochs.[46] As Malcolm Baker, an authority on sculpture and casts, remarked, by way of contextualisation, a photograph of the original was added onto the plinth. Another picture taken over a decade later shows the gallery where the Raphael cartoons were displayed alongside the lunettes and pilasters from the Vatican's *Loggia* and the set of Italian *sgabelli* (chairs) from the Soulages Collection, then believed to be untouched and unrestored sixteenth-century examples (fig. 10).[47] Rather appropriately, an easel can be seen in the background: the photograph recorded an actual instance of copying. On the whole, the museum favoured the grouping of objects by material and type as it was thought to facilitate the study and comparative viewing of objects.[48] However, with this display, it is easy to see how the grouping of pieces of the same perceived period, style and origin was probably an attempt to evoke an 'authentic' historical interior. Here

Fig. 10: J. Davis Burton, the Raphael Cartoons, c.1895, albumen print.
Victoria and Albert Museum: 60:748

originals and copies were juxtaposed to create a simulacrum of authenticity, a proto-period room.

Touring exhibitions and networks of exchange

As already mentioned, the South Kensington Museum was 'not for London alone' and its strategy of touring exhibitions was thought to be highly beneficial to designers: A journalist in *The Times*, writing in September 1860, observed that 'the manufactures of Birmingham have very much improved in purity of design and beauty of outline within the last five or six years, which I attribute to the South Kensington Museum indirectly acting through our Birmingham School of Art'.[49] Far from being restricted to the confines of the museum, casts and copies participated in a wider network of exchange and were circulated to provincial museums and schools of design. Their status as fully fledged museum objects was reinforced by their inclusion in the circulation collections that included a wide variety of original objects, both historical specimens and pieces of contemporary manufacture. Founded in

1852, the Circulation Department regulated the museum's lending strategies, and administered the loans to provincial museums and schools of art. Originally restricted to a 'Circulating Museum' of nearly six hundred objects, the collection became more fluid and, as the demands of regional institutions grew larger, the boundaries between the circulating and 'non-circulating' collections more permeable.[50] In other words, although those loans consisted mostly of reproductions, nearly all museum objects could effectively be enlisted to tour the provinces, to satisfy the needs of both students and art lovers.

Blurring the distinction between 'fake' and genuine

One can argue that the Circulation Department had a levelling effect upon the somewhat disparate collections it managed. It challenged the insular character of copies, contributing to the blurring of the distinction between original pieces and reproductions. Replicas thus acquired an additional 'layer of identity': displaced in the regions and acting as the material

embodiment of the museum's intellectual agenda, they were reconfigured as objects for circulation and were fully invested with a museological and aesthetic mission. We can therefore see how replicas and originals participated equally in the museum's educational and exhibitionary programmes, blurring the distinction between what was 'fake' and what was genuine, and elevating copies to the status of aesthetic exemplars. Yet, as Malcolm Baker demonstrated, this harmonious and balanced spatial coexistence of replicas and originals was nevertheless to be short-lived. The last decades of the nineteenth century witnessed a growing marginalisation of copies that was largely conditioned and dictated by the general demise of copies as instructional tools.[51] No longer 'the next best thing', copies became increasingly regarded as second-rate, inferior objects that had no place in a world-class museum of decorative arts. In fact, a committee for the re-arrangement of the collections, appointed in 1908, explicitly articulated their demotion by stating that 'the museum [was] primarily of originals', in other words of 'first generation' objects,

regardless of the fact that they might have been heavily restored or remodelled after they were made.[52] Here we see how for the museum authenticity became primarily defined as a concept antinomic to reproductive seriality.

The acquiring and commissioning of replicas was a pan-European nineteenth-century phenomenon, and numerous national museums built collections like those described in this chapter. Unlike many of its counterparts, however, the Victoria and Albert Museum succeeded in preserving its own collections and the original sites for their display, and in some cases, also retaining original methods of display, as exemplified by the Cast Courts. Today, those copies and replicas demand the same level of care and consideration as the originals they originally represented. Appropriately, the sheet of drawings by Shelley discussed earlier bears the note, 'this example must not be hung in strong light'. The student exercise has now become an aesthetic paradigm, and the copy an authentic museum object to be conserved in its own right.

6. Authentic the Second Time Around? Eduardo Paolozzi and Reconstructed Studios in a Museum Environment

by Bernard Vere

Fig. 1: Eduardo Paolozzi, *Recreation of Eduardo Paolozzi's Studio* at the Scottish National Gallery of Modern Art, Edinburgh.
Scottish National Gallery of Modern Art. © Trustees of the Paolozzi Foundation, licensed by DACS 2012

I am standing in Edinburgh, but I am also in Chelsea, London. What is in front of me is the studio of the British artist Eduardo Paolozzi. However, Paolozzi, a son of Leith, Edinburgh's port, never had a Scottish studio. He divided his time between London and Germany. What is in front of me are those items from Paolozzi's studio that the artist gifted to the National Galleries of Scotland in 1995, which were placed in a replica of his London studio constructed in the Scottish National Gallery of Modern Art Two (formerly the Dean Gallery) and opened to the public in 1999 (figs 1, 2). Nor is Paolozzi's case unique: I could be in Dublin looking at the London studio of Francis Bacon, in the courtyard of the Pompidou Centre looking at the reconstruction of Constantin Brancusi's Montparnasse studio, or (until recently at least) in the centre of Bologna looking at that of Giorgio Morandi. Although all contain original items from the artists' studios, all are (or were) placed in museum settings and therefore differ from studios of artists left *in situ*, such as Henry Moore's at Hoglands. (Morandi is something of a special case. His studio, having been installed in Bologna's central Morandi Museum, has now moved to the newly opened Casa Morandi, his former home.) Although the reconstructions have differing histories, they all opened in this form within about ten years of each other, between 1993 and 2001.[1]

These studio reconstructions raise some interesting problems in relation to notions of authenticity. There is no doubt about the authenticity of the contents of the studios. If any of the works seen in the photographs were to leave the Paolozzi reconstruction and be displayed in the adjoining galleries no one would question whether or not they were by Paolozzi. What is in front of me is authentic. Only its location is inauthentic. This inauthenticity has two aspects to it: the first is the replication of the working space of the studio itself. Whether this is painstakingly accurate or reconstructed to give a general impression of the working space, there always remain some things that differ from the original studio (for example, restrictions on access or the positioning of windows). The second is the transposition of the studio to a museum setting in a new city, divorcing the studio from the area that surrounds it. The viewer at the Scottish National Gallery of Modern Art stands in another exhibition room in order to view the reconstruction through what is, in effect, a removed fourth wall, rather like a stage set. Leaving the gallery, they enter the pleasant gardens of the museum, which feature several of Paolozzi's own works. They do not encounter the streets of Chelsea that Paolozzi used on a daily basis. Behind these two questions of inauthenticity lies a further question, one that applies as much to studios left *in situ* as it does to reconstructions: to what extent does the studio provide an authentic experience of artistic creativity? Or, to put it another way, why have studios been considered so important that galleries choose to build copies of them?

Copies, reconstructions and replicas

Raising the question of copies inevitably leads to Walter Benjamin's seminal essay 'The Work of Art in the Age of Its Technological Reproducibility', better known by the title of the first English translation, 'The Work of Art in the Age of Mechanical Reproduction'. Before moving too hastily into what Benjamin has to say on the subject of mechanical copies, we must remember that he allowed that 'in principle, the work of art has always been reproducible', offering as an example 'replicas ... made by pupils in practicing for their craft, by masters in disseminating their works, and, finally, by third parties in the pursuit of profit'.[2] This notion of the replica, sharing some of the characteristics of the unique artwork and some of the characteristics of mechanical reproduction, seems more appropriate when analysing the status of reconstructions of studios.

A reconstruction of a studio is clearly not an artwork in any conventional sense, although it will usually contain works of art. Nevertheless, it trades on what Benjamin terms 'aura', which he links to presence, originality and locale. He argues that:

> In even the most perfect reproduction, *one* thing is lacking: the here and now of the work of art – its unique existence in a particular place. ... The here and now of the original underlies the concept of its authenticity, and on the latter in turn is founded the idea of a tradition which had passed the object down as the same, identical thing to the present day.[3]

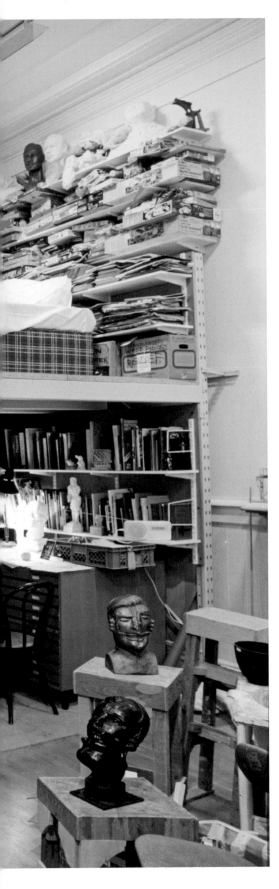

Although the reconstruction of Paolozzi's studio is filled with original objects, it is not itself the original studio and its presence in a museum alters its context dramatically. As an illustration of the stakes involved in reconstructing the studio, the example of Constantin Brancusi's studio is informative. Following his bequest of the studio space and its contents in 1956, controversy ensued as to whether it should be preserved *in situ*. Advocates of leaving the studio in Montparnasse, such as the sculptor Henryk Berlewi, were adamant that moving the studio would compromise its identity: 'Brancusi's studio may not be demolished ... The preservation of this studio, which is absolutely intact, in which everything should be left in the order or disorder it is presently in, is self-evident.'[4] Following the demolition of the building that housed the original studio in 1961, it moved initially to the Musée National d'Art Moderne at the Palais de Tokyo and then transferred with the museum to the new Pompidou Centre in 1977 before being installed in a dedicated building in the Pompidou's courtyard in 1997 (fig. 3). In the estimation of Albrecht Barthel, an architect and preservationist, these subsequent reconstructions 'would fail to recapture what had been lost in the demolition, even though they would display Brancusi's sculptures in their original configuration'.[5] This is because the reconstruction does not preserve the aura inherent in the original site, the continuity of experience that Benjamin thinks vital to the authenticity of the object:

> The authenticity of a thing is the quintessence of all that is transmissible in it from its origin on, ranging from its physical duration to the historical testimony relating to it. Since the historical testimony is founded on the physical duration, the former, too, is jeopardised by reproduction, in which the physical duration plays no part. And what is really jeopardised when the historical testimony is affected is the authority of the object, the weight it derives from tradition.[6]

Aura in a replica, however, might not be so easily dismissed. In drawing a distinction between the modern photographer and the painter or sculptor, Benjamin aligns the latter two with the figure of the magician and it is here that the auratic character of the artist's studio is most clearly established. Setting up the terms

Fig. 3: Renzo Piano Building Workshop, *Reconstruction of the Atelier Brancusi,* Place Beaubourg, Paris, 1992/1996. *Photo: iodh, 2009*

of that opposition, Benjamin claims that 'the earliest artworks originated in the service of rituals – first magical, then religious. It is highly significant that the artwork's auratic mode of existence is never entirely severed from its ritual function. In other words: 'The unique value of the "authentic" work of art always has its basis in ritual.'[7] Even when presented photographically, studios of modern painters have a long history that mixes secrecy and accessibility and presents to the world the ritual basis of creation. Although in principle secretive, the studios of Modernist artists had always been carefully documented, often by prominent Modernist photographers. Brassaï's photographs of Pablo Picasso's studio, published in the first issue of the journal *Minotaure*, are exemplary in this regard:

As a photo-essay in the genre of photo-journalism, Brassaï's exposure of Picasso's studio is presented as the publication of something hitherto unknown: the penetration of the public eye into secret places ... The artist, a man set apart by his special magic qualities, works in isolation in his own secret asocial space, much more a magician's cell than the workshop of an artisan or the studio of an 'artiste-peintre'.[8]

A photograph of the studio can convey the aura of the place, even though photography itself has no aura and Benjamin illustrates technological reproduction by using as an example a cathedral that 'leaves its site to be received in the studio of an art lover', writing that although 'these changed circumstances may leave the artwork's properties unchanged, ... they certainly

devalue the here and now of the artwork'.[9] Even if Benjamin is right on this point (and it seems highly contentious; the aura of the cathedral at Rheims, for example, seems to have been substantially increased through its photographic reproduction following its shelling by the Germans in the First World War), the focus on the magician/painter's aura has much to do with the appeal of studio reconstructions. Unlike the photograph of the cathedral, or Brassaï's shots of Picasso's studio, they are unique in the sense that there is no place other than the Pompidou Centre where we can see Brancusi's studio, no place other than Edinburgh where we can see that of Paolozzi. The chief curator of the first reconstruction of Brancusi's studio, Jean Cassou, recalled that: 'Often when I was in the museum, I visited the phantom of Brancusi – it seemed that he was there, he had so strong a presence, almost magical.'[10] This is as clear a statement as one could wish to find of the belief that aura persists in the reconstruction. Nevertheless, Cassou's view was not universally accepted. Barthel quotes the painter Jacques Herold's perception of the second reconstruction (supposedly more faithful to the original studio than the first) as 'something fabricated', which did not 'exude the same power, the same intensity'.[11] Insofar as it is deployed against such opinions, Cassou's statement also reveals the extent to which the museum professional must maintain the belief that a reproduction can maintain aura. Both Cassou and Herold use similar language – an almost 'magical' 'presence' of the dead artist, a 'power' and 'intensity' – to talk of the studio (whether reconstructed or not), and therefore both subscribe to the magical and ritualistic basis of creating authentic art and privilege the studio as a result.

The artist's studio

The studio of Brancusi, photographed by Edward Steichen and Man Ray, and that of Piet Mondrian, photographed by André Kertesz, also disseminate a particular view of the studio, one that stresses its role as the site of exhibition. As Paul Overy points out: 'The artist's studio had already become by the end of the nineteenth century as much a place for *viewing* art as for making it, a site for its consumption as much as its production. This was one of the prime functions of both Mondrian's and Brancusi's studios.'[12] The placement of Paolozzi's studio and others like it within museums foregrounds the role of the studio as a site for consumption, with this important difference: it is no longer art that is being consumed, but the creative process. The studio in the museum is not just a site for viewing artwork, but primarily a consecration of the magical skill of the artist. Paolozzi once described himself as being 'like a wizard in Toytown, transforming a bunch of carrots into pomegranates'.[13] Fiona Pearson, curator of the Paolozzi Archive at the Scottish National Gallery of Modern Art, refers to the studio as an 'Aladdin's Cave' and to Paolozzi's 'all-seeing gaze'.[14]

In the attempt to retain aura, a rather intangible quality in Benjamin's essay, the reconstructions can exhibit a paradoxically extreme concern with materials, a fetishised desire to make order out of chaos. The reconstruction of Francis Bacon's fantastically unkempt Reece Mews studio took three years to replicate exactly in Dublin the mess Bacon had left in London. In order to complete the task, over 7,500 items were entered into a database. As the project manager, Margarita Cappock, commented, apparently without irony, 'this is exactly the mess that he left behind', almost as if, at the moment of his death, Bacon had achieved a supreme state of disorder, one that must be preserved and which would have remained the same even if Bacon had lived for a further day, month, or year. Bacon's own feeling was that a sense of chaos was necessary to his working practice, 'it's much easier for me to paint in a place like this which is a mess', and this chaos is inventoried and regulated in the studio's reconstruction. As Cappock states: 'It's unique in the art world to have such a complete archive, which has been done with such thoroughness – every single thumb print or finger print or intervention that Bacon has made has been described.'[15] The reconstruction of Paolozzi's studio does not adopt this approach. Instead it presents what the Scottish National Gallery of Modern Art's curator, Patrick Elliott, calls a 'sanitised' view of the studio, removing the knee-deep piles of material, which partially consisted of pornographic magazines kept, Elliott believes, for what they conveyed about the human body rather than for erotic gratification.[16]

Such alterations could be said to diminish the aura of the reconstruction, but is the concept of the aura, alone, the right way to approach these reconstructions? For Brancusi possibly, but for Paolozzi? Under the logic of Benjamin's essay, the copy is not inferior to the original: technological reproduction changed the whole basis of looking at art. The challenge of photography and film to the aura of the unique object was something to be acknowledged, not resisted, something that recontextualised art as being less about cult and ritual and more about politics. In 'Parallel of Art and Life', an exhibition on which Paolozzi collaborated with fellow Independent Group members Nigel Henderson and Alison and Peter Smithson for the Institute of Contemporary Arts (ICA) in 1953, Paolozzi exhibited not his original work *Plaster Blocks*, but a photograph of the work taken by Henderson. Paolozzi once said: 'It's got to the point where I would rather have a carpet made to look like the *Mona Lisa* than the real thing. It's got to that.'[17] This statement itself recalls René Magritte's comment that he preferred a picture postcard reproduction of Botticelli's *Primavera* to the real thing.[18] Paolozzi told a similar story, one that brings together Benjamin and Bacon, in conversation with Alvin Boyarsky, then director of the Architectural Association, in 1984:

> When you were asking me about the car and the aircraft carrier I was reminded of Walter Benjamin – modern man in relation to reproduction. ... It's a very modern condition. ...There's the famous story about Francis Bacon, who worked from a reproduction of a Velasquez for a long time. When he eventually got to Rome he was asked if he wanted to see the original. He said: 'What's the point?'[19]

However, while Magritte and Bacon deal in the mass-produced technology of a picture postcard, Paolozzi opts for a carpet, an item with a great deal of craft heritage, closer to Benjamin's definition of a replica. Although Henderson's photograph of *Plaster Blocks* is exactly the sort of reproducible technology that Benjamin refers to, commenting that 'from a photographic plate, for example, one can make any number of prints; to ask for the "authentic" print makes no sense',[20] this is not obviously the case here, since the single print in the context of the exhibition 'Parallel of Art and Life' retains a status as a unique work of art that any subsequent prints will not have. There is none of the substitution of 'mass existence for a unique existence' that causes the withering of aura.[21]

Viewing Paolozzi's studio

It is not permitted to walk around the reconstruction of Paolozzi's studio. A small recess allows visitors to view it from behind a wooden handrail, which prevents further access and which is carefully excised from the virtual tour available on the museum's website. The recess is situated within a pair of glass doors, which are open to the left and right of the viewing area and shield these parts of the studio.[22] Valid curatorial concerns over conservation guide such decisions, of course, but the balcony and doors also serve to keep the viewer at a distance, another quality Benjamin associates with aura. Glass is common to the other reconstructions discussed above. Barthel quotes Peter Buchanan from the Renzo Piano Building Workshop, the architects of the last of the Brancusi reconstructions, conceding that: 'The glass as usual betrays the promise of its transparency and seems to distance the artworks as much as render them visible.'[23] Despite the claims of the Scottish National Gallery of Modern Art that the reconstruction provides 'an insight into Paolozzi's work and working methods from the 1940s to the present day',[24] there is an acknowledgement that most of the sculpture was produced from the 1970s onwards (and it is the sculptures that are almost the only aspect of the reconstruction that allow reasonably detailed examination). There is almost nothing of Paolozzi the jet-age schemer, no evidence of his membership in the 1950s of the Independent Group at the ICA, whose work did so much to disrupt conventional notions of artistic value, during which time Paolozzi himself drew on the notion not simply of the replica, but of the copy. There is little to suggest the concerns of his epidiascope lecture, an influential talk on popular imagery delivered at the first meeting of the Independent Group and closely related to his 'Bunk' collage works, or even his later role as a print maker. Nothing could be less evocative of the artist as a magician than the image of Paolozzi

placing mass-produced advertising imagery onto an overhead projector in a seemingly random sequence to the accompaniment of what Henderson remembered as the 'sarcastic attacks' of the architectural critic Reyner Banham.[25] Henderson recalled that: 'The visual wasn't introduced and argued (in a linear way) but shovelled, shrivelling in this white hot maw of the epidiascope. The main sound accompaniment that I remember was the heavy breathing and painful sighing of Paolozzi to whom, I imagine, the lateral nature of connectedness of the images seemed self-evident.'[26] David Robbins writes that the epidiascope lecture 'directly confronted what [Lawrence] Alloway called "the modern flood of visual symbols". The projection of a heterogeneity of messages generated from SF magazine covers, car ads, animated film clips, and military images appears to have had a bewildering impact. No one had taken mass media imagery that seriously before.'[27]

A better place to begin an investigation into this aspect of Paolozzi's production would be the 'Krazy Kat Arkive', a collection of comics and ephemera named after the American comic strip character, which he amassed between the 1950s and 1970s and is now housed at the Victoria and Albert Museum. Paolozzi envisaged the 'Arkive' as permitting examination of 'aspects of twentieth-century iconology and popular culture'.[28] After 'This Is Tomorrow', a landmark 1956 exhibition for the Independent Group, Paolozzi himself said: 'I had moved on to other things, exploring the relationship between man and machine in sculpture: wax heads and figures embedded with found objects. But that is another story.'[29] In a 1995 interview with Glynn Williams, Paolozzi privileged the later sculptural part of his career in conceiving the reconstruction, saying that it was up to the museum 'to decide how the studio can continue to best serve sculpture in the future'. The space of the reconstruction is quiet, although Paolozzi was a compulsive listener to radio, describing it as 'the yeast to bake my bread' and he had envisaged the space of the reconstruction as 'busy, noisy and active'.[30] Just as the glass keeps viewers at a distance and the emphasis on sculpture makes it clear that this is a space in which fine art is created, so the silence creates an atmosphere for a very traditional appreciation of the space, although this is clearly not what Paolozzi himself had anticipated.

In 2009, this silence was disrupted by *Painter*, a 50-minute video made by the American artist Paul McCarthy in 1995 (fig. 4), the same year that Paolozzi agreed his bequest. The obvious target of McCarthy's satire is the grandiose image of the abstract expressionist painters. Amongst the most prominent documents of creative genius in the studio are Hans Namuth's photographs of the working methods of Jackson Pollock. Pollock was an important artist for the Independent Group, whose members knew Namuth's pictures. Alloway, a fellow Independent Group member, recalled that 'Pollock's images ... meant quite a lot to Eduardo' and photographs of Pollock works were included in 'Parallel of Life and Art'.[31] McCarthy's painter uses outsized tubes of paint, one of which is labelled 'shit', which is not simply evidence of McCarthy's scatological obsessions, but can also be taken to be a reference to Freud's equation of faeces with money (later on, having daubed his canvas with excrement, the figure of the painter will meet curators and dealers). The target of this film is very far removed from the figure of Paolozzi himself, who didn't hold himself out as a genius and had little time for it, but its deployment in this context is clearly an ambivalent comment on the reconstruction of the studio, 'a second glance at how museums present the making of art' in the words of the exhibition's publicity.[32] McCarthy's crude, self-doubting, bulbous-nosed painter initially appears to invade, perhaps even assault, the space of the Paolozzi studio. In fact, it could be argued that by introducing sound, distraction, noise and energy to the reconstruction it comes closer to the environment that Paolozzi had envisaged, that it acts to deconsecrate a space that should never have been consecrated.

The desire for authenticity

It is difficult now to look at these projects from this historical distance without conjuring up contemporaneous postmodernist conceptions, very much in vogue at the time, of pastiche and replication. Paolozzi's quote about preferring a carpet of the *Mona Lisa* to the real thing comes at a point where postmodernism, a notion that his own work with the Independent Group seemed to foster, was beginning to take hold.[33] The reconstructions on the other hand, date from a period which now appears to be

Fig. 4: Paul McCarthy, *Painter*, 1995, performance, installation, video, photographs.
Photo: Karen McCarthy/Damon McCarthy. © Paul McCarthy, courtesy the artist and Hauser & Wirth

a hinging point between postmodernism's obsession with pastiche and a residual, although naive, desire for authenticity in the face of it. The museum reconstructions faced similar problems in that both the institution of the art gallery and the myth of the artist as modernist genius had come under sustained critical attack.[34] At the same time the reconstructions hark back to an earlier conception of the artist's studio, one that was deeply concerned with a supposedly authentic, quasi-mystical construction of the creative process. If there remains an aura, it is a manufactured one.

Although there could be more artist studio reconstructions to come, their time might have passed.[35] If in recent years the trend has been away from reconstructions of artists' studios, the desire to replicate experience has not diminished. Indeed, galleries and museums have attempted to reconstruct whole shows in an effort to suggest historical impact. Paolozzi's own 'Parallel of Life and Art', originally at the ICA in Dover Street, London, in 1953, was reconstructed for the Gainsborough House in Suffolk in 2001 before travelling to the Scottish National Gallery of Modern Art, via Sheffield and concluding at London's Architectural Association. Further examples include: Robert Morris's 'Bodyspacemotionthings' (originally at the Tate Gallery, Millbank, 1971 and reconstructed at Tate Modern in 2009); the exhibition of the Italian Futurists (originally at Galerie Bernheim-Jeune, Paris in 1912 and partially reconstructed over two rooms at the Pompidou Centre's 'Le Futurisme à Paris: Une Avant-Garde Explosive' in 2008–9); and the Vorticists' exhibitions (an amalgamation of the Vorticist exhibitions at the Doré Galleries in London in 1915

and at the Penguin Club in New York in 1917, as well as Alvin Langdon Coburn's Vortographs, exhibited at the London Camera Club in 1917 and reconstructed at Tate Britain in 2011).[36] In the United States, 'New Topographics', a 1975 photography exhibition of great critical influence, was recreated at its original George Eastman House location in 2009, then shown at the Los Angeles County Museum of Art and the San Francisco Museum of Modern Art, before travelling internationally.[37]

Whether it is more of an authentic experience to stand behind a barrier looking at the reconstruction of a studio in a city where it never was, or whether it is more authentic to look at a rope originally designed for climbing simply as a 'sculptural element', as in Morris's reconstructed 'Bodyspacemotionthings', is an unanswerable question.[38] Replica exhibitions obviously come with their own set of problems and limitations. If they were in any doubt on arrival, each visitor to a reconstructed exhibition is made aware of the original's art historical significance. As the *The Daily Telegraph*'s reviewer noted: 'It's difficult to reflect on your body's response to the experience of trying to balance on a plywood square mounted on a hemisphere, as Morris intended, when there's a crowd of people watching, all desperate for you to get off and give them a go.'[39] Visitor numbers are generally significantly higher for replicated exhibitions than for the originals. Replicated exhibitions may be no more authentic, they may also trade on a notion of the aura of the original that is ultimately impossible to sustain, but such curatorial decisions emphasise the public cultural role of the artist in society, rather than the shamanistic and totemic concerns of the studio.

PART TWO

CONCEPTUAL
AUTHENTICITY

7. Authenticity, Originality and Contemporary Art: Will the Real Elaine Sturtevant Please Stand Up?

by Anthony Downey

Fig. 1: Elaine Sturtevant in *The Store of Claes Oldenburg*, 623 East Ninth Street, New York, 1967. © *Elaine Sturtevant, courtesy Galerie Thaddaeus Ropac, Paris/Salzburg*

In the winter of 1961, on the Lower East Side of New York, Claes Oldenburg opened *The Store*. Cleverly designed to fit in with the other stores on the street, down to the '99 cent' sign in the front window, Oldenburg's intervention short-circuited accepted ways of selling art and offered all the 'goods' on display direct to the public. Inside the store, which was effectively a narrow room, the objects for sale included painted plaster models of a blueberry pie, an outsized hamburger, and a wide selection of undergarments and swimsuits – all handmade by Oldenburg using chicken wire, enamel paint and plaster. Although the show was a critical success for Oldenburg, a significant number of the works displayed at the time no longer exist, having been inadvertently destroyed or simply forgotten about and discarded over time. Given its seminal status, and the fact that few of these works have survived, *The Store* has since passed into the pantheon of Pop Art folklore where it continues to maintain a mythic status. Oldenburg's gambit paid off, so to speak, and the trajectory of his international career was to thereafter closely follow that of Pop Art as a worldwide phenomenon.

Six years later, on 623 East Ninth Street, Elaine Sturtevant opened *The Store of Claes Oldenburg* (fig. 1), a 'Junk Art' store a few blocks from where Claes Oldenburg had staged his original exhibition on 107 East Second Street. Sturtevant was born in Ohio in 1930 and was a contemporary of artists such as Oldenburg and Andy Warhol. However, her practice differed from theirs insofar as she would master the techniques of painting, sculpture, photography and film in order to 'copy' works by other artists, Oldenburg and Warhol included. Complete with enamelled plaster models of hamburgers, slices of cherry cake, baked potatoes and a not inconsiderable amount of candy, Elaine Sturtevant's *The Store of Claes Oldenburg* effectively restaged Oldenburg's earlier one, including her meticulous rendition of a pie display unit complete with six pies (*Oldenburg Store Object, Pie Case*, 1967). The reaction from the public to Sturtevant's restaging was, perhaps understandably, mixed. For many, this was merely copying or, worse, fakery. The reaction of fellow artists was likewise ambivalent and, although initially supportive of Sturtevant's intervention, Oldenburg became increasingly irate at what he considered to be a case of his work being 'ripped off.'

Observing reactions at the time, the curator Christian Leigh noted that '[w]hat initially just caused laughter ... subsequently and very soon caused general anger and outrage, leading to mistrust and misunderstanding'.[1] In a further twist to this affair, and in what would be no doubt an ironic afterthought today, there are more of Sturtevant's 'remakes' still in circulation now than there are of Oldenburg's originals.[2]

It would be relatively easy to write off Sturtevant's intervention as an art-world prank or, indeed, a form of art-world self-promotion by virtue of riding on someone else's artistic coat-tails; however, such responses neglect the more radical aspect of her *oeuvre*, which has (amongst other things) recreated fellow artists' works for over four decades now, a period broadly commensurate with the history of contemporary art. Moreover, Sturtevant produced a considerable number of her works at a time when the artists she was looking at were far from famous or indeed getting known. In this context, and in what follows, I will suggest that we therefore need to understand Sturtevant's work as an engagement with issues such as authenticity, originality and the conceptualisation of singularity. I will briefly address the context out of which she emerges so as to further situate these points, but also propose that her work is effectively a rigorous investigation into the limits of terms such as authenticity and originality, nowhere more so than when used in discussions of contemporary art practices. Sturtevant, I will offer by way of a conclusion, is a disturbing presence in any theory of contemporary art that employs the ideal of authenticity as a cornerstone for understanding the conceptual foundations of contemporary art practices.

Contemporary art and authenticity

A significant element in any debate about originality and authenticity in contemporary art concerns the work of Marcel Duchamp. In its most basic sense, Duchamp's work pointed not to the object of contemplation as such (the manifest aesthetic form of an artwork), but to the abstract thought-process behind it. What, his work asks, are the parameters within which art comes to be understood as art – or, indeed, how does art come to be understood as original and authentic in the first place? The objects in question, be they bottle racks or urinals, were often the seemingly arbitrary opportunity for Duchamp's exploration of so-called 'non-retinal' art and his use of 'readymades' discloses many of the conundrums we encounter in determining notions of originality and authenticity today. Duchamp's *Bottle Rack* of 1914 – a mass-produced bottle-drying rack signed by the artist – is still widely considered to be the first readymade. However, the most famous of these readymades, or perhaps the most infamous, is his *Fountain* of 1917. Effectively a mass-produced urinal with the one-off pseudonym 'R. Mutt' painted on it, this work goes some way to describing what Duchamp meant when he used the term 'non-retinal': the objects were chosen to refute traditionally 'retinal' artwork – art that existed on a purely visual or formal level – and therefore address the realm of the intellect and the thought processes behind the ideal of the 'original' and what could constitute art. Duchamp's *Fountain*, in short, fundamentally questioned what art could be and, perhaps more importantly, interrogated the nominal notion of originality as a foundational ideal in the understanding of modern and contemporary art.

In 1965, almost fifty years after Duchamp's *Fountain* and two years before her *The Store of Claes Oldenburg,* Sturtevant continued this practice of usurping traditional notions of what constitutes originality in contemporary art practices and exploring the limits of such ideas. At the Bianchini Gallery in New York, where Andy Warhol had shown the year before, Sturtevant lined the entire space with panels of Warhol's 'flowers', a Jasper Johns 'flag' painting, a Roy Lichtenstein 'comic book' painting and, at the centre of the gallery, a George Segal sculpture – all of which appeared to be, to all intents and purposes, original works by the artists in question.[3] One year later, at Galerie J in Paris, Sturtevant restaged this exhibition in its entirety under the title 'America America', but this time with an exception: the gallery was to remain closed throughout the exhibition and the work could only be seen through its front window. In one sense, Sturtevant's exhibition in Paris could be understood as an overt engagement with Oldenburg's earlier invitation to come in and 'consume' his work. For Sturtevant, these models of consumption are based upon a desire to acquire that which can be only seen through a shop

window which she, in the withholding of any transaction other than a conceptual one, thwarts. It is to the realm of the conceptual rather than the visual – as in Duchamp's work before her – that we must turn if we are to understand these works more fully.

One of the many questions Sturtevant addresses in both of these exhibitions and throughout her *oeuvre* concerns the interior – or what she terms the 'understructure' – of an artwork and how, by engaging with the same techniques used by an artist such as Warhol, Sturtevant creates a wholly original artwork. 'The intentions', she explains, 'were to expand current notions of aesthetics, probe the concepts and limitations of originality, disclose the understructure of painting and sculpture, and break open wide spaces for ... new thinking'.[4] This is not so much about producing objects as it is about understanding how they circulate and come into being as objects; or, more specifically, how they are produced, received and understood as art. Do Sturtevant's paintings of Warhol's 'flowers' therefore represent an image of those paintings or are they more about the artistic 'understructure' and the thought processes that produced these images? The distinction is critical: are we looking at copies or are we engaging with the practice of producing art? How, that is to further enquire, do we approach her practice without getting lost down a rabbit hole of ever-decreasing interpretive returns? To address these questions, we must note that Sturtevant's works are authentically Sturtevant – they are not facsimiles (most are done by her from a memory of the work in question); nor are they an attempt at fakery (all works are signed and dated by her making them emphatically not works by Claes Oldenburg or Andy Warhol); nor can they be dismissed as appropriationist or recuperative (they were often produced at the same time or soon after the artworks they reference). Something else is afoot here and it concerns a rethinking of how the ideals of originality and authenticity prefigure the value of a painting not only in financial terms but also as a conceptual gambit.

We arrive here at a question that may at first appear obvious: when is a Warhol not a Warhol? This question has troubled commentators and interested parties alike for some time now, not least the Andy Warhol Estate, which is the effective gatekeeper of his legacy. The question has, of course, an obvious economic

purchase to it: the distinction between an accredited and a non-accredited Warhol can be the difference between a few hundred dollars and a few million. To date, there have been a number of high-profile lawsuits concerning the Andy Warhol Foundation and its subsidiary, the Art Authentication Board. One of the more recent lawsuits involves a Warhol self-portrait, from the so-called *Norgus* series (named after the New Jersey-based company responsible for the printing of the image), that had been previously authenticated by the Andy Warhol Foundation. Bought by Joe Simon-Whelan in 1989 for $195,000, the painting depicts Warhol against a red background and with a slightly raised chin. However, upon submission to the Authentication Board, and even though the painting made direct use of acetates apparently provided by the artist, the Board argued that they were produced without Andy Warhol's direct supervision and, moreover, by printers with whom he had never worked – and for those reasons, and those alone, the painting was deemed not to be an authentic Warhol.[5]

Putting to one side the intricacies of this case, it is obvious that Sturtevant's *Warhol Marilyn Diptych* and *Warhol Gold Marilyn*, dated 1972 and 1973 respectively, are emphatically not Andy Warhol paintings. They were painted from memory by Sturtevant, dated differently and signed by her, and no attempt thereafter was ever made to confuse the two, other than on the relatively superficial grounds of visual resemblance. And even here, we can always see differences between a Sturtevant 'Warhol' and a painting by the artist. Apart from the superficiality of visual correspondence – upon which we may be placing far too much emphasis if we really want to understand Sturtevant's work – these are not paintings by Andy Warhol nor have they ever been presented as such. So, what precisely is at stake when Elaine Sturtevant remakes another artist's work? To answer this question, we need to focus here on the act of repetition rather than simply remaking. We might also be better served examining an example of repetition from theatre, namely, Samuel Beckett's 1953 play *Waiting for Godot*, in which the play's two acts begin and end in the same place at more or less the same time with more or less the same characters, and in more or less the same *mise-en-scène*. Writing of the play, the Irish critic Vivien Mercier wryly noted that the playwright had written a play in 'which nothing happens,

AUTHENTICITY, ORIGINALITY AND CONTEMPORARY ART: WILL THE REAL ELAINE STURTEVANT PLEASE STAND UP?

twice'.[6] As with all things Beckettian, Mercier's aside gets to the heart of a radical gesture in his work: when nothing happens twice, something does indeed happen insofar as the repetition of an event or utterance opens up a temporal increment between when it was first said and, crucially, when it was said again. Time intervenes, as ever, but more crucially so does an emphatic and interrogative moment of difference between two related utterances or indeed objects (or, to return to the case in hand, paintings). Repetition, in sum, begets difference and a distinction between a before, during and after. To paint a painting that already exists, without any intention to deceive an audience as to its authorship, questions the authentic artistic 'gesture' so beloved of modernist critics. It goes to the core of what it is to create in the first place.

Repetition, in its introduction of difference, describes not only the uniqueness of both things and events (the difference between two events or utterances or objects), but also underwrites the notion that no artistic use of a technique or form is ever truly equivalent to its other uses and intentions. There is a clear distinction of difference being opened up between a Sturtevant 'flower' and an Andy Warhol 'flower'. When Sturtevant remakes a Warhol she is asking us to return to the genesis of the work, the processes behind the work, the moment of inception and, coterminously, the historical trajectory and reception of the work thereafter. She is asking us to rethink what it is to make art. Repetition here, the remaking of a Warhol, instils not only difference but sets up two forms of synchronistic time: the time of Warhol's painting and the time of Sturtevant's insofar as the latter's early endeavours were produced at more or less the same time as the works they reference. In that point of connection, the pause between the moment of Warhol producing his painting and Sturtevant's version of it, there are obviously two ways of thinking about originality. 'Repetition', Sturtevant has noted in this context, 'is thinking'. 'Thinking is at the centre of my work, not the visible surface. My work is the immediacy of the apparent content being denied'.[7] Elsewhere, she has noted that her practice 'repeats the seductiveness of the surface and dissolves it in the process of repetition to make room for what is really important, thinking'.[8] So, if repetition begets difference, which in turn opens up a conceptual slippage in ways of thinking about authenticity

and originality, how do we understand or indeed approach the work of Elaine Sturtevant and Andy Warhol alike – what exactly are we being left with to think about?

In 2004, I travelled to see the first retrospective of the work of Elaine Sturtevant, displayed at the world-famous Museum für Moderne Kunst (MMK) in Frankfurt. The show was appropriately titled 'The Brutal Truth' and, in room after room, Sturtevant displayed works that name-checked the history of contemporary art. This was Sturtevant's first retrospective so no one had yet witnessed the sheer magnitude and depth of her intervention into the history and trajectory of contemporary art practices. Everything in the Museum für Moderne Kunst in Frankfurt for the duration of this show – containing over 140 works in total – had been made by Elaine Sturtevant. On display were Warhol's 'Marilyn' and 'flower' series, renamed *Warhol Marilyn*, 1965, and *Warhol's Flowers*, 1971, respectively. A series of Jasper Johns' 'flags', *Johns Flag, 1965/66* (fig. 2) alongside Marcel Duchamp's 'bicycle wheel' and 'bottle rack', vied with newer works by the artist that included references to Joseph Beuys, Anselm Kiefer, Robert Gober and Paul McCarthy. Looking at these works, I was struck by a number of things. First, as already suggested, we effectively had a retrospective that covered forty years of Elaine Sturtevant's work which in turn, and albeit idiosyncratically, traced forty years of contemporary art from its origins to present-day practices. In a building renowned for its surprising traversals and reversals, I was now experiencing my own mental *mise-en-abîme*, a conceptual slippage in time and space whereby the sinuous reality and singularity of, say, a well-known Andy Warhol painting or the incontrovertible density of a lead sculpture by Anselm Kiefer were not only in question but the very authority, authorship, and authenticity associated with such works was being renounced.

Looking at these contemporaneous 'remakes' of works that have since become not only key to our understanding of contemporary art but famous in their own time, it felt as if the superficiality of the visual was being held to conceptual and critical account. The patina of Sturtevant's works – the surface ageing of what are now forty-year-old artworks – is there to behold as a verifiable fact of their age if not their conceptual

intent. This was not about images as such; this was about thinking through and beyond, if not before, the very notion and ideal of the image itself as a signifier of history, authenticity, singularity, authorship and difference. The brutal truth in question was simple: these are not copies but original works by Elaine Sturtevant that happen to explore and investigate the very notion of originality.

In conclusion

In the final chapter of *Conceptual Art: A Critical Anthology*, 1999, Thomas Crow noted how the work of Elaine Sturtevant 'acutely defined the limitations of any history of art wedded to the image'.[9] We return here to the sense that Sturtevant, despite appearances, so to speak, is not that interested in the image per se and that the image is merely the manifest coat-hanger upon which to hang investigations into the thought processes that bring an artwork into being. What, she also seems to ask, is the thought structure that disallows, for whatever reason, an artist to repeat another artist's work in any form other than that which can be recuperated under an understanding of homage or forgery? This is an interrogative as opposed to an affirmative gesture that threatens to implode – through an investigation of an artwork's 'understructure' – the very models and structures of thought that enable art to be seen as art. If we apply this to the aesthetic dimension of enquiry then Sturtevant's critique and the radicality of her art is rendered less suspect and more clear. The order of thought that enables a regime of visibility to come into being is reliant upon a manifest and misplaced ideal of originality that needs to be both relativised and revealed for what it is: an occasional but none too stable prop that was intended to uphold an outmoded and largely modernist ideal of authenticity. The

brutal truth is thereafter all the more clear: originality can be and indeed is a process of repetition.

How did Sturtevant place Warhol in aesthetic inverted commas and, thereafter, make a contribution to how we understand his and other artist's work? She did this, I would suggest by way of a provisional conclusion, by becoming an uncanny mirror to the very practices she was engaging with; a form of aesthetic 'haunting' that revisits the primal scene of thought as a moment of instability and opens it up to the play of repetition. Writing of this 'return', Belinda Bowring has observed that 'the viewer is compelled to re-enter the work and reassess the impact that it made, so that the comeback that Sturtevant stages is not one of Warhol, Marilyn, 'the 1960s', or her own career, but that of every initial encounter with the object and, more importantly, the power contained in that moment'.[10] To this end, Elaine Sturtevant's work holds up a mirror to the aesthetic practices of her age and leaves us with an uncanny impression of the history of contemporary art. If the uncanny can be understood as the destabilisation of one way of thinking (realism, for example) and its replacement with another way of thinking (say, fantasy), she produces a moment when the edifices of originality and authenticity, their agreed conditions of possibility, crumble into the unreality of difference through forms of repetition.[11] Sturtevant's uncanny aesthetic 'returns', finally, question the ontology of the aesthetic moment and propose an investigation into how objects and ideas come into being. In doing so, they propose that any idealisation of originality is irredeemably attended by a 'haunting' of sorts, a conceptual slippage or sleight of hand that will inevitably question the very notions of originality and authenticity as foundational ideals in the history of contemporary art.

8. Issues of Authenticity in Contemporary Design: The *Smoke* Series by Maarten Baas

by Lis Darby

The concept of authenticity presents challenging problems of interpretation in relation to contemporary design. A traditional reading, which contrasts the 'genuine' object with the 'fake', is inappropriate for designs of recent production where there is little incentive for forgery (although this meaning of authenticity has some relevance in terms of pirated copies and imitations of twentieth-century design classics).[1] Equally, as most designed objects are mass-manufactured using industrial techniques, an argument that sees authenticity as residing exclusively in a unique work, or in the first one off the production line but not in the subsequent identical examples, seems untenable: all these objects are authentic or genuine statements of our industrialised and consumerist society.[2]

A discussion of authenticity in relation to contemporary design may also be posited in the idea of authorship and originality, and in the notion of a genuineness of expression. An exploration of how these ideas are determined in the conception and in the realisation of a design is nonetheless far from straightforward. An object is rarely the exclusive product of one individual's creativity and authorship. In the increasingly globalised and interconnected world of contemporary design, in which vast numbers of new products flood the market each year, designers are inevitably exposed to multifarious influences. It is accepted that a designer rarely conceives of an idea in isolation and without reference to his or her immediate social, political, economic, and cultural context. Moreover, a designer often works with archetypes – in the case of furniture, with chairs, tables and so forth. Although the typology may have been modified over time (as living patterns and spaces have changed, and as new materials and processes have emerged), these historical precedents may, deliberately or subconsciously, feed into a new design so that the object expresses some sense of continuity with the past. Whilst these influences contribute to the cultural authenticity of an object, as being a product of a particular environment at a precise moment in time, individual authenticity is more elusive, notably in mass-produced design.

Designers do not tend to work alone. The conception and, more crucially, the execution of a design is usually the result of close collaboration between (amongst others) the designer, studio assistants, technicians, and the sales and marketing teams of retail companies. During the research and development stages of an object, the designer's original concept may be subject to several modifications as a consequence of the constraints of manufacture and marketing.[3] As computers are increasingly used in both the design and the production stages of an object, questions about authorship and, by implication, authenticity become ever more complex. This fruitful collaboration between creative individuals and processes results in the development of products which can be endlessly and identically produced by mass-manufacturing techniques. In this context, authenticity may be seen to lie in the initial idea, rather than the final product, so that sketches and prototypes can assume greater value as a truer and more accurate expression of the designer's original intentions.

For many designers, the mass-production of their designs is the ultimate goal, affording them a wide market and audience for their work. However, the sacrifices in concept and execution that are often required to achieve this, as outlined above, have deterred some from working for large-scale manufacturing companies. Instead, they have chosen to pursue an approach which gives them a greater opportunity for unfettered, individual expression through increased control over both the designing and the making of an object. This has led to works which sublimate the minimal aesthetic, and the preoccupation with functionality and universality in mass-market production. Instead, original and expressive forms are favoured, together with a narrative and emotional content which can stimulate our thoughts and senses; many of these objects have tested the boundaries between design and art as a result. At the same time, some designers have retreated to a pre-industrialisation model in which the designer and the maker are one and the same person. This has often entailed the creation of a workshop environment, and the designer's direct involvement with the materials and processes of making unique items, or limited numbers of an object. Whilst not necessarily framed in terms of a desire for 'authenticity' per se, these developments in contemporary design nevertheless ascribe heightened value to the idea of individual authorship and personal expression as an antidote to the uniformity of

Fig. 1: Maarten Baas, *Smoke* armchair, 2002, burnt wood, clear epoxy coating.
Photo: courtesy of Studio Maarten Baas, photographer Maarten van Houten

Fig. 2: Maarten Baas, detail of *Smoke* armchair, 2002, burnt wood, clear epoxy coating. *Photo: courtesy of Studio Maarten Baas, photographer Maarten van Houten*

mainstream production in our increasingly globalised and homogenised world.[4]

Meanings of authenticity in the work of Maarten Baas

One such figure is the contemporary designer Maarten Baas (*b.*1978).[5] The *Smoke* series, which launched Baas' career in 2002, presents an opportunity to examine the meaning of authenticity within the multifaceted context of contemporary design practice, as the series ranges from unique, handcrafted works to those which are commercially produced for the Moooi label. Moreover, to create these pieces, Baas appropriated extant pieces of furniture (both anonymous items and well-known designs of the twentieth and twenty-first centuries), stating that *Smoke* was 'just a reinterpretation of existing furniture. It meant I didn't need to design my own furniture'.[6] The reworking of existing objects is a recurrent theme in contemporary design and raises questions about originality and authorship – and therefore authenticity; an analysis of Maarten Baas' *Smoke* series allows these questions to be addressed.

The history of the *Smoke* series is well known and needs only brief reiteration here.[7] *Smoke* began life as Baas' graduation project at Design Academy Eindhoven in 2002. Questioning the accepted notion that a beautiful object must necessarily be perfect, symmetrical and smooth, and that it loses its worth once

it becomes worn or damaged, Baas began to attack the surface of pieces of furniture. He did this first by crushing, melting and throwing, before settling on the idea of burning.[8] Initial experiments with fellow Dutch designer Bertjan Pot using second-hand furniture indicate how difficult and risky the process was: the plastic items merely melted, whilst the wooden furniture either burnt away completely or became too fragile to use; it also covered the user in soot.[9] Baas had refined the process by the time of his graduation in 2002. The Ikea chairs and second-hand neo-baroque pieces acquired off the Internet that he used were carefully scorched in stages with a blowtorch, with water being applied at intervals to extinguish the fire and thus ensure an even blackening. The final charred surface was sealed with layers of a clear epoxy coating (figs 1, 2).

The graduation pieces were presented in the Milan Furniture Fair of that year and attracted immediate attention. In an event where pristine new objects usually dominate, the blackened remains of earlier designs stood out from the crowd. Murray Moss, the owner of the Moss Gallery in New York, was particularly impressed and suggested to Baas that he should move on from utilising anonymous second-hand designs, to burning design classics. In *Where There's Smoke*, Baas burnt twenty-five pieces of furniture in front of an audience at the Moss Gallery in May 2004. The design classics burnt (in chronological order of the original design) included: Thonet's chair no. 14 (1859); C. R. Mackintosh's

Fig. 3: Maarten Baas, C. R. Mackintosh's
Hill House chair (1902) being burnt,
Where There's Smoke, 2004.
Photographer Bas Princen

Fig. 4: Maarten Baas, Ettore Sottsass' *Carlton Room Divider* (1981), *Where There's Smoke*, 2004. *Photo: courtesy of Studio Maarten Baas, photographer Maarten van Houten*

Fig. 5: Maarten Baas: *Smoke* furniture for 'Nocturnal Emissions' exhibition, Groninger Museum, 2004. *Collection Groninger Museum, photographer John Stoel*

Argyle (1897) and *Hill House* chairs (1902) (fig. 3); Antonio Gaudi's *Calvet* chair (1902); Rietveld's *Red/Blue* chair (1918-1923) and *Zig Zag* chair (1934); Isamu Noguchi's freeform table (1947); Charles Eames' plywood chair (1946) and stool (1960); Ettore Sottsass' *Carlton* room divider (1981) (fig. 4) and the Campana Brothers' *Favela* chair (1991). Baas also burnt recent works by his Dutch contemporaries, such as Richard Hutten's *Table Chair* (1991) and *Poef Pouff* (1994), together with the chest of drawers entitled *You Can't Lay Down Your Memories* (1991) by Tejo Remy. These pieces were a mixture of original objects and contemporary reproductions of older designs. After burning, each piece was signed and authenticated like a work of art with a brass plaque bearing Maarten Baas' name.

The destruction of cultural icons

The irreverent destruction of cultural icons implicit in *Where There's Smoke*, which garnered considerable media attention,

reached new heights in the 'Nocturnal Emissions' exhibition staged at the Groninger Museum in Holland in the autumn of 2004. For this, Baas was invited to burn ten pieces of furniture (mainly from the nineteenth century) in the museum's stores.

He was to 'transform and resurrect from obscurity'[10] objects which were unlikely to be taken out of storage and displayed to the public, as the museum had better examples in the collection. By giving the selected pieces a new appearance, Baas turned them into examples of contemporary design. The museum acquired six pieces from the series, and these are now regularly exhibited (fig. 5).[11]

Since the Moss and Groninger exhibitions in 2004, Baas has received numerous commissions for further burnt work. This has ranged from individual items for private and public collections to interiors. He has charred a staircase at an Amsterdam hairdressing salon, a panelled dining room and a panelled timber wall in the home of Milanese architect and designer Fabio Novembre. In 2005 he collaborated with Ian Schrager on *Smoke* furniture for

each of the rooms of the Gramercy Park Hotel in New York, together with a billiard table for one of its public rooms; the hotel re-opened in 2006. In 2007, at the launch of Murray Moss's new store in Los Angeles, Baas burnt a 1938 Steinway piano on which he then played the theme tune from the film *Chariots of Fire*.[12] On the occasion of his nomination as Designer of the Year at Design Miami in 2009, Baas burnt Marc Newson's *Wooden* chair of 1992.

As these later pieces attest, Baas sees the *Smoke* series as ongoing: 'I see them as products and I can make as many as I want'.[13] This is reflected, not only in individual pieces, but also in the way in which he has teamed up with Moooi, a company set up by the designer Marcel Wanders and marketer Casper Vissers in 2001 in order to give young designers an opportunity to realise their ideas on a commercial scale. Moooi approached Baas for the rights to reproduce the original pieces of anonymous furniture that had constituted his graduation project. The armchair (fig. 1), dining chair and chandelier have been available from the company and other retail outlets since 2004 and, necessarily, production methods have been altered. The pieces are now made, burnt, finished and upholstered in quantity in Indonesia; Maarten Baas is not directly involved in their burning. This series is also ongoing:

a dining chair with arms was added to the collection in 2009. Although Baas has produced other work since 2002, his name is indissolubly associated with this particular series of pieces. There seems no reason to think that *Smoke* will not continue to play a major part in his output.

In all of these pieces (that is, those in the graduation show, the Moss and Groninger exhibitions, and in the continuing one-off and Moooi productions), the process of burning is finely orchestrated so that the original object remains discernible. Moreover, the structural integrity of the furniture is always preserved; these pieces remain functioning objects even if, as in the case of the chandelier produced for Moooi, one arm is entirely burnt away. Most of the chosen pieces are primarily constructed of wood to facilitate the burning process, and the consistency of the burnt surface replaces that of the original object. However, in the case of Sottsass' *Carlton* room divider (fig. 4) and Rietveld's *Red/Blue* chair, the coloured configuration of the original (which differentiated the individual elements of the design in each case) was entirely lost, obliterated by the fire. These two involved the most dramatic alterations to the historical piece but, even in these examples, the original objects are still recognisable and the new ones retain their usefulness. Although Baas' work

entails a destructive process, this is only partial and it is controlled, permitting the old work to be reborn in an altered state but with its primary purpose intact. The theme of Baas' *Smoke* series work is, therefore, one of resurrection. [14] As one commentator has observed, the Dutch designer came up 'with a way to destroy the past with a technique that honors it while becoming something new'. [15]

A question of authorship

Although the final appearance of the furniture is due entirely to Baas' intervention, the primary objects that he utilises are not, either in conception or making. As mentioned, Baas has stated that for him *Smoke* was 'just a reinterpretation of existing furniture. It meant I didn't need to design my own furniture'. [16] The idea of taking extant objects and modifying them is not new. Throughout history, objects have been altered or refashioned, as a result of damage, changing needs, and vicissitudes in taste. However, this is rather different to the self-conscious decision to appropriate objects and rework them as a primary mode of expression and, in consequence, it raises the question of authorship. Before considering this, however, it is important to state that Baas is not alone here: this exploitation of the past has a long history and it has become a strong theme in contemporary design.

The reuse of anonymous items has its roots in the readymades of Marcel Duchamp, and in well-known precedents such as the Castiglioni brothers' *Mezzadro* tractor seat of 1957. In his series of banal objects of the late 1970s and early 1980s, Alessandro Mendini attached decorative devices to everyday items in an endeavour to reinvigorate the design discourse. More recently, in 1991, Tejo Remy took twenty drawers from a variety of old pieces of furniture, encased each in a new frame, and reassembled them into a usable chest which he entitled *You Can't Lay Down Your Memories*. In choosing this as one of the items to burn in the *Smoke* series, Maarten Baas was, in effect, appropriating appropriated objects. In Remy's chest of drawers and in many other contemporary examples, such as Martino Gamper's *100 Chairs in 100 Days*, the work of Karen Ryan or the group 5:5 in France, the anonymous objects that are appropriated are reused,

leaving the scars of their earlier lives intact as a tangible record of their history.

The idea of subverting key works of design history, as Baas went on to do, is also a recurring theme in contemporary practice. [17] There are precedents in Alessandro Mendini's reconfiguration of Marcel Breuer's *Wassily* chair and other iconic designs in the late 1970s. Amongst contemporary designers, Martino Gamper has refashioned pieces by Gio Ponti, notably items from the Hotel Parco dei Principi (1960) in his series *If Gio Only Knew* (2005–7). John Angelo Benson's *Corrupted Classics* series of 2004, in which he drastically altered pieces such as Mies van der Rohe's *Barcelona* chair and Le Corbusier's *Grand Confort*, is another conspicuous example of such practice.

Collectively, one might interpret this widespread theme of appropriation of anonymous and design classics as a criticism of the over-production and over-consumption of design in the twenty-first century. In an age of designer hype, with its seemingly endless manufacture of similar objects and the ubiquitous reproduction of iconic pieces by firms such as Knoll, Vitra and Cassina, some designers evidently feel new designs are no longer 'needed' (to use Baas' phrase); the alteration and, in some cases, disfiguration of pre-existing works is a valid alternative approach in an over-saturated and homogenous market. But this practice raises the issue of authorship. Baas (and others) are utilising another designer's or individual's original form, an expression of the time and place of its conception. The original is an essential constituent of the new piece and remains recognisable, but in recasting it, one can suggest that a new layer of authenticity is mapped onto the first: the object acquires a second, equally valid, authenticity because appropriation is such a widespread and genuine expression of aspects of contemporary design culture. Moreover, Baas demonstrates an original approach to appropriation, particularly in terms of the manner in which the objects are manipulated.

Creating a new materiality

In every object in the *Smoke* series, Baas gives the piece a new surface. Any signs of use or wear and tear that the objects may

have sustained during their earlier incarnation are destroyed in the burning process. In this respect, *Smoke* bears some conceptual relationship to Jurgen Bey's *St Petersburg* chairs (2003), in which old pieces of furniture are given a new PVC skin that uniformly covers both the wooden frame and the upholstery with its even and colourful pattern (fig. 6). However, unlike the *St Petersburg* chairs, the recycled pieces In *Smoke* are intentionally 'redamaged' in terms of their forms. There is also a strong textural quality to the new surface that Maarten Baas creates – although the pieces are sealed with an epoxy coating, the splits and craters of burning are clearly visible (fig. 2). Baas' original transformation of both the form and the surface suggest a search for a particular expression by the designer.

Baas stated that his initial engagement with burning furniture was the result of questioning the accepted notions of beauty. He has also suggested that the neo-baroque chair (fig. 1) embodied this concept most clearly: 'There is so much ornament on a baroque chair that is not necessary. Is that ornament less beautiful when half of it is burnt away, or is it more beautiful?'[18] Fellow Dutch designer Bertjan Pot has postulated that Baas was rebelling against his teachers at Eindhoven who favoured 'slick design' whereas Baas sought to 'let things be imperfect'.[19] There are precedents for this approach, perhaps most noticeably in the work of Gaetano Pesce who, since the 1970s, has delighted in the imperfect and the unexpected. Flaws, inconsistencies and roughness have been celebrated by other designers ever since, their conscious exploitation in the 1980s, for example, expressing a rising tide of boredom both with the uniform perfection of industrially produced objects and with the superficial gloss of postmodernist works.[20] In many instances, the quality of imperfection in contemporary design is explored through the appropriation of existing pieces, with all their attendant marks of time. Judy Attfield identified the search for a 'new kind of beauty' evident in the number of works which appropriated existing objects in the exhibition 'Stealing Beauty: British Design Now' (1999) as 'an attempt to capture a form of authenticity'. She suggested that the 'elusive qualities of materials with a previous life acquired through use and time' were a response to the blandness of mass-produced design.[21] In *Smoke*, the recycled

pieces retain the ghostly form of the past, but not the patina of age. Baas has destroyed this, replacing it with his own distinctive 'new kind of beauty'.

Murray Moss suggested that Baas 'actually created a new technique for producing something'.[22] In fact, just as the notion of appropriation is found to have historical precedents and contemporary parallels, the concept of burning pre-existing works is also not entirely new. There are precedents in the art world, most noticeably the work of French-born artist Arman (1928–2005). In the series *The Day After* of the early 1980s, Arman burnt a number of pieces of furniture, some of them very similar to the types used by Baas, casting the charred and dishevelled remains in bronze (fig. 7). Arman's works are all unusable, however: they are works of art that have appropriated the vocabulary of the design world.

In the field of design, Alessandro Mendini's *Monumentino de Casa*, an archetypal chair placed atop a short staircase, may be cited. Made by Bracciodiferro, the short-lived experimental wing of the Cassina company set up in 1972, *Monumentino de Casa* was subsequently destroyed by burning in a deserted quarry near Genoa in 1974.[23] In 1985, the Japanese architect and designer Shiro Kuramata wrapped an original bentwood chair by Josef Hoffmann in metal wire. The wire was left after the object was burnt and, nickel plated and polished, it appeared as a shiny exoskeleton of the original chair, rising like a phoenix from the ashes.[24] The notion of burning a pre-existing object illustrated by these designs meshes with Baas' concept in the *Smoke* series. However, in the earlier examples, the original object is completely destroyed, not merely reconfigured. Moreover, these were individual examples and were not conceived as a series.

A contemporary of Baas, the Dutch designer Pieke Bergmans, has also burnt design classics, although this is not her primary objective. Bergmans, who describes herself as a 'Design Virus', explores the tension between materials and between mass- and hand-production by dropping molten glass onto iconic pieces of furniture such as Sori Yanagi's *Butterfly* stool of 1954 and Jasper Morrison's *Plywood* chair of 1988 (fig. 8). Here, too, the process is pre-eminent ('I design the process. The process actually designs the piece')[25] but the final result is unpredictable as the 'bubbles

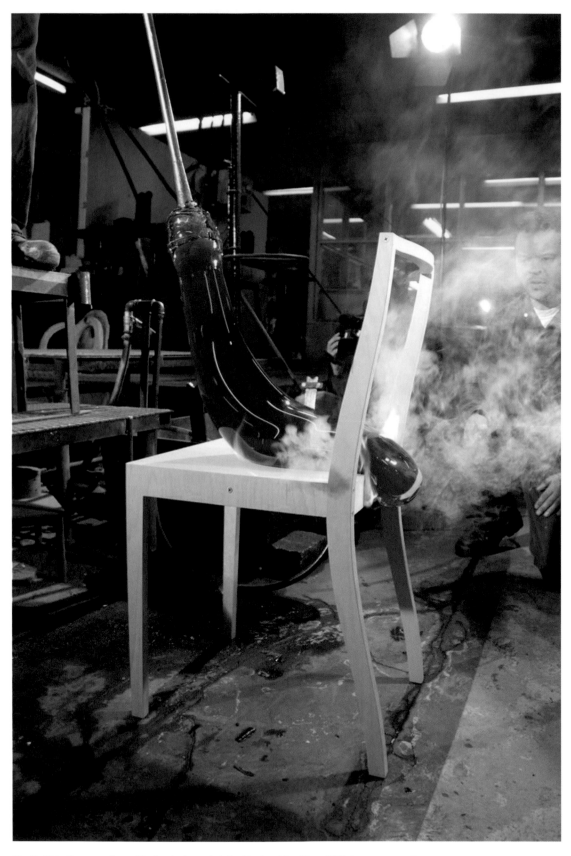

Fig. 8: Pieke Bergmans, Jasper Morrison's plywood chair with glass, Vitra Virus, 2007. *Photo: courtesy of Studio Design Virus*

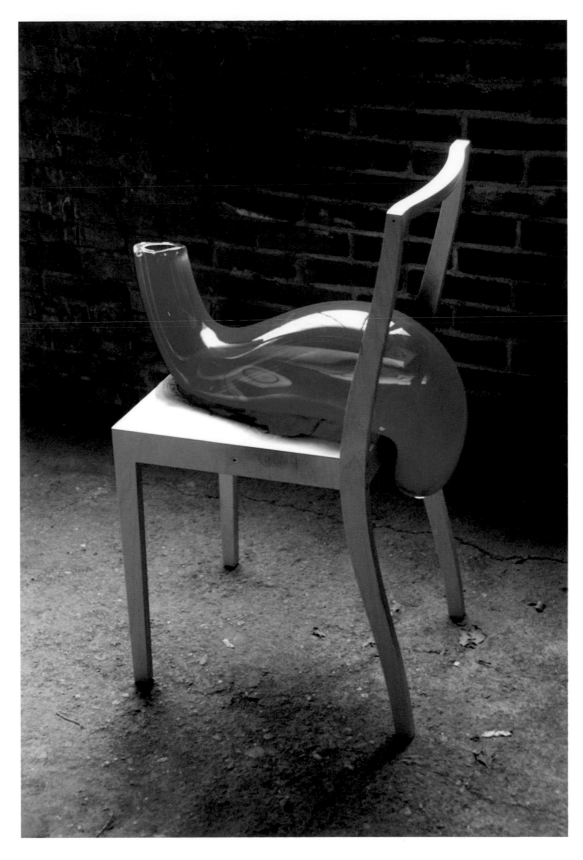

Fig. 9: Pieke Bergmans, Jasper Morrison's plywood chair with glass, Vitra Virus, 2007. *Photo: courtesy of Studio Design Virus*

of hot and fluent crystal are pressed against the furniture' and in bursts of fire and smoke they melt together'.[26] As with Baas, the original structure is still visible, but in contrast to *Smoke,* the burning is incidental and of secondary importance; the difference in materials and in the process of making between the two parts seems of greater significance than the charred surface where they collide. Moreover, the resultant work is no longer functional but is transformed into a work of sculpture: 'The piece of furniture has become a pedestal for the crystal object ... the crystal object sits on the furniture like a parasite, a virus'.[27] (fig. 9)

Appropriation, originality, and authenticity

It is clear, therefore, that Baas' *Smoke* series forms part of a considerable body of contemporary design that explores appropriation, and that even his concept of burning objects is not entirely new. Where then does the originality and authenticity of these pieces lie? What serves as a common thread through all this work is the focus on the direct intervention of the designer: all these objects circumvent mass manufacture and stand in opposition to the encroachment of computers and the technology of the production line. Baas reveals himself as more of a craftsman than a designer. He does not *design* the object in the conventional sense of making preparatory drawings, models and prototypes, but he *makes* it through the burning process: the final object emerges through Baas' direct physical intervention. Pieces in the *Where There's Smoke* series, such as the *Carlton* room divider, burnt and signed by the designer, are original, unique and, therefore, authentic pieces from Baas' own hand, which can never be replicated in the strict sense of the word.

Equally, the Groninger Museum pieces are unique works from Baas which celebrate the individualism and authentic hand of their maker; in this respect, they provide a link back to the original pre-industrial pieces Baas appropriated. However, the fact that the museum not only facilitated their creation, but also repurchased six pieces, confers another layer of authenticity on the *Smoke* series. The acquisition of an object by a museum serves to accredit that work with a measure of historical and cultural significance and value; the action authenticates the piece as a genuine expression of the material culture of a particular place and time, and one that is worthy of preserving for posterity. The acquisition of contemporary pieces poses particular problems for museum curators who, without the advantage of historical perspective and evaluation, need to ensure that the decision as to what to purchase does not fall victim to personal preferences or to art market forces. In this respect, acquisitions of pieces from the *Smoke* collection, such as the purchase of a mirror by the Victoria and Albert Museum,[28] together with the activities of the Groninger Museum, seem collectively to acknowledge the cultural authenticity of the series.

The Groninger Museum, in permitting Maarten Baas to burn items in its collection, was also making a judgement that the original, authentic objects were no longer of sufficient quality or historical significance to be displayed in their galleries.[29] Museums necessarily deaccession objects, usually seeking to find alternative homes for them, or occasionally selling them on the open market. For example, the Victoria and Albert Museum re-evaluated some pieces on their return from storage during the Second World War. Those that were deemed 'valueless' or damaged were disposed of in these ways. Others, however, which were too dilapidated or were regarded as fakes, were burnt 'like heretics'.[30] Whereas a museum's decision to deaccession an object can be seen to diminish (or even negate) its authenticity or cultural value, the Groninger Museum was complicit in the act of re-authenticating parts of its nineteenth-century furniture collection. However, in so doing, the temporal aspect of authenticity is posited. As these examples demonstrate, physical condition, the presence of duplicates or superior examples in the collection, and the expert perception of historical value are key determinants of authenticity within the museum context.[31] This raises the question as to whether the *Smoke* series will retain its historical significance over the years. It is conceivable that, sometime in the future, the process may be repeated: the Groninger (or another) Museum may deem it no longer culturally appropriate to retain examples of *Smoke*; indeed, might some pieces actually be reworked once again?

The original objects in the *Where There's Smoke* series, and in the Groninger Museum, acquire a new, or second, authorship and authenticity dependent on Baas' individual concept and direct

engagement with the physical process of re-creation. Even though Maarten Baas has been in partnership with Bas von Herder since 2005, and employs studio assistants, there is close collaboration in the workshop, and hand intervention has remained a key aspect of his work.[32] By contrast, Baas has nothing to do with the actual making of the Moooi works; he has, in effect, retreated to the collaborative design model. It is significant that Baas sees the Moooi initiative as distinctly different from the other works; as he states, 'the mass products will never have the story – they are anonymous pieces, and the story remains with the prototype'.[33] However, although these are quantity-produced pieces, each one differs slightly because of the nature of its production – the burning process cannot be identical in each case, and this is a point emphasised by Moooi.[34] In these pieces, authorship and authenticity are attested primarily through the concept embedded in the original graduation project. Nonetheless, some residual evidence of the designer's hand is captured in the Moooi products; some individualisation within the mass-produced object is achieved.

Maarten Baas' *Smoke* series speaks directly to one facet of the contemporary design market. In a visually and, more specifically, design-literate society, some consumers seek to distance themselves from the mass-produced object and the endless reproduction of 'design classics'. They desire, instead, a more individual piece, and this demand has been catered for in recent years through the rise of the limited edition market, and the prominence now accorded to prototypes and designers' models.[35] Once again, one is conscious of Maarten Baas' subtle and distinct interpretation of these developments. His pieces are not limited editions, but are allied more closely to the unique works to be found within craft practice. They are even more exclusive items than the limited edition, which may be of ten examples, but may also be of one hundred. Even for those who cannot afford a unique piece,[36] Moooi offers the possibility of an element of differentiation: the company is able to satisfy the consumer's search for a more original object which retains a vestige of the designer's intention and his manipulation of the material surface.

The *Smoke* series serves as an exemplar of many facets of contemporary design – the theme of appropriation, the interest in material and technical experimentation, and the challenge to formal neutrality and simple functionality. Its cultural authenticity is thus evident, acknowledged and reinforced by museum acquisitions and by its commercial success. Whilst there are precedents and contemporary parallels to Baas' reuse of objects and to the act of burning, his particular approach is distinct and unique to him. Above all, Baas authors an authentic piece through the transforming process with which he is so intimately involved: it is this direct intervention in the making of these objects which conveys the genuine and original expressiveness of the concept and which, it can be suggested, links the series back to a more traditional notion of authenticity rooted in pre-industrial production methods. Finally, it is the varied guises of these burnt offerings (the unique item, the mass-produced object, the museum commission) which, individually and collectively, reveal the complex and layered meanings of authenticity in relation to contemporary design.

9. Creating an Authentic Style: John Soane's Gothic Library at Stowe

by Megan Aldrich

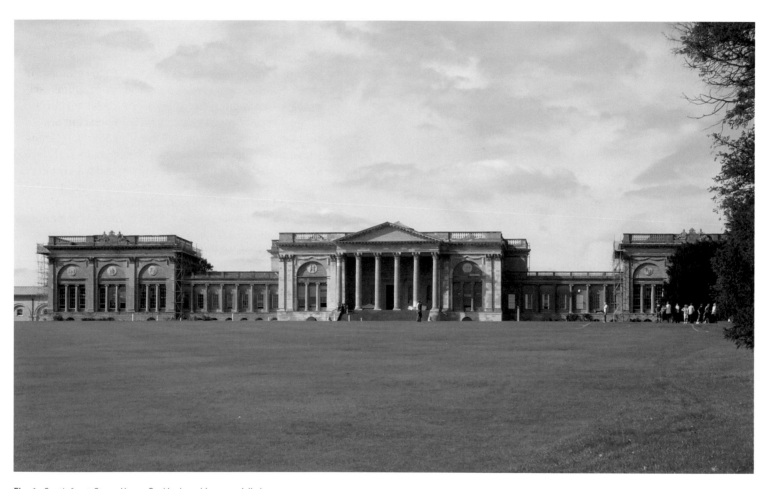

Fig. 1: South front, Stowe House, Buckinghamshire, remodelled in the 1770s by Thomas Pitt, Lord Camelford; the Gothic Library is situated on the ground floor towards the left in this view.
Photo by the author, courtesy of Stowe School

The subject of historic interiors captured the public imagination during the later twentieth century, when curatorial attention began to focus on the idea of accurately recreating 'authentic' period rooms and their furnishings in historic and country houses, in museums and in public buildings, while popular and high-profile exhibitions were devoted to this subject. [1] Such authenticity was understood to include the literal recreation of documented examples of historic designs and the inclusion of appropriately dated and stylistically consistent furnishings – preferably the original furnishings created for a particular historic interior, if one could find them. Reproductions of historic wallpapers and furnishing fabrics were widely available to buy, and the market for period furniture boomed during the final quarter of the twentieth century. Researchers and learned societies turned their attention towards the idea of achieving a quasi-scientific degree of accuracy in the reconstruction of lost interiors – and, by extension, lifestyles – of the past.

Such interests were not new, however. Antiquarian investigation during the early eighteenth century, which favoured an object-based, archaeological approach to individual artefacts from the material culture of the past, gave way to a more holistic and associative approach during the nascent Romantic Movement of the later eighteenth and early nineteenth centuries, when an interest arose in creating stylistically authentic interiors to house such antiquarian material. The Gothic Revival was perhaps the most distinctive chapter in the history of the English aesthetic imagination during the Romantic period. House owners and designers sought to reconnect to the past by creating 'authentic' gothic architecture and interiors – insofar as gothic design was understood – through tapping a rich vein of surviving medieval literature and architecture. The lost glories of the Saxon, Plantagenet and Tudor kings were recalled to suit multiple agendas, most commonly relating to politics and family history. [2] Accuracy of design, although a concern, was secondary to achieving a vaguely defined sense of overall historic authenticity.

There were a number of such designers working in revived medieval styles during the eighteenth and early nineteenth centuries, including the professional architects Robert Adam, James Wyatt, and John Soane, and the country-house owners Horace Walpole, William Beckford, and the 1st Marquess of Buckingham. This chapter will investigate the Gothic Library, or manuscript room, designed by John Soane in 1805 for one of his most important clients, Lord Buckingham, at Stowe House. In doing so, it will examine not only the striking architectural shell created by Soane and copied directly from late gothic architecture at Westminster Abbey at the request of the Marquess, but also the perceived authenticity of its furnishing scheme, where Soane mixed designs taken from medieval gothic architecture and applied them to conventional, early nineteenth-century furniture shapes. As we shall see, for his new library Lord Buckingham acquired antique furniture which was neither medieval nor European, but which was understood to be 'Tudor' at the time. This chapter will examine this complex commission in order to suggest that the understanding of authentic medieval style at Stowe was multifaceted and relative to the context in which it was deployed.

German liberty and authentic British antiquity

From the seventeenth century onwards, architects could suggest different shades of meaning in their gothic designs by drawing upon differing medieval sources. At Stowe House in Buckinghamshire (fig. 1), one of the largest neoclassical country houses in the British Isles, such shades of meaning emerge in the imposing house and its remarkable gardens. [3] The origins of the house itself stretch back to the period of Elizabeth I, the last of the Tudors. In 1848 Henry Rumsey Forster published an annotated catalogue of the great Stowe House sale of that year, including a description of the house and its collections, which were sold to pay the debts of the 2nd Marquess. Forster tells us that the very name Stowe is a Saxon word meaning, 'a strand, station, or eminence'. [4] The neoclassical character of the house and its gardens became pronounced during later eighteenth-century developments; the earlier gardens had mixed stylistic references. The Saxons and Goths were especially well represented, for they embodied the political freedoms associated with northern European traditions. In particular, Saxon designs at Stowe referred to the ascendency of the Protestant House of Hanover after the death of the final

Fig. 2, left: The Temple to Liberty, Stowe Gardens, Buckinghamshire, designed by James Gibbs c.1741 with later lanterns. *Photo by the author, courtesy of Stowe School*

Fig. 3, right: Lord Buckingham in the Large Library, Stowe House, in a drawing signed 'E.S.' and dated 1809, pencil, ink and coloured wash. *Photo by the author, courtesy of Stowe School*

Stuart monarch, Queen Anne, in 1714.[5] 'The words Saxon, Goth and German were virtually synonymous' during the eighteenth century, and all implied 'Liberty',[6] making the Stowe Gardens into a piece of beautifully designed political propaganda.

A 'Saxon grove' was established at Stowe by 1731; it may have had an additional meaning beyond a political one – that is, as a testament to the authentic antiquity of the site.[7] In 1742 it was described by an observer: 'The Saxon temple is an altar plac'd in an open grove, round which the 7 deities of this nation, that give name to the days of the week, are placed. The statues are all finished, and the scene is solemn.'[8] Nearby was the Temple to Liberty, designed in 1741 and built shortly afterwards (fig. 2). It had long been known as the Gothic Temple when Henry Forster described it in the 1840s as 'Moorish Gothic', suggesting that its association with Germanic political liberty had been forgotten.[9] With its triangular form and circular interior, the building, designed by James Gibbs, is a complex blend of influences. It was inscribed: 'I thank God that I am not a Roman'.[10] The references to Saxon liberty were explicit when it was built, and in 1744 the Saxon deities were moved from their wooded grove and placed to the east of the temple, defending Saxon liberty at the boundary

of the early gardens.[11] The theme is continued inside the building with the arms of the Saxon Heptarchy in stained glass, and in the dome, which displays the family arms of the Grenvilles and Temples, the owners of Stowe. Their ancient lineage extended back to Anglo-Saxon times, then considered the epitome of authentic British antiquity.

Archaeology, scholarship and authentic design

Appreciation of the Saxon grove at Stowe changed over time. Its political message had become obscure when Henry Forster described it in his sale catalogue of 1848 as a 'secluded circular recess' with a platform of limestone blocks used as a 'funeral pile', with bronze, glass and pottery vessels put there to accompany site excavations in which two ancient barrows with human remains had been found. In other words, the Saxon grove was now presented as an authentic archaeological site.[12]

A parallel intellectual shifting of gears was at work early in the nineteenth century when George Nugent-Temple-Grenville, 1st Marquess of Buckingham, asked the London architect John Soane for assistance in creating a new manuscript library at

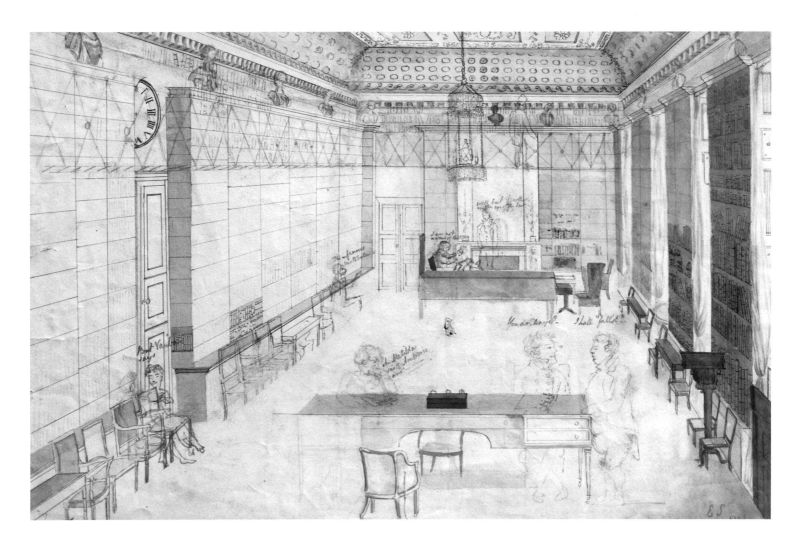

Stowe. The site of the room was amongst the family living rooms on the ground floor of the house. The new library was to be placed directly underneath the main library of the house, to which it was connected by a staircase. Lord Buckingham was a serious bibliophile and had over 20,000 books in the Large Library at Stowe, which he had created by remodelling the ballroom of the old Palladian state rooms. [13] Buckingham is portrayed in a delightfully informal drawing by the unidentified 'E.S.' in 1809, ensconced in this magnificent new interior (fig. 3).

Shortly after acquiring some important Anglo-Saxon manuscripts in 1803, the Marquess decided to create an authentic setting for them. [14] The collection came from a distinguished antiquary and friend, Thomas Astle, formerly the keeper of records of the Tower of London. Astle had offered Buckingham the option of purchasing his manuscripts at a much reduced cost in his will. The new library at Stowe was, therefore, a tribute to scholarship. Late in August 1804, Buckingham was writing to John Soane about this project:

> An idea has suggested itself to me of a sort of anti-room, that will require much consideration ... I have not the pleasure of

Mr Carter's acquaintance but every thing that I have seen of his designs, & of his writings, satisfy me that he is by many degrees the most scientifick man in this country in the history of the various Gothicks & the Saracenick architecture... [15]

John Carter, referred to above, was draughtsman to the Society of Antiquaries and a passionate admirer of gothic architecture. [16] During the 1780s he published *Specimens of Ancient Sculpture and Painting*, which illustrated aspects of Westminster Abbey; he also produced a series on the English cathedrals as a record of authentic medieval architecture. [17] Soane evidently thought well of him but there was a misunderstanding about payment due to Carter's irascible personality, so Soane was forced to proceed at Stowe without him. Initially, Soane called the new library at Stowe the 'Saxon Room' because of its manuscripts. By December 1804, however, Lord Buckingham wrote impatiently to Soane that he was awaiting the architect's arrival at Stowe to discuss 'the ideas which we have discussed relative to my Gothick room'. Saxon had now become gothic, which indicates the degree of confusion that still reigned over the different styles of medieval architecture. Buckingham continued, 'it is absolutely necessary that you should

Fig. 4: Drawing by Henry Hake Seward and Charles Malton, office of John Soane, showing details of gothic tracery from the Chapel of Henry VII, Westminster Abbey, London; 1805.

Trustees of Sir John Soane's Museum, London

see the local [*sic*] before you can judge of the whole of my ideas'. Therefore, Buckingham took the lead in terms of the overall conception of the design, while Soane used his experience and professional expertise to refine and execute it. Soane's journals in the Soane Museum in London show that he visited Stowe in January 1805 to take measurements for the new interior. By the end of the month he was able to send Lord Buckingham two plans with sections and two perspective views. [18]

Buckingham had specified that he wanted the architecture of the room to be taken from the Chapel of Henry VII at Westminster Abbey (*c*.1503–12), one of the latest and most highly ornamented examples of English gothic vaulting. This large chapel had replaced the medieval Lady Chapel of Westminster Abbey. Henry VII's official purpose in building it was to honour the Virgin, but his clear intention was to create a shrine to the new Tudor dynasty he had established in 1485 after defeating Richard III at the Battle of Bosworth Field. [19] In using this architectural model, Buckingham made reference to the scholarly career of Astle, who had transcribed and published the will of Henry VII with its detailed description of the new chapel at Westminster. [20] A dual purpose was at work, however, for the references to Henry VII were certainly also seen by Lord Buckingham as celebrating the genealogy of the owners of Stowe and its Tudor connections.

Soane's draughtsman, Henry Seward, went back and forth between Westminster Abbey and Stowe during 1805 in order to set the designs for the Gothic Library. Figure 4 illustrates one of these drawings in ink and grey wash. In the upper left is a beautiful quadrant of lace-like tracery drawn from life, *in situ* in the chapel, while Figure 5 shows a freehand study of the tracery taken from the extraordinary ceiling. Eventually the vaulting of the south aisle was chosen as the model (fig. 6). On 18 May, Seward met the carpenter John Bevans at Westminster to go over the designs; three days later he met Mr Doyle, who executed the metalwork, for the same purpose. The idea was that, by drawing directly from real medieval architecture, Soane's team were creating an authentic gothic interior. [21]

The Chapel of Henry VII had already been used on numerous occasions as a model for gothic interiors. Horace Walpole, for example, used it for the ceiling of the Gallery at Strawberry Hill shortly after 1760 and, significantly, he was assisted there by Thomas Pitt, later Lord Camelford, who designed the south front of Stowe in the 1770s. [22] We will return to Walpole before long, but it is worth considering whether Pitt gave his cousin, Lord Buckingham, an account of Walpole's Gothic Gallery at Strawberry Hill. Sir Roger Newdigate, who had attended Westminster School as a boy, made even more extensive use of Henry VII's Chapel as a source for the interiors of his own country house, Arbury Hall, in Warwickshire, during the 1750s to 1770s. [23] What was new at Stowe was the degree of interest in exact reproduction of details copied *in situ* from an existing building, and this appears to have been driven by Lord Buckingham.

For example, on 16 February 1806 Buckingham wrote to Soane:

> I think you have departed a little too much from Hy 7ths Screen which I wish to take as the bookcase round the room: I would therefore beg you to be so good as to send one of your draughtsmen simply to sketch one of the Upper Squares of the composition... [24]

Plaster casts were actually made at Westminster by Soane's workmen so that the plasterers would have an accurate model to follow at Stowe, such was Lord Buckingham's eagerness to have an authentic Gothic Library.

Writing in 1848, Henry Rumsey Forster described the Stowe manuscript library, as he called it, noting that the 'designs for the decoration of this room were *correctly modelled* from the ornaments of Henry VII's Chapel in Westminster Abbey'. [25] Forster stressed the fidelity of the gothic tracery in wood and plaster to the Tudor original made in stone. To further complicate our understanding of this fidelity, Forster describes the Stowe ceiling as 'vaulted', whereas it is relatively low and certainly flat. The library ceiling had to remain low for technical reasons, and spacious pseudo-vaulting of the kind Walpole had achieved in the Gallery at Strawberry Hill was out of the question. [26] Instead, Soane had chosen the south aisle of the Westminster Chapel as his model, with its flat passages of linear tracery relieved by traceried quadrants at the four corners of the centre of the room (fig. 7).

Fig. 8: Overdoor *bas relief* from Castle Hedingham, Essex, depicting the Battle of Bosworth, looking into the Gothic Library, Stowe, with flanking figures in plaster of Henry VII and Elizabeth of York, 1806. *Photo by the author, courtesy of Stowe School*

This clever visual device gave an effect of real movement and some depth to the ceiling, making it seem less oppressive. Some of the three-dimensional spirit of the Tudor original was captured, lending it a feeling of authenticity. It was, therefore, authentic in its ornamental design, but not in its shape.

Genealogy and homage to the Tudors

Additionally, in his description of the Gothic Library at Stowe Forster noted, 'In the centre of the *vaulted ceiling* is a circular shield, filled with armorial bearings, seven hundred and nineteen in number, of the Grenville, Temple, Nugent and Chandos families', the families of Stowe.[27] The large circular shield just visible in Figure 6 made an important genealogical statement and created a colourful visual focal point for the library interior, and it is the one significant departure from the design of Henry VII's Chapel. This again seems to have been Lord Buckingham's idea, and it brings a strong element of family history into the interior.

Soane's team had got to work by April of 1805. In May the design of the armorial shields was being finalised, and Mr Rothwell, the plasterer, received designs by the end of July 1805 so that he could begin to execute the ceiling.[28] In the meantime, Bevans, the carpenter, had begun the intricate traceried oak woodwork which included the canopies above the bookcase doors, the doors to the room, and the window frames and shutters. Underwood and Doyle supplied glazed metalwork for the spandrels and tracery of the bookcase doors, which were coloured in imitation of patinated bronze.[29] The walls and mouldings were finished in Parker's Stucco in imitation of stone, perhaps striking an inauthentic note in terms of materials, yet expense was lavished elsewhere. In January 1807 the brass founder Thomas Catherwood billed for a 'Large brass Gothic chimney piece made to

draw'g' with twelve rosette ornaments, and in December 1807 for a 'Handsome Gothic brass Stove with arches & entablature with flower ornamented leafage border' as well as accompanying gothic firedogs and a fender.[30] It was unusual to have so much expensive metalwork in a domestic Gothic Revival interior, but Soane and Lord Buckingham may have had in mind the walls of the elaborate bronze chantry chapel which surrounds the Westminster tomb of Henry VII and his queen, Elizabeth of York, where Masses would have been chanted for their souls. Lavish use of bronze was very much a part of the chapel design at Westminster, and it also played a prominent role in the library it inspired at Stowe.

Drawings in the Soane Museum tell us that the 'shrine', a genuine fifteenth-century polytych purchased by Thomas Astle in Antwerp, was intended to hang opposite his portrait over the chimney piece, and under one of the delicately carved gothic oak canopies.[31] Soon afterwards there was a change of plan: by 1809 Astle's portrait was replaced by a collection of miniatures hung above the chimney piece. This suggests a shift in intention away from creating a room dedicated to a scholar and his collection and towards the creation of a genealogical statement. The latter view is supported by the addition of an anteroom and staircase to the library which gives great prominence to the Tudors. Just as the Saxon grove changed its meaning over time, so, too, the significance of the Gothic Library was evolving.

Soane created a dramatically top-lit staircase to lead the visitor down from the light, space and classical order of Lord Buckingham's Large Library into the darker and more shadowy space of the anteroom to the Gothic Library. To make it absolutely clear to visitors that they were about to enter the domain of the Tudors, a *bas relief* of indeterminate age was placed above the doorway into the library depicting the moment at which Henry Tudor defeated Richard III at Bosworth and established his new

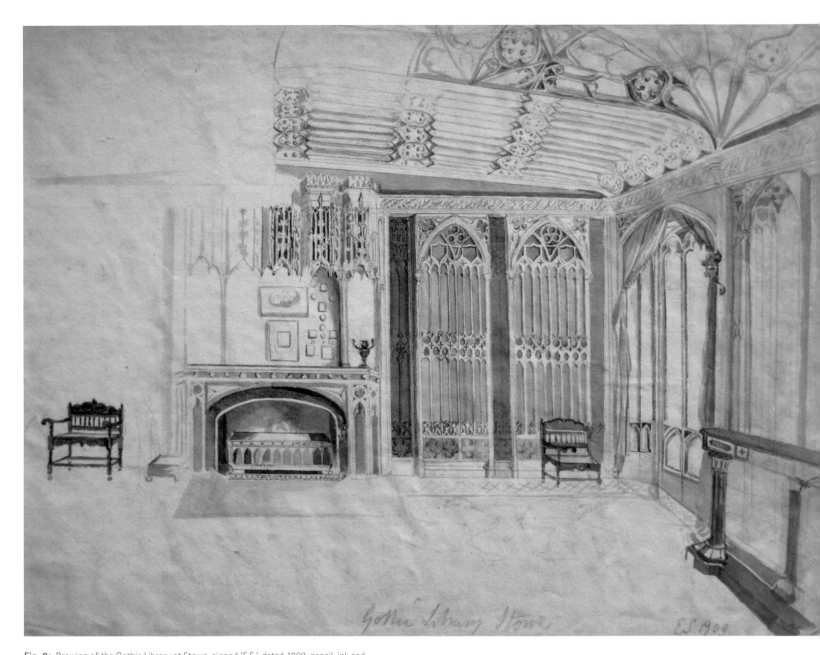

Fig. 9: Drawing of the Gothic Library at Stowe, signed 'E.S.', dated 1809, pencil, ink and wash. The original date in pencil, still faintly visible in the lower right corner of the drawing, became rubbed and was subsequently and erroneously rewritten as 1909.
Photo by the author, courtesy of Stowe School

dynasty (fig. 8).[32] To the left Soane's team added a plaster statue of Henry VII resting on his own corbelled head; to the right is his queen, Elizabeth of York.[33] The Tudor monarch, whose chapel design was reproduced inside the library, stood at its entrance.

Authentic Tudor furnishings

However faithfully its architectural shell evoked the lost age of the Tudors, the Gothic Library at Stowe needed furniture in order to function as an interior. Researching Tudor furniture was a difficult task in this period as there was little available information and royal chapels were not noted for their furniture. Soane lacked experience in the style. A drawing of 1809, illustrated in Figure 9, shows that by this time a suite of three black and white tables in the gothic style plus some black 'antique' chairs had made their appearance in the room. To the right in Figure 9 is one of a pair of pier tables made of ebonised mahogany of standard neoclassical form, but with applied gothic tracery in ivory that is nearly identical to that used in the brass chimney piece in the room. One of these tables is now on display in London, in the Victoria and Albert Museum (fig. 10), while another is in a private collection. In the drawing they are positioned against the glazed tracery of the piers of the library between the south-facing windows. The pair of pier tables was complemented by a large octagonal table, a fashionable furniture type during the first half of the nineteenth century, which was positioned directly underneath the circular shield in the centre of the room, echoing its shape and reinforcing the shield as the focal point of the entire scheme.[34]

There are no surviving documents to establish conclusively that Soane designed the two side tables and centre octagon table for the Gothic Library. Nonetheless, their traceried designs in ivory are nearly identical to the tracery from Henry VII's Chapel used for the brass chimney piece, which was designed in 1806 and is described in the accounts in the Soane Museum. This suggests that Soane designed the tables slightly later than the chimney piece, but obviously before they were recorded in the drawing by E.S., which can be confidently dated to 1809 despite the inaccurate later alteration of the date at the lower right of the drawing. Soane's carpenter, Bevans, who was skilled in the execution of

gothic work, could have made them as examples of 'authentic gothic' furniture to complement the architecture of the interior.

The colour green was significant to Lord Buckingham as it stood for the Grenville lineage. Preliminary technical investigation has suggested that dark green was used in limited amounts in the original colour scheme of the Gothic Library as colour accents: it appeared on the bronzed tracery of the glazed bookcase doors, and it was used in the decorative frieze across the niche designed for the 'shrine' opposite the chimney piece, which was relieved with contrasting gilt rosettes. There is some evidence that the original colour of the table tops was dark marbled green, which would have helped to tie the scheme together, visually.[35] The green accents were complemented by the reds used in the central circular shield, which were picked up originally in the contrasting red and white silk curtains framing the windows, while the black furniture contrasted with the off-white stone colour of the walls and ceiling. Henry VII would surely have approved.

In search of Cardinal Wolsey's chairs

In addition to tables, a library must have seat furniture. Two examples can be seen either side of the chimney piece in the sketch of the Stowe library reproduced in Figure 9. This shows a pair of low-backed black chairs with a number of small, spirally turned uprights in the back, caned seats, and low, scrolled armrests, indicating that Lord Buckingham had been shopping for antique furniture for his library. We now know these chairs were from southeast Asia and made in the seventeenth century, but in the minds of collectors of such furniture during the eighteenth and early nineteenth centuries, they were considered to be English 'Tudor' chairs of the sixteenth century.[36] In this, Buckingham took his cue from Horace Walpole, who owned a number of such chairs himself and associated them with Cardinal Wolsey, Henry VIII's doomed chancellor. It was doubtless the Tudor associations which Buckingham was after.

Walpole has already been referred to on several occasions in this chapter, and it is difficult to discuss any gothic house before 1850 without reference to his ground-breaking work at Strawberry Hill, his gothic villa in Twickenham. In his quest for

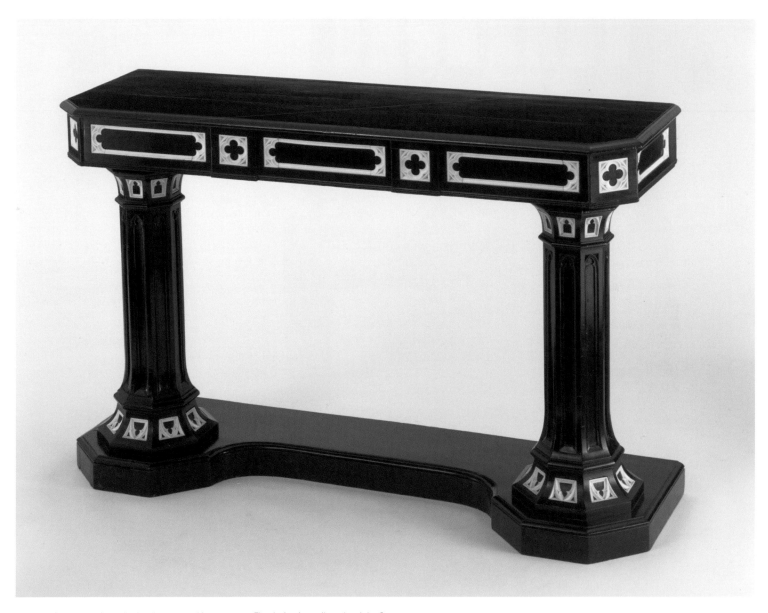

Fig. 10: Side table of ebonised mahogany and ivory, c.1807. The design is attributed to John Soane.
© Victoria and Albert Museum, London; W. 32–1972

Fig. 11: Carved ebony side chair with restored caned seat, southeast Asian, final quarter of the seventeenth century.
©Victoria and Albert Museum, London; 413–1882

authentic furnishings for his gothic interiors, Walpole initially acted as his own designer, assisted by several like-minded friends. Soon afterwards he began to purchase antique furniture in order to create a more authentically medieval effect. In analysing Strawberry Hill, it becomes apparent that Walpole used at least as much Tudor design as gothic, and he was particularly fond of historical associations with Tudor figures like Cardinal Wolsey. His quest was not so much for authentic design as for authentic associations.

In 1748, just before he began the gothic remodelling of Strawberry Hill, Walpole had visited Esher Place in Surrey in the company of the poet Thomas Gray. Cardinal Wolsey had retreated to Esher when he lost favour with Henry VIII, and his downfall began.[37] The romance of such an association must have greatly appealed to Walpole. In 1752, when Walpole was beginning to think about furnishing Strawberry Hill, Gray wrote to him and reminded him of their visit to Esher: 'As I remember, there were certain low chairs that looked like ebony at Esher, and were old and pretty'.[38] This is where the lengthy misunderstanding about the dating and origins of such ebony furniture began. Walpole began to furnish a Tudor-themed guest bedchamber, the 'Holbein Chamber', at Strawberry Hill in about 1759 using real antiques – ebony furniture, mostly chairs, which he had bought at auction. Thomas Gray wrote to a mutual friend: 'The chairs & dressing table are real carved Ebony, pick'd up at auctions.' By 1763 Walpole described how his passion for ebony furniture had developed:

> I believe I am the first man that ever went sixty miles to an auction. As I came for ebony I am up to my chin in ebony; there is literally nothing but ebony in the house ... There are two tables and eighteen chairs, all made ... two hundred years ago. These I intend to have.[39]

Walpole's eccentric house could be visited by members of the public, and Walpole publicised it and his antiquarian interiors, including his ebony furniture, in the guidebook he wrote, *A Description of the Villa of Mr. Horace Walpole*, issued in two editions of 1774 and 1784. Lord Buckingham would have been nine years old when Walpole was decorating the Holbein Chamber,

so he would have grown up with an awareness of Strawberry Hill and its famous interiors.

Walpole didn't, however, possess Cardinal Wolsey's actual ebony furniture; he purchased similar objects which he could find in auctions. The great collector and enthusiast for gothic design, William Beckford, claimed to have six of Wolsey's ebony chairs (fig. 11) installed in the oriel of St Michael's Gallery at Fonthill Abbey, the enormous gothic 'abbey' in Wiltshire designed for him by the architect James Wyatt.[40] St Michael's Gallery was furnished in about 1806, exactly the time when Lord Buckingham was furnishing his Gothic Library at Stowe. It is entirely possible that Beckford's chairs were purchased directly from Esher in 1805, when two wings of the house were demolished by a new owner and some furnishings sold off.[41] Perhaps Lord Buckingham acquired his pair of chairs from the same sale. The ebony furniture at Esher had already been 'authenticated' by Horace Walpole, so William Beckford and Lord Buckingham considered their ebony furniture to be authentically medieval and compatible with the gothic interiors they were creating at Fonthill Abbey and Stowe House, respectively.

Provenance and authenticity

In the Stowe sale catalogue of 1848, Henry Rumsey Forster describes lot 2503 as a pair of ebony chairs from Cardinal Wolsey's palace at Esher: 'the latter subsequently belonged to Mr. Beckford, and were bought by the late Duke of Buck'ham at the sale at Fonthill', along with other objects from Beckford's famous collections.[42] Richard Temple-Nugent-Brydges-Chandos-Grenville succeeded as 2nd Marquess of Buckingham in 1813; he was created 1st Duke of Buckingham and Chandos in 1822, which was also the date of the first great sale at Fonthill Abbey, when he must have acquired the chairs. Therefore, the 1st Marquess, the builder of the Gothic Library at Stowe, may have had little more than the suite of three black and white tables by Soane plus the pair of antique ebony chairs as furnishings in the Gothic Library. These chairs may or may not have come from Esher. The 2nd Marquess added a considerable amount of ebony furniture to the library, including a pair of the Esher chairs owned by

Beckford and admired by Walpole. Such a distinguished lineage of ownership and association authenticated the Stowe ebony chairs as Tudor, even though they were actually of Asian origin and seventeenth-century date.

By the sale of 1848 the Gothic Library was overflowing with ebony furniture, some twenty-one pieces in all. Lots 2500–02 were three pair of ebony chairs with low armrests, foliate carving and caned seats. Lot 2503 was the pair of chairs from Esher, via Beckford. Another two pair of ebony chairs with higher backs, lots 2504 and 2505, were said to have 'formerly belonged to Sir P. P. Rubens, and to have been brought from his house at Antwerp', although in fact they came from a Dutch collection and had nothing to do with Rubens.[43] Again, it was the association with a historical figure that was considered to be important in authenticating the antiquity of these chairs. There was a spirally carved ebony armchair with ivory, a pair of 'easy chairs' in black wood and ivory, and two black wood gothic tables with breccia tops in addition to the three black and white tables designed by Soane.

With the dispersal of these pieces in the sale of 1848, one would be tempted to think that the chapter of 'Tudor' ebony furniture at Stowe had now closed, but there was one further episode in this complex and interwoven story. The final Stowe house sale took place in 1921 on behalf of the Trustees of the late Duke of Buckingham and Chandos, and the catalogue gives detailed information about the house and its contents. The catalogue of 1921 tells us that:

> It is true there was an immense sale during the lifetime of the second Duke, when many of the rarest treasures of the house were offered for sale, but it is not generally known that the great bulk of the most valuable items have since found their way back to their old palatial home.[44]

In fact, a number of the most important furnishings in the house had been purchased by the family at the sale of 1848 and were reintroduced into the house. This included at least some of the ebony furniture used in the Gothic Library, for by 1921 the pair of chairs with the Esher provenance, associated with Cardinal Wolsey and purchased from the Fonthill sale, were back at Stowe.[45] The Esher provenance is mentioned again in the sale catalogue of 1921, indicating how important the 'story' of these chairs was in terms of establishing their antiquarian value and their authenticity.

Conclusion: authenticity by association

What conclusions about neo-medievalism and the search for authentic style can we draw when considering the story of the Gothic Library at Stowe? The complex layers of Saxon, gothic and Tudor designs demonstrate a fluid understanding of stylistic development up to c.1820. Understanding of authentic medieval styles shifted during the course of the Gothic Revival from an antiquarian appreciation of objects and places to a more layered appreciation of historical associations arising during the Romantic Movement. For well over a century at Stowe, from Saxon liberty in the garden designs of the 1720s and 30s, to the purchase and repurchase of 'authentic' Tudor furniture in the Gothic Library – which, itself, was variously called Saxon and Tudor, as well as gothic – it is apparent that the story underpinning these designs took precedence over any real understanding of or concern for their physical authenticity. Forster praises the vaulted ceiling of the Gothic Library, when in fact it was flat, and the sale catalogues of 1848 and 1921 pump up false provenances to Cardinal Wolsey and Peter Paul Rubens. Ultimately, the antiquarian interests of the 1st Marquess of Buckingham determined the design of the library, and the opinion of the connoisseur and man of letters, Horace Walpole, determined the appropriateness of furniture for this interior. During the period of Romanticism, authenticity was established by association with genuine historical events and personages; it was not until later in the nineteenth century that a more empirical and archaeological approach began to take hold.

10. 'Authentic' Identities: Cross-cultural portrayals in the Late Eighteenth Century

by Jos Hackforth-Jones

This chapter considers the rich layering involved in depicting the identities of non-European visitors to London in the eighteenth century. It focuses on the seemingly authentic identity constructed for Mai (also known as Omai), a Tahitian visitor to London in 1774. Different, seemingly 'authentic', identities were acted out by Mai to engage his society counterparts and to (wrongly) convince them of his exalted status. The visual impact of Mai's performance enabled him to assume an authentic persona of English gentlemanliness, which was immediately understood by contemporary London society and enhanced his celebrity, so that he was sought after by some of the major portrait painters of the day. With respect to portraits of Mai, we shall see that visual portrayals of him as a high-status Tahitian were reinforced by his seemingly authentic performance of gentlemanliness and nobility. Mai's fashioning of dual authentic identities, which was skilfully portrayed by artists such as Joshua Reynolds, continues to have enduring attraction.

In addition, this account will examine conventions surrounding the authentic portrayal of other high-status non-European visitors to London in the eighteenth century. Such portraits depict the sitters as 'authentically' high status by including European dress and ornaments while they were simultaneously shown as non-European via references to 'authentic' indigenous culture such as weaponry or tattooing. These issues surrounding authenticity and pictorial subject matter take us into complex and multilayered terrain.

Fashioning authentic English gentlemanliness

I found Omai ... my brother next to him & talking Otaheite as fast as possible ... He rose, and made a very fine Bow. & then seated himself again. But when ... told ... that I was not well, he again directly rose, &muttering something of the *Fire*, in a very polite *manner*, without *speech* insisted upon my taking his seat, – & he *would* not be refused.

When Mr Strange and Mr Hayes were introduced to him, he paid his Compliments with great politeness to them, which he has found a method of doing without *words*. [1]

Thus the diarist Fanny Burney describes her initial encounter with Mai, the first Tahitian visitor to London, in December 1774. [2] Her emphases are fascinating, hinging as they do on her approbation of Mai's gentlemanliness and politeness, and her appreciation of his ability to communicate these 'without words'. This is highly unusual given not only that Mai's spoken English was limited but also in the implication that gentlemanliness and politeness may not need words. During the eighteenth century politeness was constructed via the art of conversation. In fact, conversation was the supreme metaphor for politeness. [3] With this in mind, Mai's performance becomes even more impressive. Clearly he is not engaging in the art of conversation but outwardly conveying via expression, gesture and the body itself, all the outward forms of civility in order to persuade his audience of his authentic identity as a gentleman. As we shall see, both performances were intended to serve his own agenda.

Throughout his time in London, Mai seems consistently to have impressed those he met with his model gentlemanly behaviour. His capacity to do so goes to the core of his success in society drawing rooms. In many ways Fanny Burney's unquestioning response to this young man who had recently arrived from the other side of the world is astonishing, given that he had spent his life in a culture where the way of life, customs, manners and mores were on the whole remarkably different from those lived by his society counterparts in London.

The narrative of the circumstances which resulted in Mai's arrival on the London scene is fascinating: during Captain Cook's second voyage to the South Pacific (1772–5), Mai had persuaded one of Cook's officers, Captain Furneaux, to let him board *Adventure* and return with him to England. In his journal Cook had initially categorised him as 'dark, ugly and a downright blaggard', a view that he was to later to revise, and had refused to allow him to return on his ship. [4] Some commentators have also suggested that it was at this point that Mai also began to insist that he came from a more exalted rank of Tahitian society than, in fact, he did. [5]

After landing at Portsmouth, Mai reached London, ahead of Cook, on 14 July 1774. Immediately after his arrival in London, Captain Furneaux took Mai to meet Lord Sandwich, First Lord

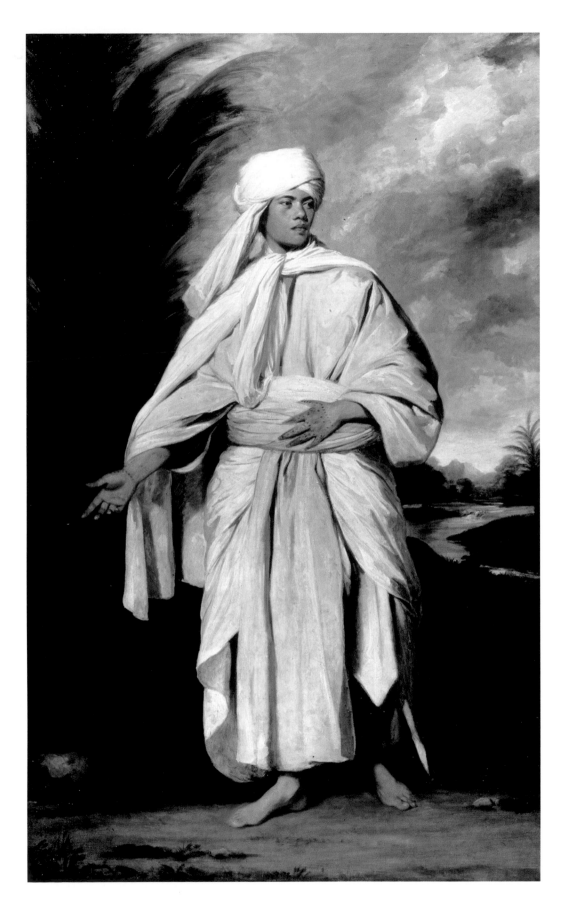

Fig. 1: Sir Joshua Reynolds, *Omai (Mai)*, 1775–6, oil on canvas, 2360 x 1455 mm (92 7/8 x 57 1/4 in). *Private Collection*

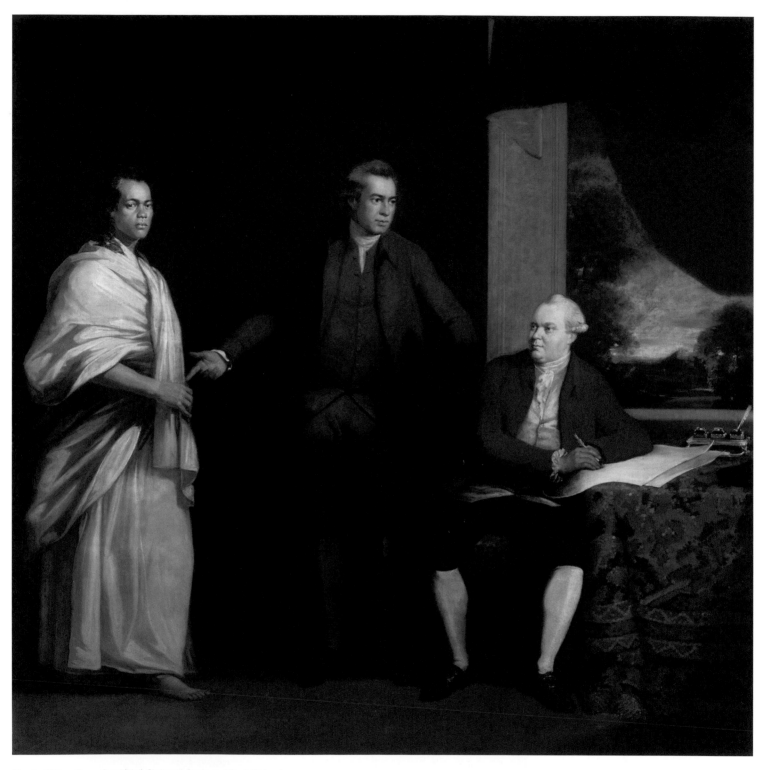

Fig. 2: William Parry, *Omai (Mai), Sir Joseph Banks and Daniel Solander*, 1775–6, oil on canvas, 1525 x 1525 mm (60 x 60 in).
National Portrait Gallery, London

of the Admiralty. The First Lord then summoned Sir Joseph Banks, president of the Royal Society, whom Mai had already encountered when Banks had accompanied Cook on his first voyage to the South Pacific in 1768. Banks also had a considerable collection of artefacts and specimens from the Pacific voyage. He took the Swedish naturalist Daniel Solander, who had also been on Cook's first voyage, to greet Mai.[6] Both Banks and Sandwich were wealthy, powerful and owned extensive estates. They were thus well positioned to become influential patrons of the young Tahitian. Banks introduced Mai to London society, established him in his London townhouse, paid his bills and presented him at court to the King and Queen only three days after his arrival. Significantly, Banks and Solander were also able to converse with Mai in Tahitian. The young visitor from the South Pacific quickly became a celebrity. Much of his celebrated status hinged on his ability to impress his new acquaintances with his sensibility and good manners and he appeared skilled in the art of performing the role of convincing gentlemanliness to a degree hitherto not encountered in non-Western visitors to the capital – all without words, as described in the above passage by Fanny Burney. In the same passage she continued:

> As he had been to Court, he was very fine. He had on a suit of Manchester velvet, Lined with white satten [sic], a *Bag*, lace Ruffles, ... He is tall & very well made ... He makes *remarkably* good Bows – not for *him*, but for *any body* [sic], however long under a Dancing Master's care.[7]

Clearly Mai here was not engaging in the art of conversation but was outwardly conveying all the forms of civility via gesture, expression and the body itself. His gentlemanliness was intrinsically connected with the visual rather than with conversation and the tongue. Since Mai came from a society that was highly performative, this experience would have stood him in good stead. Tahitian culture was also primarily visual and oral rather than literary so it was perhaps less surprising that he was quick to pick up and appropriate European visual codes. Furthermore, Mai would have felt some affinity with the stratification, codes and rituals of London society since there were parallels with the hierarchical and ritualised nature of Tahitian society and the emphasis on dance and movement as an integral part of a range of ceremonies.[8] As we shall see, Mai's visual impact in the performance of politeness also enabled him to assume an authentic identity with which his British counterparts could engage more easily and which secured him greater access into London 'society'. This, combined with his increasing celebrity, may also explain his attractiveness as a potential sitter for some of the leading portrait painters of the day. These included Joshua Reynolds, William Parry, Nathaniel Dance and William Hodges. This essay will focus on the two major portraits of Mai – by Joshua Reynolds in 1775 (fig. 1) and William Parry 1775–6 (fig. 2).

Burney goes on to suggest that in this first meeting, Mai was in some respects superior to English gentlemen, with 'an understanding far superior to the common race of *us cultivated gentry* [sic] ...'.[9] As she describes this sensibility and his exquisite manners, there is the sense here that Mai performs this role better than an Englishman. Certainly, Burney compares Mai advantageously to Philip Stanhope, Lord Chesterfield's natural son, and suggests that, unlike Mai, in spite of all that wealth and education could provide for Stanhope, he proved 'a meer [sic] pedantic Booby.'[10]

Fanny Burney's positive opinions were supported by a number of her contemporaries. James Boswell too, was impressed by the celebrated Tahitian visitor and quoted Samuel Johnson's reasoning that the 'elegance of his [that is, Mai's] behaviour'[11] was owing to the fact that 'he has passed his time, while in England, only in the best of company; so that all he had acquired of our manners was genteel'.[12] This was a persistent view at this time. Lord Chesterfield's letters had recently been published (in 1774). In them he had prioritised imitation and made the point that an individual could never be a gentleman unless he had been in the best of company, thereby giving him the opportunity to imitate the best of manners. Mai's agenda was to move in the first circles and to be accepted by polite society by fashioning himself as an authentic gentleman. His ultimate aim was to persuade George III to send him back to the South Pacific

with arms so that he could annihilate his enemies, the Bora-Borans.

Constructing an authentic Tahitian identity

Mai's apparent mastering of gentlemanly deportment and behaviour so soon after his arrival is fascinating, and it is likely that he had acquired many of these skills during the long voyage from Tahiti. E. H. McCormick has noted that Mai was originally entered on *Adventure*'s muster roll as able seaman Tetuby Homy.[13] William Hodges, who served under Cook as painter to the second voyage, made a portrait of Mai (fig. 3). This portrait was most probably completed in England. It is possible but unlikely that it was painted in the South Seas prior to Mai's arrival in England – mainly because as a Raiatean of the low to middling classes Mai would have been an unusual subject for Hodges. The posing of Mai close to the picture plane and the immediacy of the handling of paint suggests a more realistic portrayal than the other depictions of Mai and parallels Solander's description of him shortly after his arrival in London as 'very brown ... Not at all hansome [*sic*], but well made.[14] It is clear from contemporary accounts that the transformation of Mai's identity began during this long sea voyage. He soon made friends with the officers on board ship, including Fanny Burney's brother, James, and was able to spend time both participating in and observing European customs. Indeed, by the time that the ship docked at the Cape of Good Hope, he was in such favour with the captain that Furneaux 'dressed him in his own clothes, and introduced him in the best of companies'.[15] According to contemporaries it was at this point that he abandoned his lowly origins and assumed the role of an attendant upon the king as well as the name Mai. The voyage, then, was a rehearsal of the identity that he was to enact for the London performance.[16] Even his name was assumed. As one of Cook's officers put it after they had returned Mai to Tahiti in August 1777:

> poor Omai was of so little consequence here as not to be known, we found that Omai was an assum'd name, his real name being Parridero; Captain Cook asked him why he had taken the former name in preference to his own, he reply'd that ... he thought to pass for a great Man, by assuming ye name of a Chief...[17]

So here we find Mai assuming a second identity as a nobly born Tahitian (or more properly Raiatean, since Raiatea was the island near Tahiti from which he came). Furthermore, he engaged in the performance of manners in order to make this role appear authentic. In assuming the manners of the English upper classes he was also able to reinforce simultaneously his second identity as a noble Tahitian in order to make this seem convincing to his English audience.

There were a number of favourable circumstances which contributed to Mai's social success and to his emergence as a social 'lyon', in the words of Fanny Burney. The educated public were already familiar with Rousseau's notion of the superiority of 'natural' over 'civilised' man and more recently the two accounts of the Pacific by Bougainville and Hawkesworth respectively had made much of its sensuous delights and had taken the London reading public by storm.[18] The climate was ripe for Mai's reception (at the very least) as the embodiment of 'natural man'. His sensitivity to individual social situations and his capacity for mimicking the manners and behaviours of contemporaries, together with his considerable abilities as a performer, led to his participating in the London social round at the highest level.

Contemporary written accounts of Mai represent him as an 'authentic' gentleman – in fact the very model of genteel behaviour, at times (as is evident from Miss Burney's diary) even outperforming many of his English counterparts. In other words, the emphasis here is not on his otherness, his savagery, but on his innate nobility and his capacity to behave like an English gentleman.

We know, too, from other contemporary descriptions that he went about dressed in this role. His bills and visiting card also indicate that his powerful patrons were content for him to have all the necessary accoutrements, and he appears to have spent lavishly on clothes, hats, shoes, wine and servants, thus enabling

Fig. 3: William Hodges, *Omai (Mai)*, a Polynesian, 1775–7, oil on canvas, framed 850 x 700 mm (33 ¼ x 27 ½ in). *Hunterian Museum at the Royal College of Surgeons*

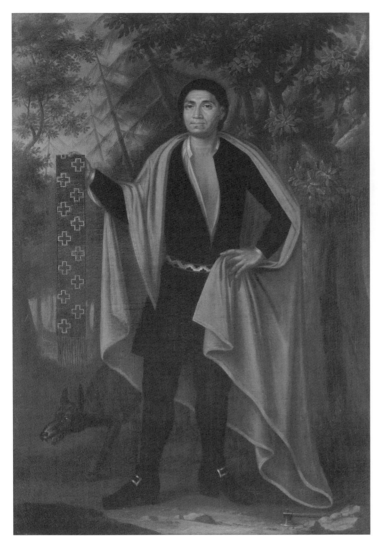

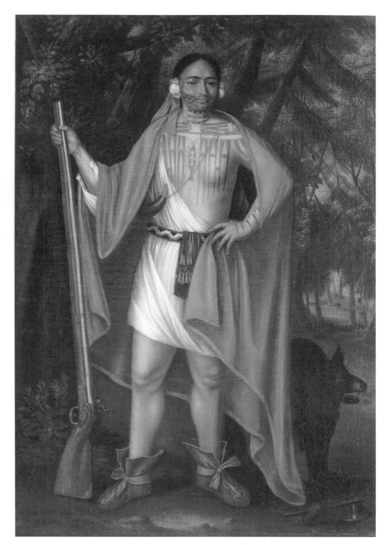

Fig. 4: Jan Verelst, *Tee Yee Neen Ho Ga Row, Emperor of the Six Nations*, 1710, oil on canvas, 915 x 648 mm (36 x 25 ½ in). *Library and Archives, Canada, acc.no. 1977-35-4, acquired with a special grant from the Canadian Government, 1977*

Fig. 5: Jan Verelst, *Sa Ga Yeath Qua Pieth Tow, King of the Maquas*, 1710, oil on canvas, 915 x 648 mm (36 x 25 ⅜ in). *Library and Archives, Canada, acc. no. 1977-35-2, acquired with a special grant from the Canadian Government, 1977*

him to pass himself off very successfully as a member of the upper classes because of his elegant dress and sensitive manners, and to transform his identity so that he was able to masquerade as a gentleman. [19]

Authentic representation: responses to other exotic high-status visitors in the eighteenth century

It is useful to compare responses to Mai with reactions to other celebrity visitors from far-off lands during the eighteenth century. A hybrid form of presentation was by far the commonest mode for the portrayal of visitors from former colonies, many of whom became celebrities, moved in the highest circles and were also presented at court. Typically the sitter was depicted with both the signs of his exoticism, such as tattooing, weaponry and possibly also some reference to his indigenous dress, in order to connote

otherness, plus a reference to his status which was generally signified by European dress and accoutrements. Genteel dress was generally worn only by visitors of exalted rank to reinforce their identity. A case in point is the portrayal of the so-called Four Indian Kings who visited London, in 1710 having left eastern New York State in order to forge an alliance with the English (figs 4, 5). Members of the Haudenosaunee or Iroquois tribe, they immediately became a sensation and were much written about and illustrated, both via crude wood engravings for dissemination as cheap broadsheets and also via other forms of engraving. On the occasion of their being presented to Queen Anne, portraits were made of each of the visitors. Interestingly, the most senior of the 'kings', Tee Yee Neen Ho Ga Row (nominated 'Emperor' by the English and known as Hendrick) was painted in largely European dress to mark his enhanced status and to affirm his identity. [20] This reminds us also of contemporary eighteenth-century English society's

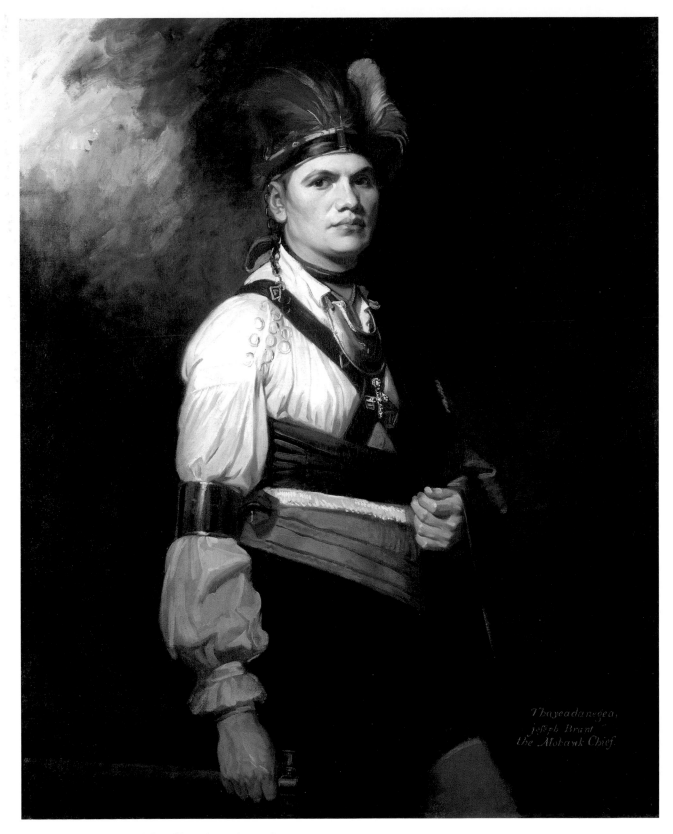

Fig. 6: George Romney, *Joseph Brant (Thayendanegea)*, 1776, oil on canvas, 1270 x 1016 mm (50 x 40 in). *National Gallery of Canada, Ottawa, transfer from the Canadian War Memorials, 1921*

Fig. 7: Gabriel Mathias, *William Ansah Sessarakoo son of John Bannishee Carrante Chinnee of Anamaboe*, 1749, oil on canvas, 666 x 558 mm (26 ¼ x 22 in).
The Menil Collection, Houston, USA

preoccupation with social standing. Hendrick is depicted by the artist Jan Verelst wearing frock coat, breeches, silk stockings and buckled shoes together with a red cloak trimmed with gold thread – a present from the Queen.[21] Hendrick's fellow delegates were portrayed wearing a hybrid form of clothing to emphasise their more in-between status, with obvious signs of their own culture – that is, bare-chested with tattoos, warrior ties and moccasin shoes.[22] In these instances, then, the authentic representation of many of these visitors from far-off lands was intrinsically connected with their perceived identity as both savage and other.

Authenticity and norms of portrayal for eighteenth–century high-status visitors to London

By the 1770s there was something of a tradition of high-status visitors from Britain's colonies visiting London – frequently as cultural or political emissaries. By then it is also possible to refer to norms for the portrayal of these visitors as typified by the portrayal of some of the Four Kings and the depiction of Joseph Brant, who was also known as Thayendanegea. He was apparently descended from one of the Mohawk men who had visited London in 1710.[23] Brant first came to London in 1775–6, at the time of the American Revolution, with a view to reaffirming alliances with the British. He visited again in 1785–6. He, too, went about in gentlemanly dress, was presented at court and did much to dislodge the perception of American Indians as uncivilised savages.[24] James Boswell remarked that when dressed in European clothes 'there did not seem to be any thing about him that marked pre-eminence ... His manners are gentle and quiet...'.[25] He reached the rank of captain in the British army, was adopted into a Masonic lodge, was presented to the King and counted a number of aristocrats among his patrons. Brant seems to have been adept at polite and gentlemanly behaviour in a manner which his European contemporaries, including certain patrons, found pleasing. The latter included the Earl of Warwick, the Earl of Moira and Hugh Percy, Duke of Northumberland. As was the custom, at their behest, he was painted by some of the leading portrait painters of the day, including George Romney in 1776 (fig. 6) and Gilbert Stuart in 1786. These portraits continue the convention of hybrid representation, referencing European conventions and accoutrements together with a reference to his indigenous heritage as a way of emphasising the authentic persona of the sitter. Both Romney and Stuart depict him wearing a feathered Mohawk headdress together with references to his English hosts. In the Romney portrait he is wearing a linen shirt and a Masonic cross with what is demonstrably European armour to emphasise his prowess as a warrior. Around his neck he wears a silver gorget or medallion, which was a present from George III. This hung from his neck, around which also hung a plaited string of the sweet hay, to which, apparently, Indians were partial.[26] In the case of the Gilbert Stuart portrait, Thayendanegea is wearing a red Indian cloak with narrow darker red stripes and a brown fur collar, which is also decorated with silver rings. As a gorget, he wears a large white shell which was an object of ritual significance to the Iroquois.[27] The Romney portrait, commissioned by the Earl of Warwick, is a striking and compelling represen-tation and had an added currency in an engraving by John Raphael Smith.[28] However, while Brant undoubtedly impressed his European counterparts he never achieved Mai's celebrity status. This may account for the discrepancy in different conventions adopted in the depiction of Mai, including evidence of his capacity to present himself as encompassing multiple identities.

Although less common than the hybrid mode of portrayal, another norm for the portrayal of high-status visitors during the eighteenth century was to paint the sitters in conventional English gentlemanly dress, wearing a frock coat, waistcoat, breeches, lace shirt and hose, plus buckled shoes. An example of such a convention was the representation of Sessarakoo, the African prince and son of a wealthy African slave trader who was captured by pirates while on the Grand Tour (fig. 7). After his ransom was paid, he eventually arrived in London in 1749. He apparently went about in genteel dress and was accepted as such because of his recognised princely status. In Gabriel Mathias' oil portrait of Sessarakoo of 1749 he is portrayed in court dress. In the eighteenth century, the high-status visitors' presentation at court was consistently the reason for the commissioning of portraits. In this instance, on the occasion of his presentation to King George

II, Sessarakoo was dressed in a magnificent red frock coat trimmed with silver thread.[29]

Visual portrayals of Mai: the fashioning of an authentic identity

When considering the most consistent mode for portraying Mai, we might expect him to be represented either in hybrid terms, as outlined above, or in gentlemanly dress, particularly given the written descriptions of him quoted earlier and the fact that Mai typically went about in genteel attire and presented himself inauthentically as a high-status visitor. In fact, as we have seen, as well as presenting himself as an English gentleman, he claimed to come from the *arii*, the highest or priestly class, when in fact he came from the *raatira*, the middling class.

Painted representations of Mai, however, beginning with that of Reynolds, consistently represent him neither in the specificities of eighteenth-century gentlemanly dress nor in a hybrid mode. Here, again, Mai's convincing performance of social identity is a significant factor in the decision of Reynolds, Parry and Dance to deviate from the norms of portrayal for high-status visitors (figs 1, 2, 9).

It was in the course of his performance of sociability, in which it is clear that he mixed with the upper strata of English society with both ease and polish, that Mai came to the attention of the circle of Joshua Reynolds. This group included Reynolds' close friends Samuel Johnson and Mrs Thrale. Reynolds made at least one study of Mai as well as his famed portrait, which was painted c.1775. Exactly when this work was painted is unclear because Reynolds' pocket books for 1774–6 have been lost, but the sittings probably took place late in 1775.[30] In a departure from his usual practice, Reynolds made a preliminary sketch for the painting. In 1762 Reynolds had painted a portrait of the leader of the Cherokee delegation, Scyacust Ukah, who was in London as part of a diplomatic mission to cement relations between the English and the Cherokees[31] (fig. 8). This painting conformed to the conventions of hybrid portrayal as a way of indicating a certain authenticity for these high-status visitors. Scyacust Ukah is shown wearing both American Indian and English garments and ornaments.[32] Around his neck he wears a silver gorget and the peace medallion awarded him by the British as a result of their recent treaty. He also holds up a pipe tomahawk.[33]

Early in his career Reynolds had begun to paint 'uncommissioned portraits of his own volition' which (according to the standard practice at the time), he kept for display in his own gallery.[34] More unusually, Reynolds went one step further to paint those who, for one reason or another, were in the news and had therefore attained the status of celebrities. According to Stella Tillyard, Mai was painted at the height of the celebrity cult and is enduring as an image today, frequently being referred to as Reynolds' most famous painting.[35] Reynolds was probably also aware of the potential market for engravings of this portrait. After the painting's completion, it was copied by James Northcote, one of his assistants, and in 1777 it was engraved by Johann Jacobé, a visiting nobleman who was also known as John Jacobi. After Mai's return to the South Pacific the print became popular since it provided a focal point for the debate around the noble savage.[36] It also served to further advertise the painting. When Reynolds exhibited this painting at the Royal Academy in 1776, it was hung with another celebrity portrait of equally imposing dimensions, that of Georgiana, Duchess of Devonshire. The painting of Mai, therefore, was one of those which he painted for his own pleasure and to enhance the public profile of both artist and sitter. The style and dimensions of this work together with its location at the Royal Academy exhibition, hanging alongside a portrait of an aristocratic celebrity, remind us of the status Mai had achieved by this time. Added to this was his perceived 'double' identity as both an English gentleman and a noble South Pacific representative.

Reynolds chose here not to portray his subject in modern dress but rather to dignify it with reference to the antique. In his discourses Reynolds had noted that if a painter 'wishes to dignify his subject, which we will suppose to be a lady, [he] will not paint her in modern dress, the familiarity of which alone is sufficient to destroy all dignity'.[37] Rather, Reynolds portrayed Mai as part of a discourse between civilisation and nature, with his pose recalling that of the artist's portrait of his friend Admiral Keppel,

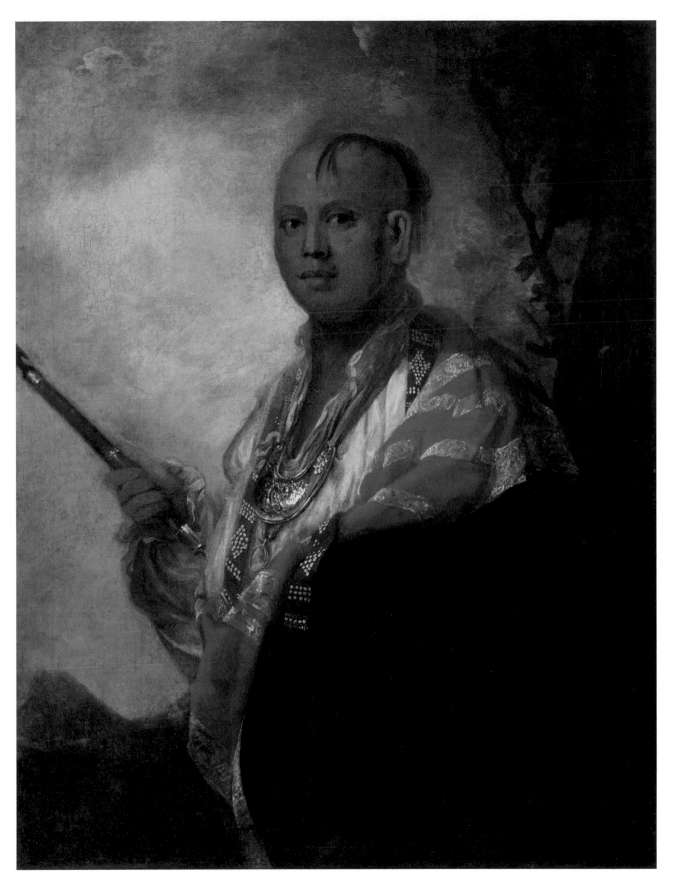

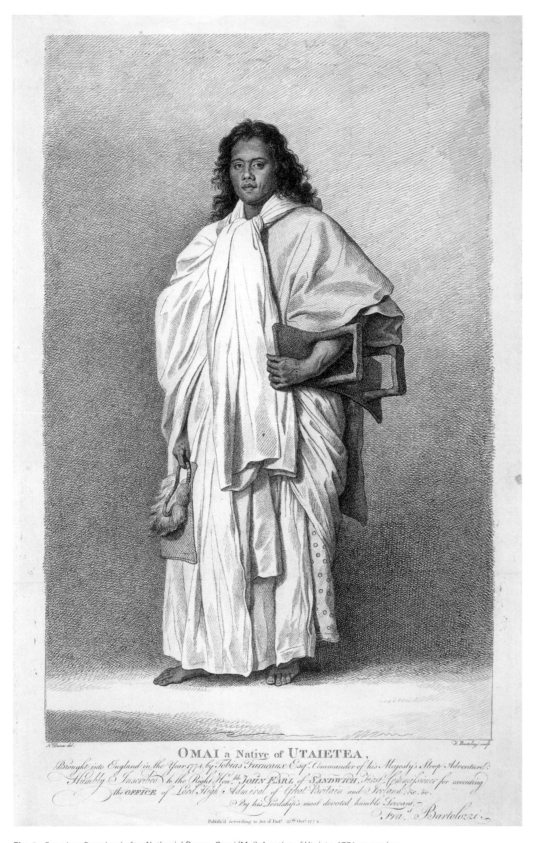

Fig. 9: Francisco Bartolozzi after Nathaniel Dance, *Omai (Mai), A native of Utaieta*, 1774, engraving, 461 x 291 mm (18 1/8 x 11 1/2 in). *The British Museum*

a portrait which in turn was based on the figure of Apollo Belvedere. Both references would not have been lost on the educated elite. The classical reference gave the portrait something of the 'general air of the antique for the sake of dignity',[38] thereby ennobling Mai by 'using the vocabulary of Western art'.[39] This ennobling of Mai by Reynolds was influenced by Mai's convincing performance of social ease and gentility and speaks to the prevailing perceptions of his authentic identity. It also hints at a common observation among educated visitors to the South Pacific such as Banks, Solander and Hawkesworth. They viewed the Tahitians as having many similarities in customs to those of the ancient Greeks.[40]

The face and the upper part of Mai's body are fluently painted, suggesting that Reynolds had painted these himself, leaving the lower part of the body and drapery (both of which are less proficiently painted) to one of his assistants. The tattooing clearly visible on Mai's left hand and on the inside of his wrist is a reminder of his Tahitian origins and firmly grounded the portrait in the specificity of 'likeness'. Reynolds had also recommended preserving 'something of the modern for the sake of likeness'.[41]

Furthermore, he is dressed as an 'authentic' Pacific islander (or so it might have seemed to Reynolds' audience) in flowing robes. This was done to reflect not only the classical model which Reynolds was indicating, but more particularly it may have been a reference to the white robes of the *arii* or highest priestly class of Tahitians to which Mai claimed to belong. As already suggested, he had represented himself as coming from this class when in fact he came from the middling classes, or *raatira*. The sash and turban in the Reynolds portrait of Mai have been identified by Pacific historians as having the drape and thickness of *tapa*, or bark cloth.[42] We could speculate that this material could have been provided by Mai or it may have come from Banks' extensive collection of Pacific artefacts with a view to reinforcing Mai's 'aristocratic' Tahitian identity. So what we have here is a representation of simultaneous identities.

It is interesting that Reynolds departed from the norms of representation for high-status visitors, which (as has already been argued) by the 1770s tended to portray such visitors either in hybrid mode or in gentlemanly dress. This may be connected not only to Mai's celebrity status but also to his ability to convince his English counterparts of his gentility and of his 'authentic' origin as a high-status member of his own society. The latter was also reinforced in the portrait by the deployment of *tapa* cloth. He was thus able not only to imitate English gentlemanliness but also to mime a position in his own culture that he did not in fact occupy, thus effectively blurring the boundaries between English and Tahitian 'aristocrats' (or the highest strata of society in both cultures). He therefore assumes an identity which is perceived as authentic but which is, in fact, inauthentic.

By representing him as a paradigmatic example of the noble savage Reynolds is able to powerfully fuse both identities. In reality Mai had successfully performed a double bluff, which Reynolds validated in his portrait.

This painting provided the template for subsequent representations of Mai, most notably the portrait by William Parry of *Omai, Sir Joseph Banks and Daniel Solander* (1775–6).[43] Parry had returned from Italy in late 1775 and this portrait was probably painted from life in December 1775 or early in 1776, perhaps using Reynolds' studio (which would have been Parry's privilege as a former student of Reynolds'). This is the only painting which depicts Mai together with two of the key players in South Seas scientific exploration, with Sir Joseph Banks in the centre seemingly pointing out the tattoos on Mai's right hand and Daniel Solander seated at a table in the right foreground. Mai is shown in an attitude possibly derived from the Reynolds portrait and wearing the same thick white robes minus the turban.[44] His pose references the noble savage convention adopted by Reynolds but without the layered subtleties of Reynolds' pose described earlier. In this painting Parry portrays Mai as a noble savage in the company of his patron, Banks, and his companion, Solander. The painting vividly suggests the notion of these non-European visitors caught 'between worlds' and hints at relationships forged across cultural boundaries.

Finally, in 1774 the painter Nathaniel Dance made a drawing of Mai carrying a feather whisk and headrest and wearing long flowing robes, very much in noble savage mode.

This was engraved by Francesco Bartolozzi later that year in October 1774[45] (fig. 9).

Epilogue: Mai, provenance and the market for authenticity

Joshua Reynolds' portrait of Mai remained in his studio after his death in 1792 and was sold by his heirs at the first posthumous sale at Greenwoods on 16 April 1796. It was bought by the 5th Earl of Carlisle, who had been a friend and patron of Reynolds.[46] The painting remained at Castle Howard from August of that year until sold by the family at Sotheby's on 29 November 2001, where it reached £10.3 million, the second highest figure for a British painting at that time.[47] The painting was purchased by an art dealer and then sold on to a Swiss company.[48] According to *The Art Newspaper*, the current owner is the family of the Dublin collector John Magnier.[49] In 2003, after the deferral of a UK export licence, Tate found an anonymous donor who offered £13.5 million so that the gallery could buy the work at the recommended price. The owner refused to sell and the painting remained in store in the UK until a temporary export licence was granted on condition that the work was exhibited in a national museum. The painting was on display from 2006 in the National Gallery of Ireland and was returned to its owner in April 2011.

It is tempting to question whether the subject and mode of portrayal, together with the perception that Reynolds was portraying the essence of Mai's authenticity – that is, as the most noble of noble savages at a time when the cult of the noble savage was at its peak – have been an integral part of the popularity of this painting and subsequently its attractiveness for the art market. One could argue that the fusion of the two authenticities has long been part of the fascination of this portrait. Presumably this was one of the reasons for Reynolds choosing to paint this subject and to paint it on such a grand scale. It is also without doubt one of Reynolds' most accomplished works and this may be because the unusual subject matter forced him to think beyond his usual stock-in-trade conventions.

Stella Tillyard has suggested that part of the continuing and current fascination of Reynolds' portrayal of Mai is that it is an image of celebrity which has particular resonance for our own culture of celebrity today.[50] It is, she argues, Reynolds' most famous painting 'precisely because it was more than a portrait and continues to be a picture in which we see some of our own longing and desire for grandeur, for simplicity, for otherworldliness and natural beauty'.[51]

The provenance of a painting is of course part of the determination of its market value, but as noted with the Reynolds portrait and, indeed, as was often the case with the portrayal of high-status visitors (such as Romney's portrait of Joseph Brant) the portrait of Mai was also one of William Parry's finest works – once again because the artist could not simply reiterate stock conventions. Since he was a student of Reynolds it is not surprising that Parry's approach recalls that of the more senior and better-known artist – that is, to present Mai in noble savage mode rather than via a hybrid or gentlemanly mode of portrayal. The early provenance of this painting is a little murky. It is not clear whether Banks commissioned the portrait or whether his uncle Robert Banks-Hodgkinson may have had a hand in the commissioning of the painting and there appear to be links between him and the later owners, the Vaughans.[52] The painting was in the collection of Sir Robert Williams Vaughan, Bt by 1838.[53] It then passed by descent to Brigadier Charles Henry Vaughan and was sold at Christie's on 2 April 1965.[54] It was subsequently in a private collection at Parham Park, West Sussex until acquired by the dealer Nevill Keating and put on the market for £1.8 million. The painting was eventually jointly purchased by the National Portrait Gallery, London, the National Museum of Wales and the Captain Cook Memorial Museum for £950,000 in 2004. Once again there were export restrictions. Notes in the National Portrait Gallery archive suggest that in view of Mai's celebrity status, Parry may have painted it with the aim of having it engraved. Nothing is known of its whereabouts until the nineteenth century.[55]

These portrayals of Mai contrast with those of other high-status non-Western visitors to London in the eighteenth century who were also described as comporting themselves in a gentlemanly manner and, like Mai, engaged in a performance of gentility. They, however, are more typically shown in contemporary hybridised dress which was employed to emphasise

their role both as cultural emissaries engaged in a performance of sociability and to demonstrate that they were authentic 'natives'. Because of his capacity to persuade his English contemporaries of his dual authenticities (and thus effectively to perform a double bluff), Mai was unusually depicted by Reynolds and Parry as having two simultaneous 'authentic' identities, both of which he was able to successfully perform as part of his own agenda to win over English society and to secure support and arms for his return to Tahiti and intended obliteration of his enemies. These dual authentic identities have undoubtedly had an impact on the enduring popularity and market attractiveness of this celebrity portrait.

11. Passing the Buck: Perception, Reality, and Authenticity in Late Nineteenth-century American Painting

by Jonathan Clancy

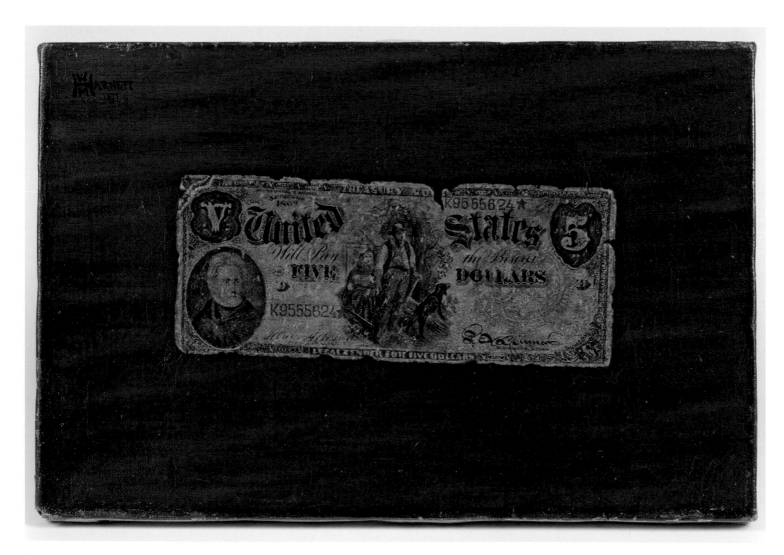

Fig. 1: William Michael Harnett, *Still Life – Five-Dollar Bill*, oil on canvas, 1877, 20.3 x 30.8 cm (8 x 12 1/8 in). *Philadelphia Museum of Art, The Alex Simpson, Jr Collection, 1943*

In the late nineteenth century, a small group of American painters began depicting money: bills, stamps, and coins placed illusionistically against a background. William Michael Harnett, a Philadelphia artist who trained in Munich, is credited with initiating this interest, following the exhibition of his *Five Dollar Bill* in 1877 (fig. 1). The group of painters who emerged in Harnett's wake embraced visual strategies that encouraged audiences to test the limits of perception. By minimising the visible brushstrokes, depicting objects at life-size, and building up the structure of the underpainting to create a physical presence for the objects, these artists depicted fictive spaces indistinguishable from real ones, and blurred the lines between representation and reality, between what is real and what is merely illusion. The notions of authenticity I intend to explore in this essay are both actual and metaphorical. On the most basic, visual level, these images are diversions; they demonstrate the artist's skills by momentarily fooling the viewer's perception and confusing object and illusion. On a metaphorical level, however, these images starkly illustrate one of the nineteenth century's most vexing intellectual issues: is reality a fixed truth or merely something perceived? If no truth is fixed and assured, what relevance can the notion of authenticity hold?

Scholarship on these paintings has linked these images to concerns about paper money, the availability of counterfeiting in the post-Civil War period, and the general increase of wealth throughout the last quarter of the nineteenth century.[1] Without divesting the images of these associations, this essay explores the manner in which these paintings reflected broader concerns about the nature of authenticity, value, and certainty that were emerging in this period. My interest lies not in proving what the artists 'meant', rather I want to anchor these images within the broader concerns of the period: the malleability of perceptions and the anxiety of an era in which concepts like authenticity and value were upended.

In order to unpack these meanings, I treat these paintings as anthropological evidence (as opposed to fine art objects), an approach pioneered by anthropologist Clifford Geertz in his seminal essay 'Art as a Cultural System'. Steeped in the discipline of semiotics, which posits that any text – visual, written, or spoken – is constructed of a system of signs that transcends mere representation and can be read in concert with the cultural ideas that helped shape it, Geertz's essay reminds readers that the intentions of the artist are a secondary concern when exploring the broader constructions of meaning within artworks. For Geertz:

> The signs or sign elements – Matisse's yellow, the Yoruba's slash – that make up a semiotic system ... are ideationally connected to the society in which they are found ... [N]ot illustrations of conceptions already in force, but conceptions themselves that seek – or for which people seek – a meaningful place in a repertoire of other documents...[2]

Rather than explaining paintings via texts, Geertz argues that they are texts. In a similar manner, I am interested in how these objects – metaphorically, consciously, and otherwise – house truths and fictions, reveal and deceive.

For many Americans the nineteenth century was a paradox in which increased positivism and scientific certainty was accompanied by self-doubt and uncertainty. As traditional systems of labour and markers of wealth changed, as economic and physical mobility became intrinsic to modernity, a dissenting murmur arose beneath the voices championing the march of prosperity. Karl Marx expressed this visually, his observation that 'All that is solid melts into air, all that is holy is profaned' reminds us of the illusory nature of knowledge, the growing sense that fixity was no longer assured.[3] In the United States, Ralph Waldo Emerson found 'a Noble doubt' and remarked upon his 'utter impotence to test the authenticity of the report of [his] senses.'[4] Essayist Henry David Thoreau echoed this in his need for a 'Realometer, that future ages might know how deep a freshet of shams and appearances had gathered from time to time.'[5]

The realisation that the world was a system of relative signs and symbols, to which value was assigned, lay at the heart of this anxiety. Rather than an objective reality, the nineteenth century – as the philosopher William James later noted – presented a subjective reality defined not by factuality but through 'pure experience'.[6] James would not formalise these ideas until the twentieth century, but by 1867 the American philosopher Charles

Sanders Peirce began investigating the elusive nature of meaning.[7] Peirce's *semiosis* uncoupled form from meaning, by stating that meaning was not inherent in an object, but created by the audience. The idea of a world defined not by static truths, but subject to the constant flux of interpretation departed radically from the bulk of human experience. It created an environment in which ideas of certainty, authenticity, and knowledge were no longer fixed quantities and where doubt, malleability, and uncertainty became the norm.

The American tradition of deception

Although practiced since the Colonial Era, *trompe l'oeil* remained more of an amusement than a serious artistic endeavour in the eighteenth century.[8] Even throughout the first half of the nineteenth century, when artists sporadically painted and exhibited deceptions, there was little market for these images, and the practice was considered among the lowest of artistic ranks. Curiously, however, money did not emerge as a theme for deceptions until the 1870s, despite all the necessary ingredients being present far earlier. To frame these paintings as a reaction to monetary policy ignores the long and often acrimonious relationship Americans had with paper currency since the birth of the nation. As early as the 1840s political pamphlets gathered quotes from venerable statesmen like George Washington, Henry Clay, and Daniel Webster condemning paper currency. In one, readers were informed of George Washington's stance in 1787: 'The wisdom of man, in my humble opinion, cannot devise a plan by which the credit of paper issues would be long supported.' This same sheet brought together a diverse group of other figures, including President Andrew Jackson, statesman Daniel Webster, and others who opposed the paper money system.[9]

In fact, it was only as Americans confronted the illusory nature of truth and knowledge that money paintings proliferated. If the currency debate following the Civil War was necessary to bring about this imagery, it alone was not sufficient. Instead, it was the combination of monetary issues and a new intellectual culture that stressed the illusory nature of truth that enabled money to become a potent and multivalent symbol. The simmering sense of distrust and confusion inherent in American culture around this period is aptly signalled by Herman Melville's 1857 novel *The Confidence Man: His Masquerade*. Composed of a series of vignettes, loosely grouped around a riverboat journey, and set on April Fools' Day, Melville employs the trope of money throughout this work to explore notions of confidence and the limits of knowledge. Scene by scene, passengers inhabit environments in which all knowledge is relative, no truths are fixed, and confidence is nearly impossible to muster. As the gruff, wooden-legged man reminds his companions in one scene: 'Looks are one thing, facts another.'[10] It is within the blurred line between the real and the represented that these images of currency function most effectively.

Strategies of representation

Artists' various depictions of money suggest different roles for knowledge and authenticity in the readings of these images. In what is likely William Harnett's earliest attempt at painting money, *Five Dollar Bill*, there is little to complicate meaning. Harnett depicted a well-worn five-dollar note pasted on a background of richly grained wood. His placement focuses the viewer's attention first on the bill – the primary layer of deception – and then on the convincing illusion of wood. The viewer receives no context for the scene – no indication of where this would occur, or why – and is left without additional elements to aid or confuse the act of viewing.

Despite the composition's simplicity, the painting defies easy explanation. One might find it to be an obvious self-promotion of talent to potential customers, but the *trompe l'oeil* imagery is complicated because it elicits a distinct three-part behavior from the viewer. First, one must believe (even if fleetingly) that the image is real. Second, there must be a moment of revelation, typically in which the viewer must disengage from the illusion, come to one's senses and realise the illusion. Third, the viewer must navigate the tension that exists in the thin line that separates the real from the represented, which ultimately leads to a heightened awareness of the artist's ability. As one reviewer noted, 'the observer can hardly convince himself that the actual articles do not lie in front of him ... so many visitors to the gallery have found

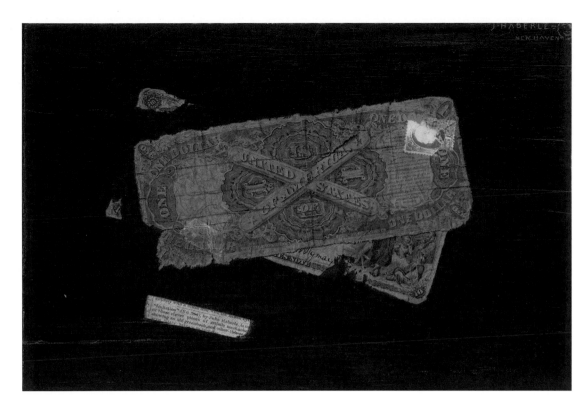

Fig. 2: John Haberle, *U.S.A.*, oil on canvas, c.1889, 21.6 x 30.5 cm (8 1/2 x 12 in).
Indianapolis Museum of Art, gift of Paul and Ruth Buchanan

it impossible to convince themselves that it is actually painted.'[11] *Trompe l'oeil* must not only cause viewers to acknowledge the artist's talent, but it must also cause viewers to mistrust their senses. It must uncouple what is observed (the seemingly actual) from what is known (the presentation of illusion).

By the early 1880s, these behaviors were already part of the narrative used to construct Harnett's reputation.[12] An 1883 article titled 'Memento of an Artist' recalled an exchange between a Special Officer Taggert, of the Pennsylvania Railroad Company, and an unidentified reporter in which Taggert quizzes the reporter about a painting by Harnett.[13] The characters' individual identities are less important than the 'types' necessary for the story to function effectively. Taggert, as a special agent for the railroad functions as an authority figure, invested with a sense of propriety and inherently bound to defend what is right or good. The reporter, who Taggert asks to opine upon the painting, functions not only as a surrogate for the audience – the key action here is looking – but also as one who reports and uncovers truth. The reporter becomes the perfect stand-in for the audience, since scrutiny, detection, and a heightened ability to see past untruths is inherent in this type.

In keeping with the ritual of viewing, the first suggestions given by the reporter confuse the painted representation with reality. His guesses – 'the best counterfeit ever made', 'the marked bill that gave a thief away', and 'the bill found on the person of the murderer' – show how viewers would identify external signals, such as the framing and display of a bill, to construct narratives for imagery. In this story, the moment of revelation happens quite literally when the viewer disengages from the image, which in this case is signalled by Taggert (operating as an external force)

revealing the deception to the viewer: 'it isn't what you think it is – isn't a bill at all. It's a painting.' The last piece is the navigation of the tensions – that thin line between the authentic and depicted – that the viewer must embark upon. In the article, the reporter takes a closer look, for despite his knowledge of the illusion he cannot fully reconcile it with his desire to accept it as authentic. The viewer finds that 'the torn edges of the bill seemed to stand out from the wood ... the head of the hero of New Orleans was as perfect as a photograph, and fictitious traces of paste along the edges completed the illusion.'[14] In addition to explicating the type of ritual associated with viewing *trompe l'oeil*, the article is an early indication of the anxiety caused by this type of image making and the pervasive fear of counterfeiting. These fears came to a head in 1886 when a number of Harnett's paintings were seized by the Treasury.

Claims of authenticity

Trompe l'oeil painting takes as its departure the ability to confuse the senses and create momentary chaos out of order. It challenges the value of sensory investigation and starkly portrays a world in which signs and symbols are indistinguishable from the objects they represent, and in which authenticity is virtually impossible to verify. It must simultaneously fool viewers while reminding them they are being fooled.[15]

Of all the money painters, no one challenged audiences' notions of authenticity more than John Haberle (1856–1933). Like Harnett, Haberle's early life included employment as an engraver, which helps explain his ability to so closely mimic printed forms.

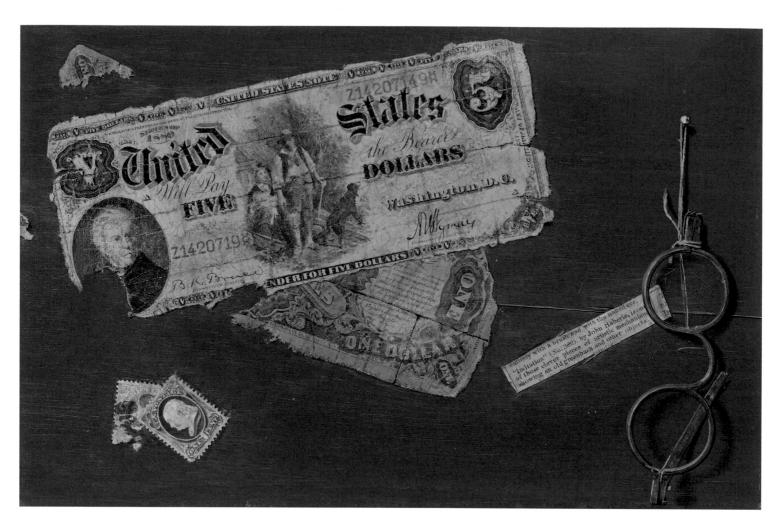

Born in New Haven, Connecticut in 1856, Haberle spent most of his professional career in Connecticut. Whereas Harnett enjoyed an artistic education in Philadelphia, and later abroad in Europe, Haberle was essentially self taught. Although he studied briefly in 1884 at the National Academy of Design in New York, he was already an exceptional draftsman, exploring the veristic style of representation that would define his *trompe l'oeil* works. In 1887, his first known painting of money, *Imitation* (1887), brought him considerable notice at the National Academy of Design Exhibition.

While *Imitation* brought Haberle early recognition, it was the controversy surrounding *U.S.A.* (*c.*1889) that best illustrates the difficulty posed by his paintings (fig. 2). Exhibited at the Art Institute of Chicago in June and July of 1889, the mimetic accuracy of Haberle's rendering caused the art critic in *Chicago Inter-Ocean* to claim that the picture was a 'fraud', an 'alleged still life' in which: 'A $1 bill and the fragment of a $10 note has been pasted on canvas covered by a thick thick scumble of paint and further manipulated to give it a painty appearance.' He even claimed he had picked off a corner of the bill.[16] Although it required subjecting *U.S.A.* to a variety of tests and experts, the image was soon exonerated and the critic printed a retraction. Significantly, once the painting was determined to be an authentic

artistic production – rather than a clever collage of authentic bills, stamps, and newspaper – the debate about the image shifted from 'is it real?' to 'is it really art?'

This aspect of the debate about Haberle's work – which applied equally to that of other money painters – suggests that lingering doubts remained as to what 'art' should mean. In a culture where reproduction through photography and printmaking was rapidly on the increase, these types of images became nodes around which issues like authenticity could be gathered. Although obviously problematic, since by their nature artworks are artifice, the debate persisted. The question was whether *trompe l'oeil* painting was a mechanical skill, or art. For some, the answer was clear: 'any amount of success in this sort of reproduction would not entitle him to be called an artist, or his imitations to be shown in any collections of works of art'.[17] Haberle's repeated use of the *Imitation* clipping – which pronounced the painting 'a clever piece of artistic mechanism' – suggests his awareness, perhaps even willingness, to engage in this broader debate.[18]

Even more so than his contemporaries, Haberle seemed to enjoy straddling the thin line between the depicted and the authentic, and challenged viewers to test the limits of their perception. It is an almost playful sense then that pervades

Fig. 3: John Haberle, *Can You Break a Five?*, oil on canvas mounted to panel, 1888, 7 3/8 x 11 1/4 in.
Amon Carter Museum of American Art, Fort Worth Texas, 1985.1

images such as *Can You Break a Five?*, which includes some of the artist's densest imagery and multilayered punning (fig. 3). On the simplest level, the title refers to the expression for making change, and also alerts the audience to one of the methods through which counterfeiting succeeds, where a fraudulent bill is passed not only for goods, but for change that is authentic. The inclusion of the spectacles, along with the newspaper clipping identifying the artist, also calls for a deeper investigation into the way in which this image is fundamentally about representation, illusion, and close inspection. Although it has been argued that, unlike traditional modes of representation, *trompe l'oeil* arrests the viewer and brings them to an external logic (rather than stepping into the image), I am not certain the same applies here, or even generally to Haberle. Indeed, by connecting the viewer directly to the object with the use of microscopic detailing, his works almost demand a total immersion in which the very notion of externality seems to dissipate to create an authentic world of their own designs.

Haberle's inclusion of the spectacles is a hint and distraction. While they signal the importance of distinguishing between looking and seeing, for this work especially, their position prevents anything useful from coming of them. The first allusion to this is the broken lens that foreshadows their compromised utility, an aspect heightened by the snippet of non-essential text they magnify. Still, Haberle's rendering of minute text commands the viewer to investigate further and this response informs the deeper layer of punning in the choice of title, where Haberle uses the term 'break' in a less obvious sense – to invalidate as false. Implicit here is a challenge, a question about truth and the limits of representation. By signing the image with a review – one that reduced his art to 'cleverness' and mechanical skill – Haberle raises the stakes further. The spectacles' presence suggests a closer scrutiny is necessary to discern the line between what is authentic, and what is merely a fiction of the artist's hand.

By all accounts, Haberle's image succeeds. Within the confines of his canvas, his illusion is virtually impossible to ruin – the texture and tone of the bills, the stamps, and the newspaper clipping all assert their authenticity. Even the ancillary objects, the glasses, the twine they hang from, and the head of the nail used to secure this to the fictive board background remain impossible to distinguish from 'real' things. In some sense too, Haberle's image exposes that not only does his practice hold up within the expanse of the canvas, but also without, as the constant worry about painters and counterfeiting suggests. In reality, the very notion that these skills are interchangeable is preposterous, but the fear of it demonstrates the slippery line between the audiences' abilities to discern the genuine and authentic from the fictive.

In essence, once we can step back – *if* we can step back – we should be certain that none of the bills in *Can You Break a Five?* or in any of the other images of money are counterfeit bills. They resemble counterfeit bills because they mimic the outward appearance of money, but unlike counterfeit money, there is no danger that someone could pay for something with a painted representation of money. These images succeed because they beckon us to examine the visual evidence without considering the objects themselves. In a sense, the audience becomes lost in a maze of attempting to discern representations, and in which the represented is almost inevitably confused for the real, which was precisely the danger that seemed avoidable by a close inspection of the image in the first place.

If this inquiry answers many questions that the painting raises, it is also worth noting that it fails to address the one put forth by the artist: *Can you break a five?* It is a question that seems so familiar, and so simple, that it hardly requires qualification. And yet, it does require explanation because the answer is in a sense both yes and no. Yes, because since the painting's creation countless people have marvelled at the illusion and commented upon the image's capacity to confuse; but no, because regardless of how good Haberle's depiction is, it is clear (though not obvious, since the point has not been previously made) that the bill is no good: the bright red serial numbers do not match one another, and the forgery is exposed.

Displays of wealth

At their most basic level, these paintings punned upon the idea of a 'display of wealth', a notion met with increasing frequency and discomfort throughout the era. While the basis for these attitudes likely emerged in the Colonial Period, by the mid-nineteenth

Fig. 4: Victor Dubreuil, detail, *A Prediction of 1900, or
A Warning for Capitalists*, oil on canvas, c.1893, 24 x 32 in.
Present Location Unknown, image: Kennedy Galleries

century they appeared in both religious and secular texts. In a story published in the *Methodist Review* entitled 'Happiness in a Cottage, or Religion Superior to the World', one character remarks: 'We see every day people who have risen from obscurity by success in trade, striving to hide their inferior origin and give themselves consequence by an ostentatious display of wealth, and by an excess of splendor and decoration.'[19] In response, his companion stresses the notion that wealth is not the same as taste, and that the latter is perhaps the rarer these days. Similar complaints emerged from more secular journals too. Readers of *Putnam's Magazine* were informed that:

> The national taste, manners, and morals, reflect in a thousand ways the prevailing love of money. The superficial and showy are preferred to the substantial and good ... Society is thus composed solely of the rich, or would-be rich, and made the occasion, by ostentation or pretence, for the mere vulgar display of wealth or its symbols.[20]

Culturally, if the period was marked by competing forces – the desire for wealth and the moral disapprobation associated with it – the newfound ease with which wealth circulated in society bound these dissonant positions. Money was a complex symbol in a democratic society; it defied easy classification because of its seductive allure and potential to wreak havoc. The distinction between the 'showy' and the 'substantial' reminds us that this debate is not simply about prosperity. It is about the danger in confusing appearance with truth, a danger that exists in a reality of fixed, objective categories of things, in which subjective truths – like Peirce's reliance on interpretation – posed no threat to the existing order.

Money not only shifted the social landscape of society, it destabilised traditional beliefs and complicated ideas about self and society. By 1880, audiences were sufficiently aware of the debate to warrant its casual inclusion in Henry James' *The Portrait of a Lady*. The character Madame Merle, talking to her friend Isabel about the value commodities have when navigating relationships and the social sphere of life, states: 'There is no such thing as an isolated man or woman, we are each of us made up of a cluster of appearances.'[21] Yet, Isabel is appalled by this notion, for hers is a world of fixed truths. Whereas Merle represents a fluid society in which the importance of objective authenticity is diminishing, Isabel represents the attendant anxiety that this transition evinces: 'Nothing that belongs to me is any measure of me,' she responds, 'on the contrary, it's a limit, a barrier, and a perfectly arbitrary one.'[22] The root of their debate is not wealth per se, but the crisis of authenticity that this rise in material status brought about.

Victor Dubreuil's images of money, when paired with his biography, make it clear that in some cases, money was used to carry a deliberate political message. The painting traditionally known as *Don't Make a Move* has been inaccurately titled, dated, and misunderstood in the literature (fig. 4).[23] An 1893 newspaper account identifies the title as *A Prediction of 1900, or A Warning for Capitalists* and sheds further light upon Dubreuil's interests.[24] As a result, the anti-Semitic representations that Edward Nygren found in the image – the male figure's large nose, the woman stealing money – are impossible to sustain since the female figure is Dubreuil's 'ex-washerwoman' and the man is a self-portrait:

> [the painting] not only tells a story of its own, but is the key to the life, struggles, and aims of the man who produced it, [it] is the most important and interesting in the place ... the entire picture is the key to the aspirations, disappointments, joys and sorrows of Victor Dubreuil.[25]

The painting posits a future in which the workers of the world will not sit idly by while the capitalist system grows wealthy at their expense.[26] The international nature of the painting's elements (the newspaper from London, the currency from the United States) suggests allegiance to the International Socialist Movement and concern for the struggle of all the working class, rather than an obsession with American financial policy. To the extent his image is autobiographical, the lens it is read through must be one of a socialist artist living in the capitalist metropolis.[27]

Similar themes pervade other works by Dubreuil, but these meanings have been obscured by scholarship that has ironically been highly specific regarding meaning, despite the speculative

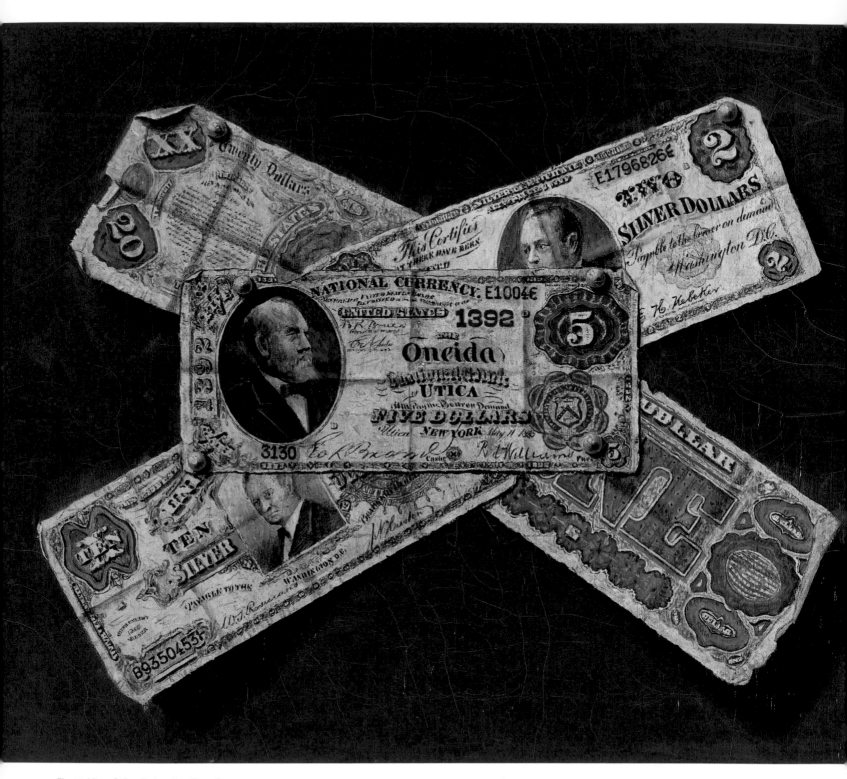

Fig. 5: Victor Dubreuil, *American Paper Currency*,
oil on canvas, c.1889–1891, 30.5 x 35.6 cm (12 x 14 in).
Courtesy Heritage Auctions

and tentative nature of the connections made. For instance, there is no reason to suggest that the image known today as *The Cross of Gold* (Private Collection) bears any relationship to the famous speech given by William Jennings Bryan at the Democratic National Convention of 1896. To begin with, both the date and title ascribed to the painting are modern inventions; they are convenient because each reinforces the veracity of the other, but neither should be accepted as true. Moreover, Dubreuil's concern (at least as can be documented in *A Prediction of 1900* and other works) was not the debates surrounding the propriety of paper currency or the standard that should back it, but the gross accumulation of wealth and the constant desire for money that accompanied capitalism. If the image functions as a commentary on society, it would seem to remind the audience of the uselessness of worshipping wealth.

The Cross of Gold is a difficult painting, encumbered further by a title that bears little relation to the visual evidence, not to mention Bryan's speech. Why, for instance, if Dubrueil wanted to comment upon the Bryan speech would he not have made his cross literally of gold or at least of bills backed by gold? Are we to understand from the image that Bryan or Dubrueil would have been more satisfied by a crucifix of greenbacks and silver certificates? While at first glance, elements of the image (cross + money) seem to confirm the title, a closer inspection of the elements quickly dissolves any coherence the image was presumed to have. If there is a visual pun present – and the dense layering of Dubrueil's imagery suggests this – it might be better served by placing the painting in the context of the *trompe l'oeil* tradition and the artist's history.

The Cross of Gold and related paintings such as *American Paper Currency* (fig. 5), and *Is it Real?* (c.1890s) are dense, multilayered images that speak to multiple meanings and metaphors.[28] The worship of wealth and the illusory nature of riches are perhaps the primary level of engagement that audiences found with each of these images. Both feature multiple bills, attached to the background with large, gold-headed tacks or pins. In each, the currency amounts are the same, thirty-eight dollars, composed of one-, two-, five-, ten-, and twenty-dollar bills. The structure of the bills – it was Dubrueil's choice to paint them

overlapping one another – suggests an awareness of contemporary images like Haberle's *U.S.A.* or Harnett's *XXX*. At the same time, in both depictions the bills form a cross and pile, which may indicate yet a deeper and more personal punning on the artist's part. Dubruiel was reportedly obsessed with the writing of François Rabelais and, as of 1893, had been working for eighteen years on annotations to Rabelais' works which he felt would 'open wide the eyes of the entire world'. The genesis of his project, which predated his arrival in the United States, likely drew to his attention a French proverb which was used to explicate some of Rabalais' works: 'Un noble prince, un gentil roy / N'a jamais ne pile, ne croix.' As one English writer explained to his readers, the phrase 'pile and cross' was generally meant to signal money, and was used by Jonathan Swift amongst other writers.[29] Dubrueil's painting then, in which he literally makes a cross out of a pile, may be another level of punning.

The notion of displaying wealth, which arises from the same impulse as worshipping money, is central to another series of works Dubrueil painted depicting barrels of money. The author likely saw a painting closely related to what is today known as *Money to Burn* (c.1893) (fig. 6) titled *Barrels o' Money* that hung to the right of *A Prediction of 1900* at Dicken's House, a bar at 38th Street and 7th Avenue in New York City.[30] Describing the sturdy oak barrels full of coins and bills, the reviewer described a scene in which diamonds and turquoise sparkle on the floor and:

> With them are large bank-note sandwiches done up in paper wrappers, over the edges of which the crisp, new edges of the bills curl so temptingly that one marvels at their mathematical truth to nature and the remarkable skill of the man who produced them with the aid of only a bristle brush and a few tubes of Windsor and Newton.

Dubruil's painting, executed during the Panic of 1893, the worst financial crisis in the United States prior to the Great Depression, would have had particular resonance among his audience. With the run on gold reserves in the nation, unemployment trending upwards to almost twenty per cent by the following year, the display of wealth – and indeed the notion of hoarding it – reads

as a commentary warning about the temporal nature of riches, but also reminds the average visitor to the saloon of the degree to which this crisis affected the working classes. The Panic, even more so than those prior to it, sent ripples throughout American culture that resulted in a deeper permeation of this crisis into the national consciousness through popular media and printed accounts.

The real dangers

While critics, lawmen, and the popular press obsessed about the dangers posed by artists, they failed to see the forest for the trees. By this I mean the obsessive concern regarding the ability to counterfeit money was misplaced, however well intentioned. As early as 1867, some publications were warning that:

> In view of the certainty that the country will soon be so flooded with counterfeits that it will be dangerous for those incapable of judging correctly to receive money, every man of business, and especially young men, should give the matter of counterfeit detection their careful attention. [31]

Thankfully, these dire predictions never came to pass, although there were occasions – such as the arrest of the artist Emanuel Ninger in 1896 – which seemed to validate those fears. In hindsight, it is remarkable that nobody seemed aware of the danger posed by the exchange of an equally lucrative commodity which was far easier to pass and far more difficult to authenticate: fine art.

The realisation that fine art was a lucrative commodity equally as susceptible to counterfeiting as money seems not to have been part of the late nineteenth-century mindset. Although the secret service seized William Michael Harnett's paintings in 1886, and critics compared John Haberle to a counterfeiter, there are no articles expressing concern that these artists might use their skills to falsify paintings. Yet, as the arrest of the money painter Ferdinand Danton for forging paintings in the 1930s suggests, this lacuna and the difficulty in assessing the authenticity of works created its own problems. [32] Perhaps because of the rarity with which the general public dealt with paintings, there was no real worry about this practice since it would by definition affect very few. Money, by contrast, created a complex web of relationships dependent on maintaining confidence. The real danger posed to paper currency was not the threat of criminals becoming rich (although that was a possibility), it was the threat of the system collapsing under the weight of doubt. The popularity of these images and the dense metaphorical layers within them suggest they functioned as objects that allowed audiences to navigate the difficult transition into modernity by creating venues in which issues of truth, knowledge, and authenticity could be comfortably debated and acknowledged.

12. National Authenticity on Display? Exhibiting Art from Emerging Markets

by Natasha Degen

Fig. 1: Sun Yuan and Peng Yu, *Old Persons Home*, 2007.
Thirteen lifesize sculptures and dynamoelectric wheelchairs.
Image courtesy of the Saatchi Gallery, London. © *Sun Yuan and Peng Yu, 2007.*
Photo © *Stephen White 2009*

The art world, many argue, is flat, with its placeless white cubes and its peripatetic jetset. Its vast internationalisation since the 1980s – via biennials, art fairs, museums of contemporary art, artists' residency programmes, and the Internet – has supposedly diluted, if not largely eliminated, distinct national schools and regional styles.[1] Yet the traditional art historical narrative defined by nations, in which 'modes of vision are refracted by nationality', persists.[2] Perhaps still the most prevalent strategy of museum display, nationality remains a convenient taxonomy; as such, it is frequently represented as the most authentic mode of exhibition – for both historic and contemporary art.

Despite its transnational nature, contemporary art is often subject to this organising principle. In addition to a spate of region-themed temporary exhibitions, the Venice Biennale (as a kind of art-oriented World's Fair) continues its tradition of showcasing contemporary work in national pavilions.[3] Such exhibitions, especially those focusing on the art of emerging markets, are seemingly on the rise, even as curators problematise the very notion of national identity and herald the effective dissolution of boundaries and borders. In London alone, recent exhibitions have included, at the Saatchi Gallery: 'The Revolution Continues: New Chinese Art' (2008), 'Unveiled: New Art from the Middle East' (2009) and 'The Empire Strikes Back: Indian Art Today' (2010); 'China Design Now' (2008) and 'India Design Now' (forthcoming, 2012) at the Victoria and Albert Museum, and at the Serpentine Gallery: 'Indian Highway' (2008–9), 'China Power Station', Part I (2006) and Part II (2007). This chapter aims to shed light on this contradiction between the deterritorialised, global language of contemporary art and the persistence of national identity as an 'authentic' mode of seeing and understanding.

The birth of the public museum with nation-themed displays and the emergence of art history as an academic discipline with national schools coincided with the rise of nationalism in the nineteenth century. With their parallel histories, the nation state and the museum share more than mere chronology: both rely on constructs of authenticity. The nation state creates notions of a unique and authentic collective identity in order to define its citizenry. Via museums, the emergent nation state 'selects, codifies, and publicises indigenous aesthetic productions as

concrete expressions of the national soul.'[4] If there are two types of authenticity – authenticity of origin (or genealogy) and authenticity of content (or identity) – the museum is the site of both. Regarding authenticity in relation to art, the literary critic Lionel Trilling wrote, 'its provenance is the museum, where persons expert in such matters test whether objects of art are what they appear to be or are claimed to be, and therefore worth the price that is asked for them – or, if this has already been paid, worth the admiration they are being given.'[5] Such a view indicates that the public accepts the museum as an arbiter of authenticity, displaying 'authentic' objects and disseminating 'authentic' narratives.

It is for this reason that the exhibition is a desirable site for asserting nation-themed narratives. There are, at present, multiple economic incentives for promoting such narratives – including corporate sponsorship, cultural diplomacy, and speculative collecting. These motives, this chapter will argue, have resulted in the recent proliferation of nation-themed exhibitions, especially those focusing on art from the world's fastest-growing economies.

Corporate sponsorship

In the last decade the Groninger Museum in Groningen, the Netherlands has hosted a series of large-scale Russia-themed exhibitions, including: 'Ilya Repin: The Secret of Russia' (2001–2), 'The Russian Landscape' (2003–4), 'Working for Diaghilev' (2004–5), 'Russian Legends, Folk Tales and Fairy Tales,' (2007–8), and 'Russia's Unknown Orient' (2010–11). This programme is the direct result of the 2001 contract between the Russian gas monopoly Gazprom and the Dutch company Gasunie Groningen. (Henk van Os, professor of art history and former director of the Rijksmuseum, had previously tried to organise a Repin exhibition, but was unsuccessful until Gazprom offered its assistance.)[6] George Verberg, former president of the International Gas Union, described the Groninger Museum's programme as a goodwill gesture to solidify the Gasunie-Gazprom relationship. 'Very early in our relationship-building with Gazprom we were intrigued by the rich cultural heritage of Russia,' he said.[7] According to energy expert Volko de Jong, the gas industry is increasingly reliant on

the art world to strengthen international ties.[8] Another exhibition of Russian art, 'From Russia: French and Russian Paintings 1870–1925,' on view from January to April 2008 at the Royal Academy in London, was also enabled by the intervention of Gazprom. The company was credited with brokering the deal to ensure that the exhibition of Russian art went ahead amid deteriorating UK–Russia relations following the poisoning of former KGB agent Alexander Litvinenko. Tim Webb wrote in *The Observer* that 'The exhibition was almost scrapped ... But Gazprom persuaded officials to authorise the transfer of the paintings to London.'[9]

Arts sponsorship often plays a role in a company's long-term strategy, as Paul Skinner, chairman of the British-Australian mining company Rio Tinto, indicated in a 2008 interview before his company's sponsorship of the Royal Ballet Tour of China: 'China's economy is expanding rapidly and is an increasingly important consumer of the metals and minerals we produce,' he said. 'We hope to forge closer ties with China by helping to make the tour possible.'[10] Morgan Stanley aimed to prove their dedication to doing business in China with their eight-month sponsorship of the exhibition 'The First Emperor: China's Terracotta Army' at the British Museum in 2008. As a spokesperson for the company said, 'this exhibition shows our clients the company is active in China and committed to doing business there'.[11] Following a series of gas discoveries in the western Nile Delta beginning in 2000, the British Museum hosted several 'BP special exhibitions', including 'Cleopatra of Egypt: From History to Myth' (2001) and 'Mummy: The Inside Story' (2003). In July 2010, BP signed an agreement with Egypt to develop two offshore gas fields.[12] Only a few months later, in November, the British Museum opened 'Journey Through the Afterlife: Ancient Egyptian Book of the Dead,' another BP special exhibition.

Such sponsorship arrangements may become increasingly prevalent as more businesses aspire to forge international links and political connections in new markets, whilst governments concurrently cut funding for the arts. Exhibitions focused on emerging markets, in particular, seem to be growing in number. HSBC's nation-themed cultural festivals, for instance, have focused exclusively on emerging economies so far – Brazil in 2010 (during which HSBC sponsored a solo show at the

Hayward Gallery by Brazilian artist Ernesto Neto), India in 2009 (during which HSBC was sole sponsor of the British Museum exhibition 'Garden and Cosmos: The Royal Paintings of Jodhpur'), and China in 2008 (during which HSBC supported the Victoria and Albert Museum's 'China Design Now').

According to the curator and critic Brian Wallis, 'the temporary exhibition serves as a remarkably flexible public relations tool. It stresses the corporation's interests in the life and culture of the host country; it promotes that culture in the home country, winning approval from both constituencies; and it functions as a bargaining chip – as another service the multinational corporation can offer.'[13] For museums that depend on so-called 'blockbuster' exhibitions for revenue, region-themed exhibitions are mutually beneficial, enabling the museum to host an expensive, large-scale show otherwise beyond their means whilst simultaneously contributing to their sponsor's credibility in a specific foreign market; but by privileging such exhibitions, corporate interests supplant authenticity as the museum's creed (assuming the remit of the museum is to present 'authentic' objects and 'authentic' narratives). The narratives proposed by these exhibitions are inevitably limited: in order to benefit corporate sponsors, they must demonstrate an appreciation for a rich history or promote the idea of a burgeoning contemporary culture whilst eluding controversy. These narratives are not necessarily inaccurate, but the fact that they are in some regards predetermined compromises the museum's claim to authenticity.

Cultural diplomacy

Art is an effective means of cementing relationships for governments as well. China has initiated the 'Year of China', a calendar of cultural events, in France, Italy, Russia, Australia, and Turkey. These cultural seasons purport to disseminate an 'authentic' national culture in the interest of fostering cross-cultural understanding. They also act as an exchange: in 2010 Australia organised an exhibition of Aboriginal art for the National Art Museum of China in Beijing, which in 2011 launched an exhibition of Chinese revolutionary art in Australia. Both

'Years' were announced amid efforts to improve China–Australia relations jarred by a series of controversies: A 2009 Australian Defence White Paper suggested China may pose a possible future threat; Canberra allowed a visit by Uighur leader Rebiya Kadeer; Rio Tinto rejected a huge investment by China's Chinalco; and Australian Rio Tinto executive Stern Hu was charged with espionage and detained. Also in 2009, the Australian Bureau of Statistics announced that China had become Australia's largest trading partner.[14]

The year 2007 was the 'Year of Russian Culture' in Turkey, and 2008 was the 'Year of Turkish Culture' in Russia. In 2009, the 'Turkish Season in France' featured a number of exhibitions, including 'From Byzantium to Istanbul: Harbour of Two Continents' at the Grand Palais, which was inaugurated by the presidents of Turkey and France, as well as 'Ottoman Textiles and Kaftans', 'Ancient Izmir and Ionia', and 'Hittites'. The 'Year of Turkey in Japan' in 2003 was reciprocated with 'Japan Year 2010 in Turkey'. In June 2010 a Memorandum of Understanding was signed between Turkey and China, announcing the 'Year of China in Turkey' and the 'Year of Turkey in China' in 2012 and 2013, respectively. Only a few months later, Turkey and China announced plans to triple bilateral trade to $50 billion within five years.[15] A leaked United States diplomatic cable noted the role of the 'Year of France' in Brazil and the 'Year of Brazil' in France in the 'love affair' between the two nations.[16]

These initiatives not only speak to the desirability of exchange with emerging markets, but also to these countries' awareness of the importance of 'soft power' – or the power to attract, as opposed to the power to coerce ('hard power'). Taking the British Council, the Alliance Française and the Goethe-Institut as models, some emerging markets have also exercised 'soft power' through newly created cultural arms, exemplified by China's Confucius Institutes (founded in 2004), Russia's Russkiy Mir Foundation-run Russia Centers (founded in 2007) and Turkey's Yunus Emre Institutes (founded in 2008). India is currently expanding its number of Indian Council for Cultural Relations (ICCR) Centres abroad and Nigeria also has plans to open cultural centres in the United States, China and Brazil.[17] Although many of these institutes function primarily to promote language study, some

also operate broader cultural programmes. Confucius Institutes, for example, have facilitated large-scale exhibitions such as 'China: A Photographic Portrait', which was sponsored by the Confucius Institute for Scotland and held at the Edinburgh City Art Centre in 2008. There are currently 523 Confucius Institutes globally, with plans to establish 1,000 Institutes by 2020.

Cultural diplomacy in this vein was first aggressively practiced by the United States in the period following the Second World War. Just as America arguably 'invented' the notion of Abstract Expressionism as a uniquely American phenomenon (and as a progenitor of other, distinctly American, avant-gardes), recent years have seen new players similarly use foreign exhibitions to promote an advantageous nation-image. Indeed, the notion of nationhood in the globalised art world is increasingly divorced from a physical or political actuality and is instead reified, becoming akin to a kind of brand. Over the last decade, governments have begun hiring public relations firms and applying brand management theory to engineer their nations' reputations (in order to attract tourism, lure foreign investment, facilitate trade, improve private-sector competitiveness, and even secure geopolitical influence). How nations or regions are perceived in the minds of investors and consumers exerts a strong influence on their ability to compete for investments and exports, and thus the stakes are high.[18] Nationally sponsored exhibitions act as an extension of such nation branding. Because the culture they present serves, first and foremost, political and economic elites, it inevitably conforms to the interests of the hegemonic mainstream. Contemporary art exhibitions, in particular, are subsumed by wider narratives; authenticity, with its gradations and idiosyncrasies, is sidelined.

Speculative collecting

The term 'neophilia' once referred to art-world spectators hungry for the next great movement or 'ism' in contemporary art. Today, neophilia is more applicable to speculative collectors wagering on which country or region will next capture the imagination of the market. Sequentially, China, India, the Middle East and Latin America have each offered the tantalising allure of the 'next big

thing' to Western buyers whilst simultaneously appealing to local *nouveaux riches*. However, as they lack arts infrastructure and internationally recognised agents of validation, these new markets are particularly reliant on region- or nation-themed exhibitions at established institutions. Such exhibitions play a significant role in legitimising art from emerging markets, and are thus useful to speculative collectors as a means of creating both exchange and sign value.

Such collectors, however, are not always content to purchase works and wait idly for them to accrue value. The Estella Collection of Chinese contemporary art, for instance, was sold at Sotheby's soon after being exhibited at the Louisiana Museum of Modern Art in Humlebaek, Denmark and the Israel Museum in Jerusalem. Officials at both museums later said they would never have organised the exhibition had they known that the works would quickly be flipped.[19] Britta Erickson, an independent scholar and leading authority on Chinese contemporary art, was asked to help select works for the collection and write essays for the exhibition catalogue, but she said she too was misled: 'I believed that it was to be a personal collection being assembled for the long term, with perhaps some pieces to be donated to museums,' she told *The New York Times*.[20] Collectors, whether mindful of the potential appreciation of their artworks or merely enthralled by the prestige of publicly displaying their collections, often wield their considerable influence to facilitate such shows.[21] But museums also have something to gain. Not only are exhibitions of single collections often logistically easier to organise and less expensive to mount, exhibitions of art from emerging markets have the added appeal of appearing timely, progressive and globally oriented (a particular asset in our 'multicultural' age).

Since opening in 2008, Charles Saatchi's new King's Road gallery has presented a programme completely comprised of geographically oriented exhibitions. Though he has championed 'national' schools before, namely 'young British art' in the 1990s, his new gallery opened with a series of shows focusing on contemporary art from non-Western emerging economies (China, India and the Middle East), evincing Saatchi's desire to propagate the new and tastemake. His gallery's aspiration to be associated with the cutting-edge is suggested by the usage of the terms

Fig. 2: Kader Attia, *Ghost*, 2007. Aluminium foil. Dimensions variable.
Image courtesy of the Saatchi Gallery, London. © Kader Attia, 2007.
Photograph: © Stephen White 2009

Fig. 3: Jitish Kallat, *Annexe*, 2006. Black Lead, Fiberglass, Stainless Steel Base, 57 x 18 x 18 in. *Image courtesy of the artist.* © *Jitish Kallat, 2011*

'new', 'today' or 'now' in the title of every Saatchi exhibition in the Chelsea space – including '*New* Chinese Art' and 'Indian Art *Today*'. These exhibitions featured paintings and sculptures with spectacular, demotic imagery and eschewed 'difficult' media such as film and video. Demonstrating his predilection for impressiveness and accessibility, these works court a mass audience with the high visual impact of advertising. They also interest a public which seeks to understand a foreign culture through representative objects that act as metonymic icons, constituting what one critic derided as an 'art-as-tourism act'. [22] Consequently, Saatchi's region-themed exhibitions offer ideal branding and merchandising opportunities, as evidenced by gift shop finds such as 'Middle Eastern' magic carpet mouse pads and 'Chinese' cat tote bags. (The Mandarin word for cat, *mao*, is of course a pun on the Great Leader's patronym.)

Perhaps indicating that Saatchi, the consummate neophile, has already shifted his attentions, some of the works exhibited at these Saatchi Gallery shows were sold at a Phillips de Pury auction in April 2010 devoted to emerging markets. Titled 'BRIC,' an acronym coined to describe the four fastest-growing economies (Brazil, Russia, India and China), the sale was held at the Saatchi Gallery. [23] Given the relationship between the Saatchi Gallery and Phillips de Pury & Company (the auction house has paid the entrance fees to the gallery since its opening), it is reasonable to assume that Saatchi had knowledge of this sale and planned his programme accordingly. Although the sale achieved mixed results, it demonstrated that the art of emerging markets is a genre in and of itself; artworks from these locales attract collectors not merely because of their aesthetics but specifically because of their nation of origin.

Many exhibitions organised around national or ethnic identities reduce complex issues of difference to easily consumed, non-threatening snapshots of foreign cultures – and, in the worst cases, propagate national stereotypes. Contemporary art from non-Western emerging markets is especially tied to this branded approach, as the 'brands' of China and India, for instance, offer particular currency: fashionable, topical and exotic, they are indebted to national stereotype and are cultural rather than locative. [24]

Each Saatchi exhibition was branded with a unique colour – a saffron hue for the Indian art exhibition, conjuring sun-soaked exoticism, spices and saris; red, the colour of the Chinese Communist Party, for 'The Revolution Continues: New Art from China' symbolising the state, and thus evoking politics and power; and green, the traditional colour of Islam, for the Middle East show. Adorning banners, leaflets and even invigilators' t-shirts, each colour scheme presented a consistent visual identity, distilling national characteristics (or stereotypes) into an immediate and efficient visual cue. Each exhibition also employed a signature typeface. Materials related to 'Unveiled' featured a white calligraphic font set against a green background, evoking the Saudi Arabian flag. 'The Revolution Continues' included red Chinese characters in a futuristic, sans-serif typeface. Conversely, the slab serif font of the 'Empire Strikes Back' logo looked to the past, with a typeface resembling the output from a strike-on typewriter, or perhaps, in a British context, missives from a Colonial Office.

The works support a single, reductive, sometimes Orientalising narrative and reveal Saatchi's own biases, contradicting each exhibition's claim to survey their respective region's artistic practice. A majority of works in the Chinese contemporary art show reference power and the state, and many depict Mao Zedong. Liu Wei's *Love It! Bite It!* (2005–7) is a model plan of a city made entirely from dog chews, re-engineering iconic symbols of power – from the Coliseum to the Guggenheim Museum – into decrepit ruins. *Old Person's Home* (2007) by Sun Yuan and Peng Yu (fig. 1) consists of thirteen hyper-realistic life-size sculptures of elderly world leaders – a bishop, an admiral, a general, plus several politicians and dictators. Although all are dressed as if still in power, adorned with the decorations and medals that symbolised their authority, they are shown slumped in electric wheelchairs that cruise aimlessly around an empty gallery, occasionally colliding, as if in remembrance of past conflicts.

The aptly titled 'Unveiled: New Art from the Middle East' evidenced a fascination with the veil and the plight of women under Islam, featuring a number of works which appeared made for foreign consumption. Kader Attia's *Ghost* (2007) (fig. 2), for instance, renders a group of women in prayer as vacant shells,

devoid of personhood or agency. 'The Empire Strikes Back' exoticised the poverty, conflict and chaos of modern-day India. Jitish Kallat's *Annexe* (2006) (fig. 3) is a sculpture of a young boy with a heavy serpentine rope over his shoulder, to be used to flagellate himself in order to seek alms. Treated in black lead, the figure literally taints those who touch him. He is situated on a stainless-steel base with a drain, representing the societal gulf between the perceived stain of poverty and the veneer of wealth. Saatchi's un-nuanced if effectively communicated narratives are supported by works of varying quality that remain on message and conform to a specific, 'Saatchi-esque' aesthetic.

Conclusion

These nation-themed exhibitions appear to be on the rise, given their appeal to cash-rich corporate sponsors, image-conscious governments and influential collectors; but in order to be useful to their sponsors and fulfil their desired function, they must not deviate from certain prescribed narratives – ones which display appropriate reverence for a historically rich culture, or suggest the promise and optimism of an emergent power, or conjure a dynamic and exciting, even exotic, environment.[25] In addition to the potentially inauthentic metanarratives they impart, nation-themed exhibitions risk compromising authenticity in the recontextualisation of objects to create such narratives; for example, artworks that may not have been intended to represent nationality or nationhood are deployed to advance political and economic agendas.

Although they ostensibly provide an alternative to the American-enforced global culture industry by presenting art that is anchored in the specificity of its region and the identity of its nation, these exhibitions are similarly ideological and, in fact, often serve the same elites. Such exhibitions suggest the advent of a new Orientalism, defined not by the hegemony of one region over another, but by the hegemony of globally dispersed powerful interests (and their efficient, marketable, imagistic narratives) over weak, imperfect, nuanced realities. It is a hegemony of inauthenticity.

Notes

Introduction

1. 'Close Examination: Fakes, Mistakes and Discoveries', National Gallery, London, 2010: a series of case studies of paintings from the National Gallery's collection closely examining the attribution of each work and authenticating them using both connoisseurship and scientific approaches; 'Leonardo da Vinci: Painter at the Court of Milan', National Gallery, London, 2011–12; 'The Metropolitan Police Service's Investigation of Fakes and Forgeries', Victoria and Albert Museum, London, January 2010: curated by the Arts and Antiquities unit at Scotland Yard, this exhibition was extended a further two weeks owing to public interest; 'Seconde Main (Second Thought)', Musée d'Art Moderne de la Ville de Paris, Paris, March–October 2010: this exhibition featured a selection of 'look-alike' works from the 1960s to the present day and examines the reappropriation of copying by modern and contemporary artists; 'Masterpieces?', Centre Pompidou-Metz, Metz, 2010–12: this exhibition explored the creation and production of masterpieces from the Middle Ages to the present day. See also *The Burlington Magazine*, July 2010, in which the entire edition was devoted to 'Attributions, Copies and Fakes'.

2. See, for example, the reviews in *The New York Times* (12 July 2010), *The Telegraph* (28 July 2010) and *The Independent* (4 July 2010).

3. *The New Shorter Oxford English Dictionary* (Oxford: Clarendon Press, 1993).

4. *Art Quarterly* (Spring 2010).

5. Marjorie E. Wieseman, *A Closer Look: Deceptions and Discoveries* (London: National Gallery, 2010).

6. Richard Dorment, 'La Bella Principessa: a £100m Leonardo, or a copy?', *The Daily Telegraph* (12 April 2010). Myths are made in various accounts of the reaction to the drawing by the dealer and collector Peter Silverman, for example in *The Daily Telegraph*. It was a sensational story which may have been intended to manipulate the media and generate interest in the drawing. Silverman had first seen it in a New York gallery in January 2007, when he bought it.

7. Martin Bailey, 'Real or Fake?', *Art Quarterly* (Autumn 2010).

8. The drawing was shown to the public for the first time in Gothenberg, Sweden from March to August 2010. It is a 33 x 24 cm drawing on vellum and is made with a combination of pen and ink, ink wash and three chalks: black, red and white. These have been overlaid with later pigments: olive green, yellow and brown. The vellum is mounted on a wooden board which appears to be old.

9. Martin Kemp and Pascal Cotte *La Bella Principessa and the Warsaw Sforziad*, www.lumiere-technology.com/news/Study_Bella_Principessa_and_Warsaw_Sforziad.pdf (October 2011)

10. See Philip Mould, *Sleuth: The Amazing Quest for Lost Art Treasures* (London: HarperCollins, 2009).

11. Martin Kemp, *Art Quarterly* (Summer 2010), p. 45. Kemp concluded that this was Bianca Sforza, the illegitimate daughter of the Duke of Milan, and that the incisions on the vellum suggested that it had been removed from a bound codex presented to her (as was Renaissance custom) possibly on the occasion of her marriage in 1496 at the age of thirteen (to Galeazzo Sanseverino, also a patron of Leonardo) or for a commemorative portrait made after her death some four months later. Kemp dates the portrait to that year.

12. See Martin Kemp and Pascal Cotte, *La Bella Principessa: The Story of the New Masterpiece by Leonardo da Vinci* (London: Hodder and Stoughton, 2010) and Martin Bailey, *Art Quarterly* (Autumn 2010).

13. With multispectral imaging investigators can look beneath the surface, creating a series of high-resolution images, including infrared. They reveal *pentimenti* and it is possible to analyse the pigments. The hatched shading around the face was almost certainly done by a left-handed artist.

14. By the time the forensic scientist Peter Paul Biro took on *La Bella Principessa* the public appetite for forensic solutions had become very strong (David Grann, 'The Mark of a Masterpiece', *The New Yorker*, 12 July 2010, p. 17.) Biro's reputation for disinterested opinions is now under dispute and an article about him in *The New Yorker* is the subject of a lawsuit. Furthermore, his 'scientific' approach to fingerprinting has been questioned by fingerprint experts.

15. *The New Yorker* (12 July 2010), p. 8. The name of the original owner of the work is Jeanne Marchig. Marchig is seeking unspecified damages but the court papers say that the picture is now valued by insurers at more than £65 million and that it could be worth £100 million. (See Stephen Adams, 'Christies Sued Over £100m Leonardo da Vinci', *The Telegraph*, 6 May 2010.) In February 2011, the United States judge dismissed the suit as being 'time-barred' – Marchig is appealing (*Financial Times,* 11 February 2011). The role of the Marchigs has received little attention. Jeanne Marchig, a Swedish citizen living in Switzerland, inherited the drawing from her husband, Giannino Marchig, a Florentine artist and picture restorer who died in 1983. He apparently acquired the drawing in 1955, believing it to be the work of Domenico Ghirlandaio. Since 'the drawing was restored in modern times, the fact that Marchig was a professional conservator suggests that he might have done the job. He was also an artist, which raises the possibility that he could have created the original drawing, possibly in homage to the Renaissance masters ...' (Martin Bailey, 'Real or Fake?', *Art Quarterly* Autumn 2010).

16. In 2011, one year after the publication of his book on *La Bella Principessa*, Martin Kemp made a discovery of further contextual evidence which might be significant in ultimately authenticating the drawing. He had originally speculated that the portrait came from a book because three stitch holes are visible on its left margin. In 2011 Kemp examined a set of books relating to the Sforza family, known as the *Warsaw Sforziad*, and found that both the dimensions and the stitch holes from the vellum drawing in question matched the stitch holes from the book. Because vellum is made from processed skins, each sheet has different qualities. The thickness and composition of this sheet is consistent with the vellum from the book located by Kemp. There are also cut marks on the edge of the book. The books examined are titled the *Sforziad* in the National Library in Warsaw. See Martin Kemp and Pascall Cotte, *La Bella Principessa and the Warsaw Sforziad*, www.lumiere-technology.com/news/Study_Bella_Principessa_and_Warsaw_Sforziad.pdf (October 2011); www.LiveScience.com (2011).

17. For a discussion of academics' liability with respect to authentication issues see Georgina Adam and Richard Pryor, 'The Law *vs* Scholarship: Taking Academics to Court Over Authentication Issues is Eroding Independent Expertise', *The Art Newspaper* (December 2011), pp. 1,8

18. 'Is This a Leonardo? National Gallery Includes Newly Discovered Painting', *The Art Newspaper* (November 2011).

19. Louis van Tilborgh and Ella Hendricks, 'Dirk Hannema and the Rediscovery of a Painting by Van Gogh', *The Burlington Magazine* (June 2010), p. 363.

20. *Seconde Main/Second Hand: An Exhibition of Look-alike Works within the Permanent Collection of Musée D'Art Moderne de La Ville de Paris*, March–October 2010, p. 3.

21. 'The Art World in the 21st Century', (London: Sotheby's Institute of Art), lecture, 9 November 2011.

22. The *Weekend Australian Financial Review* (28 December–1 January 2012).

1. Attribution and the Market:
The Case of Frans Hals *by* **David Bellingham**

1. J. Bruyn et al., *A Corpus of Rembrandt Paintings: Stichting Foundation Rembrandt Research Project*, 5 vols (The Hague, Boston and London: Martinus Nijhoff, 1982).

2. M. E. Wieseman, *A Closer Look: Deceptions and Discoveries (National Gallery Company)* (New Haven and London: Yale University Press, 2010).

3. J. Bruyn, et al., *A Corpus of Rembrandt Paintings: Stichting Foundation Rembrandt Research Project*, vol. 1, ix (The Hague, Boston and London: Martinus Nijhoff, 1982).

4. Ibid., vol. 1, xi.

5. Christiane Stukenbrock, *Frans Hals – Fröhliche Kinder, Musikanten und Zecher* (Frankfurt et al.: Peter Lang, 1993).

6. Ibid., p. 174.

7. For the critical reception history of Frans Hals, see *The Dictionary of Art* (London: Macmillan and New York: Grove, 1996), vol. 14, p. 95. For lifetime reception, see Seymour Slive, *Frans Hals*, 3 vols (New York and London: Phaidon, 1970–4), vol. 1, pp. 5–20. For later reception history, see Frances Jowell, 'The Rediscovery of Frans Hals', in Slive, Seymour et al., *Frans Hals* (Munich: Prestel, [Royal Academy exhibition catalogue] 1989), pp. 61–86.

8. Theodorus Schrevelius, *Harlemias ofte ... de eerste stichtinghe der stadt Haerlem* (Haarlem: 1648), p. 383.

9. *The Dictionary of Art* (London: Macmillan and New York: Grove, 1996), vol. 14, p. 91.

10. Frances Jowell, 'The Rediscovery of Frans Hals', in Seymour Slive, et al., *Frans Hals* (Munich: Prestel, [Royal Academy exhibition catalogue] 1989), pp. 61–86.

11. Claus Grimm, *Frans Hals: The Complete Work* (New York: Harry N. Abrams, 1989).

12. M. E. Wieseman, *A Closer Look*, publicity statement.

13. Giovanni Morelli, *Die Werke Italienischer Meister in den Galerien von München, Dresden und Berlin: Ein kritischer Versuch* (Leipzig: E. A. Seemann, 1880).

14. Giovanni Morelli, (trans by Mrs Louise M. Richter), *Italian Masters in German Galleries: A Critical Essay on the Italian Pictures in the Galleries of Munich, Dresden and Berlin* (London: Bell and Sons, 1883), p. 9.

15. Ibid., vi.

16. Wilhelm Bode, *Frans Hals und seine Schule* (Leipzig: E. A. Seemann, 1871); Wilhelm von Bode (ed.), *Frans Hals: His Life and Work* (Berlin: Photographische Gesellschaft, 1914).

17. Angenitus Martin de Wild, *Het natuurwetenschappelijk onderzoek van schilderijen* (s'Gravenhage: 1928).

18. E. Hendriks, M. van Eikema Hommes and K. Levy-van Hahm, 'Indigo Used in the Haarlem Civic Guard Group Portraits by Frans Hals' in A. Roy and P. Smith, *Painting Techniques, History, Materials and Studio Practice*, Contributions to the Dublin Congress, 711 September 1998 (London: The International Institute for the Conservation of Historic and Artistic Works, 1998), pp. 166–70, pls. 63–9.

19. A. van Grevenstein et al., 'Aspects of the Restoration and Technical Examination of the Haarlem Civic Guard Group Portraits by Frans Hals', *ICOM Committee for Conservation 9th Triennial Meeting* (Dresden: 1990). pp. 90–4,

20. E. Hendriks, M. van Eikema Hommes, and K. Levy-van Hahm (1998), pl. 65.

21. Seymour Slive, *Frans Hals*, 3 vols (New Haven and London: Phaidon, 1970–4), vol. 3, cat. 21, pp. 13–14.

22. Walter Liedtke, *Dutch Paintings in the Metropolitan Museum of Art*, 2 vols (New Haven and London: Yale University Press, 2007), vol. 1, cat. 59, pp. 260–5: the attribution to Frans Hals is repeated in the museum's online catalogue.

23. Ibid., vol. 1, p. 260.

24. Jakob Rosenberg and Seymour Slive, *Dutch Art and Architecture: 1600 to 1800* (Harmondsworth: Penguin, 1966); Haeger (1986), typical of more recent symbolic interpretations of seventeenth-century Dutch art, saw it as 'a moral exemplum and a celebration of pleasure', but rejected *The Prodigal Son* subject.

25. Walter Liedtke, *Dutch Paintings in the Metropolitan Museum of Art*, vol. 1, pp 264–5.

26. Cornelis Hofstede de Groot, *A Catalogue Raisonné of the Works of the Most Eminent Dutch Painters of the Seventeenth Century*, 8 vols [English translation by E. G. Hawke from the German edition of 1907] (London: Macmillan, 1910), p 3, p. 9, nos 1–2, pp. 41–42, no. 139.

27. François Monod, 'La Galerie Altman au Metropolitan Museum de New-York (2e article)', *Gazette des beaux-arts*, 5th ser., 8, November 1923, pp. 300–1.

28. Wilhelm Reinhold Valentiner, *Frans Hals, des meisters Gemälde*, Deutsche Verlags-Anstalt, Stuttgart, 2nd edn., 1923, p. 307; Wilhelm Reinhold Valentiner, *Frans Hals Paintings in America* (Westport, CT: F. F. Sherman, 1936), p. 9, no. 4; M. L. d'Otrange-Mastai, '"Yonker Ramp and His Sweetheart": Two Frans Hals Versions in America', *Connoisseur*, 137, April 1956, pp. 114–5.

29. Numa S. Trivas, *The Paintings of Frans Hals* (London: Allen and Unwin, 1941), p. 61.

30. Seymour Slive, *Frans Hals*, vol. 1, pp. 72–6, p. 80, p. 100, p. 141; Claus Grimm, *Frans Hals: The Complete Work* (New York: Harry N. Abrams, 1989), p. 29, pp 49–50, pp. 52–56, pp. 62–64, p. 66, p. 197, p. 200, no. A5, fig. 25 (detail).

31. Walter Liedtke, *Dutch Paintings in the Metropolitan Museum of Art*, vol. 1, p. 260.

32. M. E. Wieseman, *A Closer Look*, pp. 84–7.

33. Sotheby's, *Old Master Paintings Evening Sale*, London, 9 July 2008, pp. 88–93. The extensive catalogue entry provides details of the recent, but unpublished, dendrochronological analysis of the panel.

34. Ibid., p. 88

35. Cornelis Hofstede de Groot, *A Catalogue Raisonné of the Works of the Most Eminent Dutch Painters*, vol. 3, p. 9, nos 1–2, pp. 41–42, no. 139 [English translation by E.G. Hawke from the German edition of 1907], (London: Macmillan, 1910), p. 58, no. 190.

36. Norbert Middelkoop and A. van Grevenstein, *Frans Hals: Life, Work, Restoration* (Amsterdam: Uniepers; Haarlem: Frans Halsmuseum; Gloucester: Alan Sutton, 1989), pp. 94–7, fig. 39a.

37. Ibid., p. 96.

38. Ibid., p. 97.

39. Claus Grimm, *Frans Hals: The Complete Work*, (New York: Harry N. Abrams, 1989), p. 29, p. 126, p. 137, p. 155 and p. 203, no. A26a, pl. 116 (as a copy); ibid., p. 55 and p. 57, fig. 55e (as copy or replica from Hals's studio).

40. Seymour Slive, *Frans Hals*, vol. 1, p. 53, vol. 3, p. 66, under no. 123 (as a copy); ibid., p. 276 and p. 278, no. 2, fig. 51c (as a copy after the Brussels portrait). The Brussels Museum online catalogue currently has a '(?)' against Frans Hals' authorship, and states: 'Selon Claus Grimm: copie ou réplique d'atelier; selon Seymour Slive : pas de copie jusqu'à preuve du contraire.'

41. Only available online to registered users: www.sothebys.com/app/condition/cond.do?dispatch=readConditionReport&lotID=159447164

42. Recent examples of reattribution by art market players include: Jeremy Howard (et al.), *Frans Hals' St Mark: A Lost Masterpiece Rediscovered* ([London]:Colnaghi; [Amsterdam]: Salomon Lilian, 2008); and Bendor Grosvenor, *Finding Van Dyck: Newly Discovered and Rarely Seen Works by Van Dyck and His Followers* (London: Philip Mould, 2011).

43. North Carolina Museum of Art, *Like Father, Like Son: Portraits by Frans Hals and Jan Hals* (Raleigh, NC: North Carolina Museum of Art, c.2000); Jan Hals, *Portrait of a Gentleman*, 1644; 30.25 x 25.75 in. (North Carolina Museum of Art); Frans Hals *Willem Coymans*, 1645; 30.25 x 25 in. (The National Gallery of Art, Washington, DC).

44. *Apollo*, March 2005, p. 63 [brief news note].

45. Ernst Gombrich, *Art and Illusion*, 4th edn. (New York and London: Phaidon, 1972), p. 329.

46. Serena Urry, 'Evidence of Replication in a "Portrait of Eleonora of Toledo" by Agnolo Bronzino and Workshop', *Journal of the American Institute for Conservation*, vol. 37, no. 2, (1998), pp. 211–221. Urry reattributes a replica, formerly attributed to Bronzino alone, as 'Agnolo Bronzino and Workshop'. Her study is primarily related to connoisseurship and scientific investigation, and comments on the stylistically inferior passages painted by the workshop, as opposed to Bronzino himself. There is a general absence of revisionist replication studies in post-Renaissance art history. Recent examples of the academic reassessment of the cultural value of replicated art, all from classical studies, include: Ellen Perry, *The Aesthetics of Emulation in the Visual Arts of Ancient Rome* (Cambridge: Cambridge University Press, 2005); Miranda Marvin, *The Language of the Muses: The Dialogue between Roman and Greek Sculpture*, (Oxford: Oxford University Press, 2008); and Jennifer Trimble, *Women and Visual Replication in Roman Imperial Art and Culture*, (Cambridge: Cambridge University Press, 2011). Perry and Marvin argue convincingly against the nineteenth-century German theories of *Kopienkritik*, which underrated any Roman creativity in their replications of earlier Greek art objects. Trimble studies the cultural function of replicated images in defining the social status of Roman women.

2. A Dialogue of Connoisseurship and Science in Constructing Authenticity: The Case of the Duke of Buckingham's China *by* Morgan Wesley

1. This catalogue entry appears in Gordon Lang, *European Ceramics at Burghley House* (London: 1991).

2. As a fascinating aside, this effect of a single event disproving a widely held opinion has entered the modern world as an important theory: The Black Swan problem, which is discussed in John Stuart Mill, *A System of Logic: Ratiocinative and Inductive* (London: John W. Parker, 1843). The presumed non-existence of the black swan (since one had never been documented before the late seventeenth century) is a logical fallacy used as an illustration of falsification through new evidence arising.

3. While not restricted to the particulars of ceramics, William Bernstein, *A Splendid Exchange: How Trade Shaped the World* (London: 2009), is an excellent discussion of the transit of material and documents through trade routes from the ancient to the modern, and is a noteworthy aid to understanding the commercial backdrop that forms the basis for ceramic collecting.

4. This general confusion is well-illustrated by the proliferation of the classification systems of certain Middle-Eastern ceramics: Abraham-of-Kutahya, Golden Horn, Damascus, and Rhodian wares. These classifications for Iznik wares were established by Arthur Lane in the 1940s based on apocryphal locations of production or locations of discovery, and were originally thought to represent entirely unique productions. This confusion has been greatly reduced by Nurhan Atasoy and Julian Raby in *Iznik: The Pottery of Ottoman Turkey* (London: 1989), and by the misattribution issue discussed in Oliver Watson, *Ceramics from Islamic Lands* (London: 2004).

5. Those interested in the history and growth of the Republic of Letters and its influence on intellectual culture are encouraged to read Anne Goldgar, *Impolite Learning: Conduct and Community in the Republic of Letters, 1680–1750* (New Haven and London: 1995).

6. Refer to Père François Xavier d'Entrecolles, 'Lettre d'Entrecolles à Jao-tcheou, 1er Septembre 1712' and 'Lettre d'Entrecolles à Kim-te-tchim, le 25 Janvier 1722,' published in *Lettres édifiantes et curieuses écrites des missions estranges. Mémoires de la Chine etc.*, vols 18 and 19 (Paris: 1781).

7. While many texts have been written on early porcelain experimentation at Meissen, K. Hoffman, *Johann Friedrich Böttger: vom Alchemistengold zum weissen Porzellan: Biographie* (Berlin: 1985) and Otto Walcha, *Meissner Porzellan* (Dresden: 1973), prove to be especially fruitful. Both minimise von Tschirnhaus' role in the discovery, a slight that the *Tschirnhaus-Gesellschaft* (Tschirnhaus Society) is working to rectify in current scholarship.

8. This notion of porcelain as a product of very specific materials set the standard by which the legitimacy of porcelain was measured, and contributed to the intellectual construction of its authenticity as a material object. As discussed in the section dealing with scientific analysis, the concept of 'authentic porcelain' is itself a fallacy. 'Porcelain' was a term constructed by the western world in the fifteenth and sixteenth centuries to describe hard, translucent, white ceramics such as those produced in China. Problematically, the notion of porcelain, as communicated by d'Entrecolles, presented only a single option for the manufacture of this material, obfuscating the true nature of Chinese porcelain from the West in the seventeenth and eighteenth centuries. In addition, the demand for documents and information from China and Japan obscured the vital role of experimentation and craft knowledge in the West.

9. Rose Kerr and Nigel Wood, 'Ceramic Technology', in J. Needham (ed.), *Science and Civilization in China*, vol. 5, part XII (Cambridge: 2004), pp. 758–63, contains a particularly insightful discussion on the interaction between historic Chinese porcelains and Thomas Cookworthy's efforts.

10. The available analysis of some of Dwight's experimental works was published in Michael Tite, Mavis Bimson, and Ian Freestone, 'A Technological Study of Fulham Stoneware', in J. S. Olin and M. J. Blackman (eds), *Proceedings of the 24th International Archaeometry Symposium* (Washington: 1986), pp. 95–104. However, when compared with discussion of the great variety of possible samples in Chris Green, *John Dwight's Fulham Pottery Excavations, 1971–79* (London: 1999), it is apparent that the authors were provided with only a small sample of the pieces available for testing.

11. Georges Vogt, 'Studies on Chinese Porcelain', in Robert Tichane (trans.), *Ching-Te-Chen: Views of a Porcelain City* (New York: 1983), pp. 202–13, first published as 'Recherches sur les porcelaines Chinoises', in *Bulletin de la Société d'encouragement pour l'industrie nationale* (Paris: 1900).

12. The available techniques for testing material included: thermoluminescence (TL), x-ray diffraction (XRD), x-ray fluorescence (XRF), and scanning electron microscopy (SEM). Thermoluminescence, which can be used to determine the time elapsed since last firing for some ceramic wares, is the only technique that provides any dating information, though it can render erroneous results and be misled by some methods of fraud. It is always destructive in nature as it involves re-exposing a sample to a strong energy source. XRD is another destructive test that can be used to evaluate the crystalline structure of a piece. Since certain combinations of elements form particular minerals during firing, this information can reveal details about the composition of an object or the region where it may have been produced. XRF can be used non-destructively to ascertain ratios of elements in an object, and can be a very effective spot test for certain wares based on the appearance of rare elements. SEM gives the most reliable results for elemental analysis at the cost of preparation time of a sample. It can also be used for petrographic analysis of crystalline microstructures. Recently a non-destructive form of SEM has been introduced to allow testing of smaller objects. It provides results similar to destructive testing, though is limited in resolution in much the same way that XRF is.

13. The principles of XRF have been miniaturised for use in handheld devices, originally intended to provide recycling operations, scrapyards, and other bulk metal handlers a more reliable tool for sorting material based on elemental composition. The technology has been adopted by archaeologists and material scientists for a number of uses, and several projects are being undertaken to determine the versatility of the technology and refine its use. Currently, portable XRF is limited by a lack of resolution and is unreliable for the detection of lighter elements, such as aluminium, critical to thorough investigation in ceramics.

14. The jars are recorded as: '*A Jarr Guilt and Enameld with Cupids in three Ovalls and the Cover open Work Silver Guilt*' and '*A pair of little Jarrs and Covers guilt and Enamel'd with ffestoones and Boyes heads*'. In the Devonshire Schedule, several teacups are likewise mentioned as '*A pair of Tea Cups white within guilt and Enamel'd on a Dark ground in Three Ovalls on Each Antique ffigures and Clowdes*' and '*A little Tea Cup Enamel'd on A Gold ground with ffour Boyes upon Swans Backs,*' though these have never been reconciled with pieces in the Burghley collection or elsewhere.

15. Brownlow Cecil (1725–93) kept impeccable records of his purchases and carefully researched attributions. The daybooks record the jars as: '*two bottles of L: Elizabeth's China*' and '*A China jar and cover.*' While the 1863 inventory lists them as: '*two essence pots with covers metal mounted, one small vase much broken and repaired the above painted with festones & angels were made at the manufactury patronized by the Duke of Buckingham, time of Charles the II*', it is still uncertain where and when this patronage information was communicated to Cecil.

16. A. P. Middleton, *Report on the Examination of a Painted and Gilt Jar and Cover* British Museum Laboratory Report, envelope 6060, The British Museum (1991), (unpublished).

17. Extra thanks must be passed on to Professor William Lee, who arranged for the access to equipment at Imperial College London, and his then graduate student Rafael Sa, who were largely uncredited by the various media writing on the Buckingham porcelains when they were first published. None of the exciting results would have been possible without the action and effort of these individuals.

18. Refer to Morgan Wesley, 'The Burghley House "Buckingham" Porcelains as Documentary Objects' in *Transactions of the English Ceramic Circle,* vol. 20 (London: 2009), pp. 179–80, for a specific breakdown of analytical results and their comparison to other hard and soft-paste productions.

19. Refer to material referenced in note 6.

20. This suggestion of a Medici connection was made by J. C. Robinson in 1862 when, at an exhibition in South Kensington, he had the opportunity to view the work similar to the 'Virtues' jar owned by Lord Stamford and another piece that had originally been discussed by Horace Walpole during the eighteenth century in connection with Brownlow's attribution to Buckingham. See John Mallet, 'Discoveries and Re-Discoveries' in *Transactions of the English Ceramic Circle,* vol. 20 (London: 2009), pp. 195–204 for a historiography of the various explorations into the Buckingham porcelains in the nineteenth and twentieth centuries and the various attributions assigned to them before they dropped out of sight between the 1950s and 1991.

21. Michela Spataro, Nigel Meeks, Mavis Bimson, Aileen Dawson and Janet Ambers, 'Early Porcelain in Seventeenth-century England: Non-destructive Examination of Two Jars from Burghley House,' in *The British Museum Technical Research Bulletin,* vol. 3 (London: 2009), pp. 37–46.

22. This folio, originally published in Paris in 1654, provided the initial design source for the works. The source was edited by the enameller to provide more modest 'angelic' *putti* for the allegories than the nudes incorporated by Gerard van Opstal, the original designer for van Merle's prints.

23. Aileen Dawson, 'The Earl of Stamford's Vase Re-discovered', in *Transactions of the English Ceramic Circle,* vol. 20 (London: 2009), pp. 183–5.

24. Gordon Lang was a pioneer in an object-based approach to attribution, one that focuses on information tied to the object directly, such as material analysis, inventories, and direct comparison of its design elements. Before his death in 2010 he spoke at great length and with eloquence on the problems facing ceramic history and the challenges for future generations of scholars. He envied the students and practitioners just entering the field because of the tools now available to challenge traditional attributions and to build a better knowledge of ceramic authenticity. He was quick to task his students with investigating all ceramics as if they were unknowns, estimating that '85 per cent of what we think we know about the history of ceramics and objects in collections is wrong.' It is tempting to dismiss this soberingly large and frightening number as hyperbole, but placed within the context of all the sherds, pots, jugs, dishes, vases, cups, and statues left unexamined, unexcavated and largely unconsidered, it may well be close to accurate. When uttered by a man who spent his life as a connoisseur, academic and philosopher studying ceramic authenticity, it is certainly an estimate that bears consideration and was the prime inspiration for this chapter.

3. A Venetian Sixteenth-century Costume Book as an Authentic Visual Record *by* Sophie von der Goltz

1. A. Hyatt Mayor, 'Renaissance Costume Books', *The Metropolitan Museum of Art Bulletin,* vol. 37, no. 6 (June 1942), p. 158.

2. Cesare Vecellio, *Habiti antichi et moderni di tutto il mondo* (Venice: Appresso i Sessa, 1598).

3. As I have access to a second edition, I will use the title, *Habiti antichi et moderni.*

4. A stomacher is a detachable, front section of a bodice.

5. A partlet is a piece of women's clothing that was often made of diaphanous material and draped over the shoulders.

6. A *camicia* is a shift, often made of fine white linen called *tella di renz*, which is worn underneath the bodice and skirt. Its basic job was to absorb body oils, sweat and odours, thereby protecting the costly outer fabrics. As it was made of less expensive fabric and was simply constructed, it was sturdier and easier to wash than the bodice. See Paul Hills, *Venetian Colour – Marble, Painting and Glass, 1250–1550* (New Haven and London: Yale University Press, 1999), p. 192.

7. Muriel Baldwin, 'Costume, 1400–1600', in *Costume, Gothic and Renaissance: an exhibition in the Spencer Room* (New York: New York Public Library, 1937), p.17.

8. J. Anderson Black and Madge Garland, *A History of Fashion* (London: Black Cat, 1990), p. 110.

9. Vecellio, *Habiti antichi*, p. 97.

10. Patricia Fortini Brown, *The Renaissance in Venice: A World Apart* (London: Weidenfeld and Nicolson, 1997), pp. 166–7.

11. The fragments of the dress are on view at the Galleria del Costume in Florence.

12. Janet Arnold, *Patterns of Fashion 4: The Cut and Construction of Linen Shirts, Smocks, Neckwear, Headwear and Accessories for Men and Women* (London: Macmillan, 2008), p. 102.

13. Roberta Orsi Landini and Bruna Niccoli, *Moda a Firenze, 1540–1580: lo stile di Eleonora di Toledo e la sua influenza* (Florence: Edizione Polistampa, 2005), p. 83.

14. This can be seen in Vecellio's plate, *Donne per casa*, which is not reproduced here.

15. Vecellio, *Habiti antichi*, p. 99.

16. This is a phrase used in Landini and Niccoli, *Moda a Firenze*, p. 84. They may have meant sarsenet, canvas or buckram, as mentioned in Janet Arnold, (ed.), *Queen Elizabeth's Wardrobe Unlock'd* (Leeds: Maney and Sons, 1988), p. 146.

17. Vecellio, *Habiti antichi*, p. 99.

18. Ibid., p. 80.

19. Fortini Brown, *The Renaissance in Venice*, p. 150.

20. Vecellio, *Habiti antichi*, p. 81.

21. Hills, *Venetian Colour*, p. 174.

22. This can be seen in Vecellio's plate, *Ordinario*. See ibid., p. 173.

23. Obviously being a citizen was prestigious in Venice, and nearly as desirable as being a nobleman.

24. The festival celebrated Venice's marriage to the sea in a two-week celebration led by the Doge and culminating on Ascension Day. See Margaret F. Rosenthal, 'Cutting a Good Figure – the Fashions of Venetian Courtesans in the Illustrated Albums of Early Modern Travellers', in Martha Feldman and Bonnie Gordon (eds), *The Courtesan's Arts: Cross-cultural Perspectives* (Oxford: Oxford University Press, 2006), p. 67.

25. Catharine R. Stimpson, introduction to Margaret Rosenthal, *The Honest Courtesan: Veronica Franco, Citizen and Writer in Sixteenth-century Venice* (Chicago and London: University of Chicago Press, 1992), viii.

26. Rosenthal, 'Cutting a Good Figure', p. 52.

27. Vecellio, *Habiti antichi*, pp. 107 and 112.

28. Georgine Masson, *Courtesans of the Italian Renaissance* (London: Secker and Warburg, 1975), p. 152.

29. Rosenthal, *The Honest Courtesan*, p. 6.

30. Lynne Lawner, *Lives of the Courtesans: portraits of the Renaissance* (New York: Rizzoli, 1987), p. 4.

31. Masson, *Courtesans*, p. 152.

32. Rosenthal, *The Honest Courtesan*, p. 60.

33. Vecellio, *Habiti antichi*, p. 107.

34. Rosenthal, 'Cutting a Good Figure', p. 52.

35. Vecellio, *Habiti antichi*, p. 112.

36. Ibid., p. 114.

37. This may have been due to practicality. After all, many items of women's clothing nowadays were originally derived from men's clothing for practical reasons.

38. Rosenthal, *The Honest Courtesan*, p. 60.

39. Very possibly they were the actual trendsetters of fashion in Venice. See Rosenthal, 'Cutting a Good Figure', p. 52.

4. The Authenticity of Traditional Crafts: The Case of Ernest Beckwith *by* Noël Riley

1. Judy Attfield, *Wild Things: The Material Culture of Everyday Life* (London: Berg, 2000), p. 79.

2. These objects were shown at the Victoria and Albert Museum in the recent exhibition on Horace Walpole and Strawberry Hill (6 March–4 July 2010); see Michael Snodin, (ed.) *Horace Walpole's Strawberry Hill* (New Haven and London: Yale University Press, 2009).

3. See the chapter by Megan Aldrich in this volume. See, also, Clive Wainwright, 'Only the True Black Blood', *Furniture History* 21 (1985), p. 250.

4. *Pigot's Directory of Essex* (1835); *Kelly's Directory of Essex* (1850); William White, *History, Gazetteer and Directory of the County of Essex* (1863); and George Frederick Beaumont, *A History of Coggeshall, in Essex* (1890), p. 3.

5. *Kelly's Directory of Essex*, and *Pigot's Directory of Essex*, various dates in the 1880s and 1890s. The distinction between furniture brokers and furniture dealers is not altogether clear: the terms seem to have been used interchangeably for those engaged in selling old or second-hand furniture.

6. Noël Riley and Andrew Beckwith, *Country Practice: The Business of Ernest Beckwith, 1872–1952* (Braintree, Essex: District Museum, 2000), p. 2.

7. A whatnot, or etagère, is a mobile tiered stand for displaying or storing objects. A canterbury is a small mobile stand with vertical partitions for holding music.

8. John Claudius Loudon, *Encyclopedia of Cottage, Farm and Villa Architecture and Furniture* (1833), which has been termed, 'the vital document of middle-class taste' by Simon Jervis in the *Penguin Dictionary of Design and Designers* (Harmondsworth: Penguin Books, 1984), p. 307.

9. Riley and Beckwith, *Country Practice*, p. 4.

10. They were Arthur Layzell and Brian Saunders; Riley and Beckwith, *Country Practice*, p. 2. See Dodo Rose, *Brian Saunders, 1893–1973* (Denton: Round House Press, 1995).

11. Riley and Beckwith, *Country Practice*, p. 2.

12. See, for comparison, the fifteenth-century timber-framed north porch of St Margaret's Church, Margaretting, Essex, illustrated in James Bettley and Nikolaus Pevsner, *The Buildings of England: Essex* (New Haven and London: Yale University Press, 2007), fig. 31. For a definition of a lychgate, see John Fleming, Hugh Honour and Nikolaus Pevsner, *The Penguin Dictionary of Architecture*, 4th (rev.) edn. (London: Penguin Books, 1991), p. 277.

13. Augustus Charles Pugin, *Gothic Ornaments Selected from Various Buildings in England and France* (London: Priestley and Weale, 1831), and subsequent editions. For more on the sources of Beckwith's carving, see Riley and Beckwith, *Country Practice*, p. 4.

14. Bettley and Pevsner, *Essex*.

15. Beckwith's renovations were for many years ignored by the National Trust in its promotion of the house, perhaps because it lent a note of 'inauthenticity' to its exterior. However, Beckwith's skilful work has been more openly acknowledged since the beginning of the twenty-first century, partly through local knowledge and partly as a result of the exhibition 'Country Practice' at the Braintree Museum in 2000, which drew attention to Beckwith's role in the restoration of Paycocke's. In addition, Beckwith's contribution, a century later, can perhaps now be considered 'antique' and therefore of significance in its own right.

16. Letter from Andrew Beckwith to the author, 25 January 2011.

17. Ibid., 'Romayne', or Roman, work involved the carving of heads in profile, and was originally derived from Italian Renaissance decorations.

18. Beckwith's compilation was J. Munro Bell, *Chippendale, Sheraton and Hepplewhite Furniture Designs, reproduced and arranged* (London: Gibbings and Co, 1900).

19. Blomfield Jackson's plans for the lychgate are dated 1914 and are in the Essex Record Office in Chelmsford.

20. See Mary Huckle, 'Twentieth-century Woodcarvers of Coggeshall', *Essex Countryside* (Summer 1953), p. 114.

21. Andrew Beckwith, letter, 25 January 2011.

22. When the contents of Crittall's house, New Farm, Great Easton, were sold in 1987, Beckwith's furniture fetched significant sums and was purchased by enthusiasts for modernist design, including gallery owners and museum curators. His reproduction and remodelled pieces, however, command little interest, even when they are recognised and have a provenance.

23. For more on Silver End, see Bettley and Pevsner, *Essex*, pp. 686–9.

24. From a biographical note in the catalogue of the Phillips' house sale, *Contents of New Farm, Great Easton* (22 July 1987).

25. Conversations with Andrew Beckwith during 2010–11 support this view of Ernest Beckwith's thoughts on modernist furniture, as well as the realities of his need for a reliable income.

26. Andrew Beckwith, letter, 25 January 2011.

5. Acquiring and Displaying Replicas at the South Kensington Museum: 'The Next Best Thing' *by* Barbara Lasic

1. The research project on the V&A's collections of European paintings was conducted under the aegis of the National Inventory Research Project (2010) in collaboration with the University of Glasgow and the National Gallery, with the support of the American Friends of the V&A through the generosity of the Samuel H. Kress Foundation.

2. Report from the Select Committee (1860), p. 89.

3. Ibid.

4. See Julius Bryant (ed.), *Art and Design for All: The Victoria and Albert Museum* (London: V&A Publications, 2011); C. Wainwright, 'The Making of the South Kensington Museum', *Journal of the History of Collections,* 14, 1 (2002), pp. 12–17.

5. A. Burton, 'The Uses of the South Kensington Art Collections', *Journal of the History of Collections,* 14,1, (2002), pp. 87–88.

6. W. Dyce, 'Lecture on Ornament Delivered to Students of the London School of Design', *Journal of Design and Manufactures,* 1 (1849), p. 94.

7. M. Baker, B. Richardson (eds), *A Grand Design: The Art of the Victoria and Albert Museum* (London: V&A publications, 1997), p. 30

8. Increasing competition from millionaire collectors in Britain and abroad largely contributed to the soaring prices of historic decorative arts. See B. Lasic, 'The Collecting of Eighteenth-Century French Decorative Arts in Britain, 1789–1914' (Unpublished PhD Diss., University of Manchester, 2006).

9. Robinson Report, 14 April 1864.

10. *The Art Journal* (1 February 1862), p. 35.

11. It is not relevant for the present study to undertake a thorough examination of the curriculum of design education in nineteenth-century Britain for the subject has already been amply scrutinised by scholars. See Q. Bell, *The Schools of Design* (London: Routledge, 1963); A. Forty, *Objects of Desire: Design and Society, 1750–1980* (London: Thames and Hudson, 1986), pp. 42–61; A. Rifkin, 'Success Disavowed: The Schools of Design in Mid-Nineteenth-Century Britain', *Design History,* 1, 2 (1988), pp. 89–100. The ever expanding discourse on taste was accompanied by theoretical writings articulating rules and laws of design aimed at framing and directing the creation of decorative arts of high aesthetic quality. For instance, Owen Jones in *The Grammar of Ornament* (1854), and later Christopher Dresser in *Principles of Decorative Design* (1873), sought to establish universal laws and principles of decoration. Jones's book was particularly influential and was distributed by the Department of Science and Art to all schools of design.

12. J. C. Robinson, *Catalogue of Old Sèvres Porcelain* (London: Eyre and Spottiswoode, 1853), cat. no. 33. Students were to cater for an ever expanding middle-class market and produce affordable goods characterised by a greater restraint and simplicity of decoration. It was believed that the level of simplicity or luxury in a household should correspond to the wealth and social status of the family (W. Walton, *France at the Crystal Palace: Bourgeois Taste and Artisan Manufacture in the Nineteenth Century* (University of California Press: 1992), p 30). The condemnation of the excessive use of ornamentation of Sèvres porcelain fully illustrates the Department of Science and Art's views that decoration should be used with parsimony. Even when the objects were to be solely ornamental, as opposed to having also a practical function, Robinson stated that decoration should be accessory and secondary or it would detract the eye of the beholder from the overall structure and form of the piece (Robinson, *Old Sèvres Porcelain,* 1853, p. 11). This argument was later reiterated by Christopher Dresser, who wrote in 1872 that ornament 'cannot be other than

secondary, and must not usurp a principal place; if it is to do so, the object is no longer a work ornamented, but is degraded into a mere ornament' (*Journal of the Society of Arts,* (12 April 1872), p. 438).

13. V&A Acquisition Register, Word and Image Department, Victoria and Albert Museum, London.

14. V&A museum number: 973–1875.

15. Lady Ashburton and Leopold King of the Belgians ordered copies of the Riesener-Oeben *Bureau du Roi.* P. Hughes, *The Wallace Collection Catalogue of Furniture,* 1, (London: The Trustees of the Wallace Collection, 1996), pp. 31–32.

16. V&A museum number: 8098–1863.

17. Electroplating technology was patented by Elkington and Company in Birmingham during the 1840s. The process consisted of coating a thin layer of metal by electrolysis on to a moulded replica. Fictile ivories were replicas made in plaster of Paris. See Bryant, *Art and Design for All,* pp. 202, 204–6.

18. This amalgamation into a single whole was not intended as a strategy to bolster acquisition numbers since yearly reports separately listing acquisitions and reproductions entering the museum collections were published.

19. See A. J. Hamber, *A Higher Branch of Art: Photographing the Fine Arts in England, 1839–1880* (Amsterdam: Gordon and Breach, 1996).

20. *The Times* (28 May 1863).

21. *Catalogue of Specimens of Cabinet Work, Exhibited at Gore House,* (London: Eyre and Spottiswoode, 1853).

22. V&A museum numbers 32:634–32:714

23. *Catalogue of Works Illustrative of Decorative Art. Chromolithographs, Etchings and Photographs* (London: Eyre and Spottiswoode, 1869), p. 1.

24. See A. J. Hamber, *A Higher Branch of Art,* pp. 424–6.

25. Report of the Department of Science and Art for the Year 1873 (London: Eyre and Spottiswoode, 1873), p. 2.

26. Hamber, *A Higher Branch of Art,* p. 426.

27. The Raphael Collection sought to assemble reproductions (prints and photographs) of every known work by, or deriving from, Raphael, and consists of some 5,500 individual items. It is considered as the first comprehensive attempt to compile all the works associated with a single artist. See J. Montagu, 'The Ruland/Raphael Collection', *Visual Resource,* 3 (1986), pp. 167–83.

28. The National Archive, Kew; AR1/8, letter from Roland Wilkins to Claude Phillips, 26 March 1901.

29. The Countess wished to have copied a *vernis Martin* cartonnier which formerly belonged to Catherine II (the National Archives, Kew; AR1/254). P. Hughes, *The Wallace Collection: Catalogue of Furniture* (London: The Trustees of the Wallace Collection, 1996); J. Ingamells, (ed.), *The Hertford Mawson Letters. The 4th Marquess of Hertford to his Agent Samuel Mawson,* (London: Trustees of the Wallace Collection, 1981), p. 28; Barbara Lasic, 'Splendid Patriotism: Richard Wallace and the Construction of the Wallace Collection', *Journal of the History of Collections,* 21, 2 (November 2009), pp. 173–182.

30. *Catalogue of Specimens of Cabinet Work Exhibited at Gore House,* (London: Eyre and Spottiswoode, 1853), cat. nos 31, 48, 71. Peter Hughes has observed that Hertford's replicas were not intended to deceive and the Seymour Conway

arms were added to the copy of the Boulle table. P. Hughes, *Wallace Collection: Catalogue of Furniture* (London: The Trustees of the Wallace Collection, 1996), 1, pp. 31–32.

31. W. G. Paulson Townsend, *Measured Drawings of French Furniture from the Collections of the South Kensington Museum* (London: 1899). I am very grateful to Carolyn Sargentson for bringing this point and publication to my attention. Significantly, one of the two copies in the V&A collections is part of the Heal's archive, showing that retailers and manufacturers used those publications for their own practice.

32. 'Convention for promoting universally Reproductions of Works of Art for the benefit of Museums of all Countries' (London and Paris: 1867–8), printed original draft. One sheet (MSL, 1154) with the original signature of the Tsarevitch, inscribed 'Henry Cole 20 Oct 67'; one sheet (MSL, 1159) with the original signature of Frederick, Crown Prince of Denmark. Facsimile and MS, each H: 41.5cm, W: 26.5cm. V&A: NAL MSL/1921/1154, MSL/1921/1159.

33. Ibid.

34. 'Memorandum on the International Exchange of Copies of Works of Fine Art', 8 February 1864, reproduced in *Inventory of Plaster Casts in Various Styles including the Antique and the Renaissance acquired by the South Kensington Museum* (London: Eyre and Spottiswoode, 1874), vi.

35. *The Times* (2 November 1880), p. 8.

36. *The Art Journal*, vol. 3 (1877), p. 224.

37. *Illustrations of Art Manufactures in the Precious Metals Exhibited by Elkington Co* (London: 1873), n. p.

38. M. Baker, *The Cast Courts* (Hunstanton: Witley Press, 1982), pp. 1–5.

39. J. H. Pollen, *Description of the Architecture and Monumental Sculpture in the South East Court of the South Kensington Museum* (London: Eyre and Spottiswoode, 1874), p. 4.

40. *The Times* (11 July 1873), p. 7.

41. *The Times* (11 July 1873), p. 7.

42. H. G. Wells, *Love and Mr Lewisham* (New York: the Macmillan Co, 1906), p. 85.

43. V&A museum numbers: IPN 902, 903, 904.

44. Lt. Cole, *Catalogue of Objects of Indian Art*, 1874, p. 13. The cast was destroyed in the mid-1950s, when the Indian Museum was pulled down to make way for Imperial College.

45. Pollen, *Architecture and Monumental Sculpture*, p. 1.

46. M. Baker, 'The Reproductive Continuum: Plaster Casts, Photographs and Modes of Reproduction in the Nineteenth-Century Museum', in R. Frederiksen and E. Marchand (eds), *Plaster Casts: Making, Collecting and Displaying from Classical Antiquity to the Present,* (Berlin, New York: De Gruyter, 2010), pp. 485–500.

47. Some of the sixteenth-century *Sgabello* chairs from the Soulages Collection were heavily restored in the first half of the nineteenth century.

48. A. Burton, *Vision and Accident: The Story of the Victoria and Albert Museum* (London: V&A Publications, 1999), pp. 27, 37.

49. *The Times* (11 September 1860), p. 4.

50. By 1880, the museum was circulating over six thousand objects per year. *The Circulation Department, Its History and Scope* (London: V&A Publications, 1950) p. 1.

51. Baker (2010), pp. 485–500. By the early twentieth century, copying was no longer part of the Royal College of Art curriculum.

52. M. Trusted (ed.), *The Making of Sculpture: The Materials and Techniques of European Sculptures* (London: V&A publications, 2007), pp. 170–1. Consequently, few notable additions of copies were made over the past hundred years.

6. Authentic the Second Time Around? Eduardo Paolozzi and Reconstructed Studios in a Museum Environment
by **Bernard Vere**

1. Morandi died in 1964 and his studio reconstruction opened in 1993. Bacon died in 1992 and his reconstructed studio opened at the Hugh Lane Gallery, Dublin in 2001. Brancusi's studio moved to its present site in 1997 after having been reconstructed twice following its bequest the year before the artist's death in 1957, discussed further below.

2. Walter Benjamin, 'The Work of Art in the Age of Its Technological Reproducibility, Second version' in *The Work of Art in the Age of Its Technological Reproducibility and Other Writings on Media*, ed. Michael W. Jennings, Brigid Doherty and Thomas Y. Levin, trans. Edmund Jephcott, Rodney Livingstone, Howard Eiland et. al (Cambridge, MA and London: the Belknap Press of Harvard University Press, 2008), p. 20. All quotes are from this version. The first English translation, 'The Work of Art in the Age of Mechanical Reproduction' is in Benjamin, *Illuminations*, trans. Harry Zohn, ed. Hannah Arendt (London: Pimlico, 1999).

3. Benjamin, 'The Work of Art in the Age of Its Technological Reproducibility', p. 21.

4. Berlewi, quoted in Albrecht Barthel, 'The Paris Studio of Constantin Brancusi: A Critique of the Modern Period Room', *Future Anterior*, vol. 3, no. 2 (Winter 2006), p. 36.

5. Barthel, 'The Paris Studio of Constantin Brancusi', p. 37.

6. Benjamin, 'The Work of Art in the Age of Its Technological Reproducibility', p. 22.

7. Ibid., p. 24.

8. Christopher Green, *Picasso: Architecture and Vertigo* (New Havenand London: Yale UP, 2005), p. 211.

9. Benjamin, 'The Work of Art in the Age of Its Technological Reproducibility', p. 22. Incidentally, the choice of a cathedral as an example, no more or less an 'artwork' than the artist's studio, is just one of a number of statements in Benjamin's essay that legitimate the extension of his ideas to the latter.

10. Quoted in Barthel, 'The Paris Studio of Constantin Brancusi', p. 44, no. 8.

11. Ibid., p. 38.

12. Paul Overy, 'The Cell in the City' in *Architecture and Cubism*, ed. Eve Blau and Nancy J. Troy (Cambridge, MA and London: MIT Press, 1997), 120.

13. Paolozzi, quoted in his *Daily Telegraph* obituary (23 April 2005). Retrieved from www.telegraph.co.uk/news/obituaries/1488447/Sir-Eduardo-Paolozzi.html, 8 March 2011.

14. Fiona Pearson, 'Sir Eduardo Paolozzi: Pop Art founder with a long and distinguished career', an obituary in the Scottish newspaper *The Herald* (26 April 2005). Retrieved from www.heraldscotland.com/sport/spl/aberdeen/sir-eduardo-paolozzi-pop-art-founder-with-a-long-and-distinguished-career-1.55982, 8 March 2011. In a television interview, curator Patrick Elliott also recalls Paolozzi's uncanny ability to fall asleep during interviews only to awake and answer the question as if nothing had happened (*Romancing the Stone: The Golden Ages of British Sculpture*, episode 3, 'Children of the Revolution', BBC4 television programme, transmitted 23 February 2011).

15. The background to the reconstruction and quotes from Cappock and Bacon is taken from Louise Williams, 'Bacon Studio Re-Created in Dublin', BBC News website, 22 May 2001, http://news.bbc.co.uk/1/hi/entertainment/1345486.stm, consulted 1 March 2011.

16. Patrick Elliott, interviewed in *Romancing the Stone*. However, in 2007 the Mayor Gallery in London mounted an exhibition, 'Eduardo Paolozzi: For Adults Only – A Pornucopia of Previously Unknown Erotic Drawings/Collages.' On the subject of the pornographic magazines, it is interesting to note that Mondrian reportedly pinned up girly photographs above his bedroom adjoining the studio at Rue Départ, although these do not feature in any of the photographic documentation of the studio and any claim that they were there to inform his abstract grids would clearly be more dubious. See Overy, 'The Cell in the City', p. 126.

17. 'Speculative Illustrations: Eduardo Paolozzi in Conversation with J. G. Ballard and Frank Whitford', *Studio International*, vol. 182 (1971). Reprinted in *Eduardo Paolozzi: Writings and Interviews*, ed. Robin Spencer (Oxford: Oxford University Press, 2000), p. 206.

18. Peter Wollen, 'Magritte and the Bowler Hat' in his *Paris Manhattan: Writings on Art* (London and New York: Verso, 2004), p. 138.

19. 'Conversations between Eduardo Paolozzi and Alvin Boyarsky, May 1984', reprinted in *Eduardo Paolozzi: Writings and Interviews*, p. 318.

20. Benjamin, 'The Work of Art in the Age of Its Technological Reproducibility', p. 25.

21. Ibid., p. 22.

22. These doors are visible at the extreme edges of the Scottish National Gallery of Modern Art's virtual tour: www.nationalgalleries.org/education/activityPopup/paolozzi_studio.swf, consulted 6 October 2011.

23. Quoted in Barthel, 'The Paris Studio of Constantin Brancusi', p. 41.

24. Keith Hartley, 'Introduction' to Fiona Pearson, *Paolozzi* (Edinburgh: National Galleries of Scotland, 1999), p. 7.

25. Nigel Henderson, interview with Dorothy Morland, quoted in John-Paul Stonard, 'The "Bunk" Collages of Eduardo Paolozzi', *The Burlington Magazine*, CL (April 2008), p. 238.

26. Nigel Henderson, quoted in David Robbins (ed.), *The Independent Group: Postwar Britain and the Aesthetics of Plenty*, exh. cat. Institute of Contemporary Arts, London, 1 February–1 April 1990, then touring (Cambridge, MA and London: MIT Press, 1990), p. 21.

27. David Robbins, 'Eduardo Paolozzi' in *The Independent Group*, ed. Robbins, p. 94.

28. Paolozzi, 'The Iconography of the Present', originally published in *The Times Literary Supplement* (8 December 1972). Reprinted in *Eduardo Paolozzi: Writings and Interviews*, p. 248.

29. Eduardo Paolozzi, 'Retrospective Statements' in *The Independent Group*, ed. Robbins, p. 193.

30. 'Glynn Williams Talks to Eduardo Paolozzi'. Originally published in *Sotheby's Art at Auction: The Art Market Review* in 1995 and reprinted in *Eduardo Paolozzi: Writings and Interviews*, pp. 327, 329, 327.

31. Lawrence Alloway, quoted in Anne Massey, *The Independent Group: Modernism and Mass Culture in Britain* (New York and Manchester: Manchester University Press, 1995), p. 57.

32. '"Painter" and The Studio: Paul McCarthy and the Myth of the Artist', Dean Gallery, National Galleries of Scotland, 17 October 2009–14 February 2010. www.nationalgalleries.org/whatson/exhibition/5:368/8892, consulted 3 March 2011.

33. See David Robbins, 'The Independent Group: Forerunners of Postmodernism?' in *The Independent Group*, ed. Robbins pp. 237–48 and Massey, *The Independent Group*, pp. 128–37.

34. Especially by the group of critics involved in the journal *October*. In particular see the essays in Rosalind E. Krauss, *The Originality of the Avant-Garde and Other Modernist Myths* (Cambridge, MA and London: MIT Press, 1985) and Douglas Crimp, *On the Museum's Ruins* (Cambridge, MA and London: MIT Press, 1993).

35. The studio of Alberto Giacometti was dismantled in 1966 and awaits a permanent home.

36. In the case of the Vorticists, the curators of the Tate show, Mark Antliff and Vivien Greene, revealed in a symposium that their initial idea to recreate only the 1915 exhibition at the Doré Galleries proved impractical because of the loss of a great number of works that appeared in that show. The symposium, held on 17 June 2011, is available on the Tate Channel as 'Repositioning Vorticism: Part One': http://channel.tate.org.uk/#media:/media/1070307580001&context:/channel/talks-and-symposia?p=3&sort=date&year=2011 [accessed 6 October 2011].

37. Such historical reconstructions have been paralleled by a renewed interest in the archive, whether genuine or fictionalised, as a way of exploring and critiquing both creation and exhibition (for example work by Goshka Macuga, as well as the Atlas Group, during 2009 and 2010 at the Whitechapel Gallery, a situation complicated by the Whitechapel's decision to put parts of its own archive on display, including documentation surrounding the Independent Group's 'This Is Tomorrow', held at the Whitechapel).

38. The phrase 'sculptural element' appears as a quote, suggesting that the phrase is the Tate's, in Ben Quinn, 'Tate Modern Perfects the Idea of Living Dangerously', *The Guardian*, (12 July 2009). www.guardian.co.uk/artanddesign/2009/jul/12/tate-modern-robert-morris-injuries?intcmp=239, accessed 6 October 2011.

39. Mark Hudson, 'Robert Morris' "Bodyspacemotionthings" at the Tate Modern, review', *The Daily Telegraph*, 26 May 2009 at www.telegraph.co.uk/culture/art/art-reviews/5386206/Robert-Morris-Bodyspacemotionthings-at-the-Tate-Modern-review.html, accessed 6 October 2011.

7. Authenticity, Originality and Contemporary Art: Will the Real Elaine Sturtevant Please Stand Up? *by* Anthony Downey

1. Christian Leigh, *The New Good Old Days*, Galerie Six Friedrich, Munich, 1989. Cited in Bruce Hainley 'Löschen und wiederholen', in *Sturtevant Shifting Mental Structures* (Ostfildern-Ruit: Neuer Berliner Kunstverein, 2002).

2. That irony, moreover, is no doubt redoubled when we consider that one of Sturtevant's 'remakes' was procured by Oldenburg's gallerist, the legendary Leo Castelli.

3. To complicate matters further, the 'flowers' in both of these shows had been made on the same silk-screen presses that Warhol had used to produce both his 'flowers' and 'Marilyn' series. In later years, when asked how he had produced his painting, Warhol would reportedly reply, 'I cannot remember. Ask Elaine'. Referenced in Anne Dressen, 'Sturtevant's Fake Mirages', in *Sturtevant: The Razzle Dazzle of Thinking* (Paris: Paris Musées, 2010), p. 18.

4. Elaine Sturtevant, 'Interior/Exterior Visibilities', in *The Razzle Dazzle of Thinking*, op. cit., p. 147.

5. For a more in-depth discussion of the debates around Warhol, authenticity, and the market value of his work, see Eileen Kinsella, 'The Trouble with Warhol', *Art News* (1 April 2011), downloadable at www.artnews.com/2011/04/01/the-trouble-with-warhol/. Sturtevant's prices at auction and hence her market value have been volatile at best, which is perhaps a reflection of the degree of ambivalence surrounding her work in general. In 2008, a painting by Sturtevant titled *Warhol Marilyn*, 1969/70, with an estimate of $60–80,000, sold for $340,000 at Christie's in New York. However, a painting in the same sale, *Warhol Flowers*, from the same year and with an estimate of $50–70,000, failed to find a buyer.

6. Vivien Mercier, 'Review of *Waiting for Godot*', in the *Irish Times*, 18 February 1956, p. 6.

7. *Sturtevant: The Brutal Truth: Catalogue Raisonné 1964–2004* (Frankfurt-am-Main: Museum für Moderne Kunst, 2004), p. 27

8. Ibid p. 11.

9. Thomas Crow, *Conceptual Art: A Critical Anthology*, 1999, referenced in Bruce Hainley, 'Erase and Rewind', in *Frieze*, pp. 82–7, p. 84.

10. Belinda Bowring, 'Sturtevant: On Art and Its Time', in *Afterall*, no. 18 (summer 2008), pp. 83–92, p. 90.

11. It is perhaps relevant to note here that '*imitatio*', forms of imitation and mimicry, are terms sometimes used interchangeably for mimesis: the impulse, in visual terms, to reproduce the physical world through art. For Plato, however, mimesis could also flatter to deceive insofar as it copied the world rather than engaged in the truth of it. And this is why he wanted artists banned from his Republic: their imitations of life were so far removed from truth, he argued, that they corrupted the very meaning of the word and gave rise to confusion in people's minds as to the true nature of reality.

8. Issues of Authenticity in Contemporary Design: The Smoke Series by Marten Baas *by* Lis Darby

1. Imitations of design classics, such as the furniture of Mies van der Rohe or Le Corbusier, are available on the Internet for considerably less than the 'genuine reproductions' of companies which hold the legal rights to production (such as Knoll or Vitra). Dimensions and quality of materials and workmanship are some of the keys to distinguishing the original from the 'fakes'.

2. Walter Benjamin's seminal essay *The Work of Art in the Age of Mechanical Reproduction*, published in 1936, first suggested that the 'aura' or authenticity of a work of art experienced a paradigm shift with the advent of the technical means for accurate reproduction.

3. Adrian Forty in *Objects of Desire: Design and Society, 1750–1980* (London: Thames and Hudson, 1986) pioneered a wider contextual analysis of designed objects, challenging in particular the 'fallacious impression that the designers themselves are solely responsible' for the appearance of manufactured articles (p. 241). See also Judy Attfield, *Wild Things: The Material Culture of Everyday Life*, (London: Berg, 2000), pp. 78–81.

4. For general introductions to these developments in contemporary design, see Gareth Williams, *The Furniture Machine: Furniture since 1990* (London: Victoria and Albert Museum, 2006 and R. Craig Miller, Penny Sparke and Catherine McDermott, *European Design since 1985: Shaping the Century* (London: Merrell, in association with Denver Art Museum and Indianapolis Museum of Art, 2009).

5. Maarten Baas was born in Arnsberg, Germany but moved to the Netherlands in 1979. He studied at Design Academy Eindhoven from 1995, spending some time at the Politecnico in Milan in 2002.

6. Marcus Fairs, *Icon* 020 (February 2005). www.iconeye.com.

7. The *Smoke* series is discussed, for example, in Libby Sellers, *Why What How: Collecting Design in a Contemporary Market* (London: HSBC Private Bank, 2010), pp. 60–9 ; Gareth Williams, 2006, p. 120 and *Telling Tales: Fantasy and Fear in Contemporary Design* (London: Victoria and Albert Museum, 2009), p. 65; Marcus Fairs, *Twenty-First Century Design* (London: Carlton, 2006), pp. 150–1.

8. Marcus Fairs, 2005.

9. Marcus Fairs, 'Maarten Baas: The Red-hot Dutch Furniture-maker's Burning Ambition' *The Independent*, (6 May 2007).

10. www.maartenbaas/biography.

11. Information kindly supplied by Ruud Schenk, Curator of Modern Art at the Groninger Museum. The museum, which re-opened in 1994, has promoted contemporary architecture and design both in its collecting and exhibition policies and in its buildings, which are designed Alessandro Mendini, Philippe Starck and Coop Himmelb(l)au. The interior spaces include the work of Studio Job, Jaime Hayon and also Maarten Baas, who provided furniture based on his *Clay* series (2006) for the Mendini Restaurant at the museum.

12. Alice Rawthorn 'The Eclectic Charm of Murray Moss', *The New York Times* (29 July 2007).

13. Marcus Fairs, 2005.

14. It has been suggested that Baas' work, which debuted at the time of the Iraq War and in the aftermath of 9/11, symbolised the brutal and inflamed times in which we now live. See, for example, Libby Sellers, 2010, pp. 60–1, Gareth Williams, 2006, p. 120 and Marcus Fairs, 2007.

15. Linda Hales, 'Maarten Baas's Claims to Fame', *The Washington Post* (22 May 2004).

16. Marcus Fairs, 2005.

17. Murray Moss suggested that, in burning iconic designs, Maarten Baas was reworking the lessons he had learnt as a student of design. Libby Sellers, 2010, p. 64.

18. Marcus Fairs, 2005.

19. Marcus Fairs, 2007.

20. In this context, one could cite work of the 1980s including that by Ron Arad, Danny Lane and those associated with Creative Salvage in England, by Borek Sipek and Garouste and Bonetti. See Claire Downey, *Neo Furniture* (London: Thames and Hudson, 1992).

21. Judy Attfield, 2000, pp. 59–60. The exhibition 'Stealing Beauty: British Design Now' was held at the Institute of Contemporary Art in 1999.

22. Marcus Fairs, 2007.

23. Another version, *Non Chair*, was made in plastic laminate-covered wood for Studio Alchimia in 1981. An example was included in Phillips de Pury's *Design* sale, New York, 14 November 2009, lot 36. See also Giampiero Bosoni (ed.), *Made in Cassina* (Milan: Skira, 2008), pp. 242–3, p 253.

24. The chair is named *Begin the Beguine*, from a song by Cole Porter, which refers to the dance, the beguine. Here, and in his other work, Kuramata explored the theme of transparency, removing the physicality of an everyday object, in this instance by burning.

25. Anna Bates, 'Pieke Bergmans' *Icon* 069 (March 2009), p. 60.

26. Information kindly supplied by Pieke Bergmans.

27. Ibid.

28. This piece was included in the exhibition 'Telling Tales' held at the Victoria and Albert Museum in 2009. See Gareth Williams, 2009, p. 63 (illus.), p. 65.

29. According to Ruud Schenk, Curator of Modern Art at the Groninger Museum, the decision to allow Baas to rework objects was quickly and unanimously agreed by the curators and the director, because the selected pieces were never on public display as better examples existed in the collection.

30. Anna Somers Cocks, *The Victoria and Albert Museum: The Making of the Collection,* (London: Victoria and Albert Museum, 1980), pp. 77–8. The author suggests that some objects were subsequently recognised as genuine pieces, not fakes.

31. For issues of authenticity and museums, see David Phillips, *Exhibiting Authenticity* (Manchester: Manchester University Press, 1998).

32. In the *Clay* series (2006), for example, the industrial clay is modelled around a metal frame to create the object, leaving the imprint of the maker clearly in evidence. The pieces made for the Groninger Museum, cited in note 10, were all handmade.

33. Quoted in Libby Sellers, 2010, p. 63.

34. www.moooi.com

35. For a discussion of these see Sophie Lovell, *Limited Edition: Prototypes, One-Offs and Design Art Furniture* (Basel, Boston and Berlin: Birkhauser, 2009). See also Libby Sellers, 2010.

36. A unique Charles and Ray Eames screen (1946), burnt by Baas at Moss, New York, in 2005, sold at Phillips de Pury in London in 2010 for £16,250 (including buyer's premium) against an estimate of £10,000 –£12,000. Phillips de Pury, *Design*, London, 28 April 2010, lot 21.

9. Creating an Authentic Style: John Soane's Gothic Library at Stowe *by* Megan Aldrich

1. For example, the Victoria and Albert Museum in London mounted the 'Rococo' exhibition in 1984. See Michael Snodin (ed.), *Art and Design in Hogarth's England* (London: Victoria and Albert Museum, 1984. The Metropolitan Museum of Art responded with 'American Rococo' in 1992 (Morrison Hecksher and Leslie Bowman, *American Rococo, 1750–1775: Elegance in Ornament* (New York: Harry N. Abrams, 1992). Both these exhibitions focused on well-researched and documented examples of decorative art and their intended, or contemporary, settings.

2. The Norman kings, however, were not referenced until the nineteenth century, and then this reference was limited. As the last foreign invasion experienced by the British Isles, perhaps the message of the Norman Conquest was undesirable when compared to the 'homegrown' talents of the Plantagenets and the Tudors.

3. Stowe was rescued from a fate of demolition and its grounds from development when the school was created on the site in 1923. The first headmaster was the far-sighted and influential J. F. Roxburgh. The gardens are now looked after by the National Trust, and the house is maintained by the Stowe House Preservation Trust. For a clear summary of the history of the house, including the family history, see www.stowe.co.uk/house/about-stowe-house/history, and Michael Bevington's *History of Stowe House*, rev.edn. (London: Paul Holberton, 2003) I am indebted to Michael Bevington, the archivist of Stowe, for many stimulating ideas regarding the interpretation of the Gothic Library and understanding its patron, the 1st Marquess of Buckingham. I am also indebted to Dr Anthony Wallersteiner, headmaster of Stowe, for his kind assistance and for generously making his Gothic Library available to me.

4. Henry Rumsey Forster, *The Stowe Catalogue, Priced and Annotated* (London: David Bogue, 1848), 'Historical Notice of Stowe', xxiii.

5. Barbara Arciszewska has set forth the importance of the Hanovers to the development of English neo-Palladian architecture in *The Hanoverian Court and the Triumph of Palladio: The Palladian Revival in Hanover and England, c.1700* (Warsaw: Wydawnictwo DiG, 2002).

6. See Samuel Kliger, *The Goths in England* (1952), as quoted in John Kenworth-Browne, 'Rysbrack's Saxon Deities', *Apollo* 122 (September 1985), p. 224. Kenworthy-Browne's article gives a definitive account of the different antiquarian and political references in the early eighteenth-century gardens of Stowe. It is not surprising to find the existence of a Saxon grove and a gothic Temple to Liberty within the grounds of Stowe, as the owner of the house, the 1st Viscount Cobham, became a Whig over his dissatisfaction with the government of Sir Robert Walpole.

7. By Gilbert West, the nephew of Richard Temple, 1st Viscount Cobham, who established the early gardens of the house. West wrote, *Stowe: A Poem* in 1731 and mentioned the Saxon deities then. See Kenworthy-Brown, 'Saxon Deities', p. 222. The Rysbrack sculptures of the deities were executed in the late 1720s.

8. Samuel Boyse, 'The Triumphs of Nature', *The Gentleman's Magazine* 12 (1742), p. 380, as cited in Kenworthy-Browne, 'Saxon Deities', note 8. The seven deities are: Sunna (now in the V&A), Mona, Tiw (now at Anglesey Abbey), Woden, Thuner (now in the V&A), Friga (now in the Buckinghamshire County Museum), and Seatern. They have been carved of Portland stone with runic inscriptions. See Susan Moore, 'Hail! Gods of our Fore-Fathers: Rysbrack's "Lost" Saxon Deities at Stowe', *Country Life* 177 (31 January 1985), pp. 250–1.

9. 'Historical Notice of Stowe', xxx. Perhaps Forster may be taking his cue from Horace Walpole, who visited Stowe on more than one occasion. Forster quotes Walpole describing his visit of July 1770: 'In the heretical corner of my heart I adore the gothic building, which by some unusual inspiration, Gibbs has made pure and beautiful and venerable. The style has a propensity to the Venetian or Mosque Gothic ...' (xli).

10. See Michael McCarthy, *The Origins of the Gothic Revival* (New Haven and London: Yale University Press, 1987), p. 30; in Chapter Two, McCarthy discusses political buildings and the use of the triangular form for commemorative structures. He also points out the irony of Gibbs, the architect of the building, being a Roman Catholic educated in Rome. It was the late Michael McCarthy, in conjunction with George Clarke, who first brought my attention to the gardens and architecture of Stowe during the 1980s and who published the first extended account of the Gothic Library at Stowe (see note 15); to him this article is greatly indebted.

11. See Thomas Martyn, *The English Connoisseur: containing an account of whatever is curious in Paintings, Sculpture, etc. in the Palaces and Seats of the Nobility and Principal Gentry of England*, vol. I (London: David and Reymers, 1766), p. 103. Martyn gives a great deal of information about the stylistic variety of the garden structures, which suggested a microcosm of the world. The 'Gothic edifice dedicated to Liberty' was surrounded by the Saxon deities, with an Egyptian pyramid nearby and St Augustine's Cave, a monastic cell (see pp. 99–103). There was also a 'Chinese house' (recently restored by the National Trust) entered via a bridge 'decorated with Chinese vases' (p. 112). Suzanne Lang suggests that the gardens of Versailles, as an image of the world, may have inspired Richard Temple when laying out the Stowe gardens. See 'Stowe and Empire: The influence of Alexander Pope, *Architectural Review* 173 (March 1983), p. 53.

12. Forster was actually viewing a creative reconstruction of a so-called Saxon altar by the 2nd Marquess, who had excavated the Thornborough burial mounds (information courtesy of Michael Bevington). See Forster, 'Historical Notice of Stowe', xxx. He describes the Saxon grove as being situated between the Gothic Temple (Temple to Liberty) and the Cobham Pillar. It has been recently reconstructed by the National Trust using reproduction sculptures.

13. It is highly likely that Soane played a role in completing the principal ('Large') library, as well as connecting the two libraries. I am indebted to Michael Bevington of Stowe School for information about the 1st Marquess as bibliophile.

14. The collections were: the library of Anglo-Saxon manuscripts assembled by Thomas Astle, keeper of records of the Tower of London, and purchased by Lord Buckingham in 1803; and the O'Conor collection of early Irish manuscripts, purchased in 1804. Buckingham had served as viceroy in Ireland; his wife, the Marchioness, was Catholic, and Dr O'Conor had lived at Stowe as librarian and her chaplain. See Michael McCarthy, 'Soane's "Saxon" Room at Stowe', *Journal of the Society of Architectural Historians* 44, no. 2 (May 1985), pp. 130–1.

15. Lord Buckingham to John Soane, 26 August 1804, correspondence in Sir John Soane's Museum, Lincolns Inn Fields, London; the subsequent quotations from Buckingham's correspondence are all drawn from the letters in the Soane Museum. I am most grateful to Stephen Astley, curator of drawings, for his kind assistance and suggestions during the course of my research.

16. Carter is remembered today for being a violent critic of the architect James Wyatt. See J. Mordaunt Crook, *John Carter and the Mind of the Gothic Revival*, vol. 17, Occasional Papers (Leeds: W.S. Maney and The Society of Antiquaries of London, 1995). Carter also, and perhaps more significantly here, executed a series of watercolours in the 1780s recording the furnished interiors at Strawberry Hill in Twickenham, the gothic villa of Horace Walpole.

17. John Carter, *Specimens of Ancient Sculpture and Painting*, 2 vols (1780–6; 1787–94), cited in J. Mordaunt Crook, *John Carter and the Mind of the Gothic Revival*. Figure 12 illustrates Carter's view of the claustral entrance into the

Chapter House at Westminster. Crook calls the work, which was dedicated to Horace Walpole, 'a romantic conflation' that has 'neither chronology nor analysis' (pp. 59–62). For the cathedrals series, see pp. 11–23.

18. See Journal 3, p. 72, daybooks in the Soane Museum, entries for January through March 1805. The drawings were by Charles Malton and Henry Hake Seward, draughtsmen in the Soane office. Their initial scheme of rather monotonous gothic tracery without the quadrants from the south aisle is illustrated in McCarthy, 'Saxon Room', pp. 132–3, figs 3, 4.

19. Thus ended the long reign of the Plantagenets. For a detailed description of the chapel, see James Wilkinson, *Henry VII's Lady Chapel in Westminster Abbey* (London: JW Publications, 2007). The implications of the Battle of Bosworth are still a subject of lively discussion today. See the revisionist treatment of the Tudors' triumph in Desmond Seward, *The Last White Rose: The Secret Wars of the Tudors* (London: Constable, 2010).

20. This was in 1775. It is discussed in McCarthy, 'Saxon Room', p. 146.

21. Soane's daybooks, Journal 5, p. 30, entries for 18 and 21 May 1805. To make life confusing, Saxon, Tudor and gothic were considered more or less interchangeable terms at the time in which the Stowe manuscript library was built. It was not until the self-taught Quaker architect Thomas Rickman published his handbook of medieval architecture in 1817 that the confusion began to be dispelled. See Megan Aldrich, 'Thomas Rickman's Handbook of Gothic Architecture and the Classification of the Past', in Aldrich and Robert Wallis (eds), *Antiquaries and Archaists: The Past in the Past, the Past in the Present* (Reading: Spire Books, 2009), pp. 62–74.

22. For more on Pitt's role at Stowe, see Michael McCarthy, 'The Rebuilding of Stowe House, 1770–1777', *Huntingdon Library Quarterly* 36 (May 1973), pp. 267–98; and Michael McCarthy, 'James Lovell and his Sculptures at Stowe', *The Burlington Magazine* 115 (April 1978), pp. 221–32.

23. For a discussion of Sir Roger Newdigate, whom Walpole ignored due to their political differences and, perhaps, jealousy, see McCarthy, *Origins of the Gothic Revival*, Chapter 5.

24. Correspondence of 16 February 1806 from Lord Buckingham to John Soane, now in Soane Museum.

25. xxxvii. The italics are mine.

26. John Mander, a local carpenter working at Stowe, answered Soane's request for further clarification: 'The Depth of the Circler Pannil in Ceiling cannot be more than 6 inchis' because of the iron girder which supported the ceiling. See a letter of 19 March 1805 from John Mander at Stowe to John Soane, Lincolns Inn, now in the Soane Museum. Mander was responding to Soane's request for information about the room in preparation for designing the circular shield. The initial design showed a small pendant, as per the model at Westminster. See McCarthy, 'Saxon Room', Figure 3.

27. It is signed 'P. Sonard' and dated 1806.

28. See Drawer 33, Set 3, Schedule of Works for Lord Buckingham dated 24 May 1805; and for the plasterwork, see Bill Book E in the Soane Museum; Rothwell invoiced Soane nearly £500 principally during the first half of 1806.

29. That is according to the Schedule of Works for Lord Buckingham dated 24 May 1805. See the Schedule in Drawer 33, Set 3, Sir John Soane's Museum, London. Bevans was paid slightly above £848 for the joinery and woodwork in the library. In the Schedule of Works, it was specified that the carved oak canopies were 'To be made in Town', along with the metal tracery of the glazing bars.

30. Bill Book E, Soane Museum, London; the total amount for brassware was in excess of £187.

31. A drawing for 11 November 1805 shows the shrine being enclosed by gothic doors with canopies above, while another drawing executed the same day shows Astle's portrait above the chimney piece. (Drawer 33, Set 3, Soane Museum, London). Figures 15, 16 and 17 in McCarthy, 'Saxon Room', illustrate these drawings.

32. The relief, of uncertain date, was 'Brought from Castle Hedingham in Essex, the seat of the Veres, Earls of Oxford, depicting the battle of Bosworth Field.' This description is contained in the catalogue of the final sale of the house and contents in 1921. See Jackson-Stops, *The Ducal Estate and Contents of the Mansion*, Stowe House sale, 4–28 July 1921, p. 29.

33. The statuary was executed by Rothwell, the plasterer, and was painted in imitation of patinated bronze. Rothwell invoiced Lord Buckingham on 26 April 1806 for the 'Basso Relievo' (Bill Book E, Soane Museum). A series of six bronze reliefs showing the Crucifixion and Resurrection was originally placed beneath the Bosworth relief, but these were sold in 1848.

34. The octagon table is now owned by the Brighton Museum and Art Gallery, and the suite of three gothic tables from Stowe has an important provenance, having been formerly owned by the distinguished collector of nineteenth-century decorative art Charles Handley-Read, who acquired them from a market stall in Portobello Road, London. For an entry on this furniture, see Frances Collard, 'Side Table', in Christopher Wilk (ed.), *Western Furniture: 1350 to the Present Day in the Victoria and Albert Museum* (London: Philip Wilson, 1996), pp. 140–1.

35. I am most grateful to Anna MacElvoy, head of Stowe House Preservation Trust visitor services, for allowing me to see a preliminary analysis of the paintwork in the Gothic Library carried out in 2009 by Paul Prentice, of Purcell Miller Tritton Architects. Originally the walls and ceiling would have been stone colour (off-white), and the accents in bronze colour for the metal bookcase tracery with bands of dark green and brass. This is consistent with the colouring of the top of the privately owned pier table. The top of the V&A's pier table was repainted black by the museum shortly after its acquisition, whereas the privately owned table preserves a finish of dark, marbled green with white veining which was in place at the time of their sale from the Handley-Read Collection in 1972. It now seems that this painting may have been a restoration of the original scheme when the tables were made for the Stowe library.

36. For further discussion on the subject of this interesting and attractive furniture, see Amin Jaffer et al., *Furniture from British India and Ceylon: A Catalogue of the Collections in the Victoria and Albert Museum and the Peabody Essex Museum* (Salem, MA: Peabody Essex Museum, 2001).

37. Wolsey's doomed retreat to Esher is captured evocatively in the opening chapters of Hilary Mantel's *Wolf Hall* (London: HarperCollins, 2009).

38. The ebony chairs at Esher are discussed in Clive Wainwright, 'Only the True Black Blood', *Furniture History* 21 (1985), p. 251. The late Clive Wainwright, who pioneered the study of this furniture as an 'object of desire' for European collectors, made the intriguing suggestion that William Kent, himself, might have found the ebony furniture and brought it to Esher at the time when he added two gothic wings to the Tudor gatehouse; his work was carried out around 1733 for Henry Pelham, an antiquary and close associate of Sir Robert Walpole, Horace's father.

39. Ibid pp. 251–2. Walpole successfully secured these lots for £45 from the auction at Conyers House in Huntingdonshire, and they were used to furnish Strawberry Hill. (Ibid.)

40. For more on these chairs, see Megan Aldrich, 'William Beckford's Abbey at Fonthill: From the Picturesque to the Sublime' in Derek E. Ostergard (ed.), *William Beckford, 1760–1844: An Eye for the Magnificent* (New Haven and London: Yale University Press, 2001), p. 126, and illustrated in Fig. 7-6.

41. Wainwright, 'Only the True Black Blood', p. 253. John Spicer purchased the house from the last of the Pelham family and demolished Kent's gothic additions of 1733, leaving the fifteenth-century Tudor gatehouse.

42. Forster sale cat., lot 2503, p. 246.

43. Objects in the Gothic Library can be tracked through the Stowe sale catalogues. From the sale catalogue of 1848, it can be seen that the 2nd Marquess of Buckingham had acquired delights such as a pair of chairs from the Doge's Palace in Venice and further objects purchased from the sales at Fonthill. There were early portraits hung in the Armoury, as the anteroom to the Gothic Library was now known, and in the library was a lock of hair from Mary Tudor – the sister of Henry VIII – that was still bright gold in colour. Henry Forster noted that the late Duke was a direct descendant of this Mary Tudor. (Henry Rumsey Forster, lot 280). See Forster sale cat., pp. 245–6.

44. Jackson Stops catalogue, p. 8.

45. Ibid., pp. 188–9. Lot 2826 was the pair of Esher chairs, originally acquired from Fonthill by the first Duke of Buckingham and Chandos. Lot 2827 was the singleton from the original two pairs of chairs with the false Rubens provenance. In the Gothic Library in 1921 there were four further pieces of black furniture, and an oak table of triangular form described as 'antique'.

10. 'Authentic' Identities: Cross-cultural Portrayals in the Late Eighteenth Century by Jos Hackforth-Jones

1. Lars E. Troide (ed.), *The Early Journals and Letters of Fanny Burney* (New York: Clarendon Press, 1988), vol. II, 1774–7. Letter of 1 December, 1774, p. 601. This chapter is indebted to the conversations and input from three scholars: Michele Cohen, Mary Roberts and Megan Aldrich. As ever, the mistakes are my own.

2. Mai is referred to by a number of names – Omai, Omy, Omiah being some of them. In fact he said he came from the family of Mai, so Mai is closest to the name that he took.

3. Lawrence Klein, *Shaftesbury and the Culture of Politeness: Moral Discourse and Cultural Politics in Early Eighteenth-Century England* (Cambridge: Cambridge University Press: 1994).

4. John Cawte Beaglehole, *The Journal of Captain James Cook on His Voyages of Discovery. The Voyage of the Resolution and Adventure, 1772–5* (Cambridge: Hakluyt Society, 1961), p. 428.

5. Ibid.

6. Ibid., p. 94.

7. Ibid.

8. Captain Cook, for example, pointed out that 'Rank seems to be the very foundation of all distinction here, and, of its attendant, power;' See James Cook, *A Voyage to the Pacific Ocean undertaken by the command of his Majesty, for making Discoveries in the Northern Hemisphere...* in 3 vols, (The Strand: W. and A. Strahan, 1784). See also John Hawkesworth, *An Account of the Voyages Undertaken by the Order of His Present Majesty, for Making Discoveries in the Southern Hemisphere ...* (London: 1773).

9. Troide, op. cit., p. 62.

10. Troide, op. cit., p. 63.

11. G. B. Hill (ed.), *Boswell's Life of Johnson* (Oxford: 1934), vol. III, 1776–80.

12. Ibid. This was a persistent view at this time. Lord Chesterfield's letters had recently been published (in 1774). In them he had prioritised imitation and made the point that an individual could never be a gentleman unless he had been in the best of company, since authentic gentlemanliness was obtained not from books but via contact. See also David Roberts (ed.), *Lord Chesterfield Letters 1774* (Oxford: Oxford University Press, 1992).

13. E. H. McCormick, *Omai, Pacific Envoy* (Auckland: Auckland University Press, 1977), p. 71.

14. William Hodges, *Omai (Mai) – a Polynesian*, 1775–7, now in the Hunterian Museum at the Royal College of Surgeons, London. This is a head and shoulders portrait of Mai dressed in what appear to be white robes with less refined handling of the face than in the Reynolds or Parry portraits. See also J. Hackforth-Jones, *Between Worlds: Voyagers to Britain, 1700–1850* (London: National Portrait Gallery, 2007).

15. McCormick op. cit., p. 72.

16. Ibid., p. 72.

17. Beaglehole, op. cit., p. 1343.

18. Louis-Antoine de Bougainville, *A Voyage round the World: Performed by Order of His Most Christian Majesty, in the Years 1766, 1767, 1768, and 1769 by Lewis de Bougainville ... Commodore of the Expedition in the Frigate La Boudeuse, and the Store-ship L'Etoile* (Dublin: 1772), translated from the French by John Reinhold Forster; and John Hawkesworth, *An Account of the Voyages*

Undertaken by the Order of His Present Majesty, for Making Discoveries in the Southern Hemisphere ... (London: 1773).

19. Mai's bills are in the Banks papers in the National Library of Australia. One of his visiting cards is in a private collection in Tahiti. See also Hackforth-Jones (ed.), *Between Worlds: Voyagers to Britain 1700–1850*.

20. High-status non-Western visitors were frequently given European titles such as 'Prince', 'King' or 'Emperor' to connote their high status and identity in a manner that their English audience could understand.

21. John Verelst, *Tee Yee Neen Ho Ga Row, Emperor of the Six Nations*. Library and Archives, Canada.

22. See Stephanie Pratt, 'The Four Indian Kings' in J. Hackforth-Jones (ed.), *Between Worlds: Voyagers to Britain 1700–1850* (London: National Portrait Gallery, 2007). Examples of warrior ties and moccasin shoes are in the Sir Hans Sloane Collection in the British Museum.

23. Ibid.

24. Ibid., pp. 57–8.

25. Ibid., pp. 58–9.

26. J. R. Fawcett Thompson, 'Thayendanegea the Mohawk and His Several Portraits', *Connoisseur*, no. 170 (1969), p. 49.

27. Ibid., p. 51.

28. George Romney, *Joseph Brant (Thayendanegea)*, (1776). Ottawa, National Gallery of Canada; Gilbert Stuart, *Joseph Brant (Thayendanegea)*, also known as the Moira portrait, 1786. London, The British Museum.

29. Gabriel Mathias, *William Ansah Sessarakoo, son of John Bannishee Carrante Chinnee of Anamboe, 1749*. Houston, The Menil Collection.

30. E. H. McCormick, op. cit., p. 174.

31. Martin Postle, and Mark Hallett, *Joshua Reynolds: The Creation of Celebrity* (London: Tate Publishing, 2005), p. 214.

32. Sir Joshua, Reynolds, *Scyacust Utah, 1762*. Tulsa, Gilcrease Museum.

33. Ibid.

34. Martin Postle (ed.), *Joshua Reynolds: The Creation of Celebrity*, exhibition catalogue (London: Tate Publishing, 2005), p. 27.

35. Ibid., p. 69.

36. Ibid., p. 246.

37. Robert R. Wark, (ed.), *Sir Joshua Reynolds, Discourses on Art* (New Haven and London: Yale University Press, 1975) (1st ed. 1959). Discourse VII, p. 140.

38. Ibid.

39. Postle, op. cit., p. 218.

40. Bernard Smith, *European Vision and the South Pacific* (Oxford: Oxford University Press, (1960) 1989).

41. Ibid.

42. Caroline Turner, 'Images of Mai' in *Cook and Omai: The Cult of the South Seas*, (Canberra: The Australian National Library, 2001), p. 27. Pacific historians argue that Mai's clothing was within the normal range of Tahitian dress. A similar turban is evident in drawings made in Polynesia by William Hodges.

43. William Parry, ARA, (1743–91) was a pupil of Reynolds and then went on to the Royal Academy schools before going to Rome (1770–5). Parry was the son of John Parry (1710–82), the famous blind harper and harpist to George III.

44. It is thought that the portraits of Banks and Mai were taken from life but that the portrait of Solander was probably derived from his portrait by Zoffany. See National Portrait Gallery, Heinz Archive and Library RP 6652.

45. Nathaniel Dance, *Portrait of Omai, 1774*. Library and Archives, Canada.

46. *The Independent* (29 November 2001).

47. Constable's *The Lock* was the top price paid for a British painting and sold for £10.7 million in 2001.

48. *The Irish Times* (12 January 2006) (front page). See also *The Daily Telegraph* (27 March 2003).

49. Martin Bailey, 'Reynolds' Portrait of Omai to go to National Gallery of Ireland', *The Art Newspaper* (13 January 2006).

50. Postle, op. cit., p. 69.

51. Ibid.

52. National Portrait Gallery, Heinz Archive and Library RP 6652.

53. Ibid.

54. Ibid.

55. Ibid.

11. Passing the Buck: Perception, Reality and Authenticity in Late Nineteenth-Century American Painting *by* Jonathan Clancy

1. See, for instance, Bruce Chambers, *Old Money: American Trompe L'oeil Images of Currency*, exh. cat. (New York: Berry Hill Galleries, 1988); Edward J. Nygren, 'The Almighty Dollar: Money as a Theme in American Painting', *Winterthur Portfolio* 23 (Summer–Autumn 1988), pp. 129–50. The principle exception to this rule is Meredith Paige Davis, 'Fool's Gold: American Trompe L'oeil Painting in the Gilded Age,' (PhD diss., Columbia University: 2005), especially p. 110 where Davis discusses the art of the period as 'inseparable from questions of authenticity, authority, and representation'.

2. Clifford Geertz, 'Art as a Cultural System', *MLN* 91 (December 1976), p. 1478. See also, Robert Goldwater, 'Art and Anthropology: Some Comparisons of Methodology', in *Primitive Art and Society*, A. Forge (ed.), (London: 1973), p. 10.

3. Karl Marx and Frederick Engels, *Manifesto for the Communist Party* (London: 1848), p. 5.

4. Ralph Waldo Emerson, *Nature* (Boston: James Munroe, 1849), p. 45.

5. Henry David Thoreau, *Walden, or Life in the Woods* (1854) (Boston and New York: Houghton Mifflin, 1893), p. 154.

6. William James, 'The Experience of Activity' in *Essays in Radical Empricism* (New York: Longmans, Green and Co., 1912), p. 160: 'The principle of pure experience is also a methodical postulate. Nothing shall be admitted as fact, it says, except what can be experienced at some definite time by some experient ... In other words: Everything real must be experienceable somewhere, and every kind of thing experienced must somewhere be real.'

7. Indeed, the term 'subjective truth' was in circulation even earlier than Peirce's work. In *The Baptist Magazine* in 1862, for instance, readers were warned: 'We hear a great deal of jargon about *subjective truth*, which we confess is to us utterly unintelligible. For what is subjective truth stripped of its metaphysical garb of words? It shrinks into what we mean by *opinion*. Subjective truth is *truth as it exists in our minds,* and truth in a man's mind is simply opinion.' Rev. John Stock, 'Systems of Theology', *The Baptist Magazine* 54 (January 1862), p. 22.

8. *New England Journal* (27 May 1740) reported the death of the painter Nathaniel Emmons and mentioned: 'some of his imitations of the works of art are so exquisite, that tho' we know they are only paints, yet they deceive the sharpest sight while it is nearly looking on them'.

9. Library of Congress, Printed Ephemera Collection; Portfolio 154, Folder 3c.

10. Herman Melville, *The Confidence Man, His Masquerade* (London: 1857), p. 17.

11. Rene S. Parks, 'The Fine Arts', *Boston Daily Advertiser* (21 November 1892).

12. 'Memento of an Artist: What an Absent Philadelphian Left in the Keeping of a Friend', *Milwaukee Sentinel* (22 March 1883). The article originally appeared in the *Philadelphia Times*.

13. The 'Taggert' mentioned in this article may be William Taggert, whose name is seen in the Harnett painting *Still Life With Letter to William Taggert,* 1878. See Frankenstein, *After the Hunt,* pp. 167–8.

14. 'The Hero of New Orleans' refers to Andrew Jackson, whose portrait graced the Five Dollar Bill. This image appears to be identical to the one presently in the Philadelphia Museum's collection, with the exception of a natural wood background instead of one painted black.

15. This aspect has been evident since ancient times. For the origin of this story, see Pliny the Elder, *Natural History,* vol. 35, in which he recalled the competition between the painters Zeuxis and Parrhasias to see who was best. Zeuxis, full of confidence after painting a bunch of grapes so lifelike that birds came to peck at them, turned triumphantly to Parrhasias and instructed him to remove the cloth from his painting so that all could see it. Poor Zeuxis, of course, had been duped; the cloth *was* the painting and it was Parrhasias's ability to deceive his fellow artist that secured his victory.

16. Quoted in Gertrude Grace Sill, *John Haberle: American Master of Illusion* (New Britain Museum: 2010), p. 25.

17. 'The True Artistic Goal', *Chicago Daily Tribune* (7 July 1889).

18. The distinction frequently made throughout the nineteenth century differentiated imitation from art. As early as 1878, for instance, Harry Willard French wrote in *Art and Artists in Connecticut* (Boston: Lee and Shepard, 1879), p. 26: 'copying, in the sense of reproducing another's picture, is here purposely ignored. It is simply parroting in art, which any one with a knowledge of colors can indulge in. Imitation is not art.'

19. 'Happiness in a Cottage, or Religion Superior to the World', *The Methodist Review* 19 (July 1837), pp. 276–7.

20. 'Making the Most of Oneself', *Putnam's Magazine* (February 1868), p. 207.

21. Henry James, *The Portrait of a Lady,* vol. 1 (London: Macmillan and Co., 1883), p. 233. This story originally appeared as a serial in the *Atlantic Monthly* in 1880–1.

22. Ibid., p. 234.

23. See Chambers, *Old Money,* pp. 78–9; Nygren, 'Money as a Theme,' pp. 147–9.

24. The article appeared originally as 'Paints Millions But Hasn't a Cent' (New York) *World* (3 October 1893). It was soon reprinted under various titles across the nation, see for instance, 'Paints Money: Victor Dubreuil, Soldier, Socialist, Artist, Journalist, and Banker', *St. Louis Post-Dispatch* (29 October 1893).

25. Also calls him 'ex-financier, soldier, journalist, organizer, porter and stableman, and at present artist, author and socialist agitator'.

26. See Nygren, p. 149.

27. Based on the age of his self-portrait in *A Prediction of 1900* as well as some of the claims made in 'Paints Millions But Hasn't a Cent' (New York) *World* (3 October 1893), Dubreuil was born, probably in France, about 1840. He was a soldier during the French intervention in Mexico from 1862 to 1865 and likely stayed in the army until the beginning of the Franco-Prussian War. Later he was involved in banking, and reportedly began a short-lived newspaper titled *La Politique d'Action*. He claimed to have started an African development company – the French equivalent to the East India Company – but with profits benefitting the workers. By 1886 he was living in New York City and in 1888 was granted a patent for a design of suspenders (US Patent no. 386,973, 31 July 1888). He had hoped to make enough money to return to France, and his absence after 1908, along with the discovery of a painting of a 500 franc note by a dealer in Amsterdam, suggests he may have made it back. His perpetual depiction of money – stemming no doubt from his socialist beliefs and buttressed by his penniless predicament – function as a commentary on the gross displays of wealth attendant to the period.

28. Heritage Auctions, Lot 77034, Auction 5024, Thursday, June 11, 2009. The date of 1880 assigned by the Allen Memorial Art Museum for *Is It Real?* (acc. no. 1904.1213) is too early.

29. 'Cross and Pile', *Notes and Queries: A Medium of Inter-Communication for Literary Men, Artists, Antiquaries, Genealogists, etc.* 6 (27 November 1852), p. 513. The issue arose in regard to a recent publication of Rabelais' *Works* by Henry George Bohn.

30. In size, date, and description *Money to Burn* matches *Barrels o' Money* exceptionally well, although the author claimed to discern diamonds and turquoises near the base of the kegs. See 'Paints Millions But Hasn't a Cent' (New York) *World* (3 October 1893).

31. John F. Beazell, *The United States Counterfeit Detector* (Pittsburgh, 1867), p. 8.

32. Although a complete telling of Ferdinand Danton's story is beyond the scope of this chapter, some highlights of biography are useful. During the 1930s, and using the name 'John J. Hughes, MD', Danton forged several portraits which he claimed were by Rembrandt Peale and sold them to the Delaware History Museum. File No. 1975.003 contains correspondence related to the sales, in which Danton (posing as Hughes) pressured the museum to make the sales quickly, pleading extraordinary circumstances and financial distress. The portraits were cautiously authenticated by Richard and Mantle Fielding, as part of the museum's vetting process. He was arrested shortly after this in Washington, DC and released on parole on 12 January 1937. The United States Naval Academy has three works also believed to be by Danton, each with a fraudulent Peale family provenance. I am grateful to James W. Cheevers, Associate Director at the USNA Museum, and Jennifer Potts, Curator of Objects at the Delaware Historical Society for generously sharing their knowledge.

12. National Authenticity on Display? Exhibiting Art from Emerging Markets *by* Natasha Degen

1. This development has inspired Zeitgeist-defining exhibitions such as the 'Tate Triennial 2009', in which curator and neologist Nicolas Bourriaud announced a new era – the altermodern. Superseding postmodernism and its focus on identity politics, altermodernism is characterised as polyglot and rootless. Artists, whom Bourriaud calls *homo viators*, are its globally mobile nomad-protagonists, inhabiting Marc Augé's 'non-places' and eschewing prescribed identity formations. Chrissie Isles and Philippe Vergne's 2006 'post-national' 'Whitney Biennial' similarly presented national culture as artifice. Recent publications, including *Is Art History Global?* (2007) edited by James Elkins and *Real Spaces: World Art History and the Rise of Western Modernism* (2003) by David Summers, concern the possibility of a single, global art history and address the need for non-Euro- or Americo-centric historiographic methodologies to explicate non-Western art. Both projects aspire to open up and globalise the discourse.

2. Heinrich Wölfflin, excerpt from *Principles of Art History* (1915), reproduced in *Art History and Its Methods: A Critical Anthology* (London: Phaidon Press, 1995), p. 149.

3. Moreover, exhibition press releases often identify an artist's nationality within the first sentence as the primary descriptor, suggesting that national identity is central to the artist's practice: for example, 'Thirteen new paintings by Scottish artist Christopher Orr go on display tonight at Hauser & Wirth Zürich'; 'Timothy Taylor Gallery is proud to present the fourth solo exhibition at the gallery of new works by renowned French artist, Jean-Marc Bustamante.'

4. The eighteenth-century German philosopher J. G. Herder was a major exponent of the notion of the purity of authentic local cultures: 'If the nation is a refuge from modern anomie, the question then arises as to who has a right to that refuge. One paradigm for citizenship, which makes the socially constructed nation-state appear deeply rooted in nature and history, is that individuals whose forebears were born into the nation all share a primordial identity with those who have the same biological ancestry and therefore the same primeval collective experiences.' See Charles Lindholm, *Culture and Authenticity* (Oxford: Blackwell, 2008), pp. 98–103.

5. Lindholm, *Culture and Authenticity*, p. 99. With their authoritative architectural rhetoric and prime city-centre locations, 'museums embody and make visible the idea of the state.' See Carol Duncan and Alan Wallach, 'The Universal Survey Museum', *Art History,* 3:4 (December 1980).

6. Lionel Trilling, *Sincerity and Authenticity* (London: Oxford University Press, 1974), p. 93.

7. Karel Berkhout, '*Het Russische sprookje van kunst en gas in Groningen*', *NRC Handelsblad, Cultureel Supplement* (14 March 2008).

8. Advisory Council on International Affairs (Adviesraad Internationale Vraagstukken). 'Cooperation between the EU and Russia: A Matter of Mutual Interest', symposium, 27 October 2008, *www.eerstekamer.nl/behandeling/20081027/verslag_eu…/f=x.doc*

9. Karel Berkhout, op. cit.

10. Tim Webb, 'Gazprom, New Lord of the Dance', *The Observer* (27 January 2008).

11. British Council, 'Royal Ballet China Tour', www.britishcouncil.org/china-arts-drama-rb.htm

12. 'Analysis: Arts Sponsorship Paints a Bright Future for B2B brands', (14 May 2008), www.b2bm.biz/News/ANALYSIS-Arts-sponsorship-paints-a-bright-future-for-B2B-brands

13. 'BP Signs Major Gas Deal with Egypt', *Al Jazeera* (20 July 2010), <http://english. aljazeera.net/news/middleeast/2010/07/2010719164848174444.html

14. Brian Wallis, 'The Art of Big Business', *Art in America* (June 1986), p. 30.

15. 'Exports Up as China Becomes Australia's Biggest Trading Partner', (5 November 2009), www.foreignminister.gov.au/releases/2009/fa-s091105.html

16. 'China and Turkey Eye Trade Boost', *Al Jazeera* (10 October 2010), <http:// english.aljazeera.net/business/2010/10/2010101011238154634.html>

17. American Embassy Paris/Wikileaks, 'Cable 09PARIS1526: France and Brazil: The Start of a Love Affair', (17 November 2009), http://wikileaks.ch/ cable/2009/11/09PARIS1526.html

18. Lekan Olaseinde, 'Nigeria to Establish Cultural Centres in U.S., China, Brazil', *Nigerian Compass Newspaper* (26 July 2010), www.compassnewspaper.com/NG/ index.php?option=com_content&view=article&tid=64285

19. According to the Design Council's 1999 report for 'Creative Britain', 72 per cent of businesses questioned in a survey conducted on 200 of the world's leading companies claimed that they considered national images important with respect to influencing purchasing decisions. See Simon Ford and Anthony Davis, 'Art Capital', *Art Monthly*, no. 213 (February 1998). Furthermore, according to Melissa Aronczyk's research findings, place branding consultants believe that nation branding amounts to little else than an updated, advanced version of national identity. See Melissa Aronczyk, '"Living the Brand": Nationality, Globality and Identity Strategies of Nation Branding Consultants', *International Journal of Communication,* vol. 2 (2008), pp. 41–65.

20. When an artwork is 'flipped', it means it is resold quickly for profit.

21. David Barboza, 'An Auction of New Chinese Art Leaves Disjointed Noses in Its Wake', *The New York Times* (7 May 2008), www.nytimes.com/2008/05/07/arts/ design/07coll.html

 Moreover, the artists represented in the Estella Collection believed that the works were being amassed by a wealthy Westerner who would eventually donate some of the pieces to prominent museums. In reality, the Estella Collection originally belonged to a small group of investors, including Sacha Lainovic, a director of Weight Watchers International, and Ray Debbane, the chief executive of the private-equity firm the Invus Group. Critics say they quickly cashed in, selling the works to Sotheby's and the Manhattan dealer William Acquavella, for reportedly around $25 million. The group of 200 works was auctioned at Sotheby's in 2008.

22. Recent single-collection exhibitions of art from emerging markets include: 'Facing China – Works of Art from The Fu Ruide Collection' (Fu Ruide is the pseudonym of an Icelandic collector), which has been shown at Akureyri Art Museum (2008), Kunstraum Innsbruck (2008), Stadtgalerie Schwaz (2008), Haugar–Vestfold Kunstmuseum Thonsberg (2009), Salo Art Museum (2009), Kuopio Art Museum (2009), Ystads Konstmuseum (2009–10), Singer Museum, Laren (2011), Kunsthalle Recklinghausen (2012); 'RADAR: Selections from the Collection of Vicki & Kent Logan' at the Denver Art Museum (2006–7); 'Half-Life of a Dream: Contemporary Chinese Art from the Logan Collection' at the San Francisco Museum of Modern Art (2008); 'Indian Focus. Artistes Indiens Contemporains dans la Collection de Claude Berri', Espace Claude Berri, Paris (2008); 'Passage to India Part I: New Indian Art from the Frank Cohen Collection' at Initial Access, Wolverhampton (2008); 'Passage to India Part II: New Indian Art from the Frank Cohen Collection' at Initial Access, Wolverhampton (2009); 'Facing East: Recent Works from China, India and Japan from the Frank Cohen Collection' at the Manchester Art Gallery (2010); 'The Silk Road: Works from the Saatchi Gallery: China, India, Middle East', at Le Tri Postal, Lille (2010–11).

23. Jackie Wullschlager, 'Saatchi and Middle East Art', *The Financial Times* (30 January 2009).

24. Phillips de Pury & Company, 'Press Release: BRIC: Brazil, Russia, India and China', *www.phillipsdepury.com/media/275124/lonbricmar2010pressrelease.pdf*

25. Brands can thus be defined here as imagistic equivalents of 'personalities' (in the words of Wally Olins), reputations or even stereotypes.

26. Perhaps Brussels's BOZAR recognised this when they organised a sixth exhibition as part of their 2010 ¡Viva México! Festival. 'El Horizonte del Topo (The Mole's Horizon)', the only exhibition not to explicitly acknowledge sponsorship from the Mexican Embassy in Belgium, was described as 'an antidote to the ideological epic of official Mexico'. Other exhibitions in the Festival included a Frida Kahlo retrospective, 'Imágenes del Mexicano', which told 'the history of Mexico and its quest for identity in 150 portraits', a show of contemporary Mexican photography, an exhibition of Mexican modern architecture, and a display of *Alebrijes,* or Mexican folk art sculptures.

Further Reading

Introduction *by* **Jos Hackforth-Jones and Megan Aldrich**

Bailey, Martin, 'Real or Fake?', *Art Quarterly*, Autumn 2010

The Burlington Magazine, July 2010 (Attributions, Copies and Fakes)

Dorment, Richard, 'La Bella Principessa: a £100m Leonardo or a Copy?', *The Daily Telegraph*, 12 April 2010

Kemp, Martin and Pascal Cotte, *La Bella Principessa: The Story of the New Masterpiece by Leonardo da Vinci*, Hodder and Stoughton, London, 2010

Kemp, Martin and Pascal Cotte, *La Bella Principessa and the Warsaw Sforziad*, October 2011, www.lumiere-technology.com/news/Study_Bella_Principessa_and_Warsaw_Sforziad

Mould, Philip, *Sleuth: The Amazing Quest for Lost Art Treasures*, HarperCollins, London, 2009

Wieseman, Marjorie E., *A Closer Look: Deceptions and Discoveries*, National Gallery, London, 2010

1. Attribution and the Market: The Case of Frans Hals *by* **David Bellingham**

Bode, Wilhelm, *Frans Hals und seine Schule*, E. A. Seemann, Leipzig, 1871

Bode, Wilhelm von (ed.), *Frans Hals: His Life and Work*, Photographische Gesellschaft, Berlin, 1914

Bruyn, J. et al., *A Corpus of Rembrandt Paintings: Stichting Foundation Rembrandt Research Project*, 5 vols, Martinus Nijhoff, The Hague, Boston and London, 1982

D'Otrange-Mastai, M. L. '"Yonker Ramp and His Sweetheart": Two Frans Hals Versions in America', *Connoisseur*, no. 137, April 1956

Gombrich, E., *Art and Illusion*, Phaidon, New York and London, 4th edn, 1972

Grevenstein, A. van et al., 'Aspects of the Restoration and Technical Examination of the Haarlem Civic Guard Group Portraits by Frans Hals', *ICOM Committee for Conservation 9th Triennial Meeting*, Dresden, 1990, pp. 90–4

Grimm, Claus, *Frans Hals: Entwicklung, Werkanalyse, Gesamtkatalog*, Mann, Berlin, 1972

Grimm, Claus, *Frans Hals: The Complete Work*, Harry N. Abrams, New York, 1989

Groot, Cornelis Hofstede de, *A Catalogue Raisonné of the Works of the Most Eminent Dutch Painters of the Seventeenth Century*, 8 vols, English translation by E. G. Hawke from the German edition of 1907, Macmillan, London, 1910

Grosvenor, Bendor, *Finding Van Dyck: Newly Discovered and Rarely Seen Works by Van Dyck and His Followers*, Philip Mould, London, 2011

Hendriks, E., van Eikema Hommes, M. and Levy-van Hahm, K., 'Indigo Used in the Haarlem Civic Guard Group Portraits by Frans Hals' in A. Roy, and P. Smith, *Painting Techniques, History, Materials and Studio Practice*, Contributions to the Dublin Congress, 711 September 1998, The International Institute for the Conservation of Historic and Artistic Works, London, 1998

Howard, Jeremy et al., *Frans Hals' St Mark: A Lost Masterpiece Rediscovered*, Colnaghi, [London]; Salomon Lilian, [Amsterdam], 2008

Jowell, F., 'The Rediscovery of Frans Hals' in Slive, Seymour et al., *Frans Hals*, Prestel, Munich, [Royal Academy exhibition catalogue], 1989

Köhler, N., *Painting in Haarlem, 1500–1850: The Collection of the Frans Hals Museum*, Ludion, Ghent, 2006

Liedtke, Walter, *Dutch Paintings in the Metropolitan Museum of Art*, 2 vols, Yale University Press, New Haven and London, 2007

Middelkoop, Norbert and A. van Grevenstein, *Frans Hals: Life, Work, Restoration*, Uniepers, Amsterdam; Frans Halsmuseum, Haarlem; Alan Sutton, Gloucester, 1989

Monod, François, 'La Galerie Altman au Metropolitan Museum de New-York (2e article)', *Gazette des beaux-arts*, 5th ser., 8, November 1923

Morelli, Giovanni, *Die Werke Italischer Meister in den Galerien von München, Dresden und Berlin: Ein kritischer Versuch*, E. A. Seemann, Leipzig, 1880

Morelli, Giovanni, (trans. Mrs Louise M. Richter), *Italian Masters in German Galleries: A Critical Essay on the Italian Pictures in the Galleries of Munich, Dresden and Berlin*, Bell and Sons, London, 1883

Rosenberg, Jakob and Seymour Slive, *Dutch Art and Architecture: 1600 to 1800*, Penguin, Harmondsworth, 1966; Haeger, 1986

Schrevelius, Theodorus, *Harlemias ofte ... de eerste stichtinghe der stadt Haerlem* Haarlem, 1648

Slive, Seymour, *Frans Hals*, 3 vols, Phaidon, New York and London, 1970-4, vol. 3, cat. 21, pp. 13-14

Stukenbrock, Christiane, *Frans Hals – Fröhliche Kinder, Musikanten und Zecher*, Peter Lang, Frankfurt et al., 1993

Valentiner, Wilhelm Reinhold, *Frans Hals, des meisters Gemälde*, Deutsche Verlags-Anstalt, Stuttgart, 2nd edn, 1923, 307

Valentiner, Wilhelm Reinhold, *Frans Hals Paintings in America*, F. F. Sherman, Westport CT, 1936, 9, no. 4

Trivas, Numa S. *The Paintings of Frans Hals*, Allen & Unwin, London, 1941

Wieseman, M. E., *A Closer Look: Deceptions and Discoveries (National Gallery Company)*, Yale University Press, New Haven and London, 2010

Wild, Angenitus Martin de, *Het natuurwetenschappelijk ondersoek van schilderijen*, s'Gravenhage, 1928

2. A Dialogue of Connoisseurship and Science in Constructing Authenticity: The Case of the Duke of Buckingham's China *by* Morgan Wesley

Atasoy, Nurhan and Julian Raby in *Iznik: The Pottery of Ottoman Turkey*, London, 1989

Bernstein, William, *A Splendid Exchange: How Trade Shaped the World*, London, 2009

Dawson, Aileen, 'The Earl of Stamford's Vase Re-discovered' in *Transactions of the English Ceramic Circle,* vol. 20, London, 2009

d'Entrecolles, Père Francois Xavier, 'Lettre d'Entrecolles à Jao-tcheou, 1er Septembre 1712' and 'Lettre d'Entrecolles à Kim-te-tchim, le 25 Janvier 1722', published in *Lettres édifiantes et curiouses écrites des missions estranges. Mémoires de la Chine etc.*, vols 18 and 19, Paris, 1781.

Goldgar, Anne, *Impolite Learning: Conduct and Community in the Republic of Letters, 1680–1750*, Yale, 1995

Green, Chris, *John Dwight's Fulham Pottery Excavations, 1971–79,* London, 1999

Hoffman, K., *Johann Friedrich Böttger: vom Alchemistengold zum weissen Porzellan: Biographie*, Berlin, 1985

Kerr, Rose, and Nigel Wood, 'Ceramic Technology' in J. Needham (ed.), *Science and Civilization in China,* vol. 5, part XII, Cambridge, 2004

Lang, Gordon, *The Wrestling Boys: An Exhibition of Chinese and Japanese Ceramics from the 16th to the 18th Century in the Collection at Burghley House*, London, 1983

Lang, Gordon, *European Ceramics at Burghley House,* London, 1991

Mallet, John 'Discoveries and Re-Discoveries' in *Transactions of the English Ceramic Circle,* vol. 20, London, 2009

Mill, John Stuart, *A System of Logic: Ratiocinative and Inductive*, London: John W. Parker, 1843.

Spataro, Michela, Nigel Meeks, Mavis Bimson, Aileen Dawson and Janet Ambers, 'Early Porcelain in Seventeenth-century England: Non-destructive Examination of Two Jars from Burghley House' in *The British Museum Technical Research Bulletin*, vol. 3, London, 2009

Tite, Michael, Mavis Bimson, and Ian Freestone, 'A Technological Study of Fulham Stoneware' in J. S. Olin and M. J. Blackman (eds), *Proceedings of the 24th International Archaeometry Symposium*, Washington, 1986

Vogt, Georges, 'Studies on Chinese Porcelain' in Robert Tichane (trans.), *Ching-Te-Chen: Views of a Porcelain City*, New York, 1983, pp. 202–13, first published as 'Recherches sur les porcelaines Chinoises' in *Bulletin de la Societé d'encouragement pour l'industrie nationale*, Paris, 1900

Walcha, Otto, *Meissner Porzellan*, Dresden, 1973

Watson, Oliver, *Ceramics from Islamic Lands*, London, 2004

Wesley, Morgan, 'The Burghley House 'Buckingham' Porcelains as Documentary Objects' in *Transactions of the English Ceramic Circle,* vol. 20, London, 2009

3. A Venetian Sixteenth-century Costume Book as an Authentic Visual Record by Sophie von der Goltz

Anderson Black, J. and M. Garland, *A History of Fashion*, Black Cat, London, 1990

Arnold, Janet, *Patterns of Fashion 4: The Cut and Construction of Linen Shirts, Smocks, Neckwear, Headwear and Accessories for Men and Women*, Macmillan, London, 2008

Baldwin, Muriel, 'Costume, 1400–1600' in *Costume, Gothic and Renaissance: An Exhibition in the Spencer Room*, New York Public Library, New York, 1937

Fortini Brown, Patricia, *The Renaissance in Venice: A World Apart*, Weidenfeld and Nicolson, London, 1997

Hills, Paul, *Venetian Colour – Marble, Painting and Glass, 1250–1550*, Yale University Press, New Haven and London, 1999

Hyatt Mayor, A., 'Renaissance Costume Books', *The Metropolitan Museum of Art Bulletin*, vol. 37, no. 6, June 1942

Lawner, Lynne, *Lives of the Courtesans: Portraits of the Renaissance*, Rizzoli, New York, 1987

Masson, Georgine, *Courtesans of the Italian Renaissance*, Secker and Warburg, London, 1975

Orsi Landini, Roberta and Bruna Niccoli, *Moda a Firenze, 1540–1580: lo stile di Eleonora di Toledo e la sua influenza*, Edizione Polistampa, Florence, 2005

Rosenthal, Margaret F., 'Cutting a Good Figure – The Fashions of Venetian Courtesans in the Illustrated Albums of Early Modern Travellers' in Martha Feldman and Bonnie Gordon, eds, *The Courtesan's Arts: Cross-cultural Perspectives*, Oxford University Press, Oxford, 2006

Stimpson, Catharine R., Introduction to Margaret Rosenthal, *The Honest Courtesan: Veronica Franco, Citizen and Writer in Sixteenth-Century Venice*, University of Chicago Press, Chicago and London, 1992

Vecellio, C., *Habiti antichi et moderni di tutto il mondo*, Appresso i Sessa, Venice, 1598

4. The Authenticity of Traditional Crafts: The Case of Ernest Beckwith by Noël Riley

Attfield, Judy, *Wild Things*, Berg, Oxford and New York, 2000

Beaumont, George Frederick, *A History of Coggeshall, in Essex*, 1890

Bell, Munro, *Chippendale, Sheraton and Hepplewhite Furniture Designs, Reproduced and Arranged*, Gibbings and Co., London, 1900

Bettley, James and Nikolaus Pevsner, *The Buildings of England: Essex*, Yale University Press, New Haven and London, 2007

Chinnery, Victor, *Oak Furniture*, Antique Collectors' Club, Woodbridge, Suffolk, 1979

Fleming, John, Hugh Honour and Nikolaus Pevsner, *The Penguin Dictionary of Architecture*, 4th (rev.) edn, Penguin Books, London, 1991

Huckle, Mary, 'Twentieth-Century Woodcarvers of Coggeshall', *Essex Countryside*, Summer 1953

Kelly's Directory of Essex, 1850

Loudon, John Claudius *Encyclopedia of Cottage, Farm and Villa Architecture and Furniture*, 1833

The Penguin Dictionary of Design and Designers, Penguin Books, Harmondsworth, 1984

Pigot's Directory of Essex, 1835

Pugin, Augustus Charles, *Gothic Ornaments Selected from Various Buildings in England and France*, Priestley and Weale, London, 1831

Musgrave, Clifford, *Regency Furniture*, Faber, London, 1961

Riley, Noël and Andrew Beckwith, *Country Practice: The Business of Ernest Beckwith, 1872–1952*, District Museum, Braintree, Essex, 2000

Rose, Dodo, *Brian Saunders, 1893–1973*, Round House Press, n.p., 1995

Wainwright, Clive, 'Only the True Black Blood', *Furniture History* 21, 1985

5. Acquiring and Displaying Replicas at the South Kensington Museum *by* Barbara Lasic

Baker, M. and B. Richardson (eds), *A Grand Design: The Art of the Victoria and Albert Museum*, V&A Publications, London, 1997

Bell, Q., *The Schools of Design*, Routledge, London, 1963

Bryant, Julius (ed.), *Art and Design for All: The Victoria and Albert Museum*, V&A Publications, London, 2011

Burton, A., 'The Uses of the South Kensington Art Collections', *Journal of the History of Collections,* 14, 1, 2002

Dyce, W., 'Lecture on Ornament Delivered to Students of the London School of Design', *Journal of Design and Manufactures,* 1, 1849

Eyre, George and William Spottiswoode, *Catalogue of Specimens of Cabinet Work, Exhibited at Gore House*, Eyre and Spottiswoode, London, 1853

Eyre, George and William Spottiswoode, *Catalogue of Works Illustrative of Decorative Art. Chromolithographs, Etchings and Photographs*, Eyre and Spottiswoode, London, 1869

Forty, A. *Objects of Desire: Design and Society, 1750–1980*, Thames and Hudson, London, 1986

Hamber, A. J., *A Higher Branch of the Art: Photographing the Fine Arts in England, 1839–1880*, Gordon and Breach, Amsterdam, 1996

Hughes, P., *The Wallace Collection Catalogue of Furniture,* 1, The Trustees of the Wallace Collection, London, 1996

Ingamells, J. (ed.), *The Hertford Mawson Letters. The 4th Marquess of Hertford to his Agent Samuel Mawson*, Trustees of the Wallace Collection, London, 1981

Lasic, B., 'The Collecting of Eighteenth-Century French Decorative Arts in Britain, 1789–1914', unpublished PhD diss., University of Manchester, 2006

Paulson Townsend, W. G., *Measured Drawings of French Furniture from the Collections of the South Kensington Museum*, London, 1899

J. Montagu, 'The Ruland/Raphael Collection', *Visual Resource*, 3, 1986

Rifkin, A., 'Success Disavowed: The Schools of Design in Mid Nineteenth-century Britain', *Design History,* 1, 2, 1988

Robinson, J. C., *Catalogue of Old Sèvres Porcelain*, Eyre and Spottiswoode, London, 1853

Trusted, M. (ed.), *The Making of Sculpture: The Materials and Techniques of European Sculptures*, V&A Publications, London, 2007

Wainwright, C., 'The Making of the South Kensington Museum', *Journal of the History of Collections,* 14, 1, 2002

Walton, W., *France at the Crystal Palace: Bourgeois Taste and Artisan Manufacture in the Nineteenth Century*, University of California Press, 1992

6. Authentic the Second Time Around? Eduardo Paolozzi and Reconstructed Studios in a Museum Environment *by* Bernard Vere

Benjamin, Walter, 'The Work of Art in the Age of Its Technological Reproducibility, Second Version' in Walter Benjamin, *The Work of Art in the Age of Its Technological Reproducibility and Other Writings on Media*, Michael W. Jennings, Bridgid Doherty and Thomas Y. Levin (eds), Edmund Jephcott, Rodney Livingstone, Howard Eiland et al. (trans.), the Belknap Press of Harvard University Press, Cambridge, MA and London, 2008

Barthel, Albrecht, 'The Paris Studio of Constantin Brancusi: A Critique of the Modern Period Room', *Future Anterior*, vol. 3, no. 2, Winter 2006

Crimp, Douglas, *On the Museum's Ruins*, MIT Press, Cambridge, MA and London, 1993

Krauss, Rosalind E., *The Originality of the Avant-Garde and Other Modernist Myths*, MIT Press, Cambridge, MA and London, 1985

Overy, Paul, 'The Cell in the City' in *Architecture and Cubism*, Eve Blau and Nancy J. Troy (eds), MIT Press, Cambridge, MA and London, 1997

Pearson, Fiona, *Paolozzi*, National Galleries of Scotland, Edinburgh, 1999

Pearson, Fiona, 'Sir Eduardo Paolozzi: Pop Art Founder with a Long and Distinguished Career', an obituary in the Scottish newspaper *The Herald*, 26 April 2005

Robbins, David, 'The Independent Group: Forerunners of Postmodernism?' in *The Independent Group*, Robbins (ed.), pp. 237–48 and Massey, *The Independent Group*

Spencer, Robin (ed.), *Eduardo Paolozzi: Writings and Interviews*, Robin Spencer (ed.), Oxford University Press, Oxford, 2000

Wollen, Peter, 'Magritte and the Bowler Hat' in his *Paris Manhattan: Writings on Art*, Verso, London and New York, 2004

'Conversations between Eduardo Paolozzi and Alvin Boyarsky, May 1984', reprinted in *Eduardo Paolozzi: Writings and Interviews*

7. Authenticity, Originality and Contemporary Art : Will the real Elaine Sturtevant Please Stand Up? *by* Anthony Downey

Bowring, Belinda, 'Sturtevant: On Art and its Time' in *Afterall*, no. 18, Summer 2008

Crow, Thomas, *Conceptual Art: A Critical Anthology*, 1999

Dressen, Anne, 'Sturtevant's Fake Mirages' in *Sturtevant: The Razzle Dazzle of Thinking*, Paris Musées, Paris, 2010

Kinsella, Eileen, 'The Trouble with Warhol', *Art News*, 1 April 2011

Leigh, Christian, *The New Good Old Days*, Galerie Six Friedrich, Munich, 1989, cited in Bruce Hainley 'Löschen und wiederholen' in *Sturtevant Shifting Mental Structures*, Neuer Berliner Kunstverein, Ostfildern-Ruit, 2002

Sturtevant, Elaine, 'Interior/Exterior Visibilities' in *The Razzle Dazzle of Thinking*, ARC/Musée d'Art moderne de la Ville de Paris, 2010

Sturtevant, Elaine, *Sturtevant: The Brutal Truth: Catalogue Raisonné, 1964–2004*, Museum für Moderne Kunst, Frankfurt

8. Issues of Authenticity in Contemporary Design: The Smoke Series by Marten Baas *by* Lis Darby

Attfield, Judy, *Wild Things: The Material Culture of Everyday Life*, Berg, London, 2000

Bates, Anna, 'Pieke Bergmans', *Icon*, 069, March 2009

Benjamin, Walter, 'The Work of Art in the Age of Mechanical Reproduction' in *Illuminations*, Harry Zohn (trans.), Hannah Arendt (ed.), Pimlico, London, 1999

Bosoni, Giampiero (ed.), *Made in Cassina*, Skira, Milan, 2008

Downey, Claire, *Neo Furniture*, Thames and Hudson, London, 1992

Fairs, Marcus, *Twenty-first Century Design*, Carlton, London, 2006

Fairs, Marcus, *Icon* 020, February 2005

Fairs, Marcus, 'Maarten Baas: The Red-hot Dutch Furniture-maker's Burning Ambition', *The Independent*, 6 May 2007

Forty, Adrian in *Objects of Desire: Design and Society, 1750–1980*, Thames and Hudson, London, 1986

Hales, Linda, 'Maarten Baas's Claims to Fame', *The Washington Post*, 22 May 2004

Lovell, Sophie, *Limited Edition: Prototype One Off and Design Art Furniture*, Birkhauser, Basel, Boston and Berlin, 2009

Miller, R. Craig, Penny Sparke and Catherine McDermott, *European Design since 1985: Shaping the Century*, Merrell, London in association with Denver Art Museum and Indianapolis Museum of Art, 2009

Phillips, David, *Exhibiting Authenticity*, Manchester University Press, Manchester, 1998

Rawthorn, Alice, 'The Eclectic Charm of Murray Moss', *The New York Times*, 29 July 2007

Sellers, Libby, *Why What How Collecting Design in a Contemporary Market*, HSBC Private Bank, London, 2010

Somers-Cocks, Anna, *The Victoria and Albert Museum: The Making of the Collection*, Victoria and Albert Museum, London, 1980

Williams, Gareth, *The Furniture Machine: Furniture since 1990*, Victoria and Albert Museum, London, 2006

Williams, Gareth, *Telling Tales: Fantasy and Fear in Contemporary Design*, Victoria and Albert Museum, London, 2009

9. Creating an Authentic Style: John Soane's Gothic Library at Stowe *by* Megan Aldrich

Aldrich, Megan, 'Thomas Rickman's Handbook of Gothic Architecture and the Classification of the Past' in Aldrich and Robert Wallis (eds), *Antiquaries and Archaists: The Past in the Past, The Past in the Present*, Spire Books, Reading, 2009

Aldrich, Megan, 'William Beckford's Abbey at Fonthill: From the Picturesque to the Sublime' in Derek E. Ostergard (ed.), *William Beckford, 1760–1844: An Eye for the Magnificent*, Yale University Press, New Haven and London, 2001

Arciszewska, Barbara, *The Hanoverian Court and the Triumph of Palladio: The Palladian Revival in Hanover and England, c.1700*, Wydawnictwo DiG, Warsaw, 2002

Bevington, Michael, *History of Stowe House*, rev. edn., Paul Holberton, London, 2003

Boyse, Samuel, 'The Triumphs of Nature', *The Gentleman's Magazine* 12, 1742

Carter, John, *Specimens of Ancient Sculpture and Painting*, 2 vols, 1780–6; 1787–94, cited in J. Mordaunt Crook, *John Carter and the Mind of the Gothic Revival*, vol. 17, Occasional Papers, W. S. Maney and The Society of Antiquaries of London, Leeds, 1995

Collard, Frances, 'Side Table' in Christopher Wilk (ed.), *Western Furniture: 1350 to the Present Day in the Victoria and Albert Museum*, Philip Wilson, London, 1996

Crook, J. Mordaunt, *John Carter and the Mind of the Gothic Revival*, vol. 17, Occasional Papers W. S. Maney and The Society of Antiquaries of London, Leeds, 1995

Hecksher, Morrison and Leslie Bowman, *American Rococo, 1750–1775: Elegance in Ornament*, Harry N. Abrams, New York, 1992

Jackson-Stops Estate Agency, *The Ducal Estate and Contents of the Mansion*, Stowe House sale, 4–28 July 1921

Jaffer, Amin et al., *Furniture from British India and Ceylon: A Catalogue of the Collections in the Victoria and Albert Museum and the Peabody Essex Museum*, Peabody Essex Museum, Salem, MA, 2001

Kenworth-Browne, John, 'Rysbrack's Saxon Deities', *Apollo*, 122, September 1985

Lang, Suzanne, 'Stowe and Empire: The Influence of Alexander Pope', *Architectural Review* 173, March 1983

Martyn, Thomas, *The English Connoisseur: Containing an Account of Whatever is Curious in Paintings, Sculpture, etc. in the Palaces and Seats of the Nobility and Principal Gentry of England*, vol. I, David and Reymers, London, 1766

Mantel, Hilary, *Wolf Hall*, HarperCollins, London, 2009

McCarthy, Michael, *The Origins of the Gothic Revival*, Yale University Press, New Haven and London, 1987

McCarthy, Michael, 'Soane's "Saxon" Room at Stowe', *Journal of the Society of Architectural Historians*, 44, no. 2, May 1985

McCarthy, Michael, 'The Rebuilding of Stowe House, 1770–1777', *Huntingdon Library Quarterly*, 36, May 1973

McCarthy, Michael, 'James Lovell and his Sculptures at Stowe', *The Burlington Magazine*, 115, April 1978

Moore, Susan, 'Hail! Gods of our Fore-Fathers: Rysbrack's "Lost" Saxon Deities at Stowe', *Country Life*, 177, 31 January 1985

Rumsey Forster, Henry, *The Stowe Catalogue, Priced and Annotated*, David Bogue, London, 1848,

Seward, Desmond, *The Last White Rose: The Secret Wars of the Tudors*, Constable, London, 2010

Snodin, Michael (ed.), *Art and Design in Hogarth's England*, Victoria and Albert Museum, London, 1984

Wainwright, Clive, 'Only the True Black Blood', *Furniture History* 21, 1985

Wilkinson, James, *Henry VII's Lady Chapel in Westminster Abbey*, JW Publications, London, 2007

10. 'Authentic' Identities: Cross-cultural Portrayals in the Late Eighteenth Century *by* Jos Hackforth-Jones

Beaglehole, John Cawte, *The Journal of Captain James Cook on His Voyages of Discovery. The Voyage of the Resolution and Adventure 1772–5*, Hakluyt Society, Cambridge, 1961

de Bougainville, Louis-Antoine, *A Voyage round the World: Performed by Order of His Most Christian Majesty, in the Years 1766, 1767, 1768, and 1769 by Lewis de Bougainville ... Commodore of the Expedition in the Frigate La Boudeuse, and the Store-ship L'Etoile*, translated from the French by John Reinhold Forster, Dublin, 1772

Fawcett Thompson, J. R., 'Thayendanegea the Mohawk and His Several Portraits', *Connoisseur,* no. 170, 1969

Hackforth-Jones, J. (ed.), *Between Worlds: Voyagers to Britain, 1700–1850*, National Portrait Gallery, London, 2007

Hawkesworth, John, *An Account of the Voyages Undertaken by the Order of His Present Majesty, for Making Discoveries in the Southern Hemisphere ...*, London, 1773

Hill, G. B. (ed.), *Boswell's Life of Johnson*, Oxford, 1934, Vol III 1776–80

Klein, Lawrence, *Shaftesbury and the Culture of Politeness: Moral Discourse and Cultural Politics in Early Eighteenth-Century England*, Cambridge University Press, Cambridge, 1994

McCormick, E. H., *Omai, Pacific Envoy,* Auckland University Press, Auckland, 1977

Postle, Martin and Mark Hallett, *Joshua Reynolds: The Creation of Celebrity*, Tate Publishing, London, 2005

Postle, Martin (ed.), *Joshua Reynolds: The Creation of Celebrity*, exh. cat., Tate Publishing, London, 2005

Pratt, Stephanie, 'The Four Indian Kings' in J. Hackforth-Jones (ed.), *Between Worlds: Voyagers to Britain, 1700–1850*, National Portrait Gallery, London, 2007

Roberts, David (ed.), *Lord Chesterfield Letters, 1774*, Oxford University Press, Oxford, 1992

Smith, Bernard, *European Vision and the South Pacific*, Oxford University Press, Oxford, (1960) 1989

Troide, Lars E. (ed.), *The Early Journals and Letters of Fanny Burney*, Vol II. 1774–7, letter of 1 December 1774, Clarendon Press, New York, 1988

Turner, Caroline, 'Images of Mai', p. 27 in *Cook and Omai: The Cult of the South Seas*, exh. cat., The Australian National Library, Canberra, 2001

Wark, Robert R. (ed.), *Sir Joshua Reynolds, Discourses on Art*, Yale University Press, New Haven and London, 1975 (1st edn 1959), Discourse VII

11. Passing the Buck: Perception, Reality and Authenticity in Late Nineteenth-Century American Painting *by* Jonathan Clancy

Beazell, John F., *The United States Counterfeit Detector*, Pittsburgh, 1867

Chambers, Bruce, *Old Money: American Trompe l'Oeil Images of Currency*, exh. cat., Berry Hill Galleries, New York, 1988

Davis, Meredith Paige, 'Fool's Gold: American Trompe l'Oeil Painting in the Gilded Age', PhD diss., Columbia University, 2005

Emerson, Ralph Waldo, *Nature*, James Munroe, Boston, 1849

Frankenstein, Alfred, *After the Hunt*, University of California Press, Berkeley, 1975

French, Harry Willard in *Art and Artists in Connecticut*, Lee and Shepard, Boston, 1879

Geertz, Clifford, 'Art as a Cultural System', *MLN*, 91, December 1976

Goldwater, Robert, 'Art and Anthropology: Some Comparisons of Methodology' in A. Forge (ed.), *Primitive Art and Society*, London, 1973

James, Henry, *The Portrait of a Lady,* vol. 1, Macmillan and Co., London, 1883

James, William, 'The Experience of Activity' in *Essays in Radical Empricism*, Longmans, Green and Co., New York, 1912

Marx, Karl and Frederick Engels, *Manifesto For the Communist Party*, London, 1848

Melville, Herman, *The Confidence Man, His Masquerade*, London, 1857

Nygren, Edward J., 'The Almighty Dollar: Money as a Theme in American Painting', *Winterthur Portfolio*, 23 (Summer–Autumn 1988)

Parks, Rene S., 'The Fine Arts', *Boston Daily Advertiser,* 21 November, 1892

Pliny the Elder, *Natural History,* vol. 35

Sill, Gertrude Grace, *John Haberle: American Master of Illusion*, New Britain Museum, 2010

Stock, Rev. John, 'Systems of Theology', *The Baptist Magazine,* 54, January 1862

Thoreau, Henry David, *Walden, or Life in the Woods* (1854), Houghton Mifflin, Boston and New York, 1893

'Memento of an Artist: What an Absent Philadelphian Left in the Keeping of a Friend', *Milwaukee Sentinel,* 22 March 1883

'The True Artistic Goal', *Chicago Daily Tribune,* 7 July 1889

'Happiness in a Cottage, or Religion Superior to the World', *The Methodist Review* 19, July 1837

'Making the Most of Oneself', *Putnam's Magazine of Literature, Art, Science, and National Interests* 1, February 1868

'Paints Millions But Hasn't a Cent', (New York) *World,* 3 October 1893

'Cross and Pile', *Notes and Queries: A Medium of Inter-Communication for Literary Men, Artists, Antiquaries, Genealogists, etc.* 6, 27 November 1852

12. National Authenticity on Display? Exhibiting Art from Emerging Markets *by* Natasha Degen

Aronczyk, Melissa, '"Living the Brand": Nationality, Globality and Identity Strategies of Nation Branding Consultants', *International Journal of Communication,* vol. 2, 2008

Barboza, David, 'An Auction of New Chinese Art Leaves Disjointed Noses in Its Wake', *The New York Times,* 7 May 2008

Berkhout, Karel, 'Het Russische sprookje van kunst en gas in Groningen', *NRC Handelsblad, Cultureel Supplement,* 14 March 2008

Boswell, David and Jessica Evans, (eds), *Representing the Nation: A Reader: Histories, Heritage and Museums,* Routledge, London, 1999

Duncan, Carol and Alan Wallach, 'The Universal Survey Museum', *Art History,* 3: 4, December 1980

Elkins, James, *Is Art History Global?* Routledge, New York and London, 2007

Ford, Simon and Anthony Davis, 'Art Capital', *Art Monthly,* 213, February 1998

Lindholm, Charles, *Culture and Authenticity,* Blackwell, Oxford, 2008

Olaseinde, Lekan, 'Nigeria to Establish Cultural Centres in U.S., China, Brazil', *Nigerian Compass Newspaper,* 26 July 2010

Stallabrass, Julian, *Art Incorporated: The Story of Contemporary Art,* Oxford University Press, Oxford, 2004

Summers, David, *Real Spaces: World Art History and the Rise of Western Modernism,* 2003

Trilling, Lionel, *Sincerity and Authenticity,* Oxford University Press, London, 1974

Wallis, Brian, 'The Art of Big Business', *Art in America,* June 1986

Webb, Tim, 'Gazprom, New Lord of the Dance', *The Observer,* 27 January 2008

Wölfflin, Heinrich, excerpt from *Principles of Art History* (1915), reproduced in *Art History and its Methods: A Critical Anthology,* Phaidon Press, London, 1995

Wullschlager, Jackie, 'Saatchi and Middle East Art', *The Financial Times,* 30 January 2009

Index

Abstract Expressionism 170
Adam, Robert 123
Adventure (ship) 138, 142
African art 7, 19
Age of Realism 22
Albert, Crown Prince of Saxony 81
Albert Edward, Prince of Wales 81
Albert, Prince 79, 83
Albertina Museum, Vienna 12
Alexander, Tsarevitch of Russia 81
Alfred, Duke of Edinburgh 81
Alliance Française 169
Alloway, Lawrence 95
Altman, Benjamin 26
Amarna Princess (Shaun Greenhalgh) 8
Ambers, Janet 47
American Art Journal 83
Amsterdam hairdressing salon, staircase 113
'Ancient Izmir and Ionia' exhibition (2009) 169
Andy Warhol Foundation 102
Anne, Queen 144
Arbury Hall, Warwickshire 128
Architectural Association, London 97
Arman, *The Day After: Pompei's Syndrome* 116, *117*
Arnoux, Léon 77
Art Authentication Board 102
Art Institute of Chicago, exhibition (1889) 158
Art and Language 16
artists' studios reconstructed 88–97
Arts and Crafts Movement 62, 63
Arundel Society 70
Astle, Thomas 125, 128, 130
Attfield, Judy 116
Attia, Kader, *Ghost* *171*, 173
Australia, Aboriginal art exhibition 169

Baas, Maarten
 Smoke series 17, 108–21
 Carlton Room Divider (Sottsass) *111*, 113, 114
 Smoke armchair *109*, *110*, 114, 116
 Smoke furniture for 'Nocturnal Emissions' exhibition, Groninger Museum, (2004) *113*
Bacon, Francis 16, 18, 89, 94
 reconstructed studio 18, 93
Baker, Malcolm 84, 86
Banham, Rayner 95
Banks, Sir Joseph *140*, 141, 151
Banks-Hodgkinson, Robert 152

Barbizon school 22
Barthel, Albrecht 91, 93, 94
Bartolozzi, Francisco 152
 Omai (Mai), A native of Utaieta (after Dance) *150*
Bavaria, Elector of 79
Beckett, Samuel, *Waiting for Godot* 102, 105
Beckford, William 123, 135, 136
Beckwith, Ernest 16, 17, 62–71, *62*
 chairs
 'ribbon-back' *70*
 splat-back 66
 Chelmsford Cathedral, stall 70
 oak bracket *64*
 Paycocke's restoration 68, *69*
 St Andrew, Clevedon, screen 68, *68*
 St Gregory's, Sudbury, pulpit 70
 St Mary, Gestingthorpe, lychgate 66–7, *67*, 70
 St Mary the Virgin, Saffron Walden, screen, stalls and altar 70
 St Peter's-in-the Fields, Bocking, screen 70
 tripod table *66*
Benjamin, Walter 94
 'The Work of Art in the Age of Mechanical Reproduction' 89, 91–3
Benson, John Angelo, *Corrupted Classics* 115
Bergmans, Pieke 116, 120
 Jasper Morrison's plywood chair with glass *118*, *119*
Berlewi, Henryk 91
Beuys, Joseph 105
Bevans, John 128, 130
Bey, Jurgen, *St Petersburg* chairs *114*, 116
Bianchini Gallery, New York 101
Biesboer, Pieter 30
Bijl, Martin 30
Bimson, Mavis 47
Birmingham School of Art 85
Blazwick, Iwona 17
Bode, Wilhelm von 25
Boswell, James 141, 147
Böttger, Johann Friedrich 41, 42, 45
Botticelli, Sandro, *Primavera* 94
Boucher, François, *Pastorale* 72, *73*
Bougainville, Louis Antoine de 142
Bowring, Belinda 106
Boyarsky, Alvin 94
BP special exhibitions 168
Bracciodiferro, Cassina company 116
Brancusi, Constantin 89, 91, 93
 reconstruction of Atelier Brancusi *92*

Brant, Joseph (Thayendanegea) *145*, 147
Brassaï 92, 93
Brazil
 BRIC sale 173
 cultural diplomacy 169
Bredius, Abraham 15
Breuer, Marcel, *Wassily* chair 115
'BRIC' sale, Phillips de Pury 173
British Council 169
British Museum
 and Buckingham jars 44
 and Iran 18
 Sir Percival David Collection, Yuan dynasty temple vases 40
 exhibitions
 'Cleopatra of Egypt: From History to Myth' (2001) 168
 'Garden and Cosmos: The Royal Paintings of Jodhpur' (2009) 169
 'Journey Through the Afterlife: Ancient Egyptian Book of the Dead' (2010) 168
 'Mummy: The Inside Story' (2003) 168
 'The First Emperor: China's Terracotta Army' (2008) 168
BRML (British Museum Research Lab) 44, 45
Brussels 27
Bryan, William Jennings 163
Buccleuch, Duke of 79, 81
Buchanan, Peter 94
Buckingham, George Nugent-Temple-Grenville, 1st Marquess of 123, 124, *125*, 128, 136
Buckingham, George Villiers, 2nd Duke of 45, 47, 49
Buckingham, Richard Temple-Nugent-Brydges-Chandos-Grenville, 2nd Marquess of 135
Buckingham jars 15, 16, 38–49, *38*, *39*, *48*
Burghley House, Lincolnshire 15, 38
 Devonshire Schedule
 'China Guilt and Enamel'd' 43–4, *43*, 46
 Octagonal plate, Chelsea Factory *46*
 Small octagonal cup, Kakiemon style *46*
 exhibitions
 European Ceramics at Burghley House (1991) 38
 The Wrestling Boys: An Exhibition of Chinese and Japanese Ceramics from the 16th to the 18th Century in the Collection at Burghley House (1983) 38
 see also Buckingham jars; Virtues jar
Burney, Fanny 138, 141, 142
Burney, James 142
Burton, J. Davis, the Raphael Cartoons *85*

Campana Brothers, *Favela* chair 113
Cappock, Margarita 18
Captain Cook Memorial Museum, Whitby 152
Carlisle, Frederick Howard, 5th Earl of 152
Carter, John, *Specimens of Ancient Sculpture and Painting* 125
Casa Morandi, Bologna 89
Cassina 115, 116
Cassou, Jean 93
Castiglioni brothers, *Mezzadro* tractor seat 115
Castle Hedingham, Essex, Overdoor bas relief *130*

Castle Howard, Yorkshire 152
Catherwood, Thomas 130
Cecil, Anne, Countess of Exeter 43
Cecil, Brownlow, 9th Earl of Exeter 39, 44, 45–6, 49
Cecil, Elizabeth, Countess of Devonshire 43
Chancellor, Wykeham 70
Chapman and Hall 70
Chatsworth House 46
Chesterfield, Philip Stanhope, 4th Earl of, *Letters to his son* 141
Chicago Inter-Ocean (journal) 158
China
 BRIC sale 173
 cultural diplomacy 169
Chippendale style 63
Chippendale, Thomas 70
Christie's, New York 10, 12
Clay, Henry 156
Clifford, Sir Timothy 47
Coburn, Alvin Langdon, Vortographs 97
Coccina, Alvise and family 54, *54*
Coggeshall, Essex 63, 65
Cole, Henry 72, 75, 78, 81
 Memorandum on the International Exchange of Copies of Works of Art 83
Confucius Institutes 169, 170
contemporary design 108–21
Convention, 1867 81
Cook, Captain James 138
Cookworthy, Thomas 42
Le Corbusier, *Grand Confort* 115
Corcoran Gallery of Art, Washington 83
corporate sponsorship 18, 168–9
Cotte, Pascal 10, 12
Crittall, W.F. 71
Crow, Thomas, *Conceptual Art: A Critical Anthology* 106
cultural diplomacy 18, 168, 169–70
Culverhouse, Jon 45
Cundell, Downes and Co. 70

Dance, Nathaniel, *Omai (Mai), A native of Utaieta* 141, 148, *150*, 151–2
Danton, Ferdinand 165
Dawson, Aileen 47
Dean Gallery *see* Scottish National Gallery of Modern Art
Department of Science and Art, Great Britain 72, 78, 79
Design Academy Eindhoven 110
Design Miama, 2009 114
Devonshire, Georgiana, Duchess of 148
Diaghilev, Sergei 168
Dicken's House, New York City 163
Doré Galleries, London 97
Doyle, Mr (metalworker) 128, 130
Dublin 152
 Francis Bacon's reconstructed studio 18, 93
Dubreuil, Victor 18
 American Paper Currency 162, 163
 Barrels of Money (Money to Burn) 163, *164*

The Cross of Gold 163
Is It Real? 163
A Prediction of 1900, or A Warning for Capitalists 160, *161*, 163
Duchamp, Marcel 17, 101, 102, 105, 115
 Bottle Rack 101
 Fountain 101
Dwight, John 42, 47, 49

Eames, Charles, plywood chair and stool 113
Earee, F.P. 70
Eastlake, Charles Lock 9
Edinburgh City Art Centre, 'China:
 A Photographic Portrait' (2008) 170
Elkington and Company 83
Elliott, Patrick 93
Emerson, Ralph Waldo 155
English Ceramic Circle 47, 49
d'Entrecolles, Père 41, 42
Erikson, Britta 170
Esher Place, Surrey 135
Estella Collections of Chinese contemporary art 170
Etruscan Warrior (sculpture) 8
Exeter, Brownlow Cecil, 9th Earl of *see* Cecil, Brownlow
Exposition Universelle, Paris, 1867 81

Fonthill Abbey 135
Forster, Henry Rumsey 123, 124, 128, 130, 135
Four Indian Kings 144, 147
France, 'Turkish Season in France' (2009) 169
Franco, Veronica 60
Frans Hals Museum, Haarlem 24, 25
Frederick, Crown Prince of Denmark 81
Friedrich, Caspar David 26
'From Byzantium to Istanbul: Harbour of Two Continents'
 exhibition (2009) 169
Furneaux, Captain Tobias 138, 142
'Le Futurisme à Paris: Une Avant-Garde Explosive'
 exhibition (1912; 2008-8) 97

Gainsborough House, Suffolk 97
Galerie Bernheim-Jeune, Paris 97
Galerie J, Paris, 'America, America' exhibition 101
Gamper, Martino, *If Gio Only Knew* 115
Gasunie Groningen 168
Gaudi, Antonio, *Calvet* chair 113
Gazprom 168
Geertz, Clifford, 'Art as a Cultural System' 155
George Eastman House 97
George II, King 147-8
George III, King 141
Gibbs, James, Temple of Liberty, Stowe 124, *124*
Gimpel & Wildenstein 26
Gober, Robert 105
Goethe-Institut 169
Gore House 78, 79, 81
Gothic Revival 123, 136
Government School of Design 75

Grammercy Park Hotel, New York 114
Grand Palais, Paris, 'From Byzantium to Istanbul:
 Harbour of Two Continents' exhibition (2009) 169
Granville, Earl 81
Gray, Thomas 135
Great Exhibition, 1851 72
Greenhalgh, Shaun 8
Grevenstein, Anne van 27
Grimm, Claus 24, 26, 30, 36
Groninger Museum, Groningen
 'Ilya Repin: The Secret of Russia' (2001-2) 168
 'Nocturnal Emissions' (2004) 113, *113*, 120, 168
 'Russian Legends, Folk Tales and Fairy Tales' (2007-8) 168
 'Russia's Unknown Orient' (2010-11) 168
 'The Russian Landscape' (2003-4) 168
 'Working for Diaghilev' (2004-5) 168
Groot, Cornelis de 26
Groot, Hofstede de 24
Grüner, Ludwig 79

Haberle, John 18, 157-8, 165
 Can You Break a Five? 158, 159
 Imitation 158
 U.S.A. 157, 158, 163
The Hague 31
Hals, Dirck 26
Hals, Frans 9, 22-36
 The Prodigal Son 26
 Willem Coymans 34, *35*
 *Willem van Heythuysen, Seated on a Chair
 and Holding a Hunting Crop* 27-31, *28*, *29*, *30*
 Young Man and Woman in an Inn (attrib.) *25*, 26
Hals, Jan, *Portrait of a Gentleman* 31, *31*, *32*, *33*, 36
Hamilton, Duke of 81
Hannema, Dirk, and H.G. Luitwieler looking
 at *The Supper at Emmaus 14*
Harnett, William Michael 18, 157, 158, 165
 Still Life - Five Dollar Bill 154, 155, 156
 XXX 163
Haudenosaunee tribe 144
Hawarden, Clementina, Lady Hawarden 78
Hawkesworth, John 142, 151
Hayward Gallery, London, Ernesto Neto exhibiton (2010) 168-9
Henderson, Nigel 94, 95
Hendrick (Tee Yee Neen Ho Ga Row,
 Emperor of the Six Nations) 144, *144*, 147
Henry VII, King 128
Hepplewhite style 63, 70
Herder, Bas von 121
Herman, R.W., *Drawing from a Plaster Cast 74*, 75
Herold, Jacques 93
Hertford, Richard Seymour-Conway, 4th Marquess 81
Heythuysen, Willem van 27, *28*, *29*, *30*
'Hittites' exhibition (2009) 169
Hodges, William 141, 142
 Omai (Mai), a Polynesian 142, *143*
Hoffmann, Josef 116

Hoglands, Henry Moore's studio 89
Holbein, Hans, the Younger 9
Hotel Parco dei Principi 115
HSBC, sponsored exhibitions 168-9
Hu, Stern 169
Hutten, Richard
 Poef Pouff 113
 Table Chair 113

Imperial College, London 45
Impressionism 22
Independent Group, ICA 94, 95
 'This is tomorrow' exhibition (1956) 95
India, BRIC sale 173
Indian Council for Cultural Relations (ICCR) 169
Institute of Contemporary Art, Independent Group 94, 95
 'Parallel of Art and Life' (1953) 94, 95, 97
International Socialist Movement 161
Iran, and British Museum 18
Iroquois tribe 144
Israel Museum, Jerusalem 170
Italian Futurism 97
Iznic wares 77, *77*, *78*

Jackson, Andrew 156
Jackson, Arthur Blomfield 70
Jacobé, Johann (John Jacobi) 148
James, Henry, *The Portrait of a Lady* 161
James, William 155
Japan, cultural diplomacy 169
'Japan Year 2010 in Turkey' 169
Jerome Napoleon Bonaparte, Prince de France 81
Jesuit Church, Chinese and Indian missions 41
Johns, Jasper 101, 105
Johnson, Samuel 141, 148
Jong, Volko de 168

Kadeer, Rebiya 169
Kallat, Jitish, *Annexe 172*, 174
Keating, Nevill 152
Kemp, Martin 10, 12, 15
Keppel, Admiral Augustus 148-9
Kertesz, André 93
Kiefer, Anselm 105
Knoll (furniture) 115
'Krazy Kat Arkive' 95
Kuramata, Shiro 116

Lang, Gordon 38, 44, 45
Le Gray, Gustave 78
Leigh, Christian 101
Leonardo da Vinci
 La Bella Principessa 10, *11*, 12, *13*, 15
 St Jerome in the Vatican 10
 Salvator Mundi 12
Lichtenstein, Roy 101
Liedtke, Walter 26

Litvinenko, Alexander 168
London Camera Club 97
Los Angeles County Museum of Art 97
Loudon, J.C. 65
Louisiana Museum of Modern Art, Humlebaek, Denmark 170
Ludwig, Prince of Hesse 81
Luitwieler, H.G. 15
Lumière Technology 10

McCarthy, Paul 105
 Painter 95, *96*
McCormick, E.H. 142
Mackintosh, C.R.
 Argyle chair 113
 Hill House chair 110, *111*
Magnier, John 152
Magritte, René 94
Mai (Omai) (act. Parridero) 17-18, 138-44, *139*, *140*, 147, 148-53
Mallet, John 45
Malton, Charles *see* Seward, Henry Hake
Mao Zedong 173
Marx, Karl 155
Mathias, Gabriel, *William Ansah Sessarakoo 146*, 147
Mauritshuis, The Hague 31
Medici Porcelain production 45
Meegeren, Han van 15, 24
 Boy Smoking a Pipe (style of Hals) *23*
 Christ and the Disciples at Emmaus (style of Vermeer) *14*, 15
Meeks, Nigel 47
Meissen factory, Saxony 41, 42
Melville, Herman, *The Confidence Man: His Masquerade* 156
Mendini, Alessandro 115
 Monumentino de Casa 116
Mercier, Vivien 102, 105
Merle, Jacques van 47
Methodist Review, 'Happiness in a Cottage, or
 Religion Superior to the World' 161
Metropolitan Museum of Art, New York 25
Michelangelo
 David, cast 84
 Moses, cast 84
Middelkoop, Norbert 27, 30, 47
Middleton, Andrew 44
Mies van der Rohe, *Barcelona* chair 115
Milan Furniture Fair (2002) 110
Minotaure (journal) 92
Minton & Co. 77
 bottle vase *78*
Moira, John Rawdon, 1st Earl of 147
Mondrian, Piet, studio 93
Monod, François 26
Moooi company 114, 121
Moore, Henry 89
Morandi, Giorgio 89
Morelli, Giovanni 24, 25
Morgan Stanley 168
Morris, Robert, 'Bodyspacemotionthings' (1971; 2009) 97

Morris, William 16, 62, 63
Morrison, Jasper, *Plywood* chair 116, *118*, *119*
Moscow 83
Moss Gallery, Los Angeles 114
Moss Gallery, New York 110
Moss, Murray 110, 116
Musée National d'Art Moderne, Paris 91
Musées Royaux des Beaux-Arts de Belgique, Brussels 27
Museo di Palazzo Reale, Pisa 55
Museum für Moderne Kunst (MMK), Frankfurt,
 'The Brutal Truth' 105
Museum of Manufactures, Marlborough House (later South
 Kensington Museum; Victoria and Albert Museum) 72

Namuth, Hans 95
nation-themed exhibitions 167–74
National Academy of Design Exhibition (1887) 158
National Art Library 70
National Art Museum of China, Beijing, Aboriginal
 art exhibition (2011) 169
National Court of Art Instruction (NCAI) 75
National Gallery of Art, Washington 24
National Gallery of Ireland, Dublin 152
National Gallery, London 31
 'Close Examination: Fakes, Mistakes and Discoveries' (2010)
 9, 22, 24, 26
 Leonardo da Vinci: Painter at the Court of Milan (2011-12) 12
National Inventory Research Project 72
National Museum of Wales 152
National Portrait Gallery, London 152
'New Topographics' (1975; 2009) 97
New York 12, 25, 97, 101, 110, 113, 163
Newdigate, Sir Roger 128
Newson, Marc, *Wooden* chair 114
Nicholson, Sir Charles 70
Nigeria, cultural diplomacy 169
Ninger, Emanuel 165
Noguchi, Isamu, freeform table 113
North Carolina Museum of Art 31
Northcote, James 148
Northumberland, Hugh Percy, Duke of 147
Novembre, Fabio 113
Nygren, Edward 161

Oates, Captain Lawrence 70
Oldenburg, Claes 100, 101
 The Store 100
Olley, Margaret 18
Omai *see* Mai
Orry, Père 41
Os, Henk van 168
d'Otrange-Mastai 26
'Ottoman Textiles and Kaftans' exhibition (2009) 169
Overy, Paul 93

Palais de Tokyo, Paris 91
Palais Kinsky, Vienna 27

Panofsky, Erwin 9
Paolozzi, Edward 16, 94–5
 Plaster Blocks 94
 reconstructed studio, Scottish National Gallery of Modern Art
 88, 89, *90-1*, 93–5
 'Parallel of Life and Art' exhibition (1953; 2001)
 88, 89, *90-1*, 93–4, 97
Parham Park, West Sussex 152
Parry, William 141
 Omai (Mai), Sir Joseph Banks and Daniel Solander
 140, 148, 151, 152, 153
Paycocke's, Coggeshall 68, *69*
Pearson, Fiona 93
Peirce, Charles Sanders 155–6, 161
Penguin Club, New York 97
Penny, Nicholas 12
Pesce, Gaetano 116
Phillips de Pury, 'BRIC' sale 173
Picasso, Pablo, studio 92, 93
Pisa 55
Pitt, Thomas, Lord Camelford 122, 128
Pollen, John Hungerford 83, 84
Polley, William Bally 65, 66
Pollock, Jackson 95
Pompidou Centre, Paris 91, 97
Ponti, Gio 115
Pop Art 100
Postmodernism 95, 97
Pot, Bertjan 110, 116
Provence, Comtesse de 79
Pugin, A.C., *Gothic Ornaments* 68
Putnam's Magazine 161

Rabelais, François 163
Raiatea, South Pacific 142
Raphael 79
 Cartoons 84, *85*
Ray, Man 93
Redgrave, Richard 72, 75
Reece Mews, London 93
Rembrandt Research Project 22, 24
Remy, Tejo, *You Can't Lay Down Your Memories* chest of drawers
 113, 115
Renzo Piano Building Workshop 92, 94
 Reconstruction of the Atelier Brancusi 92
Repin, Ilya 168
replicas, South Kensington Museum 72–86
replicated exhibitions 97
Reynolds, Sir Joshua 17, 138, 141
 Omai (Mai) *139*, 148, 149, 151, 152
 Scyacust Ukah 149
Rheims cathedral 93
Riesener, J.H. 79, 81
Rietveld, Gerrit
 Red/Blue chair 113, 114
 Zig Zag 113
Robbins, David 95

Robinson, John Charles 72, 75, 79
Romantic Movement 123
Romney, George, *Joseph Brant (Thayendanegea)* *145*, 147, 152
Rosenthal, Margaret F. 60, 61
Rothwell, Mr (plasterer) 130
Rousseau, Jean-Jacques 142
Royal Academy, London 24
 'From Russia: French and Russian Paintings 1870-1925' (2008)
 168
Royal Ballet, Tour of China 168
Royal Collection 79, 81
Rubens, Peter Paul 136
Ruskin, John 16, 62, 63
Russia
 BRIC sale 173
 cultural diplomacy 169
 exhibitions at Groninger Museum 168
 Russkiy Mir Foundation 169

Sa Ga Yeath Qua Pieth Tow, King of the Maquas 144, *144*
Sa, Raphael 45
Saatchi, Charles 170
Saatchi Gallery 170
 'The Empire Strikes Back: Indian Art Today' (2010) 167, 173, 174
 'The Revolution Continues: New Chinese Art' (2008) 167, 173
 'Unveiled: New Art from the Middle East' (2009) 167, 173
St Petersburg 83
San Francisco Museum of Modern Art 97
Sanchi Tope Eastern Gateway, cast, Victoria and Albert Museum
 84, *84*
Sandwich, John Montagu, 4th Earl of 138, 141
Santiago de Compostels Cathedral, cast 84
Schrager, Ian 113
Schröder, Klaus 12
Scott, General Henry 84
Scottish National Gallery of Modern Art 88, 89, 91, 93, 94, 95, 97
 Paolozzi Archive 93
Scyacust Ukah 148, *149*
Segal, George 101
Serpentine Gallery
 'China Power Station' (2006-7) 167
 'Indian Highway' (2008-9) 167
Sessarakoo, William Ansah *146*, 147
Sèvres china 72, 75
Seward, Henry Sake 128
 Chapel of Henry VII, Westminster Abbey (with Charles Malton)
 126, *127*
Shelley, F. 75, 77
 Ceramics in the South Kensington Museum 76, 86, 94
Sheraton designs 70
Silver End, Braintree 71
Silverman, Peter 10
Simon-Whelan, Joe 102
Skinner, Paul 168
Slive, Seymour 24, 26, 30, 36
Smith, John Raphael 147
Smithson, Alison and Peter 94

Soane, John 17, 123, 128
 furniture designed by *133*, 136
 Gothic Library at Stowe 122-36
Solander, Daniel *140*, 141, 142, 151
Sottsass, Ettore, *Carlton Room Divider* *111*, 113, 114
Soulages Collection 84
South Kensington Museum (later Victoria and Albert Museum)
 artefacts
 French secretaire *80*, 81, *81*
 Iznic bottle *77*
 Cast Courts *82*, 83-4, 86
 Making a cast of the Sanchi Tope *84*
 Trajan's Column *82*
 Circulation Department 85
 photography 78-9
 replicas 72-86
Spataro, Michela 47
Stamford, Earl of 49
Stanhope, Philip 141
'Stealing Beauty: British Design Now' (1999) 116
Steichen, Edward 93
Stowe House, Buckinghamshire 17, *122*, 123
 Gothic Library 122-36, *129*, *131*
 furniture 132-6
 sale catalogues 135-6
 Large Library, *Lord Buckingham in the Large Library* 125
 Temple to Liberty *124*
"Strauss Tankard" 83
Strawberry Hill 128, 132, 135
Stuart, Gilbert 147
studio reconstructions 88-97
Sturtevant, Elaine 9, 17, 100-6, *100*
 Duchamp descendant l'escalier 104
 Johns Double Flag *103*, 105
 Oldenburg Store Object, Pie Case 100
 The Store of Claes Oldenburg 100, *100*, 101
 Warhol Gold Marilyn 102
 Warhol Marilyn 105
 Warhol Marilyn Diptych 102
 Warhol's Flowers 105
Swift, Jonathan 163

Taggert, Special Officer 157
Tahiti 138, 141
Tate Britain, London 97
Tate Modern, London 97
Tee Yee Neen Ho Ga Row, Emperor of the Six Nations (Hendrick) 144,
 144, 147
Testelin, Louis, 'La Fidelité' *47*
Thompson, Charles Thurston 79
Thonet's chair no. 14 (1859) 110
Thoreau, Henry David 155
Thrale, Mrs Hester 148
Tillyard, Stella 148, 152
Tintoretto, portrait of Procurator Jacopo Soranzo 54
Titian 54
 Girl with a Fan *53*, 54

portrait of Doge Marcantonio Trivisani 54
Toledo, Eleonora, funeral dress 55, 56, *56*
Townsend, W.G. Paulson, *Measured Drawings of French Furniture...*
 80
Trajan's Column, cast *82*, 84
Trilling, Lionel 168
Trivas, N.S. 26
trompe l'oeil 156–9, 163
Tschirnhaus, Ehrenfried Walther von 41, 42, 45
Turkey, cultural diplomacy 169
'Turkish Season in France' 169
Tweed River Art Gallery 18

Umberto, Crown Prince of Italy 81
Underwood, Mr (metalworker) 130
United States, cultural diplomacy 170
Universal Exhibition, Vienna, 1873 83

Valentiner, Wilhelm 26
Vatican, *Loggia*, cast 84
Vaughan, Brigadier Charles 152
Vaughan, Sir Robert Williams 152
Vecellio, Cesare
 Habiti antichi et moderni 50–61
 Avogadori 59
 Cancelliere Grande 59
 Cortigiana *59*, 60
 Donne la vernata 61
 Meretrici publiche 61
 Nobile ornata 50, *51*, 56–7, *57*, *58*, 60
 Rettore di Scolari 50, *52*, 54
 Senator et Cavallieri 59, *59*
 Spose sposate 53
 Usati in Venetia 53, *53*, 54
 Venetiane per casa 61
Venice, society in 16th century 57–61
Venice Biennale 167
Verberg, George 168
Verelst, Jan 147
 Sa Ga Yeath Qua Pieth Tow, King of the Maquas 144
 Tee Yee Neen Ho Ga Row, Emperor of the Six Nations 144
Vermeer, Jan 15
 Christ and the Disciples at Emmaus (attrib.; act. van Meegeren)
 14, 15
 Veronese, Paolo, *Adoration of the Virgin by the Coccina family*
 54–5, *54*, *55*, 57
Victoria and Albert Museum 19, 44, 47, 72, 75, 120
 artefacts
 carved ebony side chair, southeast Asian *134*
 side table attributed to John Soane 132, *133*
 exhibitions
 'China Design Now' (2008) 169
 'India Design Now' (2012) 167
 'Specimens of Cabinet Work' exhibition (1853) (Gore House
 exhibition) 79, 81
 'Krazy Kat Arkive' 95
 see also South Kensington Museum

Vienna 12, 27, 83
Virtues jar *44*, 45, 46–7, 49
Vissers, Casper 114
Vitra company 115
Vogt, Georges 42
Vorticism 97

Wallace Collection 79, 81
Wallis, Brian 169
Wallis, George 83
Walpole, Horace 17, 63, 123, 128, 132, 136
Wanders, Marcel 114
Warhol, Andy 17, 100, 101, 102, 105, 106
 Norgus series 102
Warwick, George Greville, 2nd Earl of 147
Washington, DC 24, 83
Washington, George 156
Watt, James 123
Webb, Tim 168
Webster, Daniel 156
Wei, Lui, 'Love It! Bite It!' 173
Wells, H.G., *Love and Mr Lewisham* 84
Wesley, Morgan 45
Westminster Abbey 123, 125, *126*, *127*, 130
Where There's Smoke, Moss Gallery, New York (2004) 110, 113, 120
Wieseman, Marjorie E. *A Closer Look: Deceptions and Discoveries* 9
Wild, A.M. de 25
Williams, Glynn 95
Wind, Edgar 9
Wolsey, Cardinal Thomas 132, 135, 136
woodcarving 66–71
Wyatt, James 135

Yanagi, Sori, *Butterfly* stool 116
'Year of Brazil' in France 169
'Year of China in Turkey' (2012) 169
'Year of France' in Brazil 169
'Year of Russian Culture' in Turkey (2007) 169
'Year of Turkey in China' (2013) 169
'Year of Turkey in Japan' (2003) 169
'Year of Turkish Culture' in Russia (2008) 169
Yu, Peng *see* Yuan, Sun
Yuan, Sun and Peng Yu, *Old Person's Home* 166–7, 173
Yunus Emre Institutes, Turkey 169